PHILADELPHIA MUSEUM OF ART

HANDBOOK

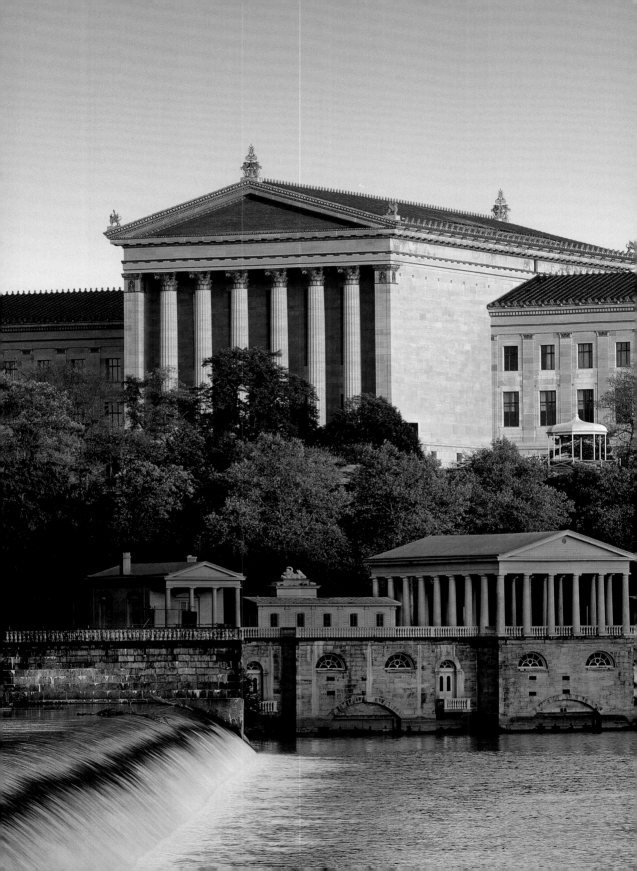

PHILADELPHIA MUSEUM OF ART

HANDBOOK

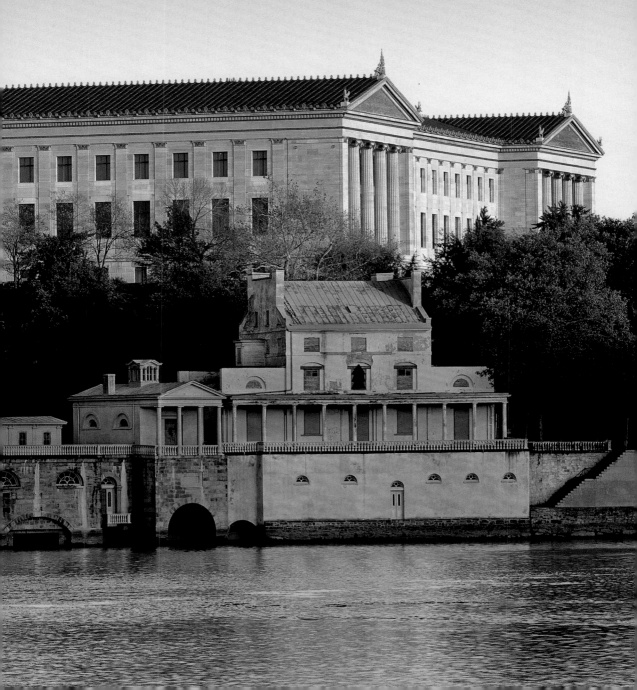

Edited by Sarah Noreika
Production by Richard Bonk
Design by Katy Homans
Color separations, printing, and binding by Conti Tipocolor S.p.A., Florence, Italy

Produced by the Publishing Department
Philadelphia Museum of Art
Sherry Babbitt
The William T. Ranney Director of Publishing
2525 Pennsylvania Avenue
Philadelphia, PA 19130-2440 USA
philamuseum.org

Second printing

Front cover: Marcel Duchamp, *Nude Descending a Staircase (No. 2)*, 1912 (p. 237)

Frontispiece: The Philadelphia Museum of Art and the Fairmount Water Works seen from the
banks of the Schuylkill River (photograph by Graydon Wood)

Details on divider pages: Asia, *Screen with Lotuses*, Korea, Joseon dynasty, 19th century (p. 74);
Europe, Joseph Mallord William Turner, *The Burning of the Houses of Lords and Commons*,
1834–35 (p. 180); Americas, *Shawl*, Mexico, late 18th century (p. 273); Contemporary, Felix
Gonzalez-Torres, *"Untitled" (Petit Palais)*, 1992 (p. 404)

ISBN 978-0-87633-258-0 (PMA)
ISBN 978-0-300-20799-6 (Yale)

Library of Congress Control Number: 2014948083

CONTENTS

PREFACE

The publication of this new handbook of the collection of the Philadelphia Museum of Art is a welcome event. Several years in the making, it will provide readers who are not familiar with the institution with a sense of the breadth and scope of our holdings of Asian, European, American, and contemporary art. For those who know the Museum well, the handbook will serve as a welcome reminder of why our collection is considered to be one of the finest of its type in this country.

Taken as a whole, the descriptions of individual works of art and brief essays contributed by some fifty-five members of our curatorial staff, past and present, offer a rich and fascinating portrait of a collection of many different parts. Shaped over time by the contributions of countless individuals, it represents an extraordinary achievement. As stewards of this remarkable resource, it is our responsibility not only to care for the collection and utilize it in creative ways, but also to continue to strengthen the legacy we have inherited. In this regard, it is important to note that a significant number of the works included in this new edition of the handbook have been acquired since we published the first edition nearly twenty years ago.

The production of a new handbook that surveys a collection of the size and scope of ours requires the work of many hands, and it is my great pleasure to acknowledge all those who have contributed to its success. This project would not have gotten underway or proceeded as smoothly as it has without the leadership of Sherry Babbitt, our William T. Ranney Director of Publishing, who oversaw, with her characteristic good cheer, every aspect of its development with a clear understanding of what we had set out to accomplish. A number of members of Ms. Babbitt's staff made material contributions to the handbook's editing, design, and production, most notably Richard Bonk, Book Production Manager, and Sarah Noreika, Associate Editor, who deserves special mention. As the editor of this publication, she has done an exceptional job of managing a complex schedule, shaping and improving the texts submitted by many different authors, and working closely with Katy

Homans, whose ingenuity and creative talent are clearly evident in the design of the handbook. Special gratitude is also owed to the Museum's Photography Studio, headed by Graydon Wood, which so ably fulfilled countless photography requests.

I would like to offer my personal thanks to several individuals who have given freely of their time and knowledge to help move this project forward: Maude de Schauensee, a longtime friend and supporter of this institution who provided generous research assistance for the preparation of the introductory essay; Susan K. Anderson, the Martha Hamilton Morris Archivist here at the Museum, whose guidance to information about the Museum's early history proved invaluable; and Alice Beamesderfer, our Pappas-Sarbanes Deputy Director for Collections and Programs, who worked very closely with Ms. Babbitt and me during the handbook's early stages of development and the review of successive drafts and designs.

On behalf of our staff and Board of Trustees, I am delighted to be able to recognize the significant financial contribution that the members of our Associates and Chairman's Council programs made to this publication, and to take this opportunity to express our gratitude for their generous support of such a worthy cause. I am also pleased to offer a heartfelt thanks to the many members of our curatorial departments and our division of Education and Public Programs who reviewed the collections, recommended the works of art to be included in this publication, and wrote the entries for each.

Finally, I would like to acknowledge the generative role that our donors, past and present, have played in the development of the Museum's collection. The remarkable record of their generosity and their steadfast belief in the future of this institution and the city it was founded to serve can be found in the pages of this book, and it is to them that we owe our greatest thanks.

TIMOTHY RUB
The George D. Widener Director and Chief Executive Officer

This new edition of the Museum's handbook has been made possible thanks to the generosity of many members of the Philadelphia Museum of Art Associates and Chairman's Council on the occasion of the fortieth anniversary of the Associates in 2011. For more than four decades, the Associates have been at the very heart of this institution, providing a continued legacy of advocacy and support.

Authors

Matthew Affron	MA		John B. Ravenal	JBR
Elisabeth R. Agro	ERA		Yael Rice	YR
Christopher Atkins	CA		Christopher Riopelle	CR
Peter Barberie	PB		Joseph J. Rishel	JJR
David L. Barquist	DLB		Susan Rosenberg	SR
Carlos Basualdo	CB		Darrel Sewell	DS
Erica F. Battle	EFB		Innis Howe Shoemaker	IHS
Caitlin M. Beach	CMB		Carol E. Soltis	CES
Dilys Blum	DB		Nathaniel M. Stein	NMS
Amanda N. Bock	ANB		Carl Brandon Strehlke	CBS
Laura L. Camerlengo	LLC		Brittany A. Strupp	BAS
Ainsley M. Cameron	AMC		Michael Taylor	MT
Mark A. Castro	MAC		Ann Temkin	AT
Martha Chahroudi	MC		Pierre Terjanian	PT
Donna Corbin	DC		Jennifer A. Thompson	JAT
Eda Diskant	ED		Mark S. Tucker	MST
Felice Fischer	FF		Anna Vallye	AVa
Kathleen A. Foster	KAF		John Vick	JV
Emily Hage	EH		Adelina Vlas	AVl
H. Kristina Haugland	HKH		Dean Walker	DW
Kathryn Bloom Hiesinger	KBH		James Wehn	JW
Jack Hinton	JH		Hyunsoo Woo	HW
John Ittmann	JI			
Anna Juliar	AJ			
Mary Anne Dutt Justice	MADJ		## Photographers	
Hiromi Kinoshita	HK			
Kyoko Kinoshita	KK		Principal photography by	
Alexandra Alevizatos Kirtley	AAK		Graydon Wood	
Nora S. Lambert	NSL			
Shelley R. Langdale	SRL		Additional photography by	
Darielle Mason	DM		Jason Wierzbicki, Lynn Rosenthal,	
Mark D. Mitchell	MDM		Constance Mensh, and Joe Mikuliak	
Ann Percy	AP		(except as noted)	

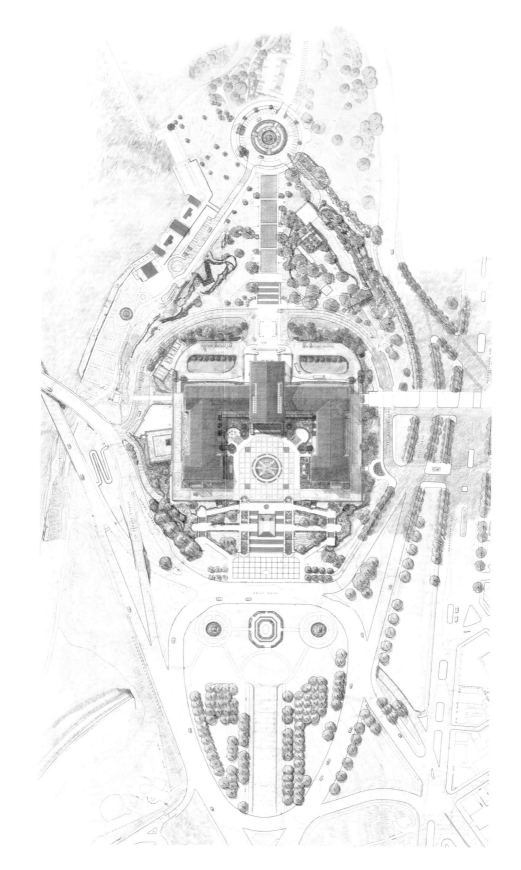

INTRODUCTION

Founded in 1876, on the occasion of the Centennial Exhibition, the first world's fair to be held in the United States, the Philadelphia Museum of Art is one of this country's oldest public art museums and has long been recognized as one of its finest. It is in many ways an exceptional place, possessed of a rich and distinguished history and a collection that is remarkable for its breadth as well as its depth.

This new edition of the Museum's handbook, the first to be published in nearly twenty years, is intended to serve several purposes. Its primary function is to introduce readers to our holdings of Asian, European, American, and contemporary art through what might best be described as an executive summary of the collection. The works included in this survey represent all the Museum's curatorial departments, and they have been chosen to provide the reader with a sense of the scope of their holdings as well as their most distinctive characteristics.

In addition to offering a comprehensive overview of the collection, the handbook includes extended entries on a number of works that we consider to be of particular significance. Equal emphasis has been given to the way in which the collection has grown over the course of nearly 140 years. This is a fascinating story, and one that is central to understanding the history of both the Museum and the city it was founded to serve. It is also, and perhaps most importantly, about the energy, enthusiasm, and intelligence that countless dedicated individuals—collectors, curators,

Fig. 1. OLIN. Rendered plan for the Philadelphia Museum of Art, 2014
© OLIN

and directors—have brought to the task of shaping a collection that is today one of Philadelphia's most significant cultural resources and the envy of many museums in this country and throughout the world.

The decision to establish the Pennsylvania Museum and School of Industrial Art, the name by which this institution was known until 1938, was motivated by a sense of civic pride in Philadelphia's history and its rich artistic traditions as well as by the belief that the creation of a new museum and school would yield substantial economic benefits for both the city and state. Following the model of the recently established South Kensington Museum in London (today the Victoria and Albert Museum), the founders of the new museum in Philadelphia envisioned "the development of the art industries of the State by means of exhibits of objects in all branches of industrial art, in connection with the furnishing of instruction in drawing, painting, modeling, designing, etc., through practical schools, special libraries and otherwise" (*Bulletin of the Pennsylvania Museum*, April 1, 1905, pp. 17–18). Education was central to the mission of this institution at the time of its founding, and this remains the case today.

From the outset, however, the new museum and school were managed essentially as separate institutions. The school, which grew rapidly with support from both private and public funds, was housed initially in rented facilities in several locations until, in 1893, a permanent home was secured with the purchase of the beautiful Greek Revival building at the northwest corner of Broad and Pine Streets that had been designed by the great Philadelphia architect John Haviland to house the Pennsylvania School for the Deaf. It continues to function today as the University of the Arts.

The art gallery designed by Herman J. Schwarzmann for the Centennial Exhibition, one of the few permanent structures built to house exhibits at the fair, was designated as the Museum's new home. It was opened to the public for the first time as the rechristened Memorial Hall on May 10, 1877 (fig. 2). Adapting this building to its new purpose did not prove to be an easy task. As a consequence, the annual reports issued by the Museum's trustees during its early years were filled with descriptions of the work that

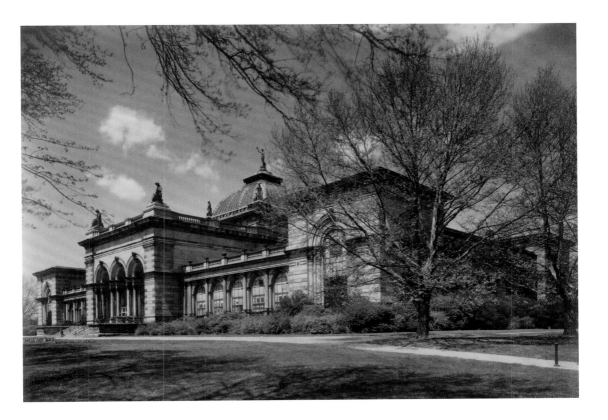

Fig. 2. Memorial Hall, c. 1930.
Building designed by Herman J.
Schwarzmann for the 1876
Centennial Exhibition

was required to keep the building in good repair and with pleas to the city and state to provide the funds to do so.

The location of Memorial Hall in West Fairmount Park, some four miles from the center of the city, also posed significant challenges in terms of public access. Nevertheless, attendance grew steadily during the Museum's first several decades, and by the early 1890s it had become apparent that the building could not accommodate additional visitors or, for that matter, the needs of a growing collection.

In its earliest years the Pennsylvania Museum and School of Industrial Art struggled to attract both gifts of works of art and the contributions needed to purchase objects for its collection, which in essence had to be built from scratch. This is not surprising, as the formation of collections of the fine and decorative arts, both by individuals and by public museums, was at the time still in its infancy in this country. Given the purpose for which the institution had been founded, the Museum's initial focus was the acquisition of outstanding examples of the applied or decorative arts, historical as well as

contemporary. This approach, it was argued, would not only fulfill the new Museum's mission, but also shape the development of its collection in ways that would distinguish it from those of public art museums that had recently been founded in other American cities such as Boston, Chicago, and New York.

At the outset these efforts yielded mixed results, but over time the collection began to take shape with the help of a number of dedicated supporters who believed in the promise of the young institution. Among the most important of these early benefactors were Clara Bloomfield Moore, whose collection of paintings and decorative arts became the Museum's first significant gift when it was received in 1882; Robert H. Lamborn, who donated his collection of Mexican colonial paintings and pre-Columbian art to the Museum in 1895; and John T. Morris. The head of a prosperous ironworks in Philadelphia, Morris served as a trustee of the Museum for twenty-three years and over time donated to the institution more than fifteen hundred works of art that he and his sister Lydia had acquired. Among these were outstanding examples of European and American ceramics, glass, and metalwork; Japanese sculpture; and arms and armor. Morris, who had developed a deep interest in early American ceramics, also was responsible for purchasing for the Museum the extensive collection of this material that had been assembled by Edwin AtLee Barber, one of the pioneering scholars in the field.

The interest in American art that Morris and Barber shared was not singular; rather, it reflected a broader ambition on the part of trustees and staff to create a distinctive place for it within the collection and, once again, to set the Museum apart from its peers. Given the prominent role that Philadelphia has played in the development of American art for more than three hundred years, this has remained an important focus of our collecting efforts, with the result that today the Museum boasts one of the most varied and extensive collections of this type in the country.

Barber joined the Museum as its curator in 1901 and later became its director, but he had first been asked to serve, in 1892, as an honorary curator of the newly created department of American pottery and porcelain, contributing on a voluntary basis both his

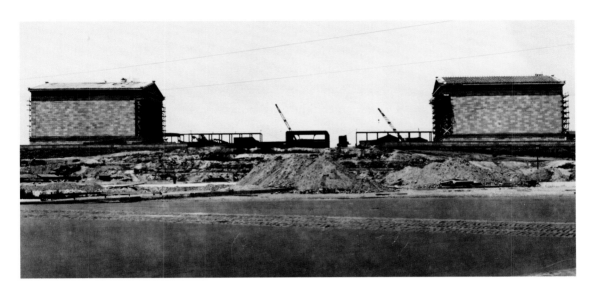

Fig. 3. Construction of the side pavilions of the Museum, 1925. Building designed by Horace Trumbauer and Zantzinger, Borie and Medary

expertise on the subject and his ability to attract gifts. He was but one of a number of such honorary curators—others included Cornelius Stevenson, a noted collector of arms and armor, and the sculptor Alexander Stirling Calder—whom the Museum enlisted to the cause of researching and enriching its collections when funds were too scarce to retain professional staff. The participation of these individuals, who gave freely of their time and knowledge, came at a critical moment. It also set a pattern for volunteer engagement that has continued to be vitally important to the development of the collection.

The decision in 1909 to decommission the Fairmount Water Works on the banks of the Schuylkill River, which for nearly a century had served as the city's principal water supply, provided those who had long advocated for a new and much larger home for the Museum the opportunity they had been waiting for. With the hill that rose above the waterworks no longer needed as a reservoir, this prominent location at the western end of the broad, landscaped parkway that had been proposed to connect the center of the city to Fairmount Park was selected as the site for a new building.

After nearly a decade of planning and vigorous debate, construction began in 1919 and was completed in 1928 (fig. 3). The grand structure, clad in a buff-colored limestone, soon became— and remains—one of Philadelphia's great architectural landmarks

and a powerful symbol of its artistic ambitions. Yet only twenty of its galleries were finished and ready for use when it opened on March 26, 1928, causing one critic to dub the building "a great Greek garage": an impressive but still largely empty vessel. With the Depression and the wartime economy that followed making construction funds scarce and, at times, nonexistent, it would take more than thirty years to finish the interior of the building.

Nevertheless, this vast new structure provided the Museum's young and energetic director, Fiske Kimball (see fig. 10), an architect and architectural historian who had been appointed to the post in 1925, and his curators with a large canvas upon which to realize their ambitious plans for the development of the collection. The new galleries initially provided much-needed space to exhibit gifts such as the group of paintings that had been bequeathed to the city of Philadelphia (and entrusted to the care of the board of commissioners of Fairmount Park) in 1890 by Mrs. W. P. Wilstach, and the two impressive collections of, respectively, European and English paintings that had more recently been bequeathed to the Museum by William L. Elkins and his son George W. Elkins (see pp. 164–65), and by John Howard McFadden. Adding a sense of urgency to the construction schedule, both donors had stipulated that a new building to house their gifts be completed within a reasonable time after their deaths.

Other generous gifts soon followed. These included old master prints from the collection of Charles M. Lea (1928); a large body of works by Thomas Eakins donated in 1929 and 1930 by his widow, Susan Macdowell Eakins, and their friend Mary A. Williams (see pp. 292–93); a comprehensive collection of European and American glass from George H. Lorimer (1938); and the fine collection of French eighteenth-century decorative arts that had been assembled by Eleanore Elkins Rice (1939; see pp. 164–65).

In addition, during the years immediately after the opening of its new home on Fairmount, the Museum was asked to take responsibility for the care and display of several other important collections that had recently been donated to the citizens of Philadelphia. These included the extensive holdings of sculpture and drawings by Auguste Rodin that the American cinema and real estate magnate Jules

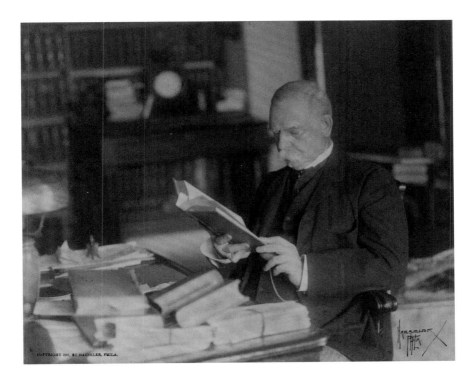

Fig. 4. John G. Johnson, 1907

Mastbaum had acquired in the early 1920s and had pledged to house in a building designed for this purpose on the new parkway that was later named in honor of Benjamin Franklin, and the remarkable collection of old master and nineteenth-century paintings that the esteemed corporate lawyer John G. Johnson had bequeathed to the city upon his death in 1917 (fig. 4; see also pp. 134–35).

Not satisfied with developing the Museum's collection by gifts alone, Kimball actively—and often with great success—sought funds for the purchase of works of art that he felt would strengthen and broaden its holdings. Among his finest accomplishments was persuading his trustees to acquire the exceptional collection of the French connoisseur Edmond Foulc (fig. 5; see also pp. 104–5). Comprised of more than two hundred works of Gothic and Renaissance decorative arts and sculpture, this purchase, finalized in October 1929, was an extraordinary step to take at a time when the country was on the brink of a severe economic depression.

Perhaps the most resourceful of the Museum's directors, Kimball left an indelible stamp on the installation of its collection in the new building. The galleries were laid out under his supervision,

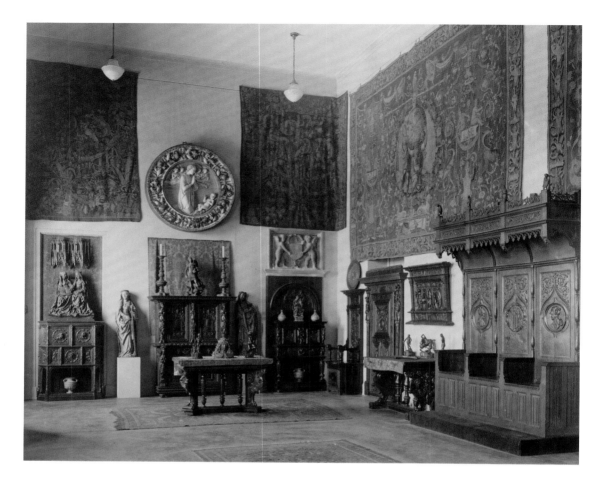

Fig. 5. Selections from the collection of Edmond Foulc displayed in one of the Museum's galleries, c. 1930

and many were designed by his own hand (see, for example, fig. 6). A showman at heart, Kimball also encouraged his curatorial staff to find architectural interiors that would provide sympathetic settings for the masterpieces of Asian, European, and American art already in the collection as well as those he hoped to acquire. "The work has just begun," Kimball wrote in the Museum's *Bulletin* in February 1928 (p. 5).

> Ten rooms and ten galleries are installed. Twenty-seven more
> rooms are needed to carry out the project in its full extent.
> Many of these rooms have been found and await their givers;
> others still are being sought. There is an opportunity now
> for individuals to aid. The works of art—paintings and
> sculpture—may and will be acquired over a period of many
> years. But the authentic antique interiors and backgrounds

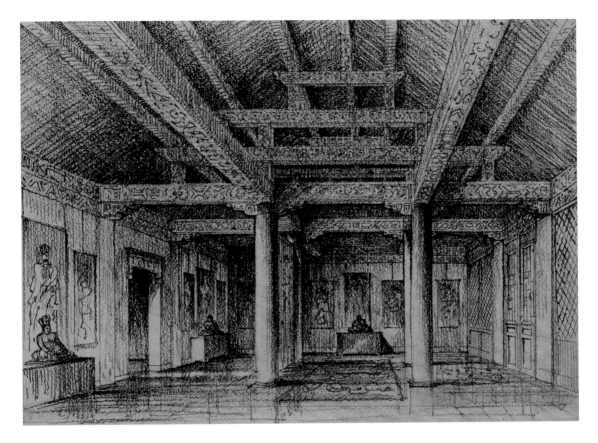

Fig. 6. Attributed to Fiske Kimball. Drawing for the Ming dynasty reception hall (p. 56), late 1920s

that will make these rooms live again must be had at once, to be built in as the finishing of the galleries progresses.

Through this effort, the Museum came into the possession of some of the most extraordinary works in its collection, including the Chinese reception hall dating to the late Ming dynasty (p. 56) and the elegant Neoclassical drawing room from Robert Adam's Lansdowne House in London, designed in the 1760s (p. 162). These interiors imbue our galleries with their distinctive character and continue to delight visitors today.

It was also at this time that the Museum accepted responsibility for the management and care of three other buildings: the new Rodin Museum, an elegant Beaux-Arts pavilion for the Mastbaum collection designed by the French-born Philadelphia architect Paul Philippe Cret along with Jacques Gréber, which opened to the public in

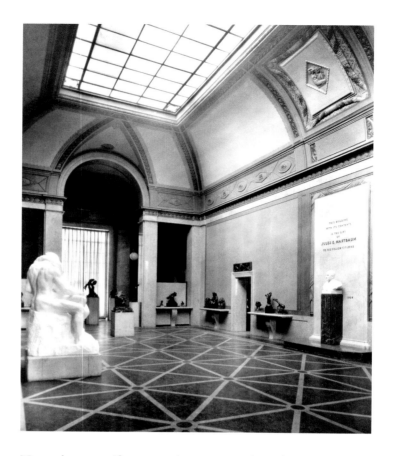

Fig. 7. Main gallery, Rodin Museum, 1929. Building designed by Paul Philippe Cret with Jacques Gréber

November 1929 (fig. 7; see also pp. 214–15); and two historic houses in Fairmount Park. Mount Pleasant, a country villa built by the Scottish ship captain John Macpherson between 1762 and 1765, was described by John Adams as "the most elegant seat in Pennsylvania" (fig. 8). Cedar Grove, a handsome stone structure that once stood in the Frankford section of the city, had served as the summer home for a Quaker family from the mid-eighteenth century to the 1920s, when it was presented as a gift to Philadelphia and moved to its present location, not far from Memorial Hall.

The Museum's initial focus on collecting the industrial arts (with a number of curatorial departments—such as those devoted to ceramics, metalwork, and textiles—established to accomplish this purpose) was broadened during the first several decades of the twentieth century to include—and eventually to favor—the fine arts. This shift was, perhaps, inevitable given the direction in which education in the visual arts and, more broadly, the interests of the

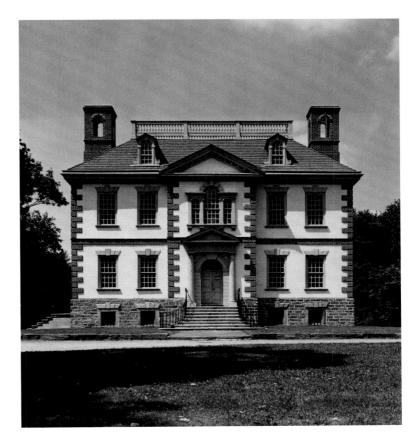

Fig. 8. Mount Pleasant, c. 1970. Building designed by Thomas Nevell; constructed 1762–65

public had evolved over the course of time; but the Museum's early commitment to the "useful arts," as they were once called, is still evident in our galleries and, most especially, in our rich holdings of American ceramics, furniture, and metalwork.

Through an understanding established in the 1930s with the University of Pennsylvania Museum of Archaeology and Anthropology that the two institutions would collect in a complementary rather than competitive way, it was agreed that the Philadelphia Museum of Art, which assumed its present name later in that decade, henceforth would focus almost exclusively on the acquisition of American art, European art from the early medieval period to the present day, and Asian art. Perhaps born of necessity at a time when resources were scarce, this division of labor has continued to serve both institutions well.

Among its peers, the Museum has distinguished itself through a sustained focus on modern and contemporary art. However

energetically he may have developed the institution's holdings of earlier American, Asian, and European art, Kimball did not neglect the art of his own time. To the contrary, he and his curatorial staff embraced it, actively engaging leading collectors such as Louise and Walter Arensberg and Albert E. Gallatin (figs. 9, 10; see also pp. 236–37, 242–43). Rich in works by, among others, Constantin Brancusi, Marc Chagall, Fernand Léger, Joan Miró, Pablo Picasso, and, above all, Marcel Duchamp, their remarkable donations to this institution, given in 1950 and 1952, respectively, formed the foundation of what today is one of the most important collections of early modern art to be found anywhere in the world.

These transformative gifts—for it is no exaggeration to characterize them as such—undoubtedly served as inspiration for other donations that would come to the Museum in the following decades from generous collectors such as Louis E. Stern (1963); Mr. and Mrs. Carroll S. Tyson, Jr. (1963); Samuel S. White III and his

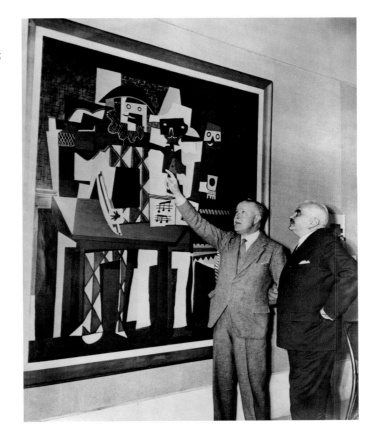

Fig. 10. Albert E. Gallatin and Fiske Kimball looking at Pablo Picasso's *Three Musicians* (1921; p. 235), 1943

wife, Vera (1967); and Carl Otto Kretzschmar von Kienbusch (1977). The Tysons' gift of twenty-two Impressionist and Post-Impressionist paintings—including one of several versions of Vincent van Gogh's *Sunflowers* (1888 or 1889; p. 200), Pierre-Auguste Renoir's *Large Bathers* (1884–87; p. 187), and a number of important paintings by Paul Cézanne and Édouard Manet—certainly stands as one of the most significant donations made to this institution, and was as consequential in its own way as those that came from Gallatin and the Arensbergs. Kienbusch's remarkable collection of arms and armor, the finest of its type in private hands, had been assembled with scholarly care over the course of more than six decades. Numbering approximately 1,200 objects, it was bequeathed to the Museum in 1977 (fig. 11).

Kimball's successors—most notably Anne d'Harnoncourt, who did so much to strengthen this institution during her long and productive tenure first as curator and then as director from 1982 to

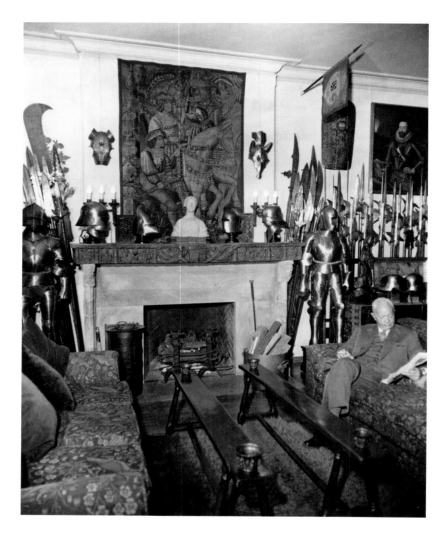

Fig. 11. Carl Otto Kretzschmar
von Kienbusch in his armory,
New York, c. 1954

2008 (see fig. 13)—have built upon his legacy and made their own distinctive contributions: Henri Marceau, by securing the Stern and Tyson collections; Evan H. Turner, through his commitment to photography and passion for contemporary art; and d'Harnoncourt, through the acquisitions of a major collection of European prints made possible by a gift from Muriel and Philip Berman and a large body of archival materials related to the life and work of Marcel Duchamp, as well as through her remarkable ability to engage a new generation of donors to assist with the ongoing development of the collection. Among d'Harnoncourt's many achievements was the expansion of the Museum's campus with the opening of the Ruth and Raymond G. Perelman Building, the great Art Deco

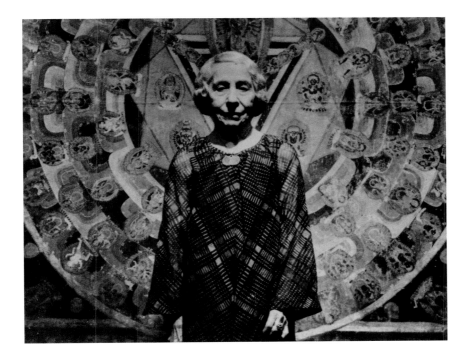

Fig. 12. Stella Kramrisch at the Museum's *Himalayan Art* exhibition, 1978

masterpiece that had been designed by the Philadelphia architectural firm of Zantzinger, Borie and Medary for the Fidelity Mutual Life Insurance Company and constructed between 1926 and 1928 (see fig. 14).

In this work, she and her predecessors were fortunate to have enjoyed the support of a talented and enterprising curatorial staff, several of whom donated their own collections to the Museum. In this regard, the generous bequests made by Henry P. McIlhenny, whose superb collection of nineteenth-century paintings and decorative arts was formed with the visual acuity of a great connoisseur (see pp. 190–91), and Stella Kramrisch, the pioneering scholar and curator of Indian art (fig. 12; see also pp. 16–17), stand out as landmarks.

The ongoing development of the Museum's collection continues to be as rich and eventful as it has been at any time in the past. In recent years we have benefited from the generous commitments of great collectors such as Robert L. McNeil, Jr., whose interest in Philadelphia and the many contributions the city has made to the history of American art is reflected in his generous bequest to the institution (see pp. 260–61); Jill and Sheldon Bonovitz, whose passion

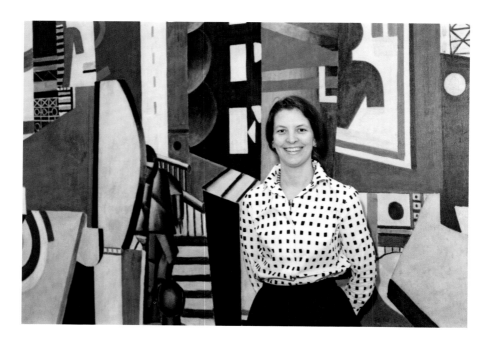

Fig. 13. Anne d'Harnoncourt in front of Fernand Léger's *The City* (1919; p. 233), 1982

for the work of self-taught artists has struck a deep and resonant chord within the community (see pp. 348–49); and Keith L. and Katherine Sachs, who have graciously pledged to the Museum their exceptional collection of contemporary art (see pp. 422–23).

Furthermore, when singular opportunities have been presented to us—for example, the first great horse and man's armors to come onto the market in more than a half century and the chance to acquire a comprehensive body of work by the renowned modernist photographer Paul Strand (see pp. 112, 320–21)—we have been fortunate to enjoy the support of enlightened donors such as Athena and Nicholas Karabots, Marguerite and H. F. (Gerry) Lenfest, and Lynne and Harold Honickman, who believe in the ability of works of art to enrich our lives and in the enduring value of strengthening the Museum's collection for the benefit of the community.

In this regard, the acquisition in 2007 of Thomas Eakins's 1875 masterpiece *Portrait of Dr. Samuel D. Gross (The Gross Clinic)* stands as an extraordinary example of the aspirations that have shaped the development of our collection in the past and continue to do so today (see p. 294). Few works of art can be said to embody this city's cultural and intellectual ambitions as powerfully as *The Gross Clinic*, a landmark in the career of one of the country's most celebrated

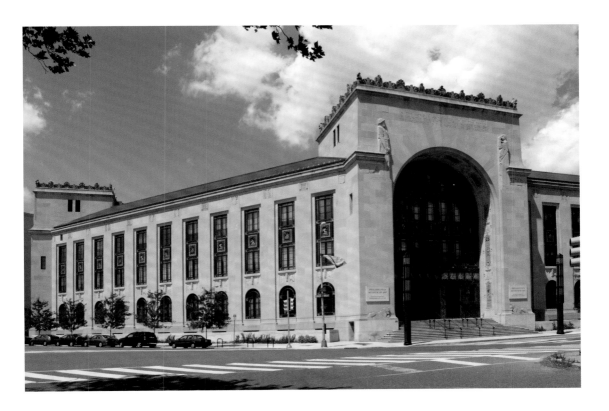

Fig. 14. Ruth and Raymond G. Perelman Building, 2009. Building designed by Zantzinger, Borie and Medary for the Fidelity Mutual Life Insurance Company; constructed 1926–28. Renovated and expanded 2007 by Gluckman Mayner Architects

artists, and a painting that is emblematic of the pivotal role that Philadelphia has played in the history of medical science. To prevent the sale of this treasure and its removal from the city, it was purchased jointly by the Philadelphia Museum of Art and the Pennsylvania Academy of the Fine Arts. This decision, which was motivated as much by a sense of civic pride as it was by an appreciation of the painting's significance to the history of American art, engendered widespread support within the community from donors—some 3,600 in all—who understood the value of honoring and preserving for the benefit of generations to come our shared cultural heritage. As this remarkable story attests, the development of a great collection like ours is, as it always will be, a shared enterprise that requires the commitment of a dedicated staff, passionate collectors, and a community that cares deeply about the arts. At the Philadelphia Museum of Art, we are fortunate to have all of these.

TIMOTHY RUB

Asia

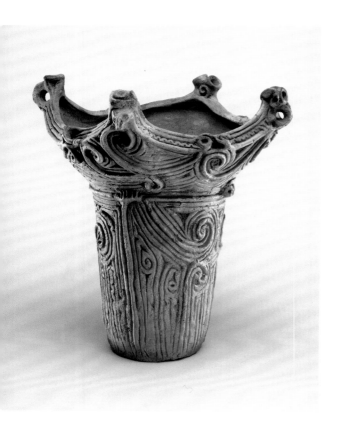

Female Figure
India, West Bengal, Tamluk, c. 3rd–early 2nd century BC
Terracotta, H. 9 in. (22.9 cm)
Stella Kramrisch Collection, 1994-148-294

This elegant female figurine—one of the finest pre-served terracotta images from early India—speaks to the global nature of the ancient world. Her heavy jewelry and undulating drapery reflect stone sculptures created for India's Maurya rulers, one of whom protected the subcontinent from the incursion of Alexander the Great. Her smooth face, however, suggests mold-made Greco-Roman figurines. Tamluk, where this terracotta was discovered in the 1940s, is located near the mouth of the Ganges. In antiquity it was a bustling city that controlled the Indian Ocean trade, as we know from the writings of some of its international visitors, including the second-century Greek geographer Ptolemy and the seventh-century Buddhist pilgrim Xuanzang. DM

Jar
Japan, Middle Jōmon period (2500–1500 BC)
Earthenware, H. 14⅛ in. (35.9 cm)
125th Anniversary Acquisition. Purchased with the Hollis Family Foundation Fund, the Henry B. Keep Fund, and the East Asian Art Revolving Fund, 1999-130-1

In the late nineteenth century, American archaeologist Edward S. Morse applied the term *jōmon* (literally "straw-rope pattern" or "cord mark") to ancient Japanese ceramics decorated by impressing cords into the wet clay. Like most *jōmon* wares, this example, the bold design of which combines straight and curved lines with an exaggerated rim resembling an ocean swell, likely would have been used for boiling food, perhaps even being placed directly into the fire. The excellent condition of this vessel therefore makes it a rare and important example of this ancient pottery type. KK

Model of a Building

China, Henan Province, Eastern Han dynasty, 2nd century
Earthenware with traces of pigment, H. 48 in. (121.9 cm)
Gift of Charles H. Ludington from the George Crofts Collection,
1925-53-9a–f

Since few ancient buildings survive, models such
as this, which were placed in tombs to accompany
the deceased in the afterlife, provide vital material
evidence of early Chinese architecture. This model
illustrates the basic building scheme used in China
for nearly two thousand years: post and crossbeam
construction, bracketing to support the weight of the
beams, and tiled roof. Originally painted, the build-
ing probably represents the main house of a large
residential complex, with a lower story for storage of
grain, upper floors for living quarters, and a watch-
tower on top. HK/FF

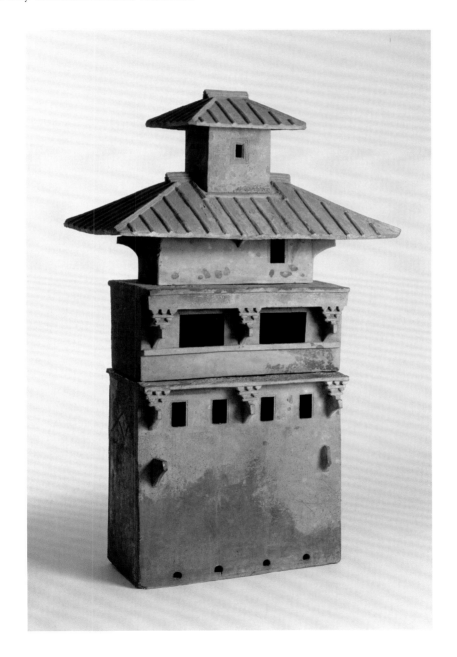

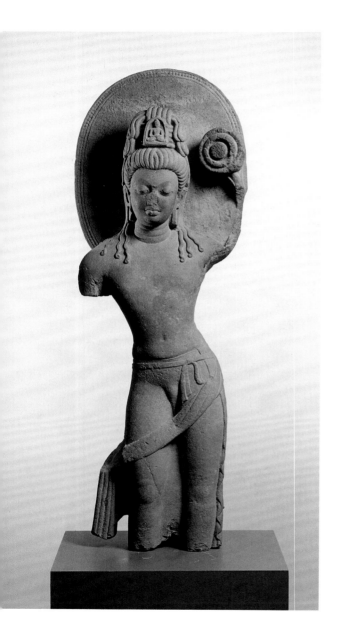

Avalokiteshvara

India, Uttar Pradesh, Sarnath, Gupta dynasty, c. 450–75
Sandstone, H. 48½ in. (123.2 cm)
Stella Kramrisch Collection, 1994-148-1

The tiny Buddha in the piled hair and the blooming lotus flower once held in the left hand identify this gently swaying male figure as the Bodhisattva Avalokiteshvara, embodiment of Buddhist compassion. The sculpture was created under the patronage of the Gupta dynasty, which dominated the subcontinent from the fourth to the sixth century. Downcast, introspective eyes fill the relaxed young face and communicate the peace of self-knowledge. In its simplicity, the breath-infused body, partially clothed in nearly invisible drapery, represents the perfection of enlightenment. These features combine to exemplify the spiritual serenity fundamental to Buddhist practice. It is no wonder that artists across Asia—from India and Nepal to Thailand, Cambodia, and even China—based their visions of enlightened Buddhist beings on such Gupta prototypes. Yet, as is evident from the Museum's early eighth-century Thai sculpture of the same deity (right), whose symmetrical monumentality emphasizes power over gentleness, later artists from different regions reinterpreted the Gupta type for their own purposes. Although missing its lower legs and arms, this Avalokiteshvara ranks among the most complete—and sublime—examples of Gupta sculpture outside India. DM

Avalokiteshvara

Thailand, c. 700–725
Sandstone, H. 69¾ in. (177.2 cm)
Purchased with the W. P. Wilstach Fund, W1965-1-1

The sheer size (originally nearly seven feet tall), columnar severity, and remote serenity of this sculpture seem to contradict its identity as the Bodhisattva Avalokiteshvara, he who looks on the world with infinite compassion. Yet he is identifiable by the meditating Buddha in his hair. The figure's quiet smile, gently downcast eyes, and pliable flesh create an extraordinarily powerful vision of protection, both spiritual and earthly. When Buddhism came to Thailand, Cambodia, and other parts of Southeast Asia from India, it took on a local character, merging spiritual and royal authority more completely, a circumstance made clear by comparing the upright power of this Avalokiteshvara with the softly introspective fifth-century Indian vision of the deity also in the Museum's collection (left). DM

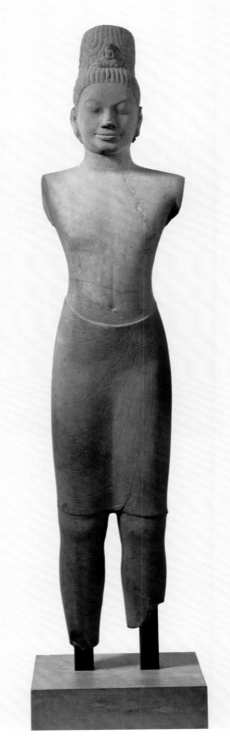

Tunic Fragment

Syria, 337–549
Wool, linen; 8 × 26½ in. (20.3 × 67.3 cm)
Purchased with the Bloomfield Moore Fund, 1933-50-1

This small textile is among ten known fragments, one of which has been carbon-dated to 337–549, that originally were part of the same tunic. Produced with an ancient weaving technique known as *taqueté*, the pattern—armed hunters and their dogs chasing boars, deer, leopards, and lions—is representative of designs found on late antique textiles and other art forms from the Mediterranean. The broad stripe along the right side formed part of a decorative band known as a clavus (see, for example, the Egyptian tunic fragment at upper right). DB

Tunic Fragment

Egypt, Akhmim, 7th–8th century
Silk, 7 × 2½ in. (17.8 × 6.4 cm)
Gift of Howard L. Goodhart, 1933-83-1

Excavated at Akhmim in Upper Egypt about 1885 by
Swiss archaeologist and art collector Robert Forrer,
this silk fragment originally decorated a tunic as
either a cuff band or a clavus, an ornamental strip
that ran vertically from the shoulders to the hemline
on a tunic. In the top panel, a bird of prey, possibly
an eagle, attacks a four-footed animal; below, a war-
rior saint, identified variously as Saint Theodore or
George, spears a dragon or similar beast. The use of
religious subjects to decorate clothing during the early
Byzantine period was a testament to the wearer's faith
and a means of invoking divine protection. DB

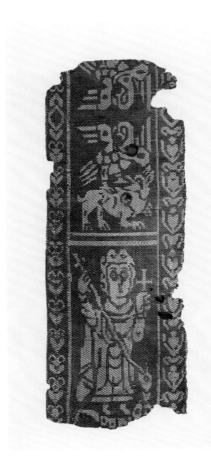

Tea Bowl

China, Jiangxi Province, Southern Song dynasty, 12th–13th
century
Glazed stoneware (Jizhou ware), DIAM. 4¾ in. (12.1 cm)
Purchased with the East Asian Art Revolving Fund, 2013-23-1

During the twelfth and thirteenth centuries, the
Jizhou kilns in southeastern China were known for
producing the most technically advanced and creative
pottery decoration. The exterior of this tea bowl is
covered in a mottled glaze that mimics tortoiseshell,
while the interior decoration of two phoenixes in
flight and stylized blossoms was created by adher-
ing paper cutouts to the vessel's surface before it was
glazed. Tea drinking became widespread in China
beginning in the tenth century, and dark-colored
wares were especially favored, as they showed off the
color of powdered white leaf tea. HK

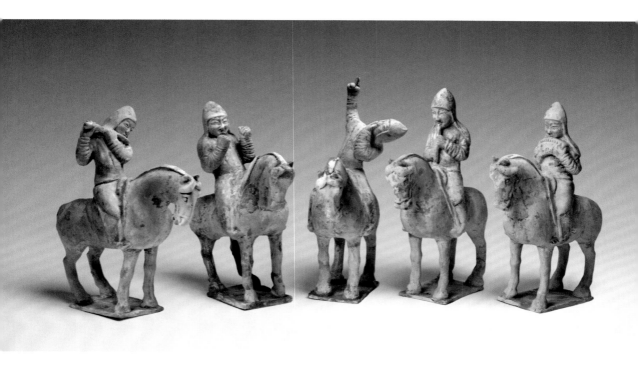

Musicians on Horseback

China, Henan Province, Tang dynasty, 7th century
Earthenware with traces of pigment, H. (tallest) 12⅜ in. (31.3 cm)
Gift of Charles H. Ludington from the George Crofts Collection,
1923-21-146–150

During the Tang dynasty (618–907), mounted bands like the one depicted here may have accompanied official processions. Animatedly playing various instruments such as flutes, cymbals, and panpipes, these five musicians were made to be placed in the tomb of a wealthy official. Exuberant melodious tunes incorporating percussion, stringed, and wind instruments originated in Central Asia and today's Xinjiang region, and came to China via the Silk Route, where they were popular from the sixth to the late ninth century. Such music was in stark contrast to the ancient stately strains featuring bronze bells, stone chimes, and zithers that traditionally were played at formal Chinese ritual ceremonies. HK

Camel

China, Shaanxi Province, Tang dynasty, mid-7th–mid-8th century
Earthenware with three-color (*sancai*) glaze, H. 32 in. (81.3 cm)
Gift of Mrs. John Wintersteen, 1964-9-1

This tomb figure of a fully laden Bactrian camel suggests the flourishing overland trade along the Silk Route that stretched from the ancient Chinese capital of Chang'an to Constantinople (now Istanbul). Strict laws regulated the size and number of the tomb figures of animals and other representations of daily life that customarily were buried with the deceased. The exceptionally large size of this impressive piece from the Museum's outstanding group of Tang tomb figures suggests it was commissioned for a high-ranking noble. Produced between the mid-seventh and mid-eighth centuries, such glazed figures were more difficult to make than painted ceramics (see, for example, the mounted musicians illustrated here; see also p. 3), which required only one firing. HK/FF

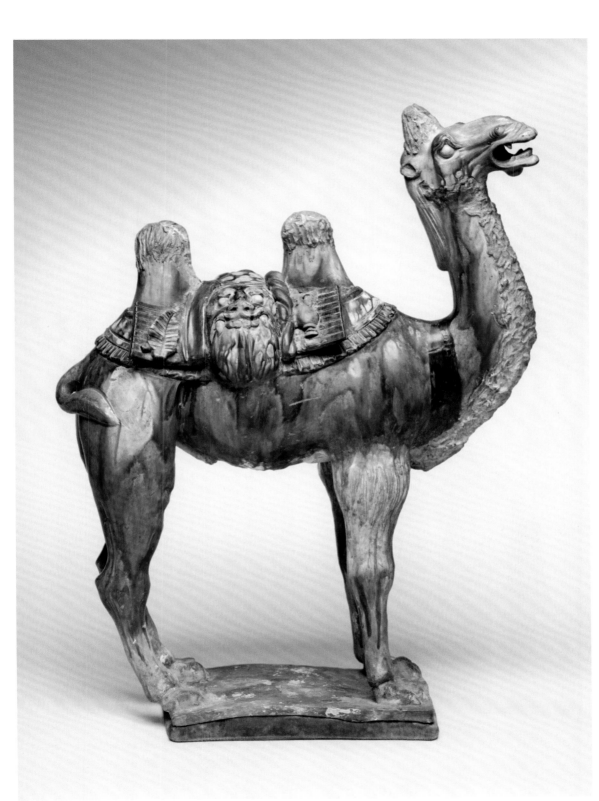

Shiva Mohra

India, Himachal Pradesh, Chamba, c. 9th century
Copper alloy, H. 11 in. (27.9 cm)
Gift of the Friends of the Philadelphia Museum of Art, 1980-99-1

Languid eyes and sensuous lips belie Shiva's charac-
ter as a great ascetic in this compelling vision of the
Hindu deity. Yet his third eye and dreadlocks, cinched
with a cobra and ornamented with a crescent moon,
reveal his identity. In the Kullu Valley region of north-
ern India, each village has a local deity, often, as here,
a form of a Hindu god. Multiple representations of
the deity are kept in the village temple as plaque-like
metal busts called *mohras*, of which this mesmerizing
example is among the oldest and finest known. At
festival times, a group of *mohras* are mounted on a
palanquin and hung with bright fabrics and garlands.
Accompanied by priests, musicians, and dancers, vil-
lagers carry their god along mountain paths to trading
centers where they can mingle and celebrate. DM

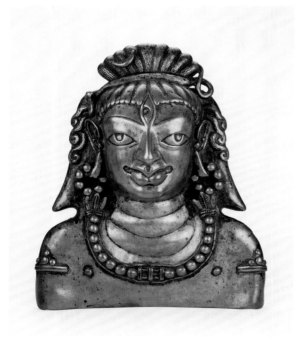

Rishabhanatha in Meditation

India, Gujarat or Rajasthan, c. 700
Copper alloy with copper and silver inlay, H. 13⅛ in. (33.3 cm)
Stella Kramrisch Collection, 1994-148-61

For Jains, followers of an ancient and still vital
Indian religion, one can achieve spiritual perfec-
tion by controlling desires and never causing harm
to living beings. Throughout history, twenty-four
individuals—called Jinas (Conquerors)—have
achieved ultimate perfection in this way and are
honored as models and teachers (see also p. 38). Here
Rishabhanatha, the first of these, sits in deep medita-
tion. Inlaid copper warms his lips and silver brightens
his eyes. Below, a wheel flanked by deer represents
the transmission of wisdom, a symbol also found
in Buddhism. On a lotus flower to his left rests his
personal protective goddess (once balanced by a god),
and nine celestial bodies guard the sculpture's base to
emphasize Rishabhanatha's elevated state. DM

Mahishasuramardini

India, Odisha, Bhubaneshwar, 8th century
Sandstone, H. 27¼ in. (69.2 cm)
Purchased with funds contributed by Miss Anna Warren
Ingersoll, Nelson Rockefeller, R. Sturgis Ingersoll, Mrs. Rodolphe
Meyer de Schauensee, Dr. I. S. Ravdin, Mrs. Stella Elkins Tyler,
Louis E. Stern, Mr. and Mrs. Lionel Levy, Mrs. Flagler Harris,
and with funds from the bequest of Sophia Cadwalader, funds
from the proceeds of the sale of deaccessioned works of art, the
George W. B. Taylor Fund, the John T. Morris Fund, the John
H. McFadden, Jr., Fund, the Popular Subscription Fund, and the
Lisa Norris Elkins Fund from the Stella Kramrisch Collection,
1956-75-7

This dramatic relief, once set into the exterior wall of an elaborately carved Hindu temple, is both illustration and icon. It shows the battle between the great goddess Durga and Mahishasura, a demon in the form of a water buffalo, an animal representative of ignorance. Durga, holding the weapons of all the other gods in her many hands, effortlessly crushes Mahishasura's head with a single elastic arm. In his final moment, the buffalo demon recognizes the divinity of the gods, and so overcomes ignorance and gains peace. Here the artist masterfully condensed the story: As Mahishasura is destroyed, he reverently raises the goddess's foot in his hand. DM

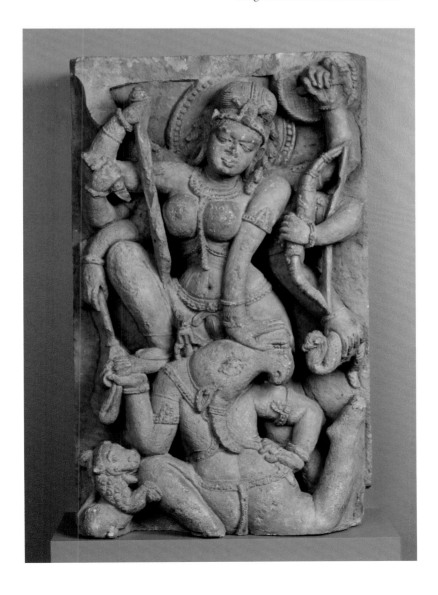

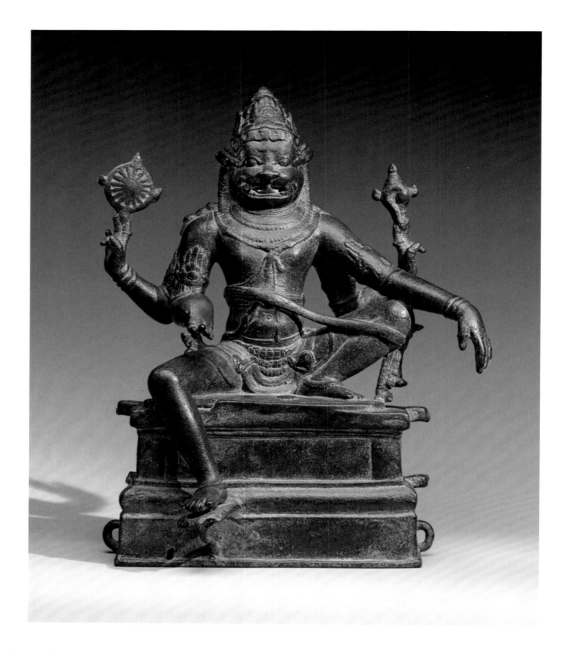

Narasimha

India, Tamil Nadu, Chola dynasty, c. 1000
Bronze, H. 14 in. (35.6 cm)
Purchased with the Stella Kramrisch Fund for Indian and
Himalayan Art, 2010-173-1

Artists working under the powerful Chola rulers,
who dominated southern India and Southeast Asia
between the ninth and thirteenth centuries, perfected
the art of bronze casting to produce some of the
most elegant sculptures ever created. With its grace-
ful human body and gently snarling lion head, this
image captures the convergence of opposites central to
the story of Narasimha, an avatar of the god Vishnu
who could kill a demon impervious to both man and
beast. As is still the practice in Hindu temples, bronze
sculptures such as this allow the deity to manifest in
portable form so that he may be paraded before his
devotees like a king before his subjects. DM

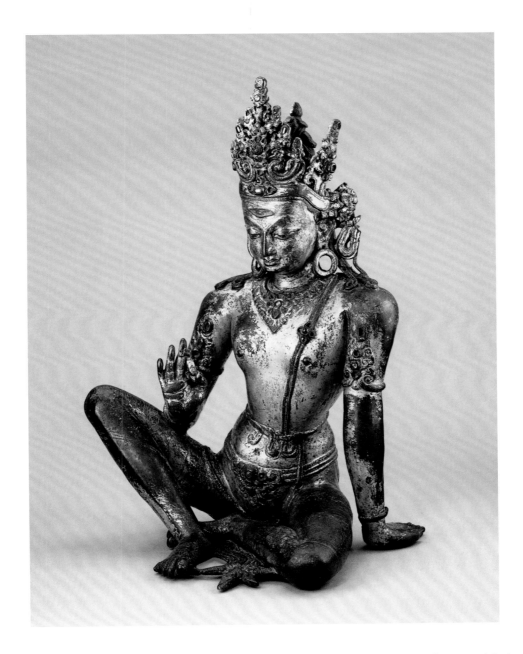

Indra

Nepal, Malla dynasty, c. 1200
Mercury-gilded copper alloy with spinel rubies, rock crystal, and turquoise; H. 15⅞ in. (40.3 cm)
Stella Kramrisch Collection, 1994-148-596

For Buddhists, Hindus, and Jains alike, the ancient storm deity Indra, distinguished by his horizontal third eye, reigns over the gods' heaven—although he is not the ultimate power. In this early, large, and supremely expressive sculpture from Nepal, Indra raises his right hand in a teaching gesture. His powerful chest contrasts with his slender waist and limbs, light with suspended motion. His face displays a beatific and mystical introspection. Rich mercury gilding incised with delicate lines of drapery and an intricate, gem-studded crown combine to make him an exemplary ruler of the celestial realm. DM

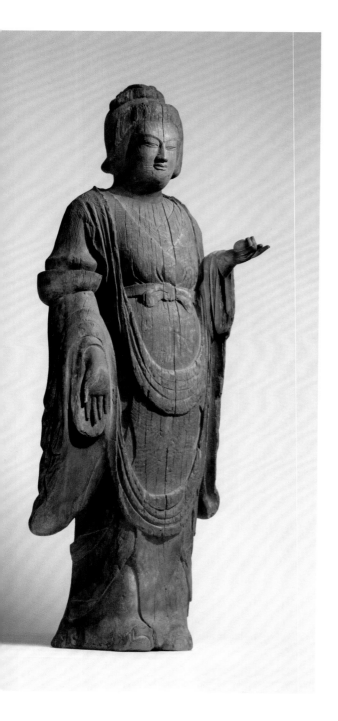

Kisshōten
Japan, Heian period, late 9th–10th century
Cypress wood, H. 46⅞ in. (119 cm)
Purchased with funds contributed by Andrea M. Baldeck, MD, in honor of Felice Fischer, the Luther W. Brady Curator of Japanese Art and Curator of East Asian Art, 2009-78-1

Unlike later Buddhist sculptures that were made with the *yosegi* technique, in which separate wood elements are joined together (see, for example, p. 25), this monumental depiction of the goddess Kisshōten was carved from a single block of Japanese cypress wood, a method known as *ichiboku*. Only the figure's hands were added separately. The sculpture must have been carved from a massive log, as its diameter measures nearly nineteen inches. Introduced to Japan along with Chinese Buddhism, Kisshōten, whose dress and hairstyle recall figures from China's Tang dynasty (618–907), has been worshipped by Japanese devotees since the eighth century as the goddess of fertility, good fortune, and happiness. The jewel in her left hand symbolizes her power to grant her followers' wishes. The artist has captured the awe-inspiring dignity and approachable generosity of the goddess, who is revered to this day. Her beneficent nature is beautifully evoked in the carving of the face: the eyes gazing down at the worshipper, and the smile at once reserved yet tender. FF

Seated Bodhisattva
China, Tang dynasty, early 8th century
Gilded bronze with traces of pigment, H. 9 in. (22.9 cm) with base
Purchased with Museum funds, 1928-114-24a,b

By the first century, Buddhism had been brought from India to China, where it became a major source of artistic inspiration, its complex pantheon of Buddhas and deities providing a rich choice of subjects. This bodhisattva, an enlightened deity who has chosen to delay his own path to enlightenment to help sentient beings, is depicted seated in a posture of ease, with his hands in a gesture signifying reassurance or tranquility. A masterpiece of bronze casting, the sculpture displays particularly fine work in the intricate details of the headdress, necklace, ribbons, and hair, in which traces of ultramarine pigment remain. HK/FF

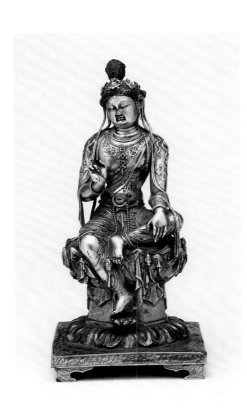

Bodhisattva

China, Northern Song or Liao dynasty, 11th century
Wood with traces of pigment, H. 60 in. (152.4 cm)
Gift of Charles H. Ludington from the George Crofts Collection,
1925-53-10

This serene bodhisattva most likely was made for a
Buddhist temple in northern China, where it might
have flanked a large image of a Buddha set against a
mural painting of paradise. Sculpted in high relief,
the deity features inlaid glazed ceramic eyes, and origi-
nally was gilded and painted in bright colors, as indi-
cated by the traces of pigment visible on its flowing
robes and scarves and ornate jewelry. Devotees would
have filled the cavity in the back of the figure with
offerings, such as prayers or colored stones, to ensure
the efficacy of the statue. HK

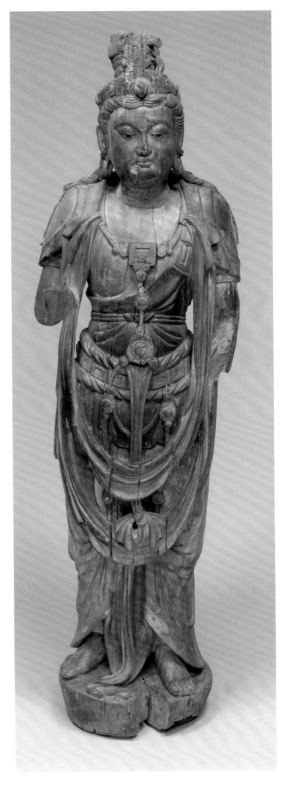

STELLA KRAMRISCH

Stella Kramrisch (1896–1993; see fig. 12) was the Museum's longtime curator of Indian art and among the twentieth century's most significant historians of the art and architecture of the Indian subcontinent. Trained in Vienna, she arrived in India in 1921 and soon became the first art historian to teach at the venerable University of Calcutta. Kramrisch simultaneously produced groundbreaking publications on a staggering range of topics relating to Indian art, from ancient clay art and mural painting, to temple architecture and sculpture, to folk textiles and modern art.

Kramrisch came to Philadelphia in 1950, soon after her personal collection of eighth- to twelfth-century Indian temple sculpture went on display at the Museum. The Museum acquired this collection in 1956, and it remains the most significant of its type, for both its historical importance and its quality, in any American museum. An example is the tenth-century sculpture of a celestial woman from Harshagiri (below), a religious complex in western India. The master artist seamlessly merged the woman's form with an oversize lotus that grows directly from the wall, as if blooming from the enshrined deity.

Kramrisch soon was hired as curator of Indian art, although she continued to teach, first at the University of Pennsylvania and later at New York University. She created a series of special exhibitions that introduced entire realms of Indian art to the

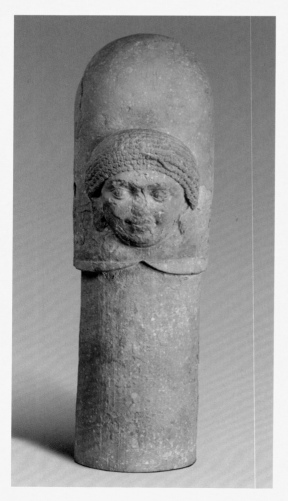

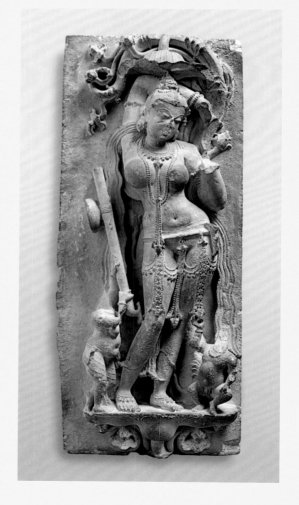

American public, including *Unknown India: Ritual Art in Tribe and Village* (1968), which gave this art its first serious aesthetic consideration. Perhaps her most significant show was *Manifestations of Shiva* (1981), a multifaceted study of the titular Hindu god and the first blockbuster exhibition of South Asian art in the United States. Images of Shiva were also some of her major acquisitions. In 1970 she donated a first- to second-century single-headed Shiva *linga* (far left), which is among the oldest known examples of the pillar-like embodiment of the god. Its naturalistic glans reveals the form's phallic origins, while the emergence of Shiva's face evokes the powerful concept of divine manifestation.

On her death, Kramrisch left more than seven hundred objects to the Museum, including spectacular paintings and sculptures from India as well as Tibet, Nepal, and Bangladesh (see pp. 2, 4, 10, 13, 27, 52, 62, 69). Among these was a boldly colored, dizzyingly complex *Vajravali* mandala (below). A meditative diagram, the painting was personally commissioned by the founder of one of the main traditions of Tibetan Buddhism. Through such transformative gifts and acquisitions (see also pp. 11, 39, 82), and through her rich scholarship, Kramrisch opened new realms of art to the Museum's visitors and to the world. DM

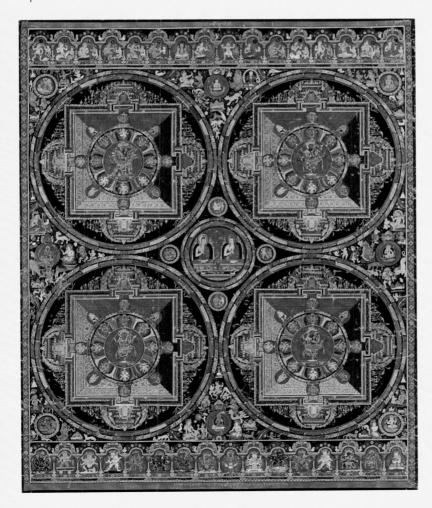

One-Faced Linga
India, Uttar Pradesh, Mathura, Kusana dynasty, 1st–2nd century
Sandstone, H. 30¾ in. (78.1 cm)
Gift of Stella Kramrisch, 1970-221-1

Celestial Woman with a Vina
India, Rajasthan, Harshagiri, 956–73
Sandstone, H. 25⅛ in. (63.8 cm)
Purchased with funds contributed by Miss Anna Warren Ingersoll, Nelson Rockefeller, R. Sturgis Ingersoll, Mrs. Rodolphe Meyer de Schauensee, Dr. I. S. Ravdin, Mrs. Stella Elkins Tyler, Louis E. Stern, Mr. and Mrs. Lionel Levy, Mrs. Flagler Harris, and with funds from the bequest of Sophia Cadwalader, funds from the proceeds of the sale of deaccessioned works of art, the George W. B. Taylor Fund, the John T. Morris Fund, the John H. McFadden, Jr., Fund, the Popular Subscription Fund, and the Lisa Norris Elkins Fund from the Stella Kramrisch Collection, 1956-75-12

Four Mandalas of the Vajravali Cycle
Central Tibet, Sakya monastic order, c. 1429–56
Colors on cloth, 35¼ × 29 in. (89.5 × 73.7 cm)
Stella Kramrisch Collection, 1994-148-635

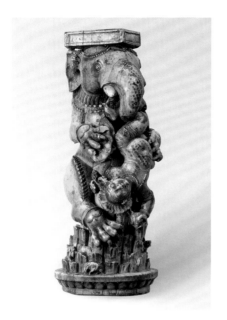

Throne Leg with an Elephant-Headed Lion
India, Odisha, c. mid-13th century
Ivory, H. 14¼ in. (36.2 cm)
Gift of Mrs. John B. Stetson, Jr., 1960-96-1

From ancient times in India, precious ivory and the battle-engine elephant from which it comes were closely associated with royal privilege. The powerful lion referenced the king himself, and many rulers incorporated the word for lion into their names. In this spectacular ivory throne leg, these regal motifs converge. A robust elephant-headed lion holds a writhing, bulging-eyed demon in its trunk while mauling him with enormous claws. The huge scale of the beast is emphasized by its placement atop a rocky mountain studded with tiny animals and trees. Two legs of this throne survive from what must truly have been a seat fit for a king. DM

Bull of the God Shiva
India, Karnataka, Mysore, Hoyshala dynasty, c. 1200–1250
Schist, L. 31¾ in. (80.6 cm)
Purchased with the Joseph E. Temple Fund, 1966-123-1

Each Hindu god has an animal that not only is a vehicle but also embodies a special characteristic. Shiva is lord of opposites: He is the great ascetic, denying his body through austerities, yet he is also the great lover. His animal is the virile bull that is often called Nandi (Joy), a sculpture of which faces into the sanctum of every Shiva temple, serving as both guardian and primary devotee. Smiling in joyful dedication to his lord, this bull was made as part of a temple commissioned under the Hoyshala rulers (r. eleventh–fourteenth century) of south-central India. The region's fine-grained schist, which can be deeply carved and finely detailed, allowed artists to create such extraordinarily elaborate images. DM

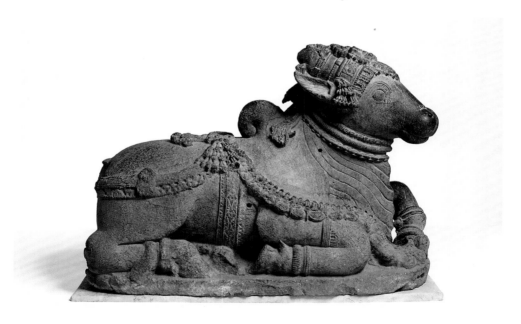

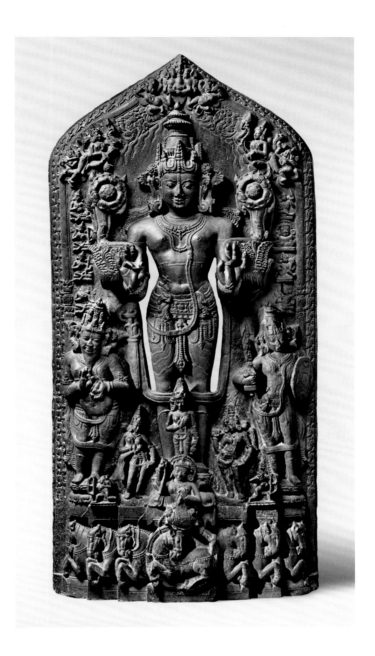

Surya

Bangladesh or India, West Bengal, Pala dynasty, c. 12th century
Phyllite, H. 62¾ in. (159.4 cm)
Gift of Mrs. N. R. Norton, Mrs. Richard Waln Meirs, Mrs.
Edwin N. Benson, Jr., and Mrs. William A. M. Fuller in memory
of Mrs. Jones Wister, 1927-9-1

This monumental black stone relief, discovered in 1833 in the mud of the Ganges delta, ranks among the finest sculptures made for the imperial rulers of the Pala dynasty (c. eighth–twelfth century) of eastern India. It depicts Surya, the Hindu solar deity, towering above his celestial chariot amid a host of divine attendants. Surya wears boots, suggesting the god's northerly origins. In each hand he grasps a lotus flower that has opened in his radiance. Flames surround his crown and even seem to comprise his fiercely rippling eyebrows. DM

Brush Washer

China, Northern Song dynasty, early 12th century
Glazed stoneware (Ru ware), DIAM. 5⅛ in. (13 cm)
Gift of Major General and Mrs. William Crozier, 1944-20-95a,b

Admired for its refined simplicity and tactile glaze, Ru ware was produced for only a short period of time, from about 1107 to 1125, and exclusively for imperial use, circumstances that helped elevate its status among later collectors. Fewer than seventy complete examples, including this elegant brush washer, survive today. Characteristically, this ceramic type features simple, sophisticated forms covered entirely with a delicate blue crackled glaze, such as that seen here. In order to prevent the glazed surfaces from fusing to the kiln during firing, vessels were set on stands with three or five conical supports, which left tiny, unglazed spur marks on the stoneware bodies. The association of Ru ware with the Northern Song emperor Huizong (r. 1101–26), who is said to have commissioned its production, increased its appeal to later rulers, especially those of the early Qing dynasty (1644–1911). In particular, the Qianlong emperor (r. 1736–95), renowned for his love of antiquities and collecting, appreciated this type of ware, as indicated by his poetic inscription on this washer's base. The poem, dated 1755, demonstrates his knowledge of how Ru ware was made in Song times, asserting that the glaze had been made from powdered agate, a method that was no longer used in the eighteenth century at the imperial kilns at Jingdezhen. HK

Cup

China, Song dynasty, 12th century
Nephrite, H. 2 in. (5.1 cm)
Gift of the Far Eastern Art Committee in honor of Henry B. Keep, 1978-41-1

This elegant, six-lobed cup is made from nephrite jade, a material venerated in China from early recorded times for its ritual significance and physical properties, holding a place equivalent to that of gold in the West. After the cosmopolitan exuberance of the arts of the Tang dynasty (618–907) (see, for example, pp. 8, 14), those of the subsequent Song dynasty (960–1279) display more restraint and refinement. Connoisseurs of the time accordingly appreciated understated materials like jade, which was valued not only for its associations with gentlemanly virtues, but also for its purity of form and texture, emphasized by this cup's absence of decoration. HK/FF

Vase

Korea, Goryeo dynasty, 12th century
Stoneware with celadon glaze, H. 16 in. (40.6 cm)
Purchased with the Fiske Kimball Fund and the Marie Kimball
Fund, 1974-133-1

Among the most important artistic and technical achievements in the history of Korean ceramics were the celadon wares produced during the Goryeo dynasty (918–1392). Referred to as "kingfisher" after the bird's blue-green feathers, the subtle hue of these ceramics, an effect primarily due to the presence of iron oxide in the glaze and the firing conditions of the kiln, was greatly admired. One of the Museum's most treasured objects, this elegant vase—known as a *maebyeong*, or "plum vase," for the flowering plum branches it was designed to hold—is a superb example of the understated beauty of Goryeo celadons. Likely made under royal patronage, this masterpiece, with a delicately incised underglaze design of herons amid mallow and lotus blossoms, once belonged to the American financier J. P. Morgan, in whose catalogue it is listed as of Chinese origin. However, although the celadon-glaze technique was introduced from China, the vase undoubtedly was made in Korea, probably at the Sadang-ri kiln, in the southwestern part of the country, where shards with similar designs have been excavated. This masterful vase is an important example among the institution's increasing holdings of Korean art, which have tripled in size over the past twenty years, largely due to the support and efforts of the Museum's Korean Heritage Group, founded in the mid-1990s to promote the art and culture of Korea. HW/FF

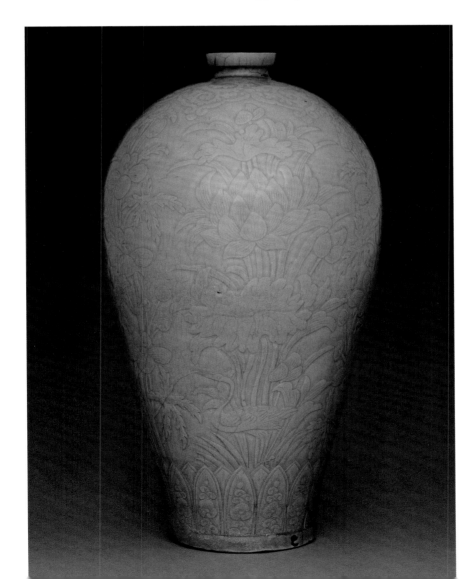

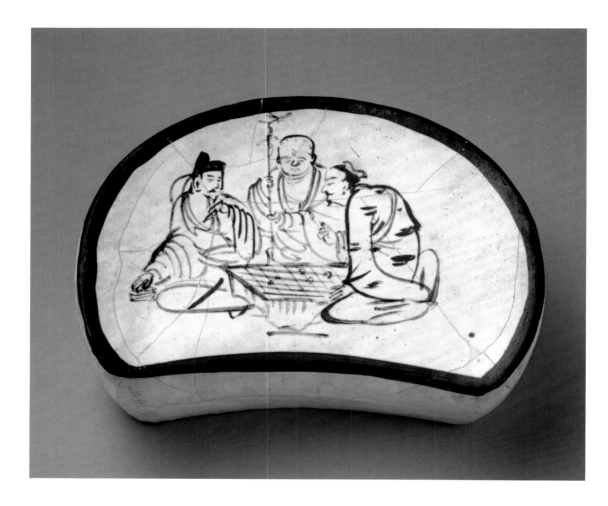

Head Rest

China, Henan Province, Jin dynasty, 1178
Stoneware with underglaze slip decoration (Cizhou ware),
w. 10⅞ in. (27.6 cm)
Gift of Mrs. Carroll S. Tyson, 1957-26-1

Cizhou ware was a popular type of ceramic made at many kilns throughout northern China. Head rests or pillows such as this, intended for use in life and in death, were common, but this example's remarkable decoration of a Confucian scholar, a Buddhist monk, and a Daoist priest playing chess is unique among known examples. By the tenth century, the three great philosophies of Chinese civilization, represented on this head rest by the individual figures, were viewed as mutually complementary and inextricably linked. Known as the Three Teachings, the subject was popular in tenth- to thirteenth-century paintings. The inscription on the base dates the head rest to the eighteenth year of the Dading period (1161–89), corresponding to 1178. HK/FF

Female Immortals

China, Yuan–early Ming dynasty, mid-14th–early 15th century
Ink and colors on silk, fan mounted as an album leaf; 9⅞ × 9¼ in.
(25.1 × 23.5 cm)
Purchased with Museum funds from the Simkhovitch Collection,
1929-40-48a,b

Since medieval times, practitioners of Daoism, an
ancient Chinese philosophical tradition, traveled to
sacred mountain sites to collect minerals and edible
plants for their healing and magical properties. This
particularly fine rendering of three female immortals
collecting plants in a remote landscape replete with
symbols of longevity—such as pine, bamboo, and
rock—highlights the middle figure, who displays a
ginseng root in her outstretched hand to her compan-
ions, one of whom holds a multicapped mushroom.
Such plants and fungi were used in Daoist ritual and
cultivation in the belief that ingesting them would
prolong one's life. HK

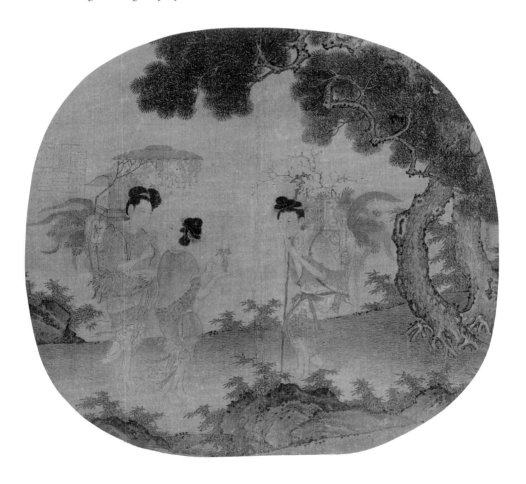

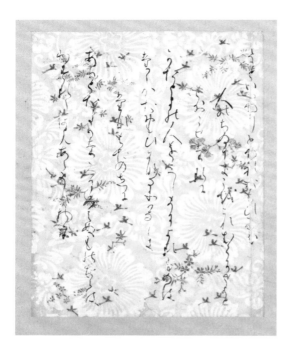

Page from the "Sanjūrokunin shū"

Japan, Heian period, 1108–12
Ink and silver over mica woodblock printing on coated paper,
mounted as a hanging scroll; 8 × 6¼ in. (20.3 × 15.9 cm)
Gift (by exchange) of Mrs. Henry W. Breyer, Sr., 1965-77-1

This page from a collection of verses by Lady Ise (died
c. 940) originally was part of a sumptuous edition of
the *Sanjūrokunin shū* (Anthology of Poems by Thirty-
Six Poets) commissioned for the sixtieth birthday
celebration of the emperor Shirakawa in 1112. Twenty
of the period's leading calligraphers worked on the
project, brushing their refined script on richly deco-
rated paper printed with a floral motif in shimmering
mica. Reflecting the aesthetic preferences of the Heian
elite, the anthology later served as a model for artists
such as Hon'ami Kōetsu (see p. 48). In 1929 its pages
were separated and several leaves, including this, were
mounted as hanging scrolls. FF

Storage Jar

Japan, Nambokuchō period (1333–92)
Stoneware with ash glaze (Tamba ware), H. 17¾ in. (45.1 cm)
Purchased with the Hollis Fund for East Asian Art Acquisitions,
2013-25-1

The kilns at Tamba, west of Kyoto, were one of several
complexes in medieval Japan that produced utilitarian
ceramic vessels such as this stately storage jar for local
markets. One of the oldest pottery types, Tamba ware
is distinctive for its warm green glaze, formed during
the firing process by liquefied wood ash flowing down
the vessel's orange-brown body, a perfect foil for the
glossy patches of green ash glaze. The incised mark on
the shoulder of this jar was used to identify its maker
after it was fired in the communal kiln. Originally
intended for storing grain or pickles, Tamba jars like
this later were used as containers for leaf tea. FF

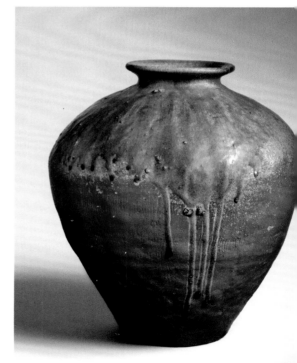

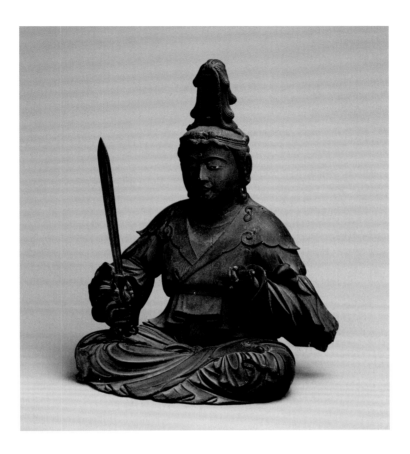

Seated Monju

Japan, Kamakura period, early 14th century
Cypress wood, glass; H. 14⅝ in. (37.1 cm)
Purchased with the Katharine Levin Farrell Fund, the Haney
Foundation Fund, the Margaretta S. Hinchman Fund, the
Bloomfield Moore Fund, the John T. Morris Fund, the Edgar
Viguers Seeler Fund, the George W. B. Taylor Fund, and with funds
contributed by Mrs. Rodolphe Meyer de Schauensee, 1979-57-1

In this depiction the typically youthful Monju, who is worshipped as the manifestation of the wisdom of the Buddha, holds a scroll symbolizing the sacred Buddhist writings in his left hand and an upright sword representing the victory of wisdom over ignorance in his right. Whereas earlier Japanese sculptors carved from a single block of wood (see, for example, p. 14), the artists of the Kamakura period (1185–1333) worked with several pieces joined together, a technique known as *yosegi* that enabled them to use a combination of the best woods with the finest grains. Here the use of the grain in the jacket and face demonstrates the craftsman's sensitivity to his medium. The inlaid eyes, probably rock crystal, were inserted from behind the hollowed-out head before the front and back sections were joined. The deeply cut folds of the drapery and the crisp, delicate carving of the elaborate topknot further reveal the highly developed techniques of the Buddhist sculptors of the time. FF

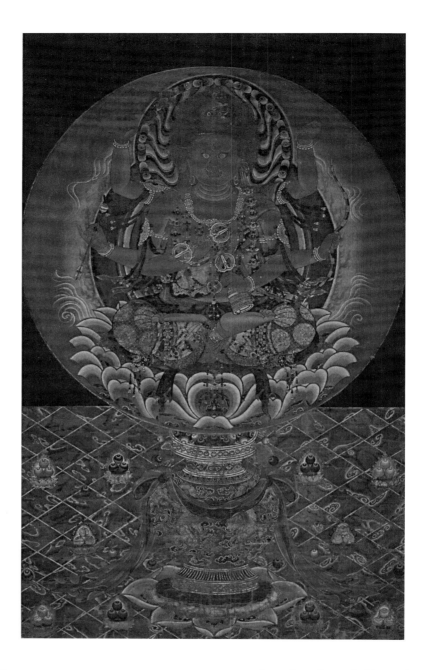

Aizen Myōō
Japan, Nambokuchō period (1333–92)
Colors and cut gold on silk, mounted as a hanging scroll;
45 × 27¾ in. (114.3 × 70.5 cm)
Purchased with the John T. Morris Fund, 1960-7-1

Depictions of multiarmed deities are among the most impressive images of Japanese Buddhism. Here Aizen Myōō, one of the five Kings of Bright Wisdom, the ferocious guardians of esoteric Buddhism, is shown seated on a lotus flower, holding in his richly jeweled arms the symbols of his power—a bell, bow and arrow, lotus, and thunderbolt. The fine detailing of the jewelry, robe, and vase is done in cut gold. In medieval Japan, worshippers invoked the protection of the Wisdom Kings against the threat of the invading Mongols, whose ultimate failure bolstered belief in their efficacy. FF

Mahakala

Central Tibet, Sakya monastic order, early 15th century
Colors on cloth, 38¼ × 26¼ in. (97.2 × 66.7 cm)
Stella Kramrisch Collection, 1994-148-638

Perhaps the greatest strength of the Museum's Himalayan collection is a group of paintings created between the twelfth and sixteenth centuries for the Sakya sect, one of the four primary branches of Tibetan Buddhism. Although made in Tibet, the paintings display a style brought there by Nepalese artists, the features of which include vibrant primary colors, boldly stylized figures, minute detail, shallow depth, and a distinctive two-toned foliate patterning. This superlative example depicts the Buddhist deity Mahakala, an enlightened protector whose fierce appearance—fangs, flaming hair, skull ornaments—symbolically teaches devotees how to overcome spiritual negatives on their path to enlightenment. DM

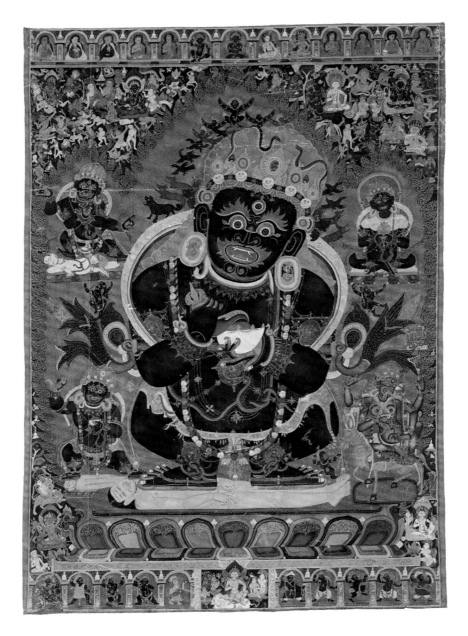

COLLECTORS OF ORIENTAL CARPETS

The Museum houses a world-renowned collection of carpets from the Caucasus, China, Egypt, Iran, South Asia, Spain, and Turkey. The most significant of these holdings draws from two Philadelphia-area collections, those of Mr. and Mrs. John D. McIlhenny (see also pp. 190–91), gifted to the Museum as a bequest in 1943, and of the Reverend and Mrs. Charles F. Williams, presented in memory of Joseph Lees Williams, their son, in 1955. Two remarkable carpets given in 1948 as gifts by the Sharples family, in memory of Philip M. Sharples, represent a smaller but important contribution.

Heir to his family's fortune, businessman John D. McIlhenny, who served as Museum president from 1918 until his death in 1925, and his wife, Frances Galbraith Plumer, assembled a remarkable collection of carpets, including the stunning "Marquand" medallion carpet (below), referred to by the name of its former owner New York banker Henry Gurdon Marquand. Purchased by Mrs. McIlhenny in the early 1930s, this rug had long been identified as a nineteenth-century Turkish copy of a sixteenth-century courtly carpet from Iran. Recent examinations, however, have provided compelling evidence that it in fact dates to the sixteenth century.

In addition to amassing one of the finest collections of Asian and Middle Eastern rugs in the United States, including a rare Para-Mamluk example (p. 34) and a splendid star-patterned one from Turkey (right), the Williamses of Norristown, Pennsylvania, were instrumental in inspiring the McIlhennys to begin collecting carpets. Their interest in antique rugs might have stemmed from their association with James Lees and Sons, a carpet factory in Bridgeport, Pennsylvania, owned by Mrs. Williams's grandfather. While Reverend Williams often is credited as the collection's mastermind, it is possible that his erudite wife, with her family's connections and wealth, was the real expert.

Inventor Philip M. Sharples enjoyed great success until the financial collapse of the 1930s. Faced with monetary ruin, he was forced, at the age of seventy-eight, to leave the mansion he had built and furnished in West Chester, Pennsylvania. Two carpets survived this reversal of fortune and entered the Museum's collection after his death in 1944. One of these is the exceptional dragon rug (far right), named for the stylized beasts that populate it. YR

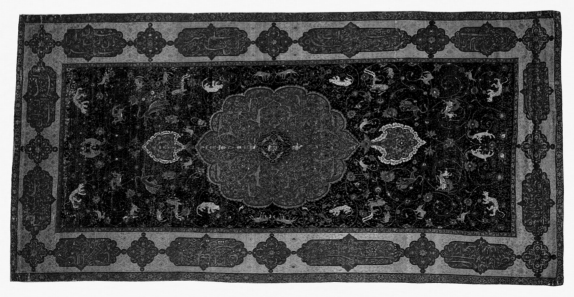

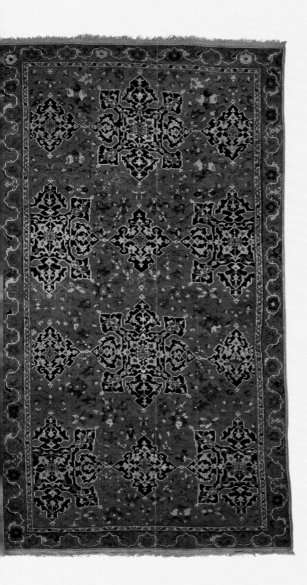

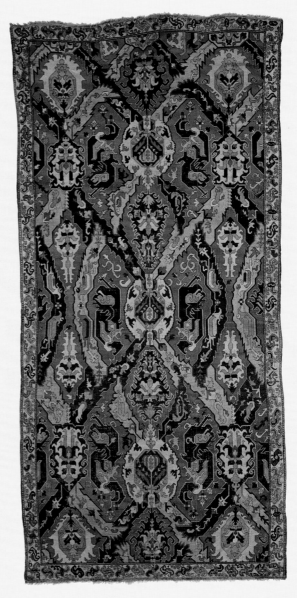

"Marquand" Medallion Carpet

Iran, probably 16th century

Wool, silk, cotton, silver brocade with traces of gilding; 5 ft. 10½ in. × 11 ft. 7 in. (1.79 × 3.53 m)

The John D. McIlhenny Collection, bequest of Mrs. John D. McIlhenny, 1943-28-1

Star Ushak Carpet

Turkey, Ushak, late 15th–early 16th century

Wool and possibly goat hair; 12 ft. 1 in. × 6 ft. 8 in. (3.68 × 2.03 m)

The Joseph Lees Williams Memorial Collection, 1955-65-16

Dragon Carpet

Azerbaijan, possibly Shemakha, 17th–18th century

Wool, 17 ft. × 7 ft. 10 in. (5.18 × 2.39 m)

Gift of the Sharples family in memory of Philip M. Sharples, 1948-83-1

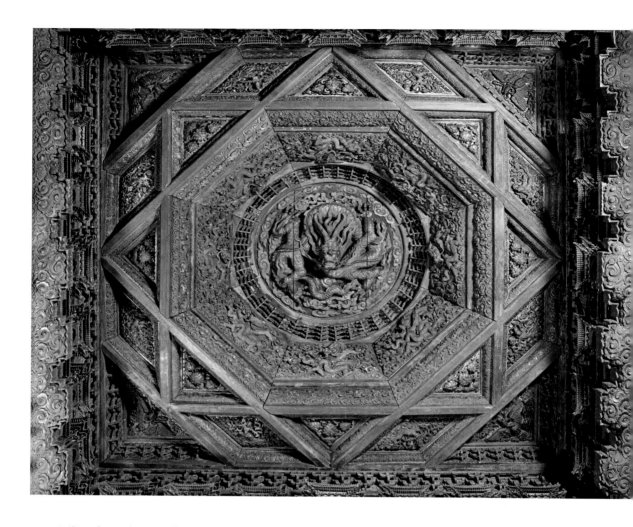

Ceiling from the Temple of Wisdom Attained (Zhihuasi)

China, Beijing, Ming dynasty, 1444
Nanmu wood with traces of lacquer and gilding
Gift of Mr. and Mrs. Joseph Wasserman, 1930-38-1a–m

A rare and splendid example of fifteenth-century imperial architecture, this coffered ceiling comes from the Hall of Great Wisdom, the second of five main halls at the Temple of Wisdom Attained, a Buddhist temple complex in Beijing built in 1444 by the Ming eunuch Wang Zhen. The elaborately carved large central panel, known as *tianjing*, or "well of heaven," features a large, writhing dragon surrounded by eight smaller depictions of the mythical serpent (nine being an auspicious and powerful number in Chinese cosmology). Phoenix-like birds, sprays of lotus, and Buddhist celestial beings surround the central dome. Bordering the ceiling's central well are miniature models of temples, each originally enclosing a delicately carved sculpture of a Buddhist deity. One of several important examples of Asian architecture at the Museum, the ceiling, originally painted with lustrous red lacquer accented with brilliant gilding, is installed with architectural elements reconstructed from measured drawings made at its original site, providing viewers with a sense of its context and majesty. HK

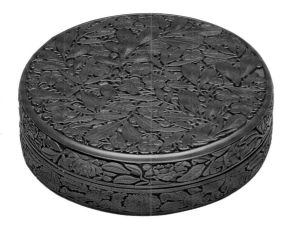

Circular Box

China, Ming dynasty, Yongle period, early 15th century
Wood with cinnabar lacquer, DIAM. 10¾ in. (27.3 cm)
Gift of Mr. and Mrs. Morton Jenks, 1953-1-1a,b

Early in the Ming dynasty (1368–1644), cinnabar lacquerwares were favored by the court, as their vivid red color was symbolic of the dynasty and the name of the imperial family. For this circular box, layers of lacquer made from tree sap and colored with the mineral cinnabar were applied to the wooden form. Once dry the thick lacquer was carved with a motif of bamboo, pine, and plum blossoms—the so-called three friends of winter. As each of these plants continues to flourish in the adverse conditions of the coldest season, together they symbolize integrity and fortitude, qualities associated with the gentleman scholar. HK

Ewer and Basin

China, Ming dynasty, Xuande period (1426–35)
Gold, gemstones; H. (ewer) 8⁹⁄₁₆ in. (21.7 cm), DIAM. (basin)
10³⁄₁₆ in. (25.9 cm)
Purchased with the John T. Morris Fund, 1950-118-1 (ewer).
Purchased with Museum funds, 1950-74-1 (basin)

Gold vessels from the Ming dynasty (1368–1644) are extremely rare, as during that time laws restricted the use of the precious material to the imperial family. Originally part of a larger set including a covered jar and a tripod vessel, this dazzling ewer and basin, engraved with five-clawed dragons and decorated with colorful gemstones, would have been used for secular or ceremonial purposes, perhaps for ritual bathing. The high quality of the craftsmanship suggests the vessels were made in the royal workshops, and the technique of inseting gems into gold, unusual in Chinese metalwork, likely was influenced by Tibetan examples, which might have been presented as gifts to the imperial court by visiting Buddhist monks. Rulers of the early Ming dynasty enjoyed a close relationship with Tibet and welcomed monks from the neighboring region to visit or even to live at court, where they instructed the Chinese emperors about Tibetan Buddhism. HK

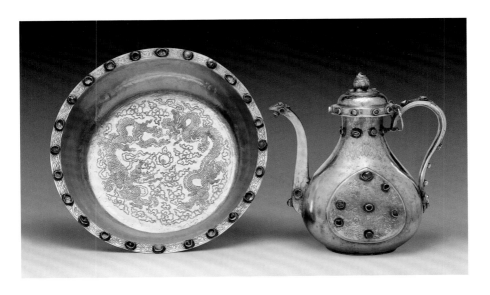

Wine Bottle

Thailand, Kalong, 14th–16th century
Stoneware with underglaze blue decoration, H. 10¼ in. (26 cm)
Gift of Dean F. Frasché, 1967-162-60

Situated along a river valley near rich deposits of high-quality clay, the ceramic center at Kalong, with over one hundred kilns, was one of the largest production sites in northern Thailand from the thirteenth to the sixteenth centuries. In later years, ceramic production moved south, and the existence of the Kalong site was forgotten until it was excavated in the 1930s. The sophisticated design of this wine bottle testifies to the center's flourishing and advanced pottery manufacture. Its top and bottom were made separately and then luted together at the middle, with the scrolling peony and vine motif, applied with iron pigments and then covered with a transparent glaze, appearing in two horizontal bands above and below the seam. FF

Dish

Vietnam, 15th–16th century
Stoneware with underglaze blue decoration, DIAM. 13¼ in. (33.6 cm)
125th Anniversary Acquisition. Purchased with funds contributed by Warren H. Watanabe and the George W. B. Taylor Fund, 1998-148-1

Ceramic production and trade were essential parts of the cultural and economic history of Vietnam. Reflecting the influence of Chinese Ming dynasty porcelains, the blue-and-white decoration of this beautifully crafted dish, a superb example of Vietnamese ceramics from the fifteenth and sixteenth centuries, features central landscapes representing the four seasons and complex foliate motifs. Such high-quality wares were greatly admired in the overseas trade, and the remnants of barnacle adhered to the underside of this dish suggest it was underwater at some point, likely the result of a shipwreck during export. KK

Double-Gourd Vase

China, Jingdezhen, Ming dynasty, Jiajing period (1522–66)
Porcelain with underglaze blue decoration, H. 18⅝ in. (47.3 cm)
The Bloomfield Moore Collection, 1882-727

One of the first works to enter the collection, this impressive vase was among the three thousand European and Chinese objects given to the Museum by the Philadelphia philanthropist Mrs. Clara Bloomfield Moore. Its double-gourd form, associated with immortality, was specifically ordered by the Ming emperor Jiajing (r. 1552–66), a devout practitioner of Daoism, as he believed that gourds contained miniature universes and the land of the immortals. Painted in inky blue cobalt are imperial five-clawed dragons, phoenixes, and cranes, mythical birds of longevity often depicted carrying enlightened Daoists to an immortal realm. HK

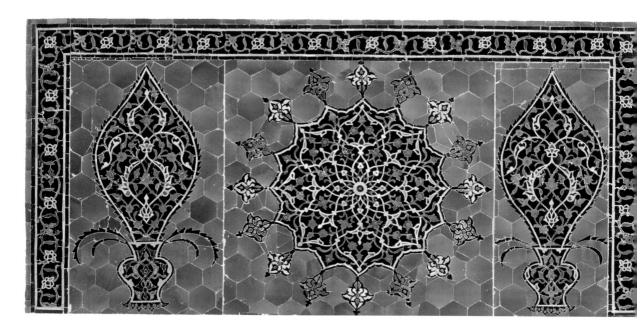

Tile Mosaic Panel

Iran, Isfahan, late 15th century
Stonepaste with polychrome glaze, 3 ft. 6 in. × 10 ft. 6 in.
(1.07 × 3.2 m)
Purchased with Museum funds, 1931-76-1

This panel is one of a group installed in the Museum
that is said to have come from a *khanqah*, a gather-
ing place for followers of the Sufi orders of Islam, in
Isfahan, Iran. The brilliantly colored star medallion,
palmette-filled vases, and flowering-vine border were
composed by setting small pieces of glazed ceramic
tile, cut to shape, in mortar. Such complex mosaic
panels were planned meticulously to ensure that all
the components fit perfectly, not unlike a giant jigsaw
puzzle. The template could then be reused or trans-
ferred to a different medium such as silk or stucco. YR

Para-Mamluk Carpet

Iran, Tabriz; northern Iraq; or northern Syria, 15th century
Wool and possibly goat hair; 70 × 49¼ in. (177.8 × 125.1 cm)
The Joseph Lees Williams Memorial Collection, 1955-65-2

Five multicolor octagonal medallions, each filled with
stars and complex interlacing, adorn the crimson field
of this rare and exquisite pile carpet. Surrounding the
large central medallion is a ring of floral and arboreal
motifs, beyond which lie intricate interlaced patterns
and a series of borders, the outermost bearing a flori-
ated band that resembles Arabic script. Part of the
important gift of the Reverend and Mrs. Charles F.
Williams (see pp. 28–29), the Museum's Para-Mamluk
rug belongs to a small group of carpets and carpet
fragments likely made for Turkmen royalty. The
designs of these carefully planned, finely woven rugs
shared an artistic vocabulary with metalwork, manu-
script illustrations, and architectural decoration. YR

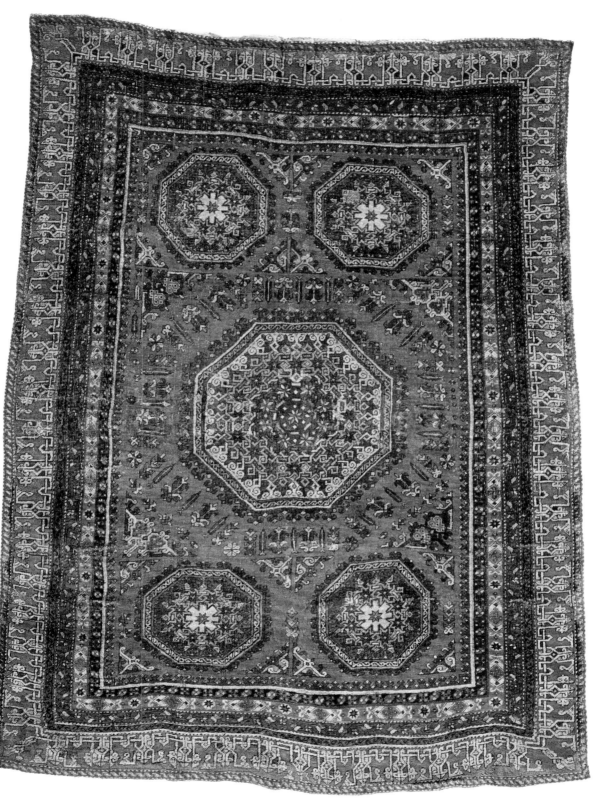

Detail of *Textile*

Turkey, Ottoman Empire, early 16th century
Silk with silver and gilt thread, 17¼ × 6¼ in. (43.8 × 15.9 cm)
Gift of Henry P. McIlhenny, 1951-98-15

This splendid textile's pattern of clustered colored balls often is referred to as *chintamani*, a Sanskrit word that, according to Buddhist and Hindu traditions, refers to an auspicious, wish-granting jewel. During the Ottoman Empire (c. 1300–1919), the motif was appropriated by its rulers as a symbol of power and royalty. The reduced scale of this example's design suggests that the textile originally was used for a small form, such as a child's kaftan or a document cover. DB

Table

Iran, Kashan, early 13th century
Stonepaste with luster decoration, H. 12 in. (30.5 cm)
Gift of Henry P. McIlhenny in memory of his parents, 1943-41-1

This small hexagonal table combines complex molded forms with superb painting to evoke a Persian garden pavilion, albeit in miniature. On each side is an elaborately decorated, recessed niche in which a nobleman sits overlooking a pond, and on the top is an enthroned figure with attendants. In addition to the dense decoration of abstract patterns and stylized fish and birds, the table bears poetic inscriptions, some executed in reserve. The surface's overall shimmer is due to the luster technique, a difficult and expensive process whose effect was meant to imitate bronze or gold. Given to the Museum by Philadelphia collector Henry P. McIlhenny (see pp. 190–91), this is the only known luster-painted table, making it an extraordinary and rare artistic achievement. YR

Turban Helmet

Western Asia, probably Ak Koyunlu, c. 1470–1500
Steel, silver, gold, and copper alloy; H. (bowl) 12³⁄₁₆ in. (31 cm)
Bequest of Carl Otto Kretzschmar von Kienbusch, 1977-167-953

One of the finest of its kind, this turban helmet exemplifies the mastery of metalworking attained by late fifteenth-century Islamic armorers working in Anatolia and adjacent territories. Its bowl is forged from a single piece of steel and elegantly modeled with whirling flutes above the crown, and the engraved ornamentation of foliage and script on the outer surface is highlighted with silver and gold. The modern designation of this head defense as a turban helmet derives from the proportions of the crown, which suggest that the type was to be worn over a turban or other heavily padded textile headgear. PT

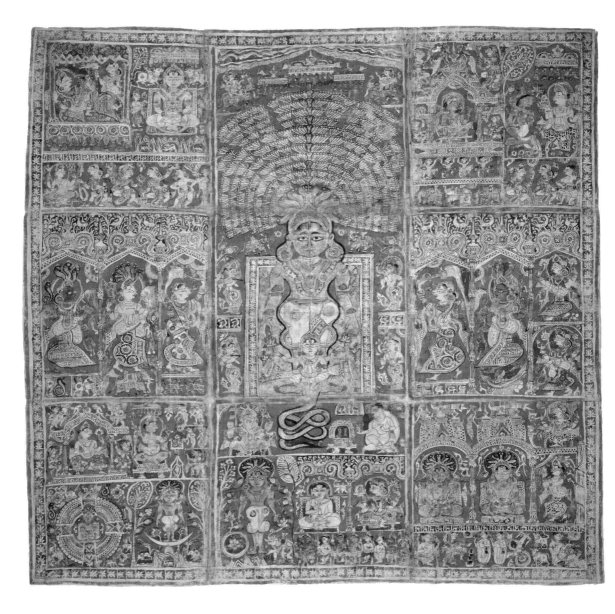

Parshvanatha Pata

India, Gujarat, c. 1450–75
Opaque watercolor on cloth, 20 × 20 in. (50.8 × 50.8 cm)
125th Anniversary Acquisition. Alvin O. Bellak Collection,
2003-143-1

This rare Jain *pata* (cloth painting) is among the masterpieces given to the Museum by Dr. Alvin O. Bellak (see also pp. 62, 67). Its limited palate, distinctively exaggerated human forms, and division into many small scenes show that it was created by a painter trained to make the devotional manuscripts Jains donated to monastic libraries. These books typically narrate the lives of the Jinas (Conquerors), the twenty-four perfected teachers of the Jain religion (see also p. 10). On this *pata*, Parshvanatha, the twenty-third Jina, stands meditating in a lotus pool under the sheltering hoods of a benevolent cobra. Around him, like a collage of manuscript illustrations, appear a Jina's stock life events: birth, tonsuring ceremony, meditation, liberation from rebirths, and final sermon in the heavenly hall. Rather than being hidden away in libraries, *patas* saw frequent use as aids to devotion and meditation, so few early examples survive. DM

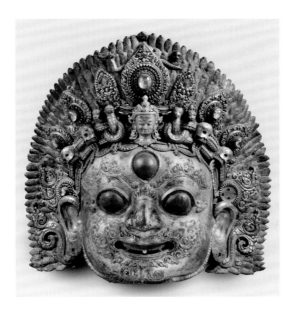

Bhairava
Nepal, Kathmandu Valley, c. 16th century
Mercury-gilded copper alloy with rock crystal, paint, foil, and
glass decoration; H. 28¼ in. (73.7 cm)
Purchased with the Stella Kramrisch Fund, 1998-77-1
Photography by Jay Muhlin

Bhairava, with three bulging eyes, flaming hair, and
a snake-and-skull diadem, is ostensibly the ferocious
form of the Hindu god Shiva. However, as the protec-
tor of Nepal's Kathmandu Valley, he also is honored
by Buddhists. This concave, reverse-hammered metal
head originally included a neck, shoulders, and jew-
eled earrings. Such busts of Bhairava are used for the
fall festival of Indrajatra, when the city of Kathmandu
receives its annual blessing. With a pot of holy beer
hidden inside, the figure is wheeled out on a wooden
platform. At the festival's crescendo, beer spurts
through Bhairava's fangs. Music plays while worship-
pers jostle to catch a mouthful of the drink and so
receive a blessing for themselves and their city. DM

Band with Royal Couple
Nepal, Malla dynasty, c. 1550–1650
Cotton with silk, 11 × 43 in. (27.9 × 109.2 cm)
Gift of Stella Kramrisch, 1963-36-1

Among the oldest surviving textiles from Nepal,
this embroidered band depicts two enthroned lovers
reclining beneath a canopy and feeding each other
betel nut, a digestive aid believed to be an aphrodisiac,
while dancing women perform for the couple's plea-
sure and mustached warriors with swords guard their
privacy. The colors, compositional arrangement, and
foliate motifs frequently are found in other Nepalese
arts from the sixteenth and seventeenth centuries, and
the costumes reflect the fashion of that period. The
brick- and chain-stitch embroidery techniques and
the crosses on the figures' costumes are believed to be
unique to early Nepalese textiles. DB

Purnabhadra
Tibet, c. late 15th or early 16th century
Mercury-gilded copper alloy inlaid with turquoise, H. 8¼ in. (21 cm)
125th Anniversary Acquisition. Gift of Hannah L. and J. Welles Henderson, 2001-44-1

Form and meaning meld in this glowing golden sculpture of Purnabhadra, king of the minor deities who attend Buddhism's Lord of Riches. Purnabhadra, whose Sanskrit name means "full of prosperity," holds aloft a *purnaghata*, an auspicious pot overflowing with foliage. His elegantly fitted horse prances atop the clouds. In his left hand he grasps a mongoose from whose mouth gushes a stream of jewels, and he sports a helmet in the form of a mythical sea creature, motifs associated with wealth deities not only in Buddhist but also in Hindu and Jain imagery. However, the sculptural style and the figure's garb reflect Chinese tradition. Such cultural intertwining recalls the international nature of Buddhism and of the Tibetan world itself. DM

Qiao Bin (Chinese, active 1482–1507)
Guanyin, Ming dynasty, 1507
Stoneware with three-colored glaze (*sancai*), H. 36⅞ in. (93.6 cm)
Gift of Charles H. Ludington from the George Crofts Collection, 1923-21-441

Dressed in flowing robes and wearing a crown embellished with an image of the seated Buddha, Guanyin (Avalokiteshvara in Sanskrit; see pp. 4, 5), the bodhisattva of compassion, sits at ease on a rocky outcrop, above a serpentine dragon and a mythical feline animal. The stylized modeling and the lustrous three-colored glaze are characteristic of the handful of surviving figures made by the famous Qiao family of artists who specialized in architectural tiles and religious sculptures. Ink inscriptions on the sculpture's sides record the names of the donor and the Buddhist temple in northern Shanxi Province where devotees of Guanyin would pray for an auspicious rebirth for themselves and their ancestors. HK

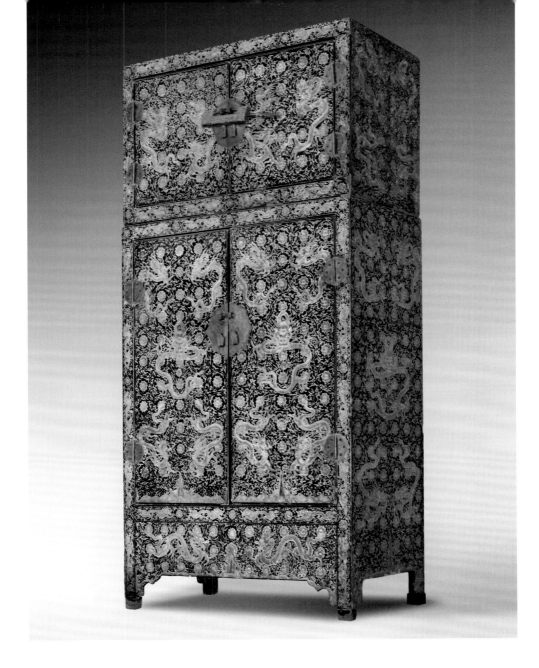

Compound Wardrobe

China, late Ming or Qing dynasty, late 16th–17th century
Lacquered wood with painted and gilt decoration; brass; H. 9 ft.
6¼ in. (2.9 m)
Purchased with the Bloomfield Moore Fund, 1940-7-2a–c

Intended for the spacious residence of a member of
the Chinese nobility, this extraordinary wardrobe, one
of a pair in the Museum's strong holdings of Chinese
furniture, was designed to store clothing, with the
smaller cupboard on top intended for hats. Its sump-
tuous red and gold decoration of lotuses and dragons,
including the imperial symbol of the five-clawed
dragon, suggests the aristocratic status of the cabinet's
owner. The frontal design of the five-clawed dragon
with pairs of smaller confronting dragons above and
below is almost identical to that found on contem-
porary imperial robes, which would have been kept
folded flat in a wardrobe such as this. HK/FF

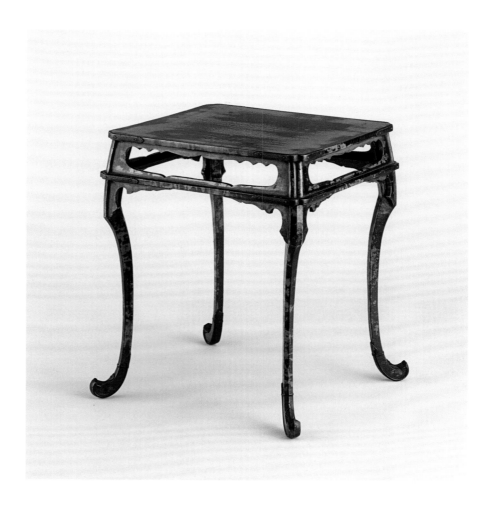

Incense Table

Japan, Muromachi period, 15th century
Lacquer on wood; metal; H. 14½ in. (36.8 cm)
Purchased with the John T. Morris Fund, 1982-4-1

This small table's mottled pattern is the result of the Japanese *negoro* technique, in which a layer of red lacquer is applied over layers of black lacquer. With age and use, the red layer wears away unevenly to expose the dark lacquer beneath, creating a subtle effect. The table's slender legs and delicately carved side panels recall Chinese forms from the eighth century, when lacquerwares were introduced to Japan by Buddhist monks from the Asian continent. Originally designed for use in temples, in later centuries these tables appealed to Japanese tea connoisseurs for the elegant simplicity of their sculptural form. FF

Jar with Lid

Korea, Joseon dynasty, late 15th–early 16th century
Porcelain, H. 10½ in. (26.7 cm)
Purchased with the James and Agnes Kim Fund for Korean Art
and with funds contributed by Maxine and Howard Lewis and
Mr. and Mrs. John Thalheimer, 2010-201-1a,b

Produced from the fifteenth through the early twenti-
eth century, simple but elegant white porcelains such
as this reflect the frugality and restraint promoted
by the Neo-Confucian ideology of the ruling Joseon
dynasty (1392–1910). The diverse shapes, sizes, and
functions of these wares suggest the period in which
they were conceived. Purchased with support from
the James and Agnes Kim Fund for Korean Art, the
Museum's first major fund dedicated to the art of
Korea, this sophisticated jar represents a type made
in the fifteenth and sixteenth centuries that featured
a full shoulder and tapered bottom. Believed to have
been used for court rituals, vessels such as this were
produced only at the royal kilns near Seoul. HW

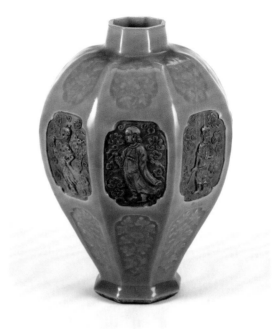

Vase with Daoist Immortals

China, Yuan dynasty, c. 1350
Glazed porcelaneous ware (Longquan ware), H. 10 in. (25.4 cm)
Gift of Mrs. S. Emlen Stokes, 1964-58-1

This octagonal vase is one of a small group of ves-
sels that combine the lustrous green glaze known as
celadon with unglazed red-brown decorative panels,
a distinctive technique developed by Chinese potters
during the Yuan dynasty (1271–1368). Before covering
a vessel's surface with glaze, the molded panels were
coated with wax, which melted away during firing,
exposing the natural clay and resulting in a bold
contrast of colors and texture. Here the decoration
depicts the Eight Immortals, Daoist symbols of lon-
gevity and happiness. This group of legendary figures
commonly was featured in Yuan literature and plays,
accounting for its popularity in the visual arts. HK/FF

Xia Chang (Chinese, 1388–1470)

Detail of *Bamboo under Spring Rain,* Ming dynasty,
Tianshun period, c. 1460
Ink on paper, mounted as a handscroll; 1 ft. 8½ in. × 31 ft. 7¹⁵⁄₁₆ in.
(0.52 × 9.65 m)
Purchased with the Joseph E. Temple Fund and the John T.
Morris Fund, 1953-51-1

Conveying associations of spiritual virtues and lon-
gevity, bamboo and rocks were ideal subjects for
scholar and artist Xia Chang to display his mastery
of brush and ink. Using calligraphic strokes, he ren-
dered older bamboo stalks with thick black brush-
strokes and younger shoots in a light gray wash.
Dotted with dry-brushed rock formations, the land-
scape is shown from a low perspective, as if observed
from ground level. Only a small section of the thirty-
one-foot-long handscroll can be viewed at any one
time as it is unrolled from right to left, offering the
viewer glimpses of the passing landscape. HK/FF

Xu Wei (Chinese, 1521–1593)

Sixteen Flowers, Ming dynasty, 16th century
Ink on paper, mounted as a hanging scroll; 10 ft. 11 in. × 3 ft. 3 in.
(3.33 × 0.99 m)
Purchased with the Fiske Kimball Fund and the Marie Kimball
Fund, 1968-29-1

An accomplished calligrapher, painter, and writer,
Xu Wei turned to these pursuits after several failed
attempts at passing the provincial civil-service
examination had forced him to engage in a variety of
occupations, including military aide and strategist.
Best known during his lifetime as a playwright, he
demonstrated his dramatic flair in the staging of the
sixteen flowers on this hanging scroll, accompanied
by a poem that he composed and inked in expressive
calligraphic script. He wished to be remembered for
his calligraphy, an art form that in China is inter-
twined inexorably with painting and poetry. This
stunning scroll, almost eleven feet long, showcases
his brushwork, depicting in vivid profusion begonia,
camellia, lotus, narcissus, and peony flowers, anchored
by a solid rock formation and counterbalanced by the
calligraphy that falls like rain from the upper right.
Ancient legend inspired him to paint flowers from all
seasons blooming simultaneously, which in his poem
he likens to beautiful young women whose looks inev-
itably fade. Although Xu's belief that immediate self-
expression should be the primary purpose of creative
activity was not shared by his contemporaries, his
work influenced later artists including Bada Shanren
(1626–1705) and Qi Baishi (1863–1957). HK/FF

Pavilions in a Mountain Landscape

Japan, Muromachi period, c. 1550
Ink and color on paper, mounted as a pair of hanging scrolls;
60 × 38 in. (152.4 × 96.5 cm) each
Purchased with the Henry P. McIlhenny Fund in memory of
Frances P. McIlhenny, the Henry B. Keep Fund, and the East
Asian Art Revolving Fund, 1990-92-1a,b

Now mounted as hanging scrolls, this pair of ink paintings originally was set into lacquered wood frames to serve as sliding doors in an upper-class residence or a Buddhist temple in sixteenth-century Japan. Displaying the Chinese-style ink-painting techniques and themes that were popular in Japan at the time, the scene across the two panels is to be read in the traditional manner, from right to left. The viewer's attention is thus immediately focused on the steep mountain cliffs at the upper right and gradually shifts downward with the movement of the waterfall. Behind the hills beyond the narrow bridge is an elegant pavilion where a group of scholars are taking tea. A grove of pines in the mist is punctuated by the pale moon above, as the scene that begins so dramatically ends on a note of harmony and respite. FF

Mokuan Shōtō (Chinese, 1611–1684)

Capacity beyond Measure, Edo period, 1679
Ink on paper, mounted as a section of a handscroll; H. 12 in.
(30.5 cm)
Purchased with the Edward and Althea Budd Fund, 1977-164-1(1)

In 1654 a group of Chinese Zen Buddhist prelates,
led by their abbot Ingen, arrived in Japan, where they
established the Mampuku-ji temple near Kyoto. This
calligraphy by Mokuan Shōtō, the temple's second
abbot, is part of a remarkable handscroll comprising writings by fifteen of the sect's early leaders. His
bold three-character inscription, "capacity beyond
measure," alludes to the infinite possibilities he foresaw for the growth of Zen Buddhism in his adopted
country. Assembled in 1679, the year the temple's final
structure, the bell tower, was dedicated, the scroll may
have been created as a tribute to Mokuan, who had
overseen the construction of the monastic complex. FF

Hon'ami Kōetsu (Japanese, 1558–1637)

Poems from the "Shinkokin wakashū," Edo period,
early 17th century
Ink, gold, and silver on paper, mounted as a handscroll;
1 ft. 1¹⁵⁄₁₆ in. × 27 ft. 2¾ in. (0.35 × 8.3 m)
125th Anniversary Acquisition. Purchased with funds contributed
by the members of the Committee on East Asian Art, 1999-39-1

Hon'ami Kōetsu, a central figure in Japanese art at the turn of the seventeenth century, revolutionized the visual effects of classical poetry scrolls, collaborating with other esteemed artists to produce striking images that complemented his distinctively bold calligraphy. This scroll features twelve poems on the subject of love, written in the traditional thirty-one-syllable *waka* format, from the early thirteenth-century anthology *Shinkokin wakashū* (New Collection of Japanese Poems from Ancient and Modern Times). Beneath the elegant calligraphy on each of the scroll's nine joined sheets of dyed paper are gold- and silver-printed motifs of ivy, grasses, and wisteria. On the verso, which is adorned with a random pattern of gold and silver butterflies, the papermaker Kamishi Sōji, with whom the artist often collaborated, stamped his rectangular seal at every other paper join. Kōetsu's transcription of the classical verses reveals his characteristic variations of dark and light ink, and broad and fine brushstrokes, and his graceful scattering of words among the grasses to create beautiful, irregular visual effects. Originally the scroll might have been longer, but it suffered fire damage at an unknown date. Its careful restoration deliberately retained some signs of the damage, preserving some of the beauty and effects of age and wear, rather than denying or disguising the work's history. FF

Hall from the Madanagopalaswamy Temple
India, Tamil Nadu, Madurai, c. 1550
Granitic stone
Gift of Susan Pepper Gibson, Mary Gibson Henry, and Henry C.
Gibson in memory of Adeline Pepper Gibson, 1919-714

The more than sixty carved granite elements that comprise this monumental space were collected by Philadelphian Adeline Pepper Gibson during a visit in 1912 to Madurai, a city in the south of India known for its wealth of Hindu temples. She found them strewn within the compound of a sixteenth-century Krishna temple called the Madanagopalaswamy, which remains active today, and purchased them from the temple authorities. Recent curatorial research shows that the pieces once formed a freestanding festival hall located in front of the main shrine. There devotees would have gathered to participate in a variety of celebratory rituals.

Emerging from the pillars lining the hall's central aisle are extraordinary oversize figures of deities and heroes related to the dramatic stories of the Hindu god Vishnu. Between delightfully fierce lion capitals, eight slabs installed at cornice level feature carved reliefs of scenes from the *Ramayana* story cycle, which tells of the hero Rama, one of Vishnu's avatars. Many more slabs from this cycle remain at the temple in Madurai, demonstrating that the original hall interior boasted a rare complete rendition of the tale. Smaller images adorn the pillars, including a portrait of the temple's architect-priest with his measuring stick.

First opening to the public in the Museum's original home at Memorial Hall, the temple hall debuted at its current location in 1940. As the only example of premodern Indian stone temple architecture outside South Asia, it provides visitors a unique opportunity to experience the extraordinary synthesis of sculpture, architecture, and symbol that characterizes the Indian temple form. DM

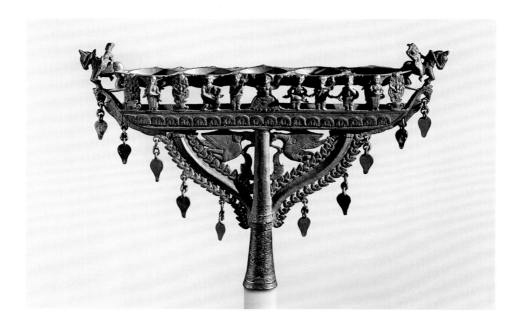

Oil Lamp

India, Kerala, 17th–18th century
Copper alloy, H. 10¾ in. (27.3 cm)
Stella Kramrisch Collection, 1994-148-109

Icon and implement, holy and whimsical, this magnificent oil lamp was a highlight of Stella Kramrisch's groundbreaking 1968 exhibition *Unknown India* (on Kramrisch, see pp. 16–17). Five shallow bowls for holding oil or clarified butter and cotton wicks are supported by a lively lineup of performers and pots, at the center of which stands the great bird-man Garuda, vehicle of the Hindu god Vishnu. Within the foliate branches, two ganders ready themselves to fly the sacred fire to the gods. By inserting a wooden rod in the lamp's central shaft, it could be carried aloft during ritual processions. Dangling metal leaves trembling, the tiny figures appearing to dance in the wavering flames, this lamp would have been a dynamic celebration of the divine. DM

Rank Badge with Qilin

China, Qing dynasty, Kangxi period (1662–1722)
Silk with silk and gilt thread, 14¾ × 13¾ in. (37.5 × 34.9 cm)
Purchased with the John T. Morris Fund from the Carl Schuster Collection, 1940-4-731

A symbol of prosperity, the *qilin* is an auspicious Chinese mythological animal associated with a wise or virtuous ruler. Beginning in the Ming dynasty

(1368–1644), government officials wore ceremonial robes with insignia designating rank, and prior to 1662 the *qilin* was used to designate a member of the nobility. After this date, the creature served as the emblem of dukes, imperial sons-in-law, and certain military officials. The Museum's important collection of Chinese textiles includes more than three dozen civilian and imperial rank badges from the Ming and Qing dynasties. LLC

Tomb Cover

Iran, Safavid dynasty, 1675–1700
Silk, 78¼ × 35⅛ in. (198.8 × 89.2 cm)
Purchased with the Membership Fund, 1922-22-90

Calligraphy is central to Islamic art, with Arabic script decorating not only manuscripts but also architecture, ceramics, metalwork, and textiles. In Iran during the Safavid dynasty (1501–1736), before being buried in shrines that housed the royal tombs, sarcophagi of prominent persons traditionally were covered with lengths of costly silks, often adorned with calligraphic texts from the Koran. In this nearly complete tomb cover, three Arabic inscriptions are repeated throughout: a verse from a sura, or chapter, of the Koran; the names of the three major figures of the Shia branch of Islam, ʿAli and his sons Hasan and Husayn; and the phrase "Oh, Husayn, the martyred one." DB

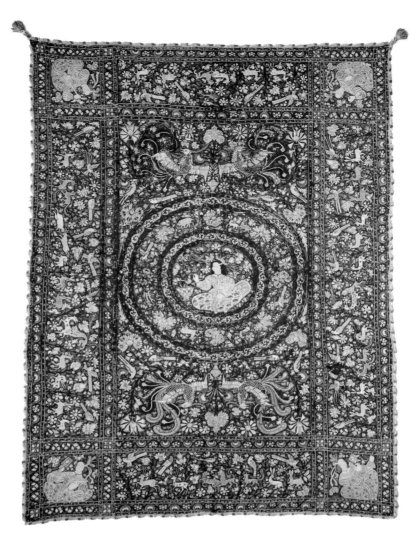

Bedcover

India or Portugal, c. 1680
Silk, 9 ft. 4 in. × 7 ft. 2 in. (2.85 × 2.18 m)
Gift of the Friends of the Philadelphia Museum of Art, 1988-7-4

This silk bedcover was made in Lisbon by Indian embroiderers or in India for the Portuguese market. The combination of European, Indian, and Persian motifs reflects the cross-cultural influences on design during the sixteenth and seventeenth centuries, a period of extensive exploration, settlement, and trade. Its embroidered decoration includes personifications of the five senses: In the central medallion, a woman petting an animal represents touch, and in each corner a female figure symbolizing one of the other four senses—hearing, sight, smell, taste—is seated among colorful plants and animals, including the magic birds of Persian lore. DB

Safavid Cubiculum

Iran, in or near Isfahan, Safavid dynasty, 17th century
Purchased with Museum funds, 1930-3-1a–d

The Museum's cubiculum, or small room, comes from a residential complex built in the seventeenth century in or near Isfahan, Iran, then the capital of the Safavid Empire. Since its acquisition by the Museum in 1930, the cubiculum has been associated with the patronage of Safavid ruler Shah 'Abbas I (r. 1587–1629), but recent research suggests it might have come from one of the scores of houses built by members of his court. Due to the devastating consequences of the Afghan invasion of Isfahan in 1722, as well as centuries of earthquakes and neglect, many of these mansions no longer exist, making the Museum's cubiculum, the only known example of Safavid domestic architecture

outside Iran, crucial to understanding this now-lost group of buildings.

The elaborate, honeycomb-like stucco projections covering the room's ceiling and the vault of its antechamber are decorative elements known as *muqarnas* that conceal the underlying supporting framework. In the antechamber, intricate designs, including images of lions and birds, were carved in a thin layer of stucco covering the *muqarnas*, while in the cubiculum the combination of stucco carving and painted decoration produces a kaleidoscope of colors and patterns. When the cubiculum was installed in its present location in the late 1930s, highly skilled craftsmen funded by the federal Works Project Administration carefully re-composed the stucco panels from hundreds of small pieces, and retouched some of the painted and carved designs. YR

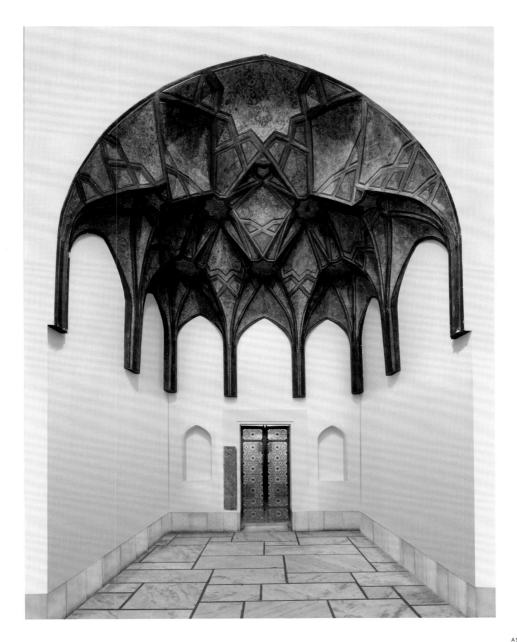

Reception Hall from the Palace of Duke Zhao

China, Beijing, Ming dynasty, 1640s
Gift of Edward B. Robinette, 1929-163-1

In a traditional courtyard residence of a Chinese nobleman, a reception hall such as this was the most formal building, where official activities were conducted. Originally part of a palace in Beijing built in the early 1640s that passed through various noble families, the last being that of Duke Zhao (after whom the complex is named), this magnificent example is the only one of its type outside China. Its soaring thirty-foot ceiling supported by red-lacquered columns and carved brackets creates a sense of grandeur, while the brilliantly painted floral and animal motifs on the beams and brackets convey auspicious wishes (see also fig. 6). HK/FF

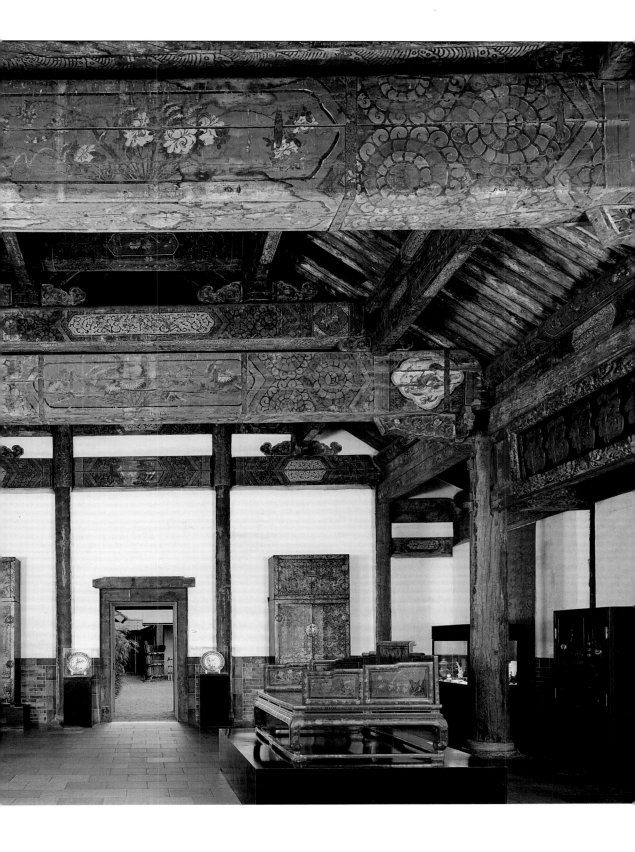

EARLY COLLECTORS OF CHINESE ART

The notable strengths of the Museum's collection of Chinese art, particularly in ceramics, are largely due to two remarkable gifts, from Major General and Mrs. William Crozier in 1944, and from Alfred and Margaret Caspary in 1955.

A West Point graduate, General Crozier (1855–1942) was stationed in Peking (now Beijing) in 1901 as part of the American military's relief expedition during the Chinese Boxer Rebellion (1898–1901). After his retirement in 1919, he and his wife often visited Peking, and around 1922 Mrs. Crozier began seriously collecting Chinese art, acquiring important examples of Song, Ming, and Qing ceramics, such as an unusual fifteenth-century blue-and-white faceted vase (far right, bottom; see also p. 20); rock-crystal carvings; and snuff bottles, including the delicately rendered glass example seen here (far right, top). Illustrating the Qianlong emperor's appreciation of Western art techniques, the bottle's painted decoration features shading and perspective that, along with European glassmaking, were introduced to the imperial court's workshops by Jesuit missionaries in the early eighteenth century. Dazzled by the Museum's impressive Ming dynasty reception hall (p. 56), Mrs. Crozier agreed to lend part of her collection for display. After the general's death, the Croziers' holdings of more than one thousand objects were given to the institution.

A successful New York stockbroker and a renowned stamp collector, Alfred H. Caspary (1877–1955) followed a very different path to collecting Chinese art than did the Croziers. His interest in Chinese ceramics may have grown from his acquaintance with his neighbor John D. Rockefeller, Jr., then a leading collector of Chinese porcelains. In 1939 Caspary purchased more than four hundred Chinese porcelains, primarily made during the reign of the Kangxi emperor (1662–1722), from the estate of Glasgow shipping magnate Leonard Gow. The collection—including a striking vase decorated in an unusual palette, formerly in the treasury of Augustus the Strong of Saxony (right)—was then put into storage, where it remained until Caspary's death in 1955, when it was given to the Museum. Asked why he had purchased the porcelains, Caspary explained that while he could make more money, he could not guarantee an opportunity such as the sale of Gow's collection would present itself again—a happy circumstance from which the Museum and its visitors have benefited greatly. HK

Vase
China, Qing dynasty, Kangxi period (1662–1722)
Porcelain with underglaze blue, overglaze polychrome enamel, and gilt decoration; H. 28⅛ in. (71.4 cm)
The Alfred and Margaret Caspary Memorial Gift, 1955-50-99

Snuff Bottle
China, Qing dynasty, Qianlong period (1736–95)
Glass with enamel decoration; brass; H. 1¹³/₁₆ in. (4.6 cm)
Gift of Major General and Mrs. William Crozier, 1944-20-551

Faceted Vase
China, Ming dynasty, Xuande period (1426–35)
Porcelain with underglaze blue decoration (Jingdezhen ware), H. 5½ in. (14 cm)
Gift of Major General and Mrs. William Crozier, 1944-20-292a,b

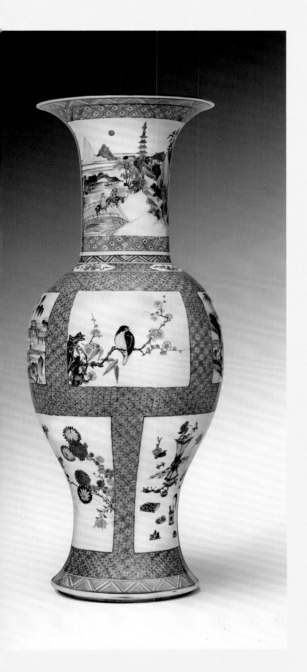

Tea Storage Jar

Japan, Edo period, 18th century
Porcelain with underglaze blue and overglaze enamel decoration (Arita ware), H. 17¾ in. (45.1 cm)
Purchased with the George W. B. Taylor Fund, 1955-10-1

In the mid-seventeenth century, the coastal city of Arita, on the southernmost island of Japan, became the country's center for porcelain manufacture and export. Renowned for their superb blue-and-white and enamel decoration in the Imari, Kakiemon, and Nabeshima styles, Arita wares were appreciated not only in Japan but also in Europe, where they were traded extensively. The graceful form of this sophisticated jar recalls teawares from Kyoto, and its delicate decoration of a fence with flowering vines, a popular subject in Edo Japan, evokes traditional Japanese painting as well as contemporary kimono design. KK

Document Box with Design of Five Butterflies

Japan, Edo period, 17th–18th century
Lacquer, deer hide, gold, silver, silk; L. 13⅜ in. (34 cm)
Purchased with the Hollis Fund for East Asian Art Acquisitions, 2004-83-1a,b

Made from lacquered deer hide, a technique developed during the Nara period (710–94) and typically used for Buddhist sutra boxes or storage chests for priests' robes, this light yet durable domed box features exquisite gold and silver decoration of butterflies, auspicious symbols of joy and immortality in Japanese culture. The bold design was strongly influenced by the popular style of Edo-period artist Hon'ami Kōetsu, renowned for his calligraphies (see, for example, p. 48), ceramics, and lacquerware designs. KK

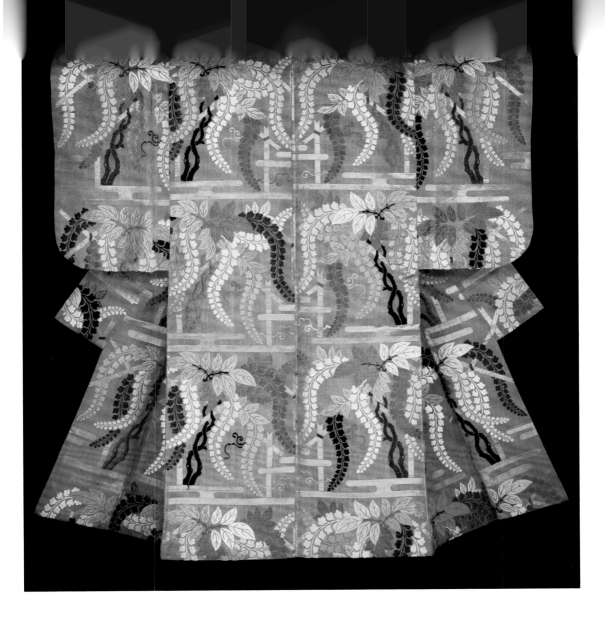

Nō Robe

Japan, Edo period, 1750–1850
Silk with silk and gilt thread
Gift of Henry B. Keep, 1964-218-1

Splendid costumes such as this are integral to traditional Japanese Nō dramas, a theatrical art form dating from the fourteenth century that emphasizes aesthetic ideals and symbolic meanings. Originally mirroring aristocratic fashions, the costumes evolved into a distinct type of stage dress that used expensive but outmoded materials and techniques, such as the intricate weave structure of *karaori* (literally "Chinese weaving"), in which floating wefts of untwisted silk give the impression of elaborate embroidery. Nō robes woven with this method, which also are known as *karaori*, generally are worn as outer garments in female roles, and are stiff and heavy, thus creating a regal effect. The wisteria and lattice motif on this sumptuous robe, one of many examples in the Museum's important collection of traditional Japanese costumes and textiles (see also p. 82), is typical of the feminine pictorial patterns of *karaori*, and the use of red indicates the robe was intended for roles portraying young women. HKH

Bhadrakali within the Rising Sun, page from a
Tantric Devi series
India; Himachal Pradesh, Nurpur, or Jammu and Kashmir,
Basohli, c. 1660–70
Opaque watercolor, gold, silver-colored paint, and beetle-shell
cases on paper; 8¾ × 8⁵⁄₁₆ in. (22.2 × 21.1 cm)
125th Anniversary Acquisition. Alvin O. Bellak Collection,
2004-149-22

At the core of an enormous golden sun stands the
dark goddess, here called Bhadrakali. Her pink lotus
jewelry is enhanced by tiny pieces of iridescent beetle
shell. Living snakes wreath her neck. Her eyes widen
hypnotically, and her red lips stretch in a faint, fang-
baring smile. Beneath her hennaed feet is a corpse
whose twisted body hovers within the sun's sphere.
Perhaps better than any other in the entire history
of Indian art, this painting illustrates the concept of
divine power at the very moment of embodiment.
Created as the opening page for a spectacular series
extolling the great Hindu goddess in her many forms,
it comes from the exceptional collection of Dr. Alvin
O. Bellak (see also pp. 38, 67). DM

Todi Ragini, page from a *ragamala* series
India, Malwa, Madhya Pradesh, c. 1660–70
Opaque watercolor and gold on paper, 8⅛ × 5¹⁵⁄₁₆ in.
(20.6 × 15.1 cm)
Stella Kramrisch Collection, 1994-148-526

Male and female musical modes (*ragas* and *raginis*)
conjure the fundamental emotional states of Indian
classical music. A *ragamala* (garland of *ragas*) is a
unique synthesis of image and verse inspired by these
modes. This extraordinary depiction of love and long-
ing describes the *ragini* called Todi; its customary
visualization is a lone woman accompanied by a deer.
Here, in a wildly fertile landscape, a woman dreams
of her lover as a buck and doe approach, their dual-
ity emphasizing her isolation. The palette of pinks
and purples moves well beyond the primary colors
typically found in images from the Malwa region of
north-central India, whose vivid paintings are a high-
light of the Museum's collection. AMC

Fairies Descending to the Bedchamber of Prince Manohar, detail of a page from a manuscript of the *Gulshan-i ʿIshq*

India, Andhra Pradesh, probably Hyderabad, 1743–44
Opaque watercolor, gold, and ink on paper; 14 × 10 in.
(35.6 × 25.4 cm)
The Philip S. Collins Collection, gift of Mrs. Philip S. Collins in memory of her husband, 1945-65-22

Written in 1657–58 by Nusrati, court poet to Sultan ʿAli ʿAdil Shah II of Bijapur, the *Gulshan-i ʿIshq* (Garden of Love) is a mystical Sufi romance comprising more than 4,500 rhyming couplets composed in Deccani Urdu, the language of central India's Muslim elite. This painting, one of ninety-seven from a complete eighteenth-century manuscript of the poem in the Museum's collection, depicts colorful fairies descending to the bedchamber of Prince Manohar, whom they will take on a journey to meet, and tragically become separated from, his beloved. Many of the manuscript's illustrations portray the fateful lovers' quests to be reunited, arduous undertakings that are symbolic of the soul's longing for the divine. YR

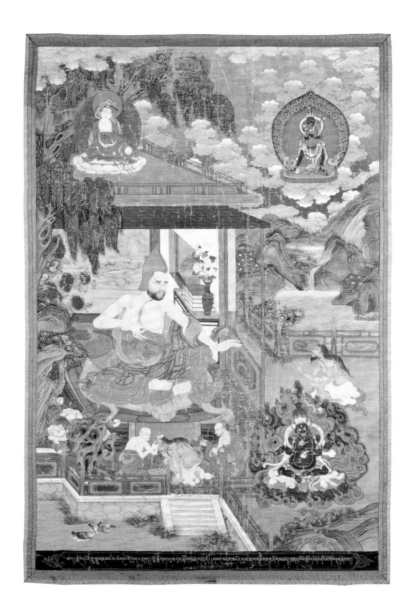

Bhavaviveka Converts a Nonbeliever to Buddhism

China or Tibet, Qianlong dynasty, Gelug monastic order, 18th century
Colors on cloth, 53¼ × 33¼ in. (135.3 × 84.5 cm)
Gift of Natacha Rambova, 1959-156-1

Large in scale and sublime in atmosphere, this painting depicts Bhavaviveka, founder of an influential school of Indian Buddhist philosophy. Sitting within an idealized Chinese-style landscape, Bhavaviveka reaches his hand toward a nonbeliever, drawing him into the Buddhist fold. On the roof sits the renowned Indian scholar Nagarjuna, Bhavaviveka's teacher, while, at right, the lineage protector Mahakala (see p. 27) dances in a flaming halo. The painting originally was part of an important set of thirteen—two of which are in the Museum's collection—illustrating the incarnations of the Panchen Lama, a position second only to the Dalai Lama in the Tibetan Buddhist hierarchy. The set likely was made in China at the court of the Qianlong emperor (r. 1736–95), a great patron of the arts. DM

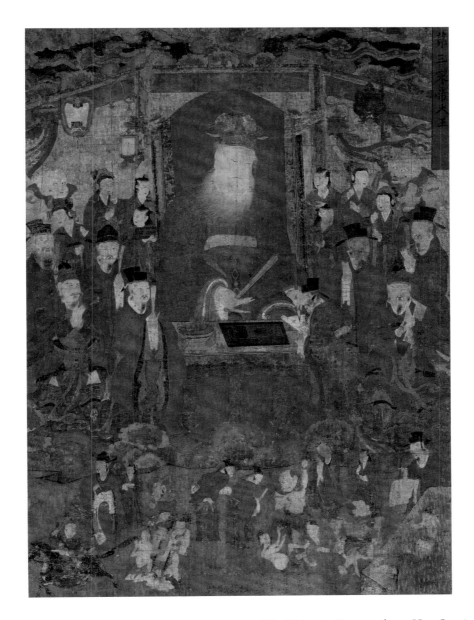

Songjae Daewang

Korea, Joseon dynasty, 18th century
Ink and colors on silk, 60 × 43¼ in. (152.4 × 109.9 cm)
Gift of Mrs. W. James Anderson, Mrs. Samuel Bell, Jr., Mrs.
Richard Drayton, and Charles T. Ludington, Jr., in memory of
their parents, Mr. and Mrs. Charles Townsend Ludington,
1970-259-3

Although belief systems other than Confucianism
increasingly were suppressed following the establish-
ment of the Joseon dynasty in 1392, this eighteenth-
century painting is evidence of the continued presence
of Buddhism in Korean culture. Here Songjae, the
third of the ten Buddhist kings of the underworld,
sits in judgment of the deceased, surrounded by his
attendants and overlooking scenes of the punishments
he has meted out. Such images usually were displayed
in the building known as the Myeongbu-jeon (Hall of
the Underworld Court) in Korean temple complexes.
Although the script is now illegible, the red cartouche
at the bottom likely contained the names of the
donors and monk painters who created this work. HW

Krishna and Radha

India, Rajasthan, Kishangarh, c. 1750
Opaque watercolor and gold on cotton, 40¾ × 37 in.
(103.5 × 94 cm)
Purchased with the Edith H. Bell Fund, 1984-72-1

One of the most popular love stories in India is that of the Hindu god Krishna and his beloved Radha, often seen as a mystical metaphor for the quest of the human soul (Radha) for the divine (Krishna). Although Krishna is a cowherd and Radha a village woman, in this unusually large composition the couple's extravagant clothing and palace setting elevate them to royal status, allowing the painting's patron to envision himself in the role of the divine. In a gesture of endearment, the princely Krishna offers betel nut to the lips of his loved one. The figures' sharp profiles, arched backs, and elegantly elongated eyes distinguish this work as a magnificent example of the refined artistry for which the Hindu Rajput court at Kishangarh is rightly renowned. AMC

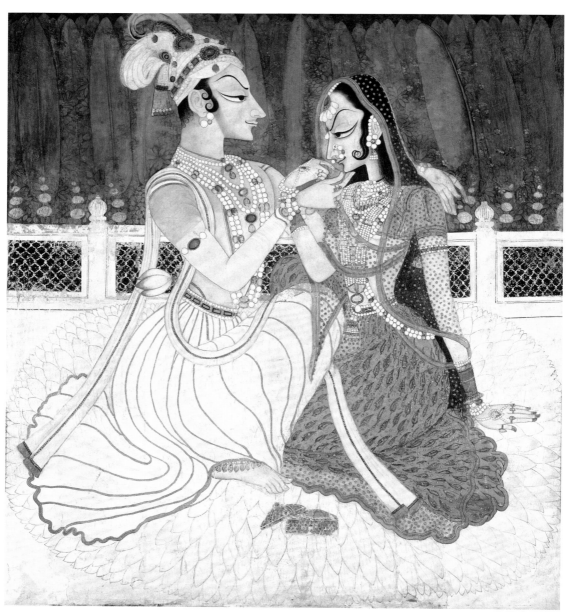

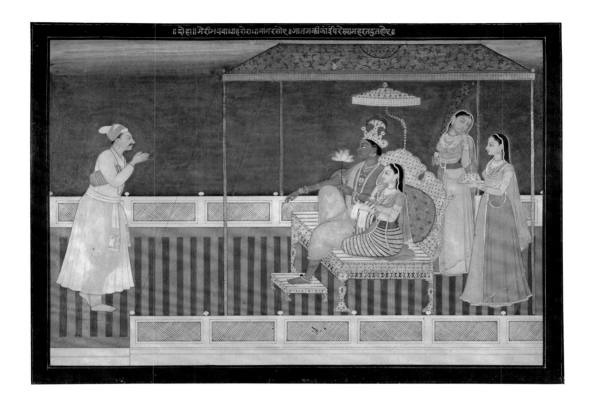

Attributed to **Nainsukh** (Indian, active mid-18th century)

The Poet Bihari Offers Homage to Radha and
Krishna, page from Bihari's *Seven Hundred Verses*, c. *1760–65*
Opaque watercolor, gold, and silver-colored paint on paper;
9⅞ × 13 in. (25.1 × 33 cm)
125th Anniversary Acquisition. Alvin O. Bellak Collection,
2004-149-71

Exquisite draftsmanship and color as well as layers
of meaning and emotion characterize this painting
attributed to the eighteenth-century master painter
Nainsukh, one of the few premodern Indian art-
ists whose name and individual style have been
pieced together by scholars. It was bequeathed to
the Museum by Philadelphia collector Dr. Alvin O.
Bellak, whose exceptional gift of ninety miniature
paintings and drawings spans four hundred years
of India's history (see also pp. 38, 62). The painting
illustrates the opening verse of a fifteenth-century
courtly poem. Although ostensibly a secular explora-
tion of relationships between lovers, the text is infused

with the poet's devotion to the Hindu god Krishna.
Krishna is the romantic hero, and he is god. Radha,
a beautiful village girl, is his heroine and the human
soul searching for god.

Here, more than a century after the poem was
written, Nainsukh demonstrated his own devotion
to the mystical lovers, depicting them as a king and
queen seated on a jeweled throne. Before them stands
a man in a fine muslin robe who holds his hands in
a reverential gesture. Under his right arm is a satchel,
which might contain pens or brushes. This man rep-
resents the poet, paying homage to his divine inspira-
tions at the beginning of his text. Yet his face, with
its distinctive mustache, buckteeth, and long neck,
resembles a painting believed to be a self-portrait of
Nainsukh. Thus, in this masterful work, Krishna and
Radha are both deities and royal patrons, while their
devotee is both the long-dead poet and the living
artist. DM

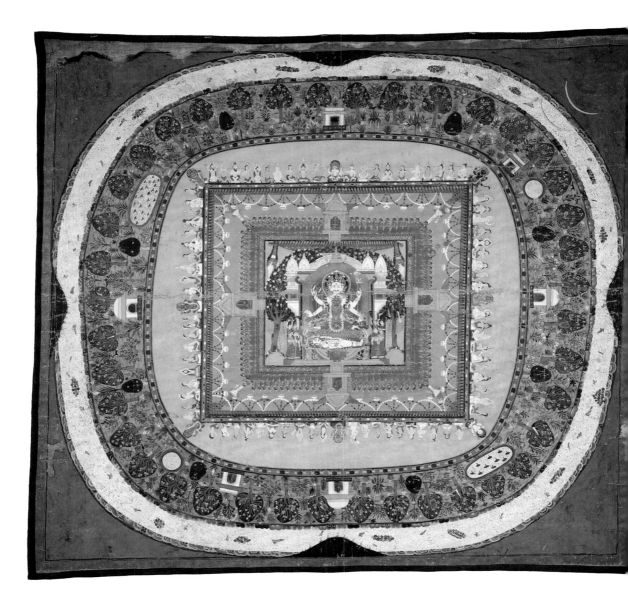

Mandala of Shiva and Shakti

Nepal, probably Bhaktapur, mid- to late 18th century
Colors on cloth, 51½ × 55 in. (130.8 × 139.7 cm)
Purchased with the Stella Kramrisch Fund, 2000-7-2

Exemplifying the inventive nature of art from eighteenth-century Nepal, this flamboyant image of the cosmos, envisioned as a series of concentric rings, holds the palace of the Hindu deity Shiva at its heart. It is a mandala, a form used in Nepal by Hindu and Buddhist devotees to guide their spiritual paths

through the divine realms. At center Shiva embraces his consort, the female energy known as Shakti, who meditates on the god's corpse. Outside the palace's gates is a ring of ash-covered yogis, who in turn are surrounded by the terrestrial realm and the ocean, replete with imaginative animals and insects. The whole is encased in the void, punctuated at upper right by a crescent moon. DM

Kantha

Bangladesh or India, West Bengal, possibly Jessore District,
early–mid-19th century
Cotton, 37½ × 37½ in. (95.3 × 95.3 cm)
Stella Kramrisch Collection, 1994-148-705

For centuries, women in what is today Bangladesh
and eastern India made embroidered textiles known
as *kanthas* for rituals and celebrations, using the rem-
nants of their families' worn garments. The Museum's
holdings, which come from the collections of Stella
Kramrisch and Jill and Sheldon Bonovitz, are the
largest and finest group of historical *kanthas* outside

the Indian subcontinent. This extraordinary example
is among the most delicately stitched and emotion-
ally charged in existence. Its images tell tender and
compelling tales of the blue-skinned Hindu god
Krishna, who is simultaneously an adorable cowherd
boy and a supreme deity. The scenes embroidered
along each side depict key episodes, including, at bot-
tom, besotted village women merging to form a horse
to carry their beloved lord, and, at right, Krishna
mischievously stealing butter and then opening his
mouth to reveal the universe within his body. DM

Dog Cage

China, probably Beijing, Qing dynasty, late 18th–19th century
Brass with cloisonné enamel and gilt decoration; jade; H. 45½ in.
(115.6 cm)
Gift of the Friends of the Philadelphia Museum of Art, 1964-205-1

This elaborate cage epitomizes the luxurious lifestyle and flamboyant taste of the imperial court of the late Qing dynasty (1644–1911). Presumably made for a dog in the royal kennel, it is decorated with the intricate enameling technique known as cloisonné, in which copper wires, called cloisons, separate areas of variously colored powdered glass that vitrify when fired at high temperature. The finials at the top as well as the five-clawed dragons and the lions' heads around the perimeter are gilded, and rows of white jade rings complete this miniature palace on wheels. HK/FF

Miniature Writing Cabinet

India, Andhra Pradesh, Vishakhapatnam, c. 1800
Ivory veneer, H. 31 in. (78.7 cm)
The Henry P. McIlhenny Collection in memory of Frances P.
McIlhenny, 1986-26-314a–u

By the eighteenth century, the natural harbor of
Vishakhapatnam in southeastern India had become a
convenient sojourn for merchant vessels, particularly
British, en route to East Asia. Settlers and traders
brought a demand for easily transportable European-
style furniture. This diminutive, precisely rendered
piece is perhaps the finest among the handful of
miniature writing cabinets in public collections. Its
charming ivory panels are incised with elaborate
architectural vignettes adapted from European engrav-
ings, while its delicate floral patterns evoke Indian
textile designs. This successful blend of local materials
and craftsmanship with imported forms reveals a long
history of cultural exchange. AMC

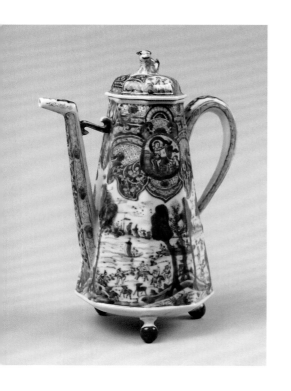

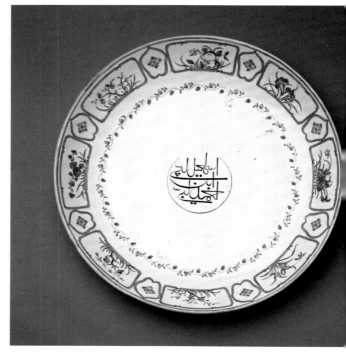

Coffeepot

China, Jiangxi Province, Jingdezhen for the Dutch market; Qing dynasty, Kangxi period, c. 1710
Porcelain with underglaze blue decoration, H. 11⅝ in. (29.5 cm)
Purchased with the Fiske Kimball Fund, 2008-226-1a,b

Early in its trade with China, the Dutch East India Company ordered porcelains that, initially in their shapes and somewhat later in their decoration, catered specifically to the European market. This coffeepot represents one of the first examples of this practice, with its octagonal form based on that of contemporary tin-glazed earthenware pots made in the Dutch city of Delft, which in turn were modeled after European silver coffeepots. A prototype of the Delft pot likely was sent to the important Chinese porcelain production center of Jingdezhen, where the Museum's coffeepot was made. DC

Charger

China, Jiangxi Province, Jingdezhen for the Indian market; Qing dynasty, Qianlong period, c. 1790
Porcelain with overglaze enamel and gilt decoration, DIAM. 14¼ in. (36.2 cm)
Gift of Sir David Bruce Duncan and Lady Deana Pitcairn Duncan, 2001-135-2

The designs on this charger differ from those found on most late eighteenth- and nineteenth-century Chinese porcelains made for export to India. Instead of motifs favored by Europeans and Indian Muslims, its decoration consists of auspicious Chinese symbols that convey wishes for peace (lotuses), longevity (peaches and purple *lingzhi* fungi), and many sons (pomegranates). The Arabic inscription in the center of the plate ("Ismail Labbay, son of Ahmed Labbay") refers to the Labbay, a Muslim community in southern India that had established trade with China as early as the late thirteenth century. HK

Scholar's Study

China, Beijing, Qing dynasty, Qianlong period, late 18th century
Gift of Wright S. Ludington in memory of his father, Charles H.
Ludington, 1929-30-1

The innermost chamber of the Chinese scholar-bureaucrat's residence was his private study, which provided an intimate, congenial space away from official duties. In this late eighteenth-century example from Beijing, part of the Museum's important hold-ings of Asian architecture, two walls are lined with hinged black-lacquered wood panels decorated with silk-covered latticework at the top and delicately painted landscapes at the bottom. The room's furnishings—such as the *huanghuali* table designed for painting or looking at scrolls, and the scholar's accoutrements, including an incense burner, an ink palette, and a scroll pot—complete this peaceful, contemplative setting. HK/FF

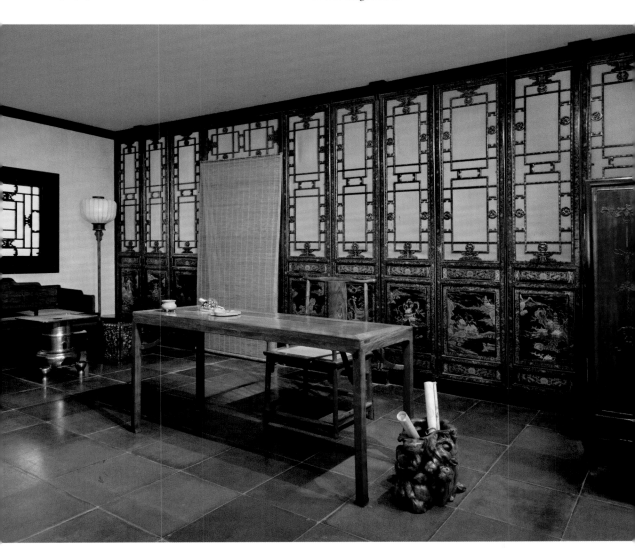

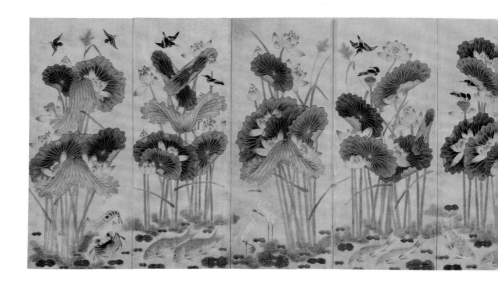

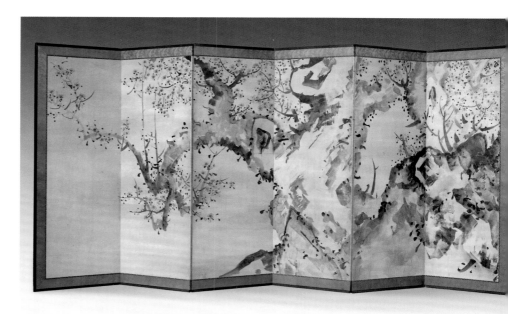

Screen with Lotuses

Korea, Joseon dynasty, 19th century
Ink and colors on paper, mounted as a ten-panel screen; H. 66 in.
(167.6 cm)
Purchased with funds contributed by members of the East Asian
Art Committee, 2011-48-1

Buddhists have long considered lotuses, aquatic
plants whose beautiful fragrant blossoms emerge from
muddy ponds, symbols of purity. With the expansion
of Buddhism in Korea during the Goryeo dynasty

(918–1392), the flower's popularity increased greatly,
and under Neo-Confucian rule in the subsequent
Joseon dynasty (1392–1910) it came to represent the
upright and faithful scholar, a meaning derived from
a play on the Chinese homophonous words for lotus
(*lian*) and uprightness (*lian*). Joseon scholars who
wished to cultivate virtue commonly installed lotus
ponds in their gardens or placed screen paintings such
as this in their studies. HW

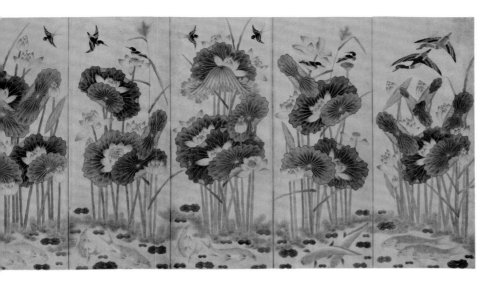

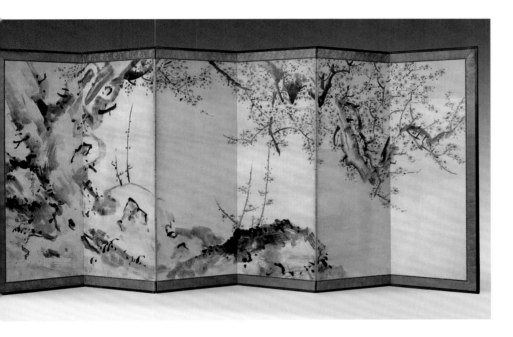

Ike Taiga (Japanese, 1723–1776)

Flowering Plum Trees in Mist, Edo period, c. 1770
Ink and gold wash on paper, mounted as a pair of six-fold screens;
H. 60 in. (152.4 cm) each
Purchased with the George W. Elkins Fund, E1969-1-1,2

A pivotal creative force of eighteenth-century Japan, the supremely accomplished and individualistic artist Ike Taiga displayed his bravura brushwork in this pair of monumental screens of plum trees. In the contrasts between the unpainted voids and the solid forms of the rugged trees, Taiga alluded to the dualities of yin and yang—darkness and light, death and rebirth—found in the natural world. The paper surface of the painting is highlighted with a pale gold wash that recalls a shimmering haze on a spring morning, subtly imparting another layer of depth to this masterful composition. FF

Mang Huli (Chinese, 1672–1736)

Seated Lady Holding a Fan, Qing dynasty, 18th century
Ink and colors on silk, 66½ × 43¾ in. (168.9 × 111.1 cm)
Gift of Mrs. W. James Anderson, Mrs. Samuel Bell, Jr., Mrs.
Richard Drayton, and Charles T. Ludington, Jr., in memory of
their parents, Mr. and Mrs. Charles Townsend Ludington,
1970-259-2

This image of an elegant woman posed in an interior
is an example of *meiren hua*, or "paintings of beauti-
ful women," a traditional genre that was especially
popular in the eighteenth century. Dressed in an
informal silk robe and holding a diaphanous silk fan,
she sits expectantly on a *luohan chuang* (couch bed).
The vase of roses and orchids on the lacquer table and
the fragrant Buddha's-hand citrus fruit on the dish by
her side evoke a delicately perfumed air, yet also carry
suggestive overtones. Characteristic of this genre is the
use of Western techniques such as spatial depth and
naturalism. HK

Courtier on Horseback
Japan, Edo period, 18th–19th century
Ink and colors on cryptomeria, mounted as a sliding door;
63¾ × 31 in. (161.9 × 78.7 cm)
Purchased with the Fiske Kimball Fund and the Marie Kimball
Fund, 1966-211-11a,b

In traditional Japanese interiors, sliding doors such as
this, known as a *sugito*, are used to divide and deco-
rate rooms. Made from a single panel of cryptomeria,
a cypress tree endemic to Japan, this door, superbly
painted with a scene of an elegant courtier riding his
dappled steed in the snow, features a gilded door pull
with an engraved design of three hollyhock leaves in
a circle, resembling the crest of the famous Tokugawa
family of shoguns. Although its provenance cannot
be confirmed, the door might have been designed for
one of the family's residences. KK/FF

Phoenixes (right) and ***Peacocks*** (left)
Korea, Joseon dynasty, 19th century
Ink and colors on paper, 61½ × 21½ in. (156.2 × 54.6 cm) each
Gift of Mrs. W. James Anderson, Mrs. Samuel Bell, Jr., Mrs.
Richard Drayton, and Charles T. Ludington, Jr., in memory of
their parents, Mr. and Mrs. Charles Townsend Ludington,
1970-259-1b,c

This pair of bird-and-flower paintings exemplifies the
superb artistic achievements of nineteenth-century
court painters from the Joseon dynasty (1392–1910).

Recent research has revealed that these images likely
were attached to the wall of a palace, where they
would have served as ornaments and symbols of good
fortune. Each panel depicts birds with their young, a
rare image in Korean painting that is believed to con-
vey a wish for many offspring. Such symbolism is sup-
ported by the inclusion of the moon and the sun, a
pairing that represents the harmony of cosmic energy,
yin and yang, dark and light, female and male. HW

Konishi Hirosada (Japanese, c. 1810–1864)

Four Actor Portraits, from the series *Sewa Suikoden no Uchi* (A Present-Day Story of *The Water Margin*), Edo period, 1847
Color woodcuts mounted on flecked Japanese paper, bound in an album; sheet: approx. 6½ × 4⅝ in. (16.5 × 11.7 cm) each
Gift of Jack Shear in memory of Anne d'Harnoncourt, 2008-62-243(16a,b),(15a,b)

In nineteenth-century Osaka, Konishi Hirosada was the leading designer of prints celebrating Kabuki theater, a popular Japanese performance art featuring strikingly costumed actors. He specialized in portraits of actors in acclaimed performances, like the four seen here, from upper right to lower left: Jitsukawa Ensaburō I and Nakayama Nanshi II, a male actor known for playing female roles, are shown in costumes from the play *Kyo Habutae Kawari Hinagata* (The Transformation of Two Capital Birds); and Mimasu Daigorō IV and Ensaburō I (again) are depicted in guises from *Hiyokumon Kuruwa no Nishikie* (A Brocade Print of Lover's Crests in the Pleasure District). These artfully arranged prints are among several hundred "headshots" mounted in three albums—probably by a theater fan—that were part of an extraordinary gift in 2008 of more than six hundred color woodcuts by Hirosada. The formation and ultimate donation of this collection were inspired by the Museum's impressive holdings, first highlighted in 1973 in the groundbreaking catalogue *The Theatrical World of Osaka Prints.* SRL

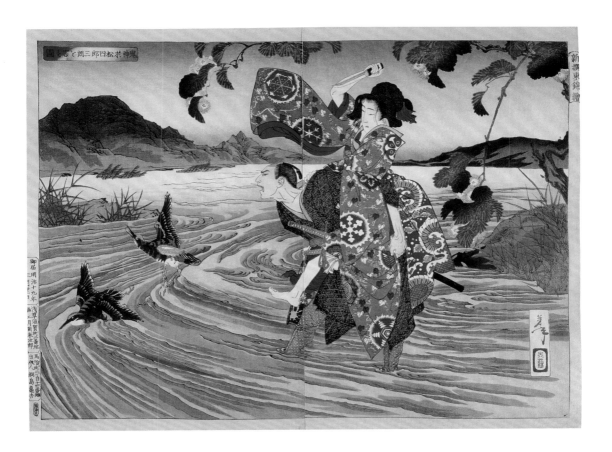

Tsukioka Yoshitoshi (Japanese, 1839–1892)

The Demon Omatsu Murders Shirôsaburô Crossing the Ford, Meiji period, 1885
Color woodcut, sheets (two joined): 15⅟₁₆ × 19⅟₁₆ in. (38.3 × 49.7 cm) overall with fabric border
Purchased with funds contributed by the E. Rhodes and Leona B. Carpenter Foundation, 1989-47-517a,b

Tsukioka Yoshitoshi is widely considered the last master of *ukiyo-e* color woodcuts, a traditional print form that typically focused on subjects—such as Kabuki theater, teahouses, and brothels—culled from the decadent, pleasure-filled *ukiyo* (literally "floating world") culture of Edo Japan. Of the Museum's nearly five thousand Japanese prints, more than one thousand are by Yoshitoshi, representing the largest collection of his prints outside his native country. He came of age as an artist in the second half of the nineteenth century, during Japan's dramatic cultural transformation as it opened to the West after two hundred years of isolation. As evident in this riveting episode from a Kabuki play, Yoshitoshi is notable for his masterful use of intense colors, made possible by newly available aniline dyes, and for his approach to figure drawing, which imbues his traditional woodcut subjects with a greater expressiveness and realism than found in earlier *ukiyo-e* prints. SRL

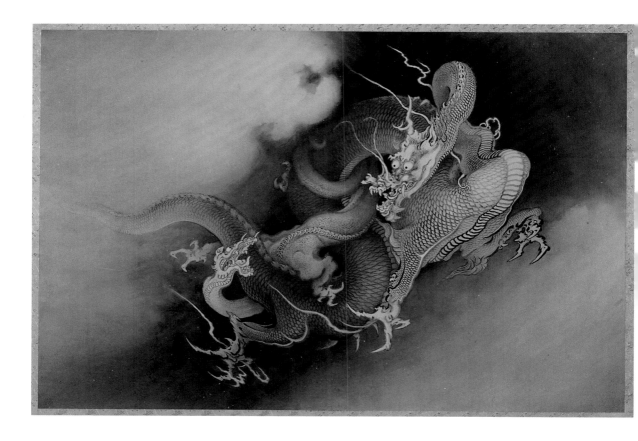

Kano Hōgai (Japanese, 1828–1888)

Two Dragons in Clouds, Meiji period, 1885
Ink on paper, 35½ × 53¾ in. (90.2 × 135.3 cm)
Gift of Mrs. Moncure Biddle in memory of her father, Ernest F. Fenollosa, 1940-41-1

This highly naturalistic rendering of intertwined dragons glistening amid clouds represents a bold experiment in adapting Western techniques to traditional Japanese ink painting. Kano Hōgai derived the sense of depth and three-dimensional perspective in this dramatic work from the Western oil paintings that recently had been introduced in late nineteenth-century Japan, while the subtle gradations of ink and the calligraphic clarity of line reflect his training in Japanese brush painting. Created for Ernest F. Fenollosa, an American educator and art historian who encouraged the revival of the Kano school of artists, this is one of several important Japanese paintings of the period from his collection at the Museum. FF

Itaya Kōji (Japanese, 1925–2006)

Screen with Golden Fox, Shōwa period, c. 1950s
Lacquer on wood with gold, gold leaf, and mother of pearl; H. 45⅛ in. (114.6 cm)
Gift of Frederick R. McBrien III, 2006-31-1

Itaya Kōji was born and worked most of his life in the coastal city of Wajima, whose artisans are renowned for their superb lacquerwares, particularly those featuring the *chinkin* technique, in which a design is incised on a lacquer surface and then filled with gold leaf. In this standing screen, a type known as *tsuitate*, Itaya demonstrated his mastery of the exacting and time-consuming process by carefully carving and filling with gold or silver leaf the individual hairs of the fox's fur and each blade of grass. The fox's eye and the crescent moon, inlaid with mother-of-pearl, shimmer against the dark ground. An exceptional example of postwar lacquerware, this screen is part of a group of twentieth-century Japanese crafts that has established the institution as one of the premier places for the study of Japan's modern and contemporary artists. FF

Manchu Semiformal Vest

China, Qing dynasty, Guangxu period, c. 1885–1905
Silk
The Samuel S. White 3rd and Vera White Collection, 1967-30-334

Adorned with Chinese symbols of spring and good fortune, this vest probably was made for Empress Dowager Cixi, who controlled Manchu China from 1861 until her death in 1908. It was part of an important bequest to the Museum from trustee Samuel S. White III and his wife, artist Vera M. White, which included Chinese and Japanese costumes and textiles; garments by twentieth-century designers Edward Molyneux, Paul Poiret, and Elsa Schiaparelli; medieval illuminated manuscripts; Japanese woodcuts; and modern paintings and sculptures by, among others, Paul Cézanne, Pablo Picasso, and Auguste Rodin. The gift also comprised works by Arthur Beecher Carles (see p. 317), who had been Vera's teacher, and prints by Philadelphia-born photographer Man Ray, including his famous image of Marcel Duchamp dressed as his alter ego, Rrose Sélavy (p. 330). LLC

Futon Cover

Japan, Meiji period, late 19th century
Cotton with rice-paste resist (*tsutsugaki*), 65¾ × 52¾ in.
(167 × 134 cm)
125th Anniversary Acquisition. Purchased with funds contributed by the Otto Haas Charitable Trust, The Women's Committee of the Philadelphia Museum of Art, Maude de Schauensee, Theodore R. and Barbara B. Aronson, Edna and Stanley C. Tuttleman, The Hamilton Family Foundation, and Maxine and Howard H. Lewis, 2000-113-35

The Japanese tradition of crafts made for everyday use, later termed *mingei*, included household textiles such as bedding and curtains that customarily formed part of a bride's trousseau. These textiles typically were decorated with the *tsutsugaki* technique, in which designs are drawn in rice paste that resists indigo dye and colored pigments. This freehand method produced bold and expressive designs, often featuring auspicious motifs or utilitarian objects. Part of the Museum's superb collection of Japanese textiles (see also p. 61), this masterful futon cover depicts utensils used during traditional tea ceremonies, including a central brazier and kettle, bowls, pieces of charcoal, whisks, a tea caddy and scoop, and a water container and ladle. HKH

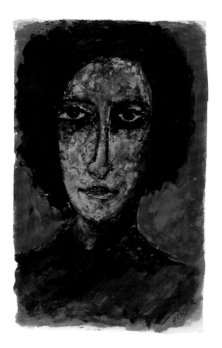

Rabindranath Tagore (Indian, 1861–1941)

Head of a Woman, c. 1934–40

Opaque watercolor on Asian paper, 15 × 8¾ in. (38.1 × 22.2 cm)
Gift of Stella Kramrisch, 1966-189-1

Rabindranath Tagore—writer, philosopher, and the first Asian Nobel laureate—remains a monumentally important figure in South Asia's cultural history. Although he did not pursue visual art in earnest until his later years, his haunting, almost psychedelic images have become central to the story of Indian modernism. It was at Tagore's invitation that art historian Stella Kramrisch first came to India to teach (on Kramrisch, see pp. 16–17), and seven of the artist's paintings, including this, were among her many gifts to the Museum. This woman's short hair even suggests that she may be an abstract depiction of Kramrisch herself. DM

Ōgi Rodō (Japanese, 1863–1941)

Sunkaraku Ceremonial Teahouse, Taisho period,
c. 1917
Purchased with Museum Funds, 1928-114-1

The name of this teahouse, Sunkaraku (Evanescent
Joys), reflects the spirit of the traditional Japanese tea
ceremony as a temporary refuge from the complexi-
ties of daily life. The architecture reveals a special
delight in natural materials, such as bamboo and
cedar. Using elements from an eighteenth-century
teahouse, Ōgi Rodō designed this retreat around 1917
for the grounds of his Tokyo home. Among the guests
he hosted at Sunkaraku were Japanese financial and
political leaders for whom he designed country homes
and teahouses. Acquired by the Museum from the
architect in 1928, this is the only example of his work
outside Japan, where just three of his buildings remain
extant. FF

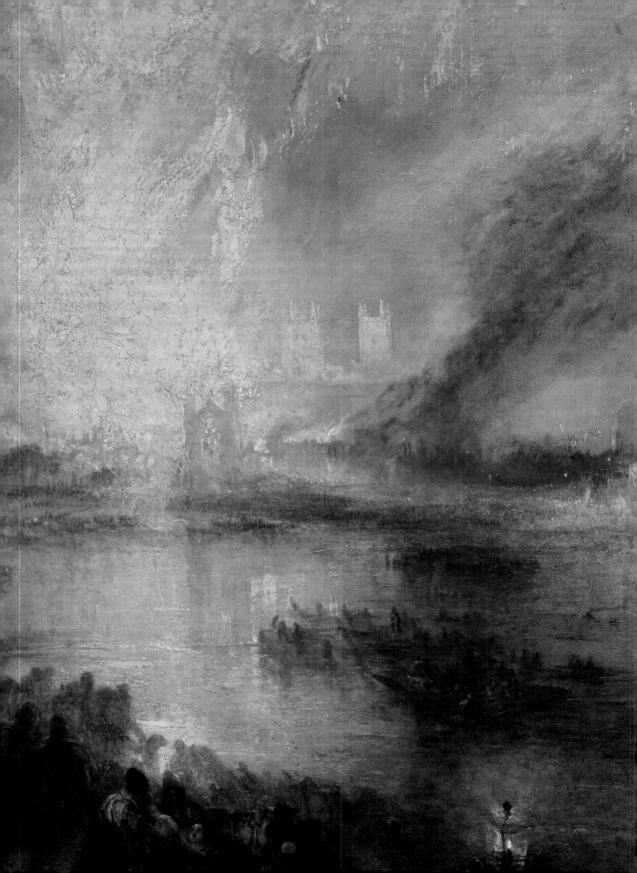

Europe

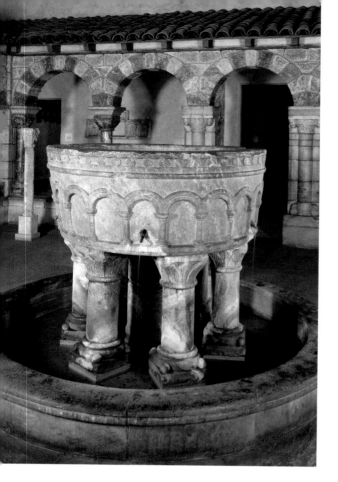

Capital from the Monastery of Saint-Rémi

France, Reims, c. 1140
Limestone, H. 13 in. (33 cm)
Purchased with Museum funds from the George Grey Barnard
Collection, 1945-25-39

This capital and three others in the Museum's collection once adorned the cloister of the important monastery of Saint-Rémi in the city of Reims in eastern France. Although the cloister was destroyed in the seventeenth century, sculpted elements remaining in Reims relate to the Museum's capitals. The talented sculptor responsible for this work drew inspiration from ancient Roman art, seen in the object's symmetry and in the execution of the lion heads at the corners. Even more striking is the way in which the entire surface of the capital is unified and animated by the deeply carved sinuous leaves, reflecting the developing naturalism of early Gothic art. JH/ED

Fountain from the Monastery of Saint-Michel-de-Cuxa

France, Roussillon, 1125–50
Marble, H. 64¼ in. (163.2 cm)
Gift of Mrs. William W. Fitler in memory of her husband,
1930-79-1

This impressive, rare fountain stands in the center of the Museum's cloister, which incorporates elements from Saint-Génis-des-Fontaines, a thirteenth-century abbey in the Roussillon in southern France. Originally from nearby Saint-Michel-de-Cuxa, the largest and most important monastery in the area, the fountain features a massive basin carved from the region's characteristic pink marble and is decorated with a continuous frieze of arches on columns that mirror the design of a Romanesque cloister. At the monastery, this fountain served important practical purposes; transplanted to the Museum, it and the surrounding cloister offer present-day visitors a space for quiet contemplation. JH

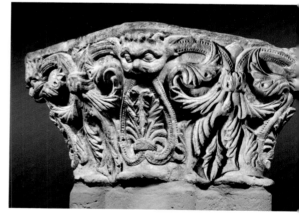

Tomb Effigy of a Recumbent Knight

France, Normandy, 1230–40
Limestone with traces of paint, L. 70⁵⁄₁₆ in. (178.6 cm)
Purchased with Museum funds from the George Grey Barnard
Collection, 1945-25-72

According to a seventeenth-century account, this
tomb originally was located in the abbey of Sainte-
Marie in La Genevraye, Normandy. The same source
claimed that the figure of the knight represents
François du Merle, a nobleman who founded the
monastery around 1160. While the stylized birds
(called *merlettes* in French) on the shield are not found
in the arms of subsequent generations of the Du
Merle family, rhyming (or "canting") emblems often
were used in this period, before the rules of heraldry
were fully established. Among the earliest known
examples of its type and of exceptional quality, this
knight has been compared to sculptures at Chartres
Cathedral. JH

Roundel Showing Holofernes's Army Crossing the Euphrates

France, Paris, 1246–48
Stained and painted glass, DIAM. 23⅜ in. (59.3 cm)
Purchased with funds contributed by Mrs. Clement Biddle Wood
in memory of her husband, 1930-24-3

This roundel is one of three at the Museum from
the Sainte-Chapelle in Paris, the spectacular Gothic
church built for Louis IX and consecrated in 1248.
The upper chapel is illuminated by fifty-foot-tall
windows with vivid stained-glass scenes from the
Bible. The Museum's panels depict episodes from
the Apocryphal book of Judith; this example's asym-
metrical composition of two conversing horsemen
and a group of mounted knights is particularly
sophisticated. When the chapel was taken over as an
archive in 1803, the roundels were removed, and that
same year they became perhaps the first examples
of medieval art to come to the United States when
Philadelphia merchant William Poyntell purchased
them while traveling in France. JH

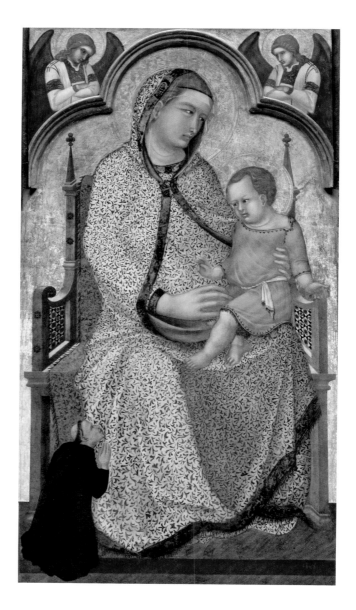

Pietro Lorenzetti (Italian, first documented 1306, last documented 1345)

Virgin and Child Enthroned and Donor, with Angels, c. 1319

Tempera and tooled gold on panel, 51¾ × 27½ in. (131.4 × 69.9 cm) overall
John G. Johnson Collection, cat. 91 (center panel). Purchased with the George W. Elkins Fund, the W. P. Wilstach Fund, and the J. Stogdell Stokes Fund, EW1985-21-1,2 (spandrels)

Many fourteenth- and fifteenth-century Italian paintings in the John G. Johnson Collection (see pp. 134–35) are fragments of altarpieces that were disassembled during and after the Napoleonic invasions of Italy, from the late eighteenth through the nineteenth century. Pietro Lorenzetti's panel of the Virgin and Child was reunited with its spandrels, each showing an angel, only in 1985, and recently another section from the original multipaneled altarpiece has surfaced. Fragments of the artist's signature, an uncommon feature on paintings from this time, are visible on the step on which an Augustinian friar kneels. His diminutive scale suggests he most likely was the person who commissioned the panel. CBS

Attributed to the **Master of Saint Veronica** (German, active c. 1395–c. 1425)

Enthroned Virgin and Child with Saints Paul, Peter, Clare of Assisi, Mary Magdalene, Barbara, Catherine of Alexandria, John the Baptist, John the Evangelist, Agnes, Cecilia, Margaret of Antioch, and George, c. 1400–1410
Oil and gold on panel, 13¼ × 9¼ in. (33.6 × 23.5 cm)
John G. Johnson Collection, cat. 742

Around the enthroned Virgin and Child a group of saints are gathered like royal attendants. The crowns and rich costumes of the female martyr saints and of Saint George—the paragon of the Christian knight, who is seated rather rakishly on the floor, with legs outstretched—underscore the courtly nature of this small panel made by an anonymous master working in Cologne, a thriving artistic center on the Rhine known for the elegant Gothic style favored by its artists. After first appearing in publication in 1852, this painting was recognized as a masterpiece of this style. CBS

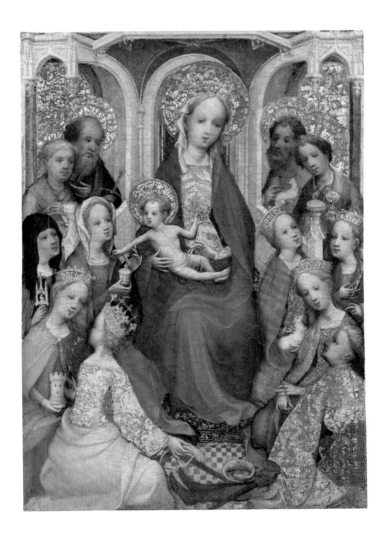

Chasuble

Italy, Florence, early to mid-14th century (orphreys), mid-15th
century (silk velvet)
Chasuble: silk; orphrey: linen with silk, silver, and gilt thread
Gift of Mrs. Donald Vaughn Lowe, 1972-47-1

Chasubles, overgarments worn by officiating priests,
traditionally are trimmed with decorative bands
known as orphreys. Constructed from silk velvet with
a pomegranate motif that dates to the mid-fifteenth
century, this chasuble is adorned with an earlier
embroidered linen orphrey depicting five scenes from
the life of Christ. Stylistic evidence, including the
simplified architectural settings of the illustrations,
date the band to the early to mid-fourteenth century,
and the embroidery represents work produced in
Florence in convent workrooms rather than in profes-
sional workshops. The background of each scene is
embroidered with a pattern of raised scrolling vines
that emulates the incised gold-leaf surfaces of contem-
porary Florentine paintings. DB

Orphrey

Germany or Bohemia, late 14th–early 15th century
Linen with silk, silver, and gilt thread; H. 42½ in. (108 cm)
Purchased with Museum and Subscription Funds from the
Charles F. Williams Collection, 1923-23-166

This embroidered Y-cross orphrey, an ornamental
band traditionally found on ecclesiastical vestments, is
characteristic of those made in the Lower Rhineland
and Bohemia during the Renaissance. The decoration
depicts the Crucifixion, with the cross shown as a
recently felled tree with its branches lopped off, and
symbols of three of the Evangelists: A lion and an
ox for Saints Mark and Luke, respectively, flank the
horizontal bar; and an angel for Saint Matthew kneels
below. Originally much longer, the orphrey was cut
and pieced at the bottom, where the angel and the
figures of Saint John and the Virgin were added
using embroidery similar in style to the original
needlework. DB

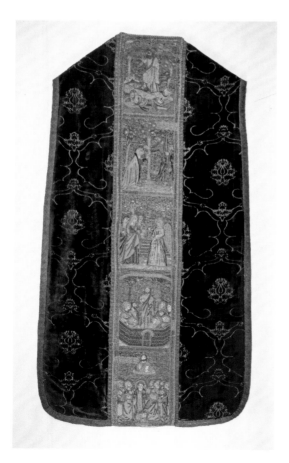

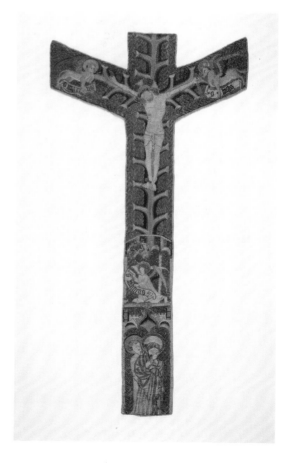

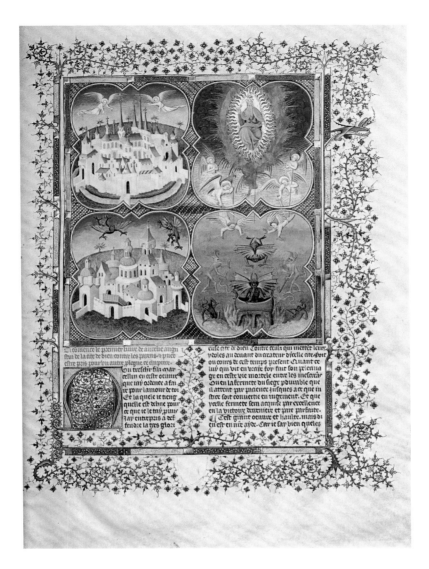

The Orosius Master (French, active c. 1400–1418) and assistants

The Heavenly and Earthly Cities and God the Father in Heaven with the Fallen Angels,
frontispiece from Saint Augustine's *La Cité de Dieu*, 1408–10
Tempera, gold, and pen and ink on parchment; sheet: 17⅛ × 12⅜ in. (43.5 × 31.4 cm)
The Philip S. Collins Collection, gift of Mrs. Philip S. Collins in memory of her husband, 1945-65-1

In 1945 seventeen illuminated manuscripts, including several fifteenth-century books of hours, from the collection of Philip S. Collins, vice president and treasurer of Philadelphia's Curtis Publishing Company, joined the Museum's recent acquisition of the George Grey Barnard Collection of medieval art (see, for example, pp. 86, 87, 102, 109, 119). The undoubted masterpiece of the Collins Collection is the spectacular French translation of Saint Augustine's fifth-century Latin treatise *De Civitate Dei* (*The City of God*). Romantically embellishing the saint's theological arguments, the translation, known as *La Cité de Dieu*, was enhanced with commentaries in courtly dialect and illustrated for its noble French audience. The Museum's version is among the most richly illustrated of the translations, with miniatures and border decorations by one of the numerous manuscript workshops active in early fifteenth-century Paris. IHS

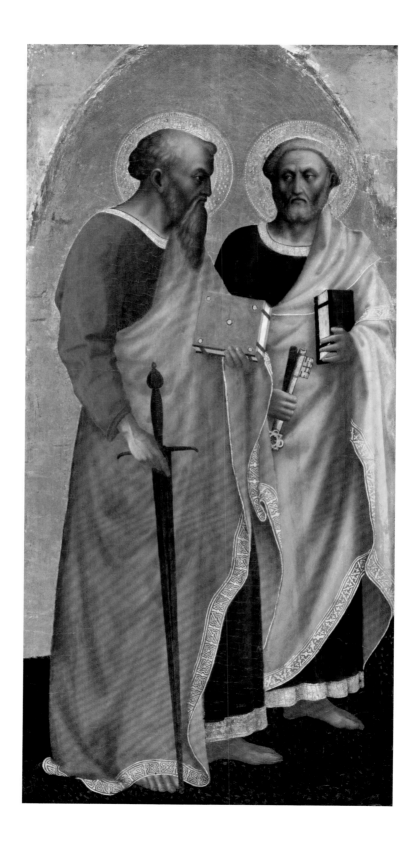

Masaccio (Italian, 1401–1428) and **Masolino** (Italian, 1383/84–after 1444)

Saints Paul and Peter, c. 1427–28
Tempera and tooled gold on panel, 45 × 21⅜ in. (114.3 × 54.3 cm)
John G. Johnson Collection, inv. 408

Florentine artists Masaccio and Masolino's collaboration on an altarpiece for the basilica of Santa Maria Maggiore in Rome was part of the renovations of religious sites following Martin V's election as pope in 1417, which ended a schism in the Roman Catholic Church and finally returned the papacy to Rome. Masaccio designed this panel of the double-sided altarpiece, but following his untimely death at the age of twenty-seven, Masolino finished it. Although he reversed the positions of the two saints, Masolino preserved as much of Masaccio's painting as possible, particularly in the figures' hands and feet. More than a century later, Michelangelo spoke of his admiration for this early Renaissance masterpiece. CBS

Robert Campin (Netherlandish, first documented 1406, died 1444)

Christ and the Virgin, c. 1430–35
Oil and gold on panel, 11¼ × 17¹⁵⁄₁₆ in. (28.6 × 45.6 cm)
John G. Johnson Collection, cat. 332

Robert Campin based this image on a now-lost Byzantine or Italian painting, which had been given by Pope Clement VI to Jean le Bon, future king of France, and kept in the royal Sainte-Chapelle in Paris. Campin retained the model's gold background, but rendered the figures with the realism for which Netherlandish painters were renowned, as evident in the depiction of Christ's left hand, which appears to rest on the edge of the frame's molding. This picture of the blessing adult Christ and the Virgin in prayer gave rise to the spread of this iconography in Netherlandish art. CBS

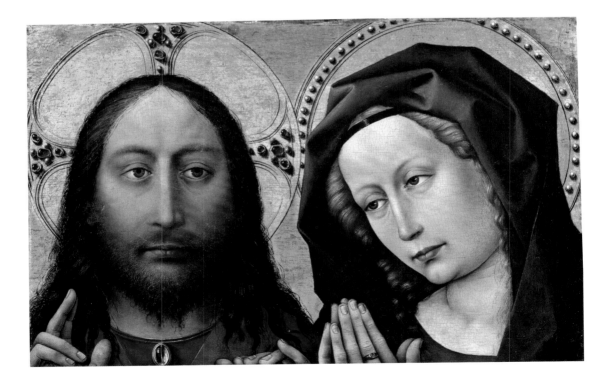

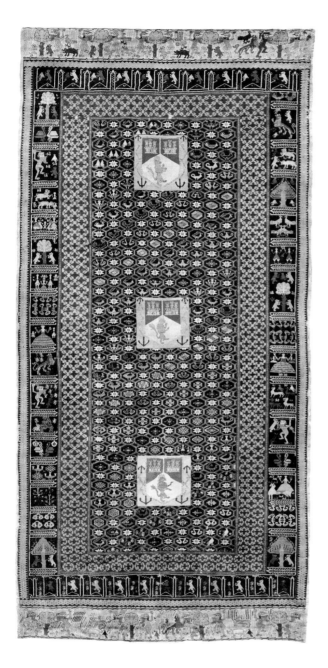

"Admiral" Heraldic Carpet

Spain, c. 1429–73
Wool, 19 ft. ¾ in. × 8 ft. 9⅛ in. (5.81 × 2.67 m)
The Joseph Lees Williams Memorial Collection, 1955-65-21

North African Muslims introduced the craft of carpet weaving to Spain, where it became an important industry in the twelfth century. This "admiral" carpet—so called because it bears the arms of Don Fadrique Enríquez de Mendoza, twenty-sixth admiral of Castile—belongs to a famous group of rugs donated by Don Fadrique's family to the convent of Santa Clara in Palencia. In this beautifully preserved carpet, shields with the Enríquez family arms stand out against the patterned background, which is framed by playful images of animals, women in wide skirts, and mythical wild men. A design in the top and bottom borders resembles Arabic script, indicating the rug's Mudéjar workmanship. JH/DW

Footed Jar with the Arms of the Pittigardi Family of Florence

Italy, Tuscany, probably Florence, 1450–1500
Earthenware with tin glaze (maiolica), H. 9¹³⁄₁₆ in. (24.9 cm)
125th Anniversary Acquisition. The Howard I. and Janet H. Stein Collection, 2012-144-1

In fifteenth-century Italy, a major stimulus for the production of maiolica (a tin-glazed ceramic) was the popularity of imported Spanish lusterware made by Mudéjar potters, a luxury beloved by wealthy Florentines. This jar's floral decoration imitates a fashionable Valencian pattern, but it features orange pigment rather than the metallic gold of Spanish examples, as the technique that produced this effect was not yet understood in Italy. The presence of the arms of the Pittigardi family, however, underlines the success of Italian potters in competing with Spanish imports. This jar is from a collection of seventy superb examples of Italian maiolica, among the finest in the country, given to the Museum by trustee Howard I. Stein. JH

Jan van Eyck (Netherlandish, c. 1395–1441)

Saint Francis of Assisi Receiving the Stigmata,

c. 1425–30
Oil on vellum on panel, 5 × 5¾ in. (12.7 × 14.6 cm)
John G. Johnson Collection, cat. 314

During a forty-day fast in the wilderness, Francis of Assisi had a vision in which he received the wounds of the crucified Christ, who here appears held aloft by a seraph. Although Jan van Eyck positioned the scene in the rocky mountain of the legend, in a bravura display of his microscopic technique, he included a bustling Netherlandish city in the distance. This is one of two nearly identical versions of the picture (the other being in the Galleria Sabauda, Turin). One of them or a copy was owned by the painter Joan Reixac of Valencia (see p. 96), where it had a profound effect on local artists. CBS

Joan Reixac (Spanish, documented 1437–84)

Mocking of Christ, 1454
Oil on panel, 15½ × 15¼ in. (39.4 × 38.7 cm)
John G. Johnson Collection, inv. 203

Although the Valencian artist Joan Reixac was influenced by contemporary Netherlandish art (he even owned a version of Jan van Eyck's painting *Saint Francis of Assisi Receiving the Stigmata*; see p. 95), he always retained a highly personal style, as seen in the pathos of this image of Christ being mocked. This was one of nine scenes of the Passion of Christ that originally formed the predella, or base, of the altarpiece in the charterhouse of Vall de Crist, located near Segorbe in eastern Spain. The picture's blue-and-white floor tiles depicting emblems of Spanish heraldry are typical of those produced near Valencia by Islamic ceramists. CBS

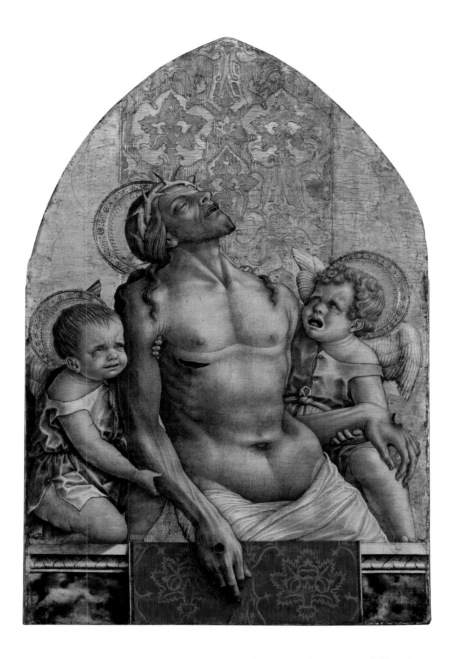

Carlo Crivelli (Italian, first documented 1457, died 1495/1500)

Dead Christ Supported by Two Angels, c. 1472
Tempera and tooled gold on panel, 28 × 18⅝ in. (71.1 × 47.3 cm)
John G. Johnson Collection, cat. 158

Originally from Venice, Carlo Crivelli worked in small towns along the Italian Adriatic coast. His isolation from major artistic centers resulted in an individualized style marked by a caricatured realism, but it was his training in figure drawing—evident here in his precise observation of Christ's anatomy—that underpinned Crivelli's permutations on the norm. The artist accentuated the brutality of death for dramatic effect, and he compensated for the height at which the painting, intended as the crowning element of an altarpiece, would have been seen by emphasizing the weight of the corpse, which the angels struggle to support. CBS

Rogier van der Weyden (Netherlandish, 1399/1400–1464)

The Crucifixion, with the Virgin and Saint John the Evangelist Mourning, c. 1460

Oil on two panels, left panel: 71 × 36⅙ in. (180.3 × 92.2 cm), right panel: 71 × 36⅞ in. (180.3 × 92.5 cm)
John G. Johnson Collection, cats. 334, 335

The innovative conception, sophisticated composition, and singular spiritual intensity of this Crucifixion scene are characteristic of Rogier van der Weyden's widely influential art. The centrally divided composition encourages contemplation of *compassio*, the parallel suffering of Christ and his mother. As Christ dies, John the Evangelist stumbles forward to support the collapsing Virgin, whose fumbling, clenched hands simultaneously suggest prayer and anguish, elegantly distilling the scene's spiritually exalted pathos. Although many scholars believed that these large panels were conceived as an independent diptych, closer study of their construction and the discovery of two paintings originally on their opposite sides (now in the National Gallery of Art, Washington, DC, and the Musée des Beaux-Arts Dijon) indicate that this scene occupied the exterior faces of hinged shutters, or wings, that closed over an immense, now-lost altarpiece. Further, the combined stylistic traits found on the Philadelphia paintings—including their shallow pictorial space and bold, full-color composition extending across adjacent panels—links them to winged altarpieces bearing carved wood sculptures on their interiors (see, for example, p. 119). The monumentality and iconic starkness of these paintings would have provided striking counterpoints to the teeming forms and glittering opulence of the painted and gilded sculpture groups revealed when the wings were opened. Esteemed as an extraordinarily affecting object of contemplation and devotion in its own right, this imposing masterwork, part of the John G. Johnson Collection at the Museum (pp. 134–35), merits additional consideration as a brilliant threshold and deeply sympathetic foil to sculpture. MST

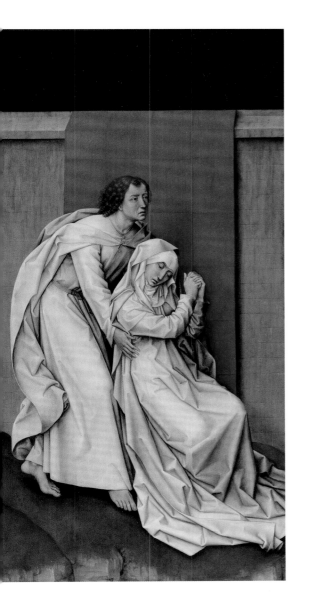
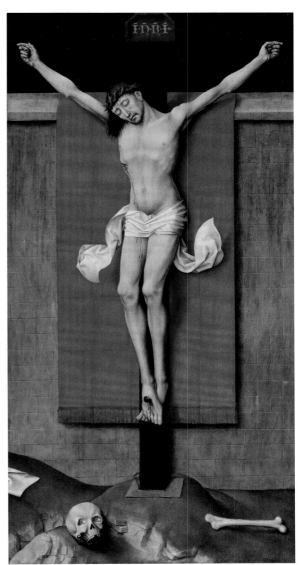

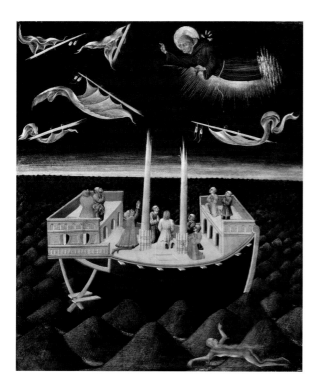

Antonello da Messina (Italian, first securely documented 1456, died 1479)

Portrait of a Young Gentleman, 1474
Oil on panel, 12⅝ × 10¹¹⁄₁₆ in. (32.1 × 27.1 cm)
John G. Johnson Collection, cat. 159

Antonello da Messina, whose career took him from his native Messina in Sicily to Naples and Venice, was one of the first Italian artists to adopt the Netherlandish use of oil, which gave his paint surfaces a luminosity that egg tempera, then the primary painting medium in Italy, could not achieve. This method served him particularly well in his portraits, which were considered the greatest in fifteenth-century Italy for their psychological penetration of character, as seen in this masterpiece, in which the sitter emerges from the dark background with only his face lit. CBS

Giovanni di Paolo (Italian, first documented 1417, died 1482)

Saint Nicholas of Tolentino Saving a Shipwreck, 1457
Tempera and gold on panel, 20½ × 16⅝ in. (52.1 × 42.2 cm)
John G. Johnson Collection, inv. 723

Giovanni di Paolo appears to have had access to a copy of the first-hand accounts of the miracles of Saint Nicholas of Tolentino in which witnesses vividly describe the terror of the shipwreck—the rolling waves, broken masts, and flying sails—and the radiant light emanating from the saint who came to save them. The artist, however, embellished the scene by adding the naked siren swimming in the foreground, enticing sailors to steer off course. The picture's dreamlike quality made it an appropriate selection for the exhibition *Fantastic Art, Dada, Surrealism* at the Museum of Modern Art in New York in 1936. CBS

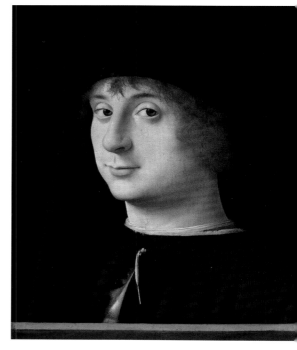

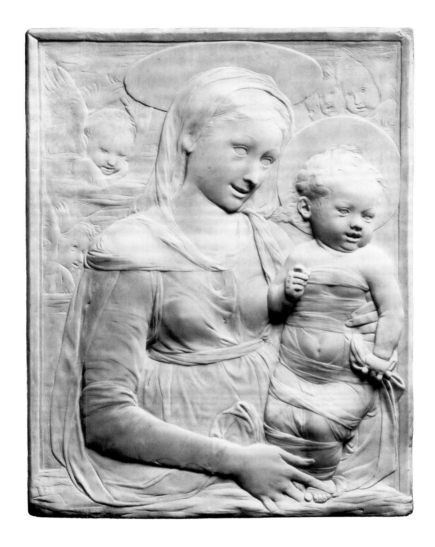

Desiderio da Settignano (Italian, 1429/32–1464)

Virgin and Child, c. 1455–60

Marble, H. 23¼ in. (59.1 cm)

Purchased with the W. P. Wilstach Fund from the Edmond Foulc
Collection, W1930-1-73

Among the innovations of the great Renaissance
sculptor Donatello was *rilievo schiacciato* (flattened
relief), a form of carving that employs line and slight
variations of surface depth to achieve its refined
effects. Here Desiderio da Settignano, Donatello's

most accomplished successor in this demanding
technique, has transformed a familiar Renaissance
religious subject into an image of atmospheric,
unearthly delicacy that retains a tender intimacy
through the engaging expressions of the Virgin and
Child. Acquired as part of the important collection
of Edmond Foulc (see pp. 104–5), this remarkable
masterpiece was realized through a near-miraculous
manipulation of the marble's shallow surface. JH

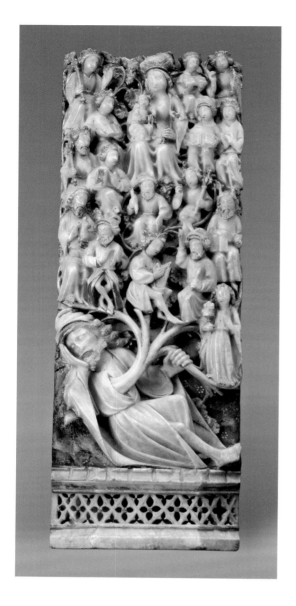

sculptors specialized in small-scale carvings of religious scenes that could be displayed individually or in groups to form large altarpieces. In this exceptionally well-preserved panel illustrating the ancestors of Christ, a marvelously undercut vine bearing the forebears of Jesus sprouts from the chest of the reclining figure of Jesse, father of King David. The sculpture likely was part of an altarpiece celebrating the Virgin Mary; another alabaster panel in the Museum's collection shows the Annunciation and probably belonged to the same ensemble. The Museum acquired these and other important medieval objects from the collection of American sculptor George Grey Barnard (1863–1938; see, for example, pp. 86, 87, 109, 119), whose interest in the art of the Middle Ages was formative to its display and study in this country. JH

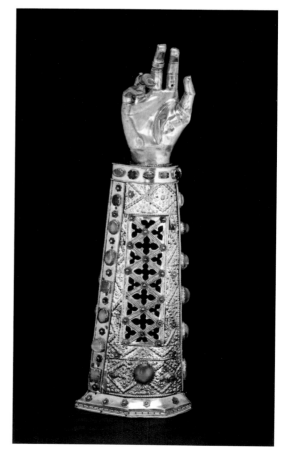

The Tree of Jesse
England, mid- to late 15th century
Alabaster with paint and gilding, H. 26 in. (66 cm)
Purchased with Museum funds from the George Grey Barnard Collection, 1945-25-108

Alabaster sculpture flourished in England from the late fourteenth until the mid-sixteenth century, and examples were traded throughout Europe. English

Arm Reliquary of Saint Babylas

Germany, Brunswick, 1467
Silver, gilded silver, glass-paste stones, rock crystals, and amethyst
on an oak core; H. 18⅝ in. (47.3 cm)
Purchased with Museum funds, 1951-12-1

According to an inventory of 1482, this life-size
reliquary enshrined an arm bone of Saint Babylas,
the bishop of Antioch martyred around the year 250.
Traditionally, reliquaries were made in forms appro-
priate to the sacred objects they contained; here the
relic, since removed, would have been visible through
the chamber's latticework door. The naturalistically
rendered hand makes a gesture of blessing, by which
bishops demonstrated their benevolent communica-
tion with the faithful. This is one of a dozen arm reli-
quaries once part of the Guelph Treasure, an important
collection of medieval sacral objects kept for centuries
at the cathedral of Saint Blaise in Brunswick, Germany,
until its dispersal in the 1930s. JH/DW

Marriage Chest with Ceres Searching for Proserpina

Italy, Tuscany, late 15th century
Wood with painted and gilded plaster decoration, w. 79½ in.
(201.9 cm)
Purchased with the Joseph E. Temple Fund, 1944-15-7

This chest is one of a pair in the Museum relating the
story of the abduction of Proserpina by Pluto, Roman
god of the underworld. Proserpina's mother, Ceres,
goddess of agriculture, is shown searching for her
daughter in a forest inhabited by satyrs and centaurs.
Italian Renaissance marriage chests, often given to a
bride by the groom's family, rarely survive as pairs;
notably, the Museum's set is decorated with sculpted,
rather than painted, compositions based on ancient
Roman sarcophagi (burial containers). Used to store
the precious textiles of the bride's trousseau, such elab-
orate chests would have been displayed prominently
in the couple's bedchamber. JH

THE EDMOND FOULC COLLECTION

Edmond Foulc (1828–1916), heir to a French silk-manufacturing fortune, amassed a spectacular collection of more than two hundred medieval and Renaissance objects that was particularly rich in French and Italian sculpture and furniture, but also included notable works from nearly every category of the decorative arts (see, for example, pp. 114, 125; see also fig. 5). Foulc began collecting around 1860, and among his first acquisitions was the beautiful bronze bust of Carlo Emanuele of Savoy (right, bottom), said to have been purchased in Avignon in 1865.

In the 1880s, to accommodate his growing collection, Foulc moved to a newly built residence in Paris, which featured a hall designed to display large works of art, such as the marble and alabaster choir screen from the château of Pagny (p. 118) and the polychrome wood sculpture of angels supporting the armorial shield of Antoine du Bois, abbot of Saint-Lucien in Beauvais from 1492 to 1537 (right, top).

This sculpture exemplifies French artists' absorption of Italian Renaissance styles and their virtuoso mastery of woodcarving, one of Foulc's particular interests as a collector.

After his death, Foulc's collection was acquired and published by Wildenstein and Company. Recognizing the opportunity to transform the Museum's displays, Director Fiske Kimball worked diligently in 1928–29 to negotiate the purchase of the collection, reaching an agreement in October 1929, at the time of the stock-market crash that heralded the beginning of the Depression. Donations from individual subscribers assisted with the acquisition, and the Museum's Wilstach Committee funded the purchase of two masterpieces of Italian Renaissance art: Desiderio da Settignano's marble relief of the Virgin and Child (p. 101) and Luca della Robbia's glazed terracotta tondo to which Foulc had added a border of plants and fruits likely made by Luca's nephew

Andrea (left). While it took some twenty years for
the institution to finish paying for the purchase, the
acquisition immeasurably raised the quality and
range of its holdings of medieval and Renaissance
art, and further shaped Kimball's ambitious instal-
lation of the second-floor galleries of the Museum's
main building. JH

Luca della Robbia (Italian, 1400–1482), possibly assisted
by **Andrea della Robbia** (Italian, 1435–1525); border
attributed to **Andrea della Robbia**
Virgin and Angels Adoring the Christ Child,
c. 1460–70s
Glazed terracotta with traces of gilt decoration, DIAM. 65¾ in.
(167 cm)
Purchased with the W. P. Wilstach Fund from the Edmond Foulc
Collection, W1930-1-64a,b

Armorial Shield Supported by Angels
France, Beauvais, late 15th–early 16th century
Painted and gilded oak, H. 39¾ in. (101 cm)
Purchased with Museum funds from the Edmond Foulc
Collection, 1930-1-166

*Bust of Carlo Emanuele of Savoy at Ten Years
of Age*
Northern Italy or possibly France, 1572
Bronze, H. 19¼ in. (48.9 cm)
Purchased with Museum funds from the Edmond Foulc
Collection, 1930-1-22

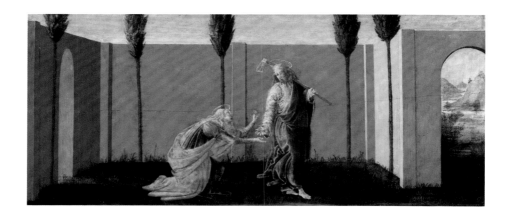

Sandro Botticelli (Italian, 1445–1510)

Noli Me Tangere, c. 1484–91
Tempera on panel, 7¾ × 17⁵⁄₁₆ in. (19.7 × 44 cm)
John G. Johnson Collection, cat. 46

Mary Magdalene, recognizing the resurrected Christ, extends her hands toward him, but he warns her not to touch him: "Noli me tangere." One of four in the Johnson Collection (see pp. 134–35), this panel formed part of the predella, or base, of an altarpiece in the chapel of Sant'Elisabetta delle Convertite in Florence, a convent for former prostitutes that was devoted to the Magdalene, who was said to have reformed her sinful ways in devotion to Christ. The altarpiece was made under the supervision of Sandro Botticelli, and the predella panels may have been executed with the help of his collaborator Filippino Lippi. CBS

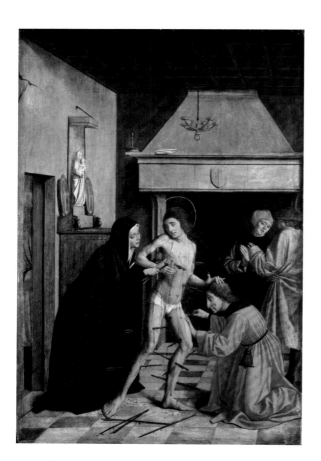

Josse Lieferinxe (French, documented 1493–1505/8)

Saint Sebastian Cured by Irene, c. 1497
Oil on panel, 32 × 21⁹⁄₁₆ in. (81.3 × 54.8 cm)
John G. Johnson Collection, cat. 767

This panel is from an altarpiece for the chapel of a confraternity in the church of Notre Dame-des-Accoules in Marseilles showing scenes from the legend of the Roman soldier Sebastian, who was persecuted for his conversion to Christianity by being shot with arrows and left for dead. Here the pious Irene tends to the wounded martyr in a wood-paneled room, featuring a canopied statue of the Virgin on the cabinet, that resembles typical late fifteenth-century northern European interiors. Such anachronistic details would have made the ancient story more immediate and familiar to the burghers who commissioned the altarpiece. CBS

Gerard David (Netherlandish, first documented 1484, died 1523)

Enthroned Virgin and Child with Angels, c. 1490–95
Oil on panel, 39⅑₆ × 25¹¹⁄₁₆ in. (99.2 × 65.2 cm)
John G. Johnson Collection, cat. 329

In a vision of holy grace, the Christ child, held by the enthroned Virgin, playfully thumbs through a prayer book while two attendant angels strum a lute and a harp. The luxuriousness of Gerard David's interior, set off from the landscape in the background, is evident in the columns of North African red porphyry, an igneous rock symbolizing royalty and divinity; the rug, which would have been imported from present-day Turkey; and the baldachin made of a gilt brocade textile of Lucchese or Florentine manufacture, resembling those traded by Italian merchants who resided in Bruges, where the artist worked. CBS

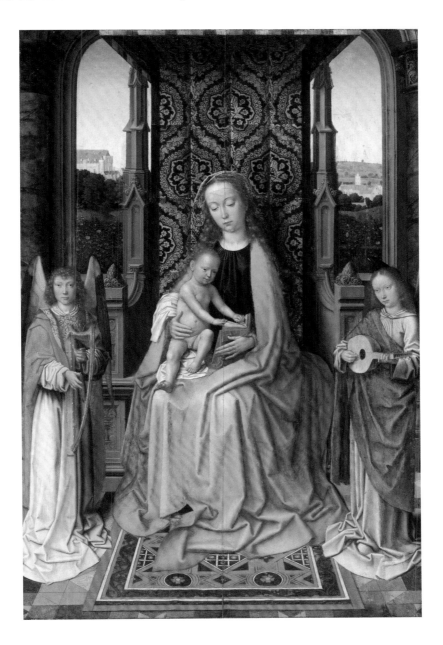

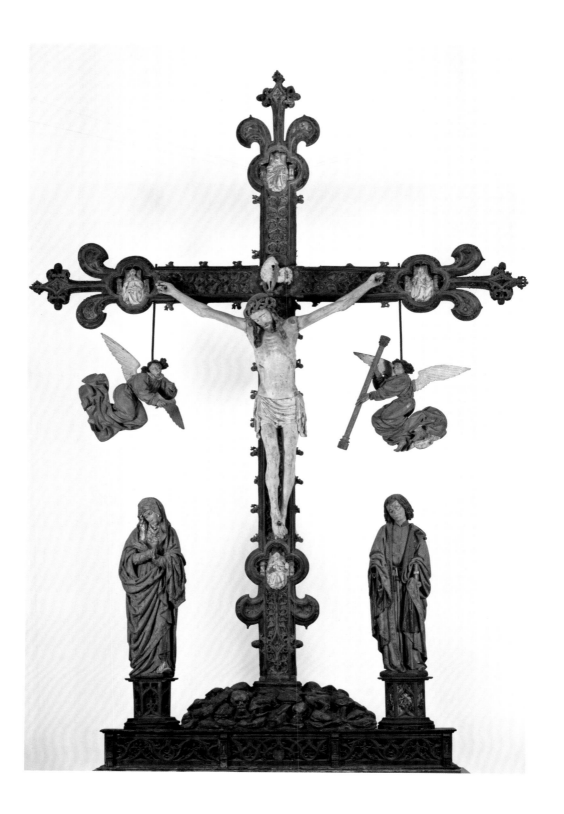

Figurario factorum Israhelis et Ide eius uxoris · I V M

The Crucified Christ with the Virgin Mary, Saint John the Evangelist, and Angels with Instruments of the Passion

Southern Netherlands (modern Belgium), possibly Brussels, c. 1500
Painted oak, H. (cross) 14 ft. (4.27 m)
Purchased with Museum funds from the George Grey Barnard Collection, 1945-25-86a,b

Thought to have come from the priory in the town of Oignies, in southern Belgium, this dramatic Crucifixion group originally would have been installed, with the support of a strong beam or screen, above the entrance to the church choir. The image of the Crucifixion relates directly to the celebration of Mass; the emotional intensity of this group's figures communicates the gravity of Christ's sacrifice for the salvation of humankind, a detail that reflects the influence of fifteenth-century Flemish painting (see, for example, p. 98). A unique example in American collections, this group stands at the entrance to the Museum's medieval galleries in a nave-like space echoing its original placement. JH

Israhel van Meckenem (German, c. 1445–1503)

Self-Portrait with His Wife, Ida, c. 1490

Engraving, sheet: 5¼ × 7⅟₁₆ in. (13.3 × 17.9 cm)
125th Anniversary Acquisition. Gift of Suzanne A. Rosenborg, 2002-59-1

In the late 1400s, European artists began to shed the anonymity of the medieval guild system. Here a Latin inscription names the sitters as Israhel van Meckenem and his wife, Ida. Not only are these the earliest known engraved portraits of identified persons, but Van Meckenem's likeness is the first self-portrait by a printmaker. Engraving emerged as a new medium in the 1430s, and by the 1490s Van Meckenem was the most successful engraver in Europe. Of the ten surviving impressions of this rare image, this example is the best preserved. JI

THE CARL OTTO KRETZSCHMAR VON KIENBUSCH COLLECTION

In the 1930s, the Museum, under Director Fiske Kimball, acquired important examples of arms and armor, including an outstanding tournament suit by the celebrated Augsburg armorer Lorenz Helmschmid. The core of the institution's distinguished holdings, however, was acquired in 1977 with the generous bequest from New York businessman and philanthropist Carl Otto Kretzschmar von Kienbusch (1884–1976; see fig. 11) of his private collection, which had long been regarded as the finest in existence. Assembled from about 1914 to his death, the Kienbusch Collection comprises approximately 1,200 objects, primarily of European origin and dating from the fourteenth to the eighteenth century, for use in battles, ceremonies, tournaments, or hunting. It features complete armors, equestrian equipment, helmets and other armor elements, such as the superb elbow gauntlets attributed to Helmschmid (right, bottom), and weapons (see pp. 120, 121, 142),

most of which can be traced to the ancestral armories of European rulers and noblemen, or the arsenals of provinces and municipalities; and to the private collections of prominent nineteenth- and twentieth-century American and European collectors.

Kienbusch's bequest included a library of more than two thousand volumes, detailed object cards, and extensive photographic documentation. At the heart of his endeavors was his intent to assemble a representative selection of some of the best expressions of armor as an art form. Thus, the ceremonial shield from the armory of the counts Zrínyi of Croatia and Hungary (below) demonstrates the accomplishments of the armorers and goldsmiths of Renaissance Italy, while the tournament armor once in the distinguished collection of New York businessman Edward Hubbard Litchfield (right, top) calls attention to the opulence of late sixteenth-century Italian works enriched with etched and gilded

ornament. Kienbusch's ambitions explain much of
the unique character of the Museum's holdings,
which since 1977 have been exhibited in a specially
built complex of galleries. PT

Ceremonial Shield
Italy, Milan, c. 1560
Steel, gold, silver, brass, leather, velvet; DIAM. 23¹⁵⁄₁₆ in. (60.8 cm)
Bequest of Carl Otto Kretzschmar von Kienbusch, 1977-167-766

Pompeo della Cesa (Italian, c. 1537–1610)

Armor for the Foot Tourney over the Barriers, c. 1590
Steel, gold, brass, leather, textile; H. 31½ in. (80 cm) from top of
helmet to bottom center of breastplate
Bequest of Carl Otto Kretzschmar von Kienbusch, 1977-167-37

Attributed to Lorenz Helmschmid (German, c. 1445–1516)

Elbow Gauntlets, c. 1485
Steel, latten, leather; L. (left gauntlet) 14³⁄₈ in. (36.4 cm),
L. (right gauntlet) 14 in. (35.5 cm)
Bequest of Carl Otto Kretzschmar von Kienbusch, 1977-167-161a,b

Horse armor made by **Wilhelm von Worms the Elder** (German, died 1538); man's armor made by **Matthes Deutsch** (German, first recorded 1485, last documented c. 1505)

Horse and Man's Armors, 1507 and c. 1505
Steel, brass, gold, leather, textiles; L. (horse armor) approx. 77 in. (195.5 cm) as mounted, from lower front edge of chest defense to lower rear edge of hind defense; H. (man's armor) approx. 71⅛ in. (180.5 cm) as mounted
Gift of Athena and Nicholas Karabots and The Karabots Foundation, 2009-117-1,2

Commissioned by Duke Ulrich of Württemberg for his personal use in a military expedition in Italy and the anticipated triumphal procession in Rome, this exquisitely decorated horse armor captures the legendary extravagance of the young prince. Wrought by Wilhelm von Worms the Elder, the leading armorer of Nuremberg, it is adorned in gold with figures of noblewomen, the duke's motto, and a spectacular dragon. The exceptional quality of the design and execution of the ornamentation suggests Wilhelm's collaboration with a notable artist, probably a painter. Although the man's armor was made in Landshut, about one hundred miles south of Nuremberg, and probably was intended for a different patron, its decoration was created using the same techniques and dates to about the same time as the horse armor, with which it has been associated since the nineteenth century. Modeled with singular care and skill, it is the richest early Renaissance armor by the Landshut school. The acquisition of these outstanding masterpieces of early Renaissance armor, made possible through the extraordinary generosity of Athena and Nicholas Karabots and The Karabots Foundation, marked a transformative addition to the Museum's celebrated collection of arms and armor. The Museum now preserves the earliest complete Nuremberg armors for man and horse, and several key works by the foremost armorers of Landshut; its collection of early Renaissance German armor ranks among the most important outside Europe. PT

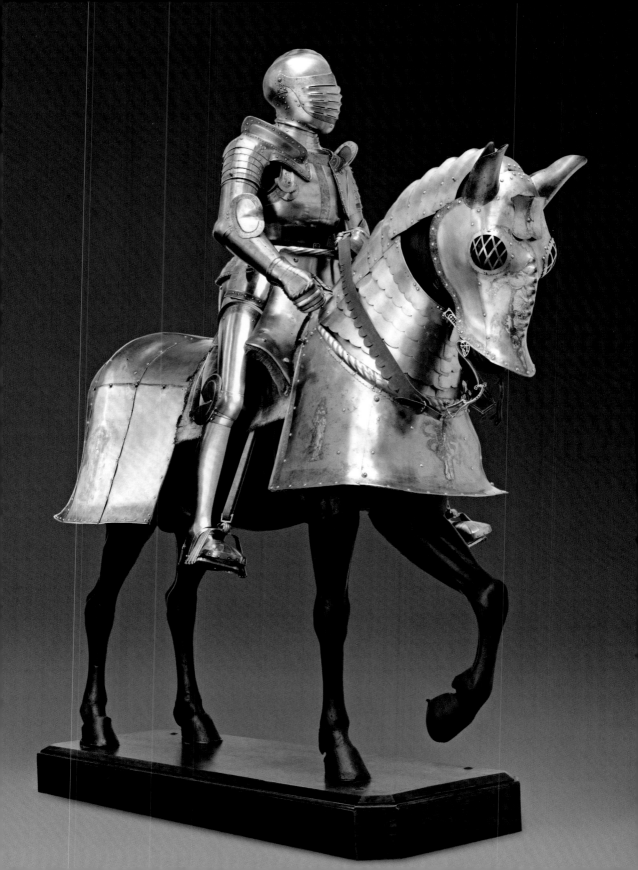

Adriano Fiorentino (Italian, c. 1450/60–1499)

Venus, c. 1490
Bronze, H. 16⅜ in. (41.6 cm)
Purchased with funds contributed by Mr. and Mrs. George D.
Widener from the Edmond Foulc Collection, 1930-1-17

Adriano Fiorentino's *Venus* is a rarity as both an early
Renaissance bronze of a female nude and a work
signed by its maker. In Italy in the second half of the
fifteenth century, renewed interest in ancient Greece
and Rome as well as ongoing discoveries of antique
sculpture spurred demand for small bronzes. While
Adriano based his figure on a specific antiquity, the
goddess and shell on which she stands reflect the
contemporary influence of Sandro Botticelli's painting
The Birth of Venus (c. 1484; Uffizi, Florence). Famous
for his skill in working bronze, Adriano demonstrated
his expertise in the flawless casting of this statuette
and integral base. JH

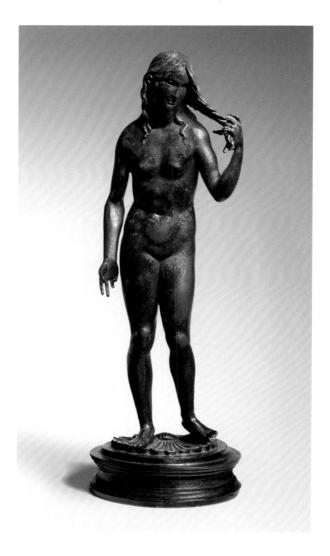

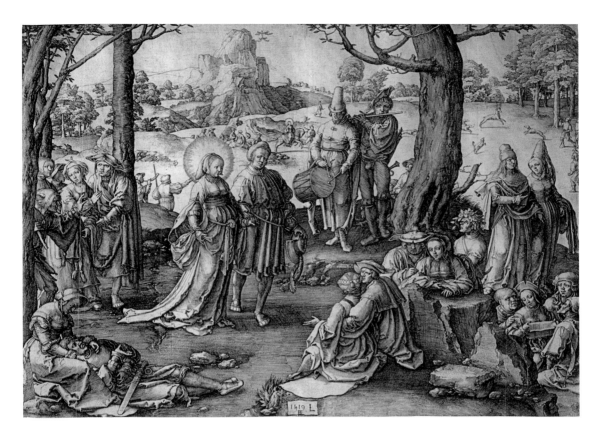

Lucas van Leyden (Netherlandish, c. 1494–1533)

The Dance of Saint Mary Magdalene, 1519
Engraving, image and sheet: 11⁵⁄₁₆ × 15½ in. (28.7 × 39.4 cm)
Purchased with the Alice Newton Osborn Fund, the Lola
Downin Peck Fund, the Print Revolving Fund, and with funds
contributed by various donors, 1979-65-1

Medieval artists elaborated the legend of Mary
Magdalene's transformation from sin to sanctity in
frescos, manuscripts, pageants, and songs. Lucas
van Leyden's picture illustrates three episodes of the
Magdalene's life: In the foreground she promenades
after a night of revelry; in the middle she hunts in the
midday sun; and in the distance, outside the moun-
tain cave where she spent her final thirty years, angels
carry her heavenward for a celestial feast. This master-
ful engraving is a marvel of subtle effects that can be
appreciated only in early proofs such as this, before
the artist's silvery burin lines wore down under the
pressure of the printing press. JI

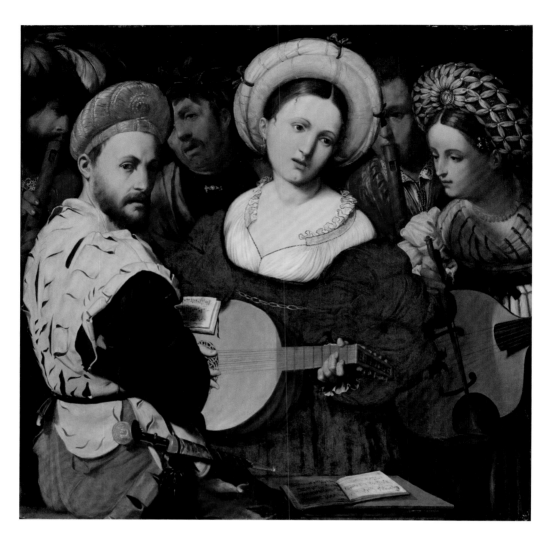

Callisto Piazza (Italian, first documented 1524, died 1561)

Musical Group, 1520s
Oil on panel, 35⅝ × 35¾ in. (90.5 × 90.8 cm)
John G. Johnson Collection, cat. 234

By the early sixteenth century, particularly in northern Italy, there was a new demand for paintings depicting scenes of daily life rather than religious or mythological subjects. This painting of a private concert by Callisto Piazza from Lodi, near Milan, is an excellent example of the trend. Two men in the background, flanking another who is crowned with the laurel wreath of a poet, play recorders, while the women in front play string instruments. The elegantly dressed man at left, who is singing from a booklet of sheet music, looks out as if inviting the viewer to join in. CBS

Lucas Cranach the Elder (German, 1472–1553)

Eros, c. 1530
Oil on panel, 31⅛ × 15 in. (79.1 × 38.1 cm)
John G. Johnson Collection, cat. 738

The winged Eros, or Cupid, playfully holding an
arrow as if looking for a victim to strike with lustful
desire, stands poised on a stone slab inscribed with
the artist's monogram. Eros was the son of Aphrodite,
whose thigh is visible in the upper right of the panel,
a fragment of a larger composition that included,
like other known paintings by the artist, the seduc-
tively naked figure of the goddess. Erotic images of
ancient Greek and Roman gods were popular among
Cranach's clientele in the German courts of the
Protestant Reformation. CBS

Joos van Cleve (Netherlandish, first documented 1511,
died 1540/41)

Portrait of Francis I, King of France, c. 1532–33
Oil on panel, 28⅜ × 23⁵⁄₁₆ in. (72.1 × 59.2 cm)
John G. Johnson Collection, cat. 769

Francis I, who ruled France from 1515 to 1547, was
one of the leading arts patrons and collectors of his
day. Here Joos van Cleve, whose fame as a painter
attracted the attention of the French king, has por-
trayed his subject in finery befitting his regal status.
Although the artist created a sense of volume and
three-dimensionality in the monarch's face and hands,
he depicted the torso as a flat, decorative surface,
the effect of which removes Francis from the earthly
realm and distinguishes the king from his subjects. CA

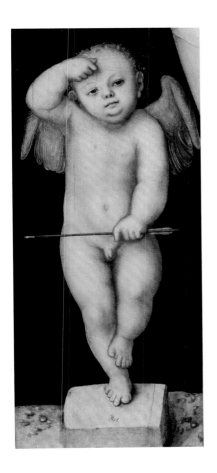

Choir Screen from the Chapel of the Château of Pagny

France, near Dijon, 1536–38
Marble, alabaster; w. 28 ft. 5½ in. (8.67 m)
Purchased with funds contributed by Eli Kirk Price from the
Edmond Foulc Collection, 1930-1-84a–d

In the 1530s the chapel of the château of Pagny in Burgundy underwent successive redecoration campaigns led by Philippe Chabot de Brion, admiral of France, and his uncle by marriage, the cardinal of Givry. Among the most significant Renaissance monuments outside France, this screen, particularly the elaborate carving on its frieze, suggests the influence of Italian Renaissance artists then working for the French king Francis I at the château of Fontainebleau. The four figures of saints on top are among the finest sculptures of their time, brilliant examples of the refined French art that developed from the fusion of late Gothic traditions with advanced Italian style. JH/DW

Altarpiece with Scenes of the Passion

Southern Netherlands (modern Belgium), Antwerp, c. 1535
Gilded and painted wood sculptures, tempera-painted panels;
w. 14 ft. (4.27 m) with wings open
Purchased with Museum funds from the George Grey Barnard
Collection, 1945-25-117,a–s

This altarpiece was purchased for the chapel at the château of Pagny in Burgundy in the 1530s, during the redecoration projects of Admiral Chabot and the cardinal of Givry. After it was removed from the chapel, its origin was largely ignored until its acquisition by the Museum, where it miraculously was reunited with the choir screen from the same chapel (left). Antwerp craftsmen specialized in such elaborate altarpieces, which surprisingly were not particularly expensive, partly because they were made from standardized components. With its detailed, gilded figures, this altarpiece demonstrates the well-established taste for Northern art in Burgundy, which had historic links to the southern Netherlands. JH/DW

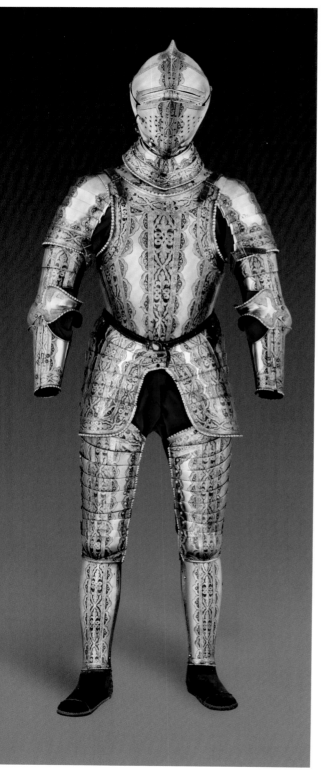

Elements of an Armor Garniture
Germany, Augsburg, c. 1550
Steel, gold, brass, leather, textile; H. 68¹¹⁄₁₆ in. (174.5 cm)
as mounted
Bequest of Carl Otto Kretzschmar von Kienbusch, 1977-167-20a–j

This armor combines elements from a garniture, a
large ensemble of pieces, made for a young member
of the House of Habsburg. Fine armor such as this
customarily was commissioned in relation to an
important event, such as a military campaign, politi-
cal summit, wedding, or the beginning of a reign; this
example, which combines elements intended for both
field and tournament use, might have been made for
Ferdinand II of Austria upon his appointment as gov-
ernor of Bohemia in 1547, when he was eighteen years
old. The costly garniture to which these pieces belong
is unsigned, but details of form and construction sug-
gest Augsburg as the likely place of manufacture. PT

Attributed to **Anton Peffenhauser** (German, 1525–1603)

Cuirass with Helmet, c. 1580

Steel, gold, brass, glass, semi-precious stones, leather, textiles;
H. 32⅞ in. (83.5 cm) as mounted
Bequest of Carl Otto Kretzschmar von Kienbusch, 1977-167-31

This exceptionally well-preserved and rare armor
originates from the ancestral arsenal of the counts
Khevenhüller in Austria. Made in Germany in the
style of light cavalry armor fashionable in Hungary,
it compares closely to documented examples, none
of which appears to have survived, commissioned
by Rudolf II, Holy Roman emperor and king of
Bohemia and Hungary, for presentation to Ottoman
dignitaries. Perhaps intended as a diplomatic gift, but
never delivered, this armor is adorned appropriately
with gilded Moorish tracery and celestial symbols, and
with turquoise stones and colored glass pastes set in
gilded-brass mounts. The original lining covered with
yellow silk survives inside the helmet. PT

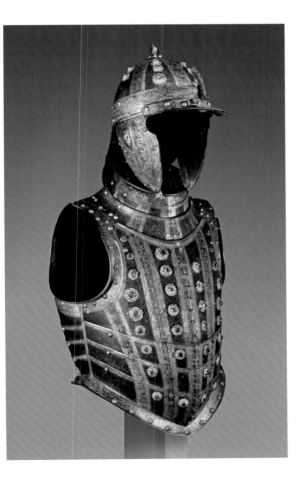

Hans Hilgers (German, active 1570–90s)

*Tankard with the Arms of England and Spain,
and Michael the Archangel,* 1573

Stoneware with salt glaze; pewter; H. 14¹³⁄₁₆ in. (37.6 cm)
Purchased with the Walter E. Stait Fund, 2002-76-1

First produced in Europe in the German Rhineland
and eastern Netherlands in the thirteenth century,
stoneware, a ceramic that when fired to high tem-
peratures becomes impervious to liquids, was an
ideal material for drinking vessels. The abbey town of
Siegburg, Germany, became an important center for
stoneware production in the fourteenth century, and
tankards decorated with reliefs of refined Renaissance
designs became its particular specialty. This vessel,
for example, bears images of the Archangel Michael
as well as the English and Spanish arms (a reflection
of the international market for these wares), and is
signed with the initials of Hans Hilgers, a member of
Siegburg's leading family of potters. JH

Agnolo Bronzino (Italian, 1503–1572)

Portrait of Cosimo I de' Medici as Orpheus,
c. 1537–39
Oil on panel, 36⅞ × 30½6 in. (93.7 × 76.4 cm)
Gift of Mrs. John Wintersteen, 1950-86-1

Agnolo Bronzino has personified Cosimo I de' Medici, the young ruler of Florence, as the mythological poet Orpheus, at the entrance to the underworld where he has traveled to reclaim his deceased wife, Eurydice. The felicitous circumstances of this allegorical portrait, painted at the time of Cosimo's marriage, warranted several modifications to the composition during its execution, including changing the three-headed dog Cerberus, guardian of the underworld, from growling to sedate, quieted by Orpheus's music. Many contemporary viewers would have noticed that the sitter's muscular body was based on the Belvedere Torso, a famous ancient sculpture then as now in the Vatican. CBS

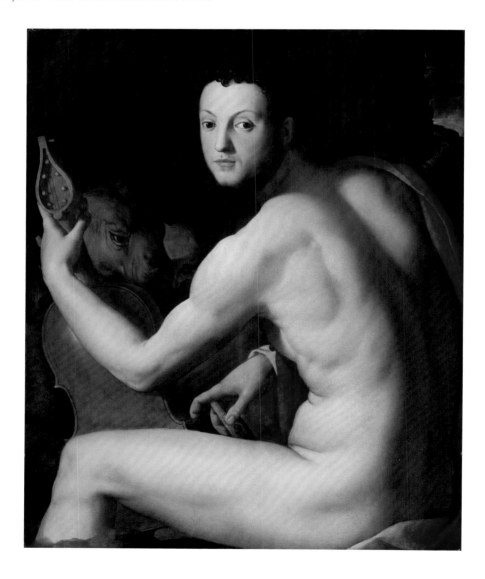

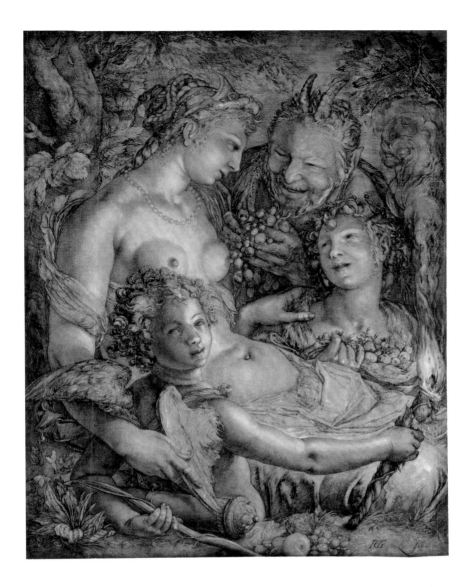

Hendrick Goltzius (Dutch, 1558–1617)

Without Ceres and Bacchus, Venus Would Freeze,
c. 1600–1603

Ink and oil on canvas, 41³/₈ × 31½ in. (105.1 × 80 cm)
Purchased with the Mr. and Mrs. Walter H. Annenberg Fund for
Major Acquisitions, the Henry P. McIlhenny Fund in memory
of Francis P. McIlhenny, bequest (by exchange) of Mr. and Mrs.
Herbert C. Morris, and gift (by exchange) of Frank and Alice
Osborn, 1990-100-1

In this so-called pen painting, Hendrick Goltzius
drew with ink on a prepared canvas before apply-
ing light touches of oil paint. The work's limited
palette calls attention to the artist's virtuoso drawn
lines; only the flaming torch, symbolizing the love
that Venus inspires, and the light it throws color the
nearly monochrome scene. As the painting's title and
the maxim on which it is based inform, the god of
wine Bacchus's grapes and the goddess of the harvest
Ceres's grains and fruits, here being offered to Venus
by a satyr and a youth, sustain the goddess and enable
love to flourish. Goltzius achieved international fame
during his lifetime, and many of the most important
collectors in Europe sought his work. Holy Roman
Emperor Rudolf II brought this picture to his court in
Prague by 1604, and around 1648 it entered the royal
collection of Christina of Sweden, before being trans-
ferred by 1660 to that of Charles II of England. CA

Jean de Court (French, active c. 1555–85)

Platter Showing the Sacrifice of Iphigenia,
c. 1575–85
Painted enamel on copper, w. 21⅝ in. (54.9 cm)
Purchased with funds contributed by the Women's Committee
and the Craft Show Committee of the Philadelphia Museum of
Art, 1979-90-1

This large platter is an outstanding example of the
works associated with Jean de Court, a prominent
enamel painter patronized by the French royal family.
Made in Limoges, a city renowned for enamel pro-
duction since the Middle Ages, objects like this were
luxury goods intended primarily for display. Sixteenth-
century enamels reflect contemporary French interest
in Renaissance styles and stories from antiquity, with
designs typically derived from printed sources. The
human and animal grotesques that decorate the plat-
ter's border and the complex narrative in the center
showing a famous episode of the Trojan War demon-
strate the brilliant sophistication of enamel work pro-
duced in Limoges during its heyday. JH

Tile with Saracen Bowman
The Netherlands, Rotterdam, 1600–1630
Earthenware with tin glaze and polychrome decoration, H. 5⅛ in.
(13 cm)
Gift of Anthony N. B. Garvan, 1983-101-106

This is one of a series of tiles designed for interior
decoration that feature figures of Roman warriors
or Saracen bowmen derived from engravings by
renowned Dutch printmaker Hendrick Goltzius
(see, for example, p. 123). Here the single figure and
the lack of corner motifs suggest that this example
most likely was intended for use as a border tile. The
Museum's collection of Dutch tiles, with holdings
spanning the sixteenth to the twenty-first century,
is among the most important in the United States.
Beginning with the initial bequest of fifteen Dutch
tiles from the estate of Mrs. Frederick Graff in 1897,
the Museum's collection has been enhanced through
subsequent acquisitions, including purchases made
possible by Edward W. Bok in 1928, and Mrs. Francis
P. Garvan and her son Anthony N. B. Garvan's
important succession of gifts, beginning in 1979, of
more than sixteen hundred tiles. MADJ

Made in the workshop of **Iacobus Fiamengo** (Flemish, active 1594–1602); scenes based on engravings by **Dirk Volkertsz. Coornhert** (Netherlandish, 1522–1590), after designs by **Maarten van Heemskerck** (Netherlandish, 1498–1574)

Writing Cabinet, c. 1600
Ebony and ebony veneer on pine with ivory inlay, w. 35¾ in. (90.8 cm)
Purchased with Museum funds from the Edmond Foulc Collection, 1930-1-188

This cabinet's decoration celebrates the triumphs of the Spanish Empire with scenes of military victories of Charles V and engraved maps of territories under Spanish rule or influence. The front panel opens to reveal an interior with functional drawers that resembles a building facade, at the center of which is an image of the enthroned king. Made of costly ebony and ivory, the cabinet was produced by craftsmen active in Naples, then under Spanish control. Among the artisans working there, the most prominent was Flemish cabinetmaker Iacobus Fiamengo, who must have been prolific—over twenty pieces produced by his workshop are known. JH/DW

Peter Paul Rubens (Flemish, 1577–1640) and
Frans Snyders (Flemish, 1579–1657)

Prometheus Bound, c. 1611/12–18
Oil on canvas, 95½ × 82½ in. (242.6 × 209.5 cm)
Purchased with the W. P. Wilstach Fund, W1950-3-1

In Greek mythology the Titan Prometheus stole fire from the gods on Mount Olympus to give to humanity. Furious, Zeus, king of the Olympians, ordered Prometheus forever chained to a rock, where each day an eagle would devour the Titan's perpetually regenerating liver. This painting, which Rubens considered one of his most important works, represents the virtuoso artist at his absolute height. Working in collaboration, a common practice for master artists in Antwerp in the first two decades of the seventeenth century, Rubens and the famed animal and still-life painter Frans Snyders, who contributed the eagle, rendered the brutal tale of Prometheus with corresponding violence. The enormous bird's beak rips open the Titan's torso, exposing blood-soaked entrails. To gain purchase on the captive's flesh, one of the eagle's talons gouges Prometheus's right eye. His left eye is locked on the predator, signaling he is fully aware of his torture, while his writhing legs, clenched fist, and tousled hair convey the Titan's abject agony. Rubens, who intensively had studied the art he saw on his travels to Italy, Spain, and England, derived the hulking figure of Prometheus, with its broad frame and dense musculature, from prototypes by Michelangelo. The picture's asymmetrical composition, in which Prometheus tumbles downward with his left arm almost reaching beyond the canvas, was inspired by a painting by Titian of the giant Tityus (1548–49; Museo del Prado, Madrid). Here Rubens masterfully synthesized and melded these sources with his own Baroque sensibilities. CA

Nicolas Poussin (French, 1594–1665)

The Birth of Venus, 1635 or 1636
Oil on canvas, 38¼ × 42½ in. (97.2 × 108 cm)
The George W. Elkins Collection, E1932-1-1

Nicolas Poussin spent most of his life in Rome, where he worked to restore the values of noble discretion and harmony as the highest purposes of art. Here a beautiful woman, whom the title identifies as Venus but whose identity in fact remains in dispute, glides on a shell drawn by dolphins, surrounded by maidens who elevate her billowing shawl as a sail. Two young tritons declare her triumphal entry with trumpet shells, and putti cast flowers on the figures below. One of the artist's greatest masterpieces, the canvas was acquired by the Museum in 1932, shortly after the Soviet government sold it from the Hermitage Museum in Leningrad (now Saint Petersburg). JJR

Designed by **Peter Paul Rubens** (Flemish, 1577–1640);
woven at **Comans–La Planche tapestry factory**
(Faubourg Saint-Marcel, Paris, 1607–33)

Tapestry Showing the Battle of the Milvian Bridge, 1623–25

Wool and silk with gold and silver threads, 15 ft. 11 in. × 24 ft.
5 in. (4.85 × 7.44 m)
Gift of the Samuel H. Kress Foundation, 1959-78-3

In September 1625, Louis XIII of France gave Cardinal
Francesco Barberini seven tapestries with scenes
designed by Peter Paul Rubens illustrating the life of
Constantine, the first Roman emperor to convert to
Christianity. Although the cardinal—who had spent
several months in Paris on behalf of his uncle Pope
Urban VIII, fruitlessly negotiating a dispute between
France and Spain involving papal interests—was
counseled not to accept the king's gift, the splendid
tapestries and their advanced style surely made them
irresistible to Barberini, who took them to Rome.

This panel provides a tumultuous illustration
of the climax of the Battle of the Milvian Bridge
near Rome in 312, when Constantine defeated his
rival Maxentius to become sole ruler of the Western
Roman Empire. Barberini, upon returning to Rome
with the weavings, established his own tapestry manu-
factory and commissioned artist Pietro da Cortona—
like Rubens, a master of the dynamic Baroque
style—to design additional hangings for the series.
The complete set of thirteen Constantine tapestries,
reunited and generously given to the Museum by the
Kress Foundation in the 1950s, represents a unique
juxtaposition of the work of two leading artists of the
day. Installed around the second-floor balcony of the
Great Stair Hall, this sumptuous display offers view-
ers a rare comprehensive experience of a monumental
Baroque narrative cycle. JH

Francisco de Zurbarán (Spanish, 1598–1664)

The Annunciation, c. 1650
Oil on canvas, 7 ft. 1⅜ in. × 10 ft. 4½ in. (2.18 × 3.16 m)
Purchased with the W. P. Wilstach Fund, W1900-1-16

A masterpiece of Francisco de Zurbarán's late style, this canvas—which probably was painted for a courtier of the Spanish king Philip IV, Gaspar de Bracamonte y Guzmán, who is said to have donated it in 1658 to a church near Salamanca in northwestern Spain—belonged to several prominent owners before its purchase in 1900 with the W. P. Wilstach Fund, which was administered by Philadelphia collector John G. Johnson. The influence of Italian Baroque painting is evident in Zurbarán's dramatic depiction of the heavenly host, yet the sobriety of his earlier style is apparent in the still-life details of the books, curtain, and vase of lilies. CBS

Rembrandt Harmensz. van Rijn (Dutch, 1606–1669)

Head of Christ, c. 1648–56
Oil on oak panel, 14⅛ × 12⁵⁄₁₆ in. (35.8 × 31.2 cm)
John G. Johnson Collection, cat. 480

In this portrait-like representation of Christ, a frequent subject in Rembrandt's oeuvre, the artist's sensitive handling of light and shadow forges a palpable presence. Subtle details such as the tilt of Christ's head and his downcast eyes heighten this impression, and imbue the figure with a sense of humanity. Rembrandt's innovation of humanizing and particularizing depictions offered Dutch audiences new ways of conceiving Christ. Here the novelty extended to Rembrandt's choice of model—a young Sephardic Jew, probably from the artist's neighborhood in Amsterdam. CA

Christoffel van den Berghe (Dutch, active c. 1617–after 1628)

Still Life with Flowers in a Vase, 1617
Oil on copper, 14¹³⁄₁₆ × 11⅝ in. (37.6 × 29.5 cm)
John G. Johnson Collection, cat. 648

During the Dutch Golden Age, fictive still lifes such as this were prized in Christoffel van den Berghe's hometown of Middelburg. Here Van den Berghe combined exacting naturalism with an imaginative composition (the different types of flowers in the bouquet, for example, would not have been in bloom at the same time). The items depicted illuminate the Dutch Republic's contacts with the world beyond: The tulips originally were imported from Turkey, and the porcelain cups on the ledge are of Chinese origin. The use of copper as the painting's support enhances the picture's jewellike luster and the artist's delicate description of textures. CA

Judith Leyster (Dutch, 1609–1660)

The Last Drop, c. 1639
Oil on canvas, 35¹⁄₁₆ × 28¹⁵⁄₁₆ in. (89.1 × 73.5 cm)
John G. Johnson Collection, cat. 440

Judith Leyster was among the most successful women artists before the twentieth century. In 1633 Leyster, who had studied under the famed painter Frans Hals, registered as an independent master in the painters' guild of Saint Luke in her native city of Haarlem. Inspired by her teacher's example, she specialized in spirited scenes of everyday life. Here the two young revelers seem unaware of the encroaching skeleton, which bears an hourglass, a skull, and a burning candle. These traditional symbols of the passing of time allude to the transience of life, perhaps especially for those who, like the youths, overindulge. CA

Jan Steen (Dutch, 1626–1679)

Rhetoricians at a Window, c. 1661–66

Oil on canvas, 29⅞ × 23¹⁄₁₆ in. (75.9 × 58.6 cm)

John G. Johnson Collection, cat. 512

The John G. Johnson Collection (pp. 134–35) features an important group of seventeenth-century Dutch genre paintings, including nine attributed to Jan Steen. Genre paintings—fictionalized depictions of contemporary life—were extremely popular during the Dutch Golden Age. While some painters opted for serious representations of everyday occurrences, Steen excelled in crafting comic episodes. In this lively scene, he has depicted a group of mirthful rhetoricians—professionals and amateurs with shared interests in wit, humor, and theater—gathered at an open window. The figure at upper right mugging playfully conveys the merry tenor of the scene, and his outward gaze encourages viewers to laugh or smile in return. CA

Paulus Potter (Dutch, 1625–1654)

Figures with Horses by a Stable, 1647

Oil on panel, 17¾ × 14¾ in. (45.1 × 37.5 cm)

The William L. Elkins Collection, E1924-3-17

Paulus Potter died at the age of twenty-eight, but despite his short career and small oeuvre, this is one of four paintings by him in the Museum. He specialized in rustic scenes such as this, in which his use of warm light and his tender treatment of figures and animals create pleasing, pleasant images. Potter's paintings would have provided his clients, which included courtiers and sophisticated city dwellers, with imaginative transport to the countryside, away from the rigors of court and urban life. Some viewers may have understood this picture as a celebration of the agrarian prosperity that helped fuel the Dutch economy in the seventeenth century. CA

THE JOHN G. JOHNSON COLLECTION

John G. Johnson (1841–1917; see fig. 4), the most distinguished corporate lawyer of his era and a leading citizen of Philadelphia, amassed one of the finest collections of paintings in the United States. While his collection is renowned for its rich and diverse holdings of old master pictures, Johnson's early taste was for Barbizon and other nineteenth-century French paintings, which he had first encountered at the 1876 Centennial Exhibition in Philadelphia. By the 1880s, however, he began to favor more ambitious and advanced French works, and he purchased important examples by artists such as Gustave Courbet, Camille Pissarro, Pierre Puvis de Chavannes, and Édouard Manet, including his dramatic depiction of the sinking of the Confederate warship the *Alabama*, the climax of one of the most critical naval battles of the American Civil War (right, bottom; see also pp. 183, 187, 199).

It was only in the 1890s that his interest in the old masters, particularly the early Italians, bloomed. With occasional guidance from experts in the field, including American art historian Bernard Berenson, whose catalogue of Johnson's collection was published in 1913, he acquired pictures by, among others, Antonello da Messina, Sandro Botticelli, and Pietro Lorenzetti, as well as Pinturicchio's tender image of the Virgin teaching the Christ child to read (left; see also pp. 88, 100, 106).

Dutch art, primarily of the Golden Age, also is well represented in his collection, which includes works by Rembrandt, Pieter Jansz. Saenredam, Jan Steen, and Jacob Issacksz. van Ruisdael, a leading landscape painter celebrated for his virtuoso skill and naturalistic compositions, such as his image of the rolling dunes near Haarlem (right, top; see also pp. 131, 133, 136).

Johnson's prescient interest in early Netherlandish art led him to, arguably, his greatest gathering of masterpieces. Among these works are Robert Campin's exquisite image of Christ and the Virgin Mary (p. 93), Jan van Eyck's meticulously rendered picture of Saint Francis receiving the stigmata (p. 95), and Rogier van der Weyden's profoundly moving Crucifixion scene (p. 98). Comprising nearly 1,200 paintings, the Johnson Collection has made the Museum an essential pilgrimage site for admirers of the old masters and continues to be a source of discovery for generations of scholars. JJR

Pinturicchio (Italian, 1454–1513)

Virgin Teaching the Christ Child to Read, c. 1494–97
Oil and gold on panel, 24⅛ × 16½ in. (61.3 × 41.9 cm)
John G. Johnson Collection, inv. 1336

Jacob Isaacksz. van Ruisdael (Dutch, 1628/29–1682)

Dunes, early 1650s
Oil on panel, 13³⁄₁₆ × 19⅜ in. (33.5 × 49.2 cm)
John G. Johnson Collection, cat. 563

Édouard Manet (French, 1832–1883)

The Battle of the USS "Kearsarge" and the CSS "Alabama," 1864
Oil on canvas, 54¼ × 50¾ in. (137.8 × 128.9 cm)
John G. Johnson Collection, cat. 1027

Pieter Jansz. Saenredam (Dutch, 1597–1665); figures attributed to **Pieter Janz. Post** (Dutch, 1608–1669)

Interior of Saint Bavo, Haarlem, 1631
Oil on panel, 32⅝ × 43½ in. (82.9 × 110.5 cm)
John G. Johnson Collection, cat. 599

Paintings of identifiable church interiors like this are distinctive to the Dutch Golden Age, and Pieter Jansz. Saenredam was the leading specialist in architectural painting. His church interiors were renowned for the remarkable illusion of depth created through rigorous implementation of mathematical linear perspective. As the artist's surviving drawings suggest, he visited and studied the spaces of each interior before undertaking the paintings in his studio. The linear perspective in the present picture is readily apparent due to the spartan decoration of the church. Ornamentation of Protestant religious sites largely was eschewed to encourage worshipers to focus on the minister's sermon. CA

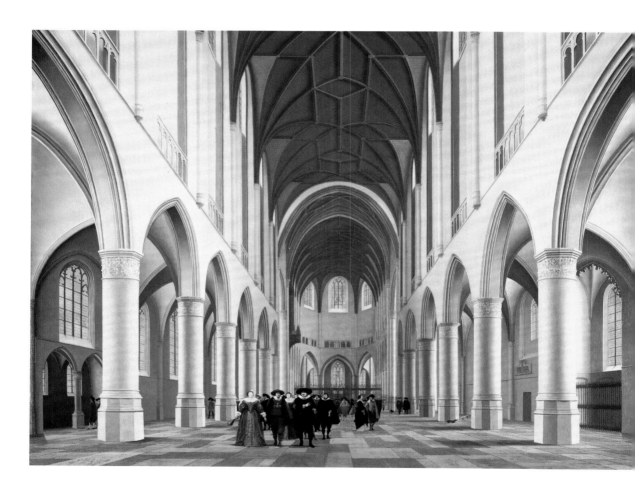

Rembrandt Harmensz. van Rijn (Dutch, 1606–1669)

Christ Crucified between Two Thieves, 1653–55

Drypoint with burin work, image and sheet: 15⅛ × 17¾ in.
(38.3 × 45.1 cm)

Acquired with the Muriel and Philip Berman Gift (by exchange)
and with the gifts (by exchange) of Lisa Norris Elkins, Bryant
W. Langston, Samuel S. White 3rd and Vera White, William
Goldman, Herbert T. Church, R. Edward Ross, Jay Cooke, Carl
Zigrosser, John Sheldon, the Charles M. Lea Collection, the
William S. Pilling Collection, the Louis E. Stern Collection, the
Print Club of Philadelphia Permanent Collection, and with funds
contributed (by exchange) from John Howard McFadden, Jr.,
Thomas Skelton Harrison, the Philip and A. S. W. Rosenbach
Foundation, and the Edgar Viguers Seeler Fund, 2003-188-1

Rembrandt Harmensz. van Rijn began his career
as a printmaker around 1630 with small etchings
of episodes from Christ's childhood and capped it
twenty-five years later with this drypoint, one of his
greatest masterpieces in any medium, illustrating
the climactic event of the New Testament. By this
time Rembrandt had produced more than 250 etch-
ings, composing directly on copperplates with the
same ease as drawing on paper. On some plates he
used a drypoint tool to raise delicate curls of copper,
called burr, along the edges of his incisions to capture
extra ink and print rich, velvety black accents. For
this image he scored the plate with deeply gouged
drypoint lines to realize an impassioned vision of the
swirling dark chaos and piercing shafts of light said
to accompany Christ's last moments. JI

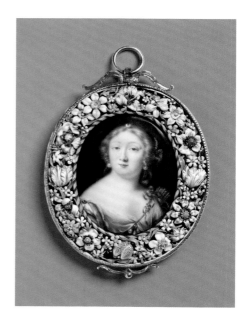

Possibly made by the factory of **George Villiers** (English, 1628–1687)

Goblet, 1663
Soda-lime glass with diamond-point engraved decoration, H. 5⅝ in. (14.3 cm)
The George H. Lorimer Collection, 1938-23-1

Among the most celebrated pieces of seventeenth-century English glass, this goblet—engraved with an image of Charles II of England framed by branches of an oak tree, along with portrait busts of the king and his queen consort, Catherine of Braganza, and the royal arms—commemorates an incident following the Battle of Worcester in 1651 in which Charles was forced to take refuge in an oak tree. It is one of only several pieces of glass believed to have been made at one of the largely experimental London or Greenwich factories of George Villiers, second Duke of Buckingham, an advisor to Charles who may have presented it to the royal couple for their marriage in 1662. DC

Jean Petitot (French, 1607–1691)

Catherine-Henriette d'Angennes, Countess of Olonne, as Diana, c. 1680
Enamel and paint, H. 2½ in. (6.3 cm) with frame
Gift of Mrs. Lessing J. Rosenwald, 1961-37-1

The Countess of Olonne was said to have been the most beautiful woman in the court of Louis XIV,

unsurpassed for its luxury, glamour, and complex social mores. Renowned for their beauty as well as their excesses, the countess and her sister were the subject of famous court gossip Louis de Rouvroy, Duke of Saint-Simon, who noted, "No woman, not even those most notorious for their love affairs, had dared to see or be seen with them anywhere." This lovely miniature, a tour de force of metalwork and painting, for centuries has been nearly as desired and pursued as was the noblewoman it depicts. JJR

Savonnerie carpet factory (Paris, 1627–1825)

Carpet, 1668–85
Wool, 26 ft. 3 in. × 18 ft. 6 in. (8 × 5.64 m)
Bequest of Eleanore Elkins Rice, 1939-41-27

This is one of ninety-three splendid carpets commissioned by Louis XIV of France as part of the major renovations to the long gallery that connected the Louvre and Tuileries palaces in Paris. The carpets, which constituted one aspect of the room's decorative scheme conceived with the court painter Charles Le Brun and architect Louis Le Vau, are replete with royal emblems and symbolism, all of which were intended for one purpose, the glorification of the king. The commission's scale and magnificence were unprecedented in the history of French woven arts, and the carpets rank among the greatest artistic achievements of the seventeenth century. DC

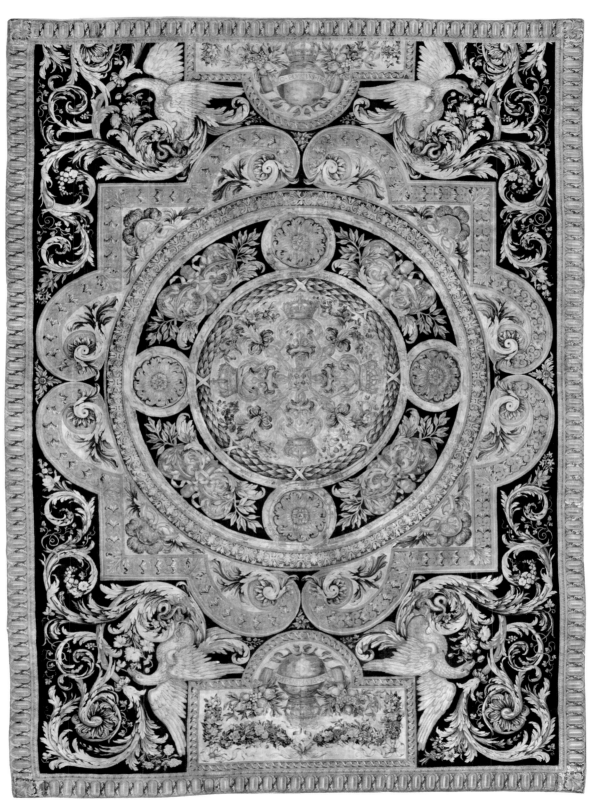

Thomas Tompion (English, 1639–1713)

Clock, c. 1693

Ebony veneer, gilded and silvered bronze; H. 16¼ in. (41.3 cm)
The Henry P. McIlhenny Collection in memory of Frances P.
McIlhenny, 1986-26-156a,b

Thomas Tompion was the most influential and
revered maker of clocks, watches, and scientific instru-
ments in seventeenth-century England, with clients
including English royalty and aristocracy. Among
his innovations was the use of a numbering system
to identify his clocks and watches, perhaps the earli-
est of its kind applied to manufactured goods (the
Museum's clock bears the number 214). Cherished
and expensive objects, clocks such as this often came
with purpose-built boxes that facilitated their trans-
port during the seasonal moves of many families
between the city and the country. DC

Textile Length

Italy, c. 1700–1705
Silk with metallic thread, 86 × 82 in. (218.4 × 208.3 cm)
Gift of Fitz Eugene Dixon, Jr., 1969-290-122

Between 1690 and 1720, the fashion in European
silks was exotic designs inspired by motifs found
on imported goods from Asia, especially China and
India, and the Middle East. These luxurious silks,
named "bizarre" in the twentieth century, are distin-
guished by the unusual forms and fantastical imagery
of their inventive patterns, which often were created
with colored and metallic threads woven into subtle
damask grounds. Decorated with a fanciful design of
aquatic plants and shells, this fabric, like other exam-
ples, probably was used for ecclesiastical vestments or
for clothing for wealthy patrons, including European
royalty. DB

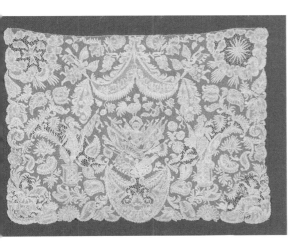

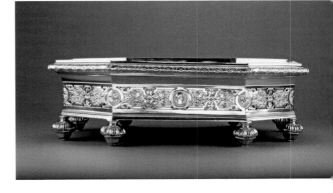

Cravat End

Belgium, Brussels, c. 1700–1715
Linen, 12¾ × 16½ in. (32.4 × 41.9 cm)
Purchased with funds contributed by the Women's Committee and the Craft Show Committee of the Philadelphia Museum of Art, 1990-1-2

In Europe in the seventeenth and eighteenth centuries, lace, an expensive luxury, was worn where it showed to best advantage. This example—one of two that originally trimmed the ends of a cravat, a fashionable form of men's neckwear—contains several allusions to the Sun King, Louis XIV, and his military victories. In the center, a rooster, symbolizing France, perches atop trophies of war flanked by figures of the gods Mars and Minerva. Emblems associated with the king fill the upper corners—at left, the cross of the Order of the Holy Ghost; at right, the sun—and his monogram, interlaced Ls, appears in the swag at the bottom center. The Museum has collected lace since its founding in 1876; today its holdings comprise more than one thousand pieces, including many early examples from Europe. DB

Elie Pacot (French, 1657–1721)

Stand, 1709–10

Silver, L. 15⁷⁄₁₆ in. (39.2 cm)
Gift of Henry P. McIlhenny, 1961-196-1

This silver stand, with its strapwork decoration and applied portrait medallions, originally was part of a monumental twenty-one-piece *surtout de table* (centerpiece). The various elements of this grand surtout would have been arranged on a table in a visually pleasing manner, each stand filled with fruits or sweetmeats. Silversmith Elie Pacot made this ensemble in Lille, France, in 1709–10, when the city, having fallen in a battle of the War of the Spanish Succession (1701–14), was occupied by British, Dutch, and Austrian troops. It may have been during this time that Pacot's centerpiece, along with other spoils of war, was presented to the British crown. DC

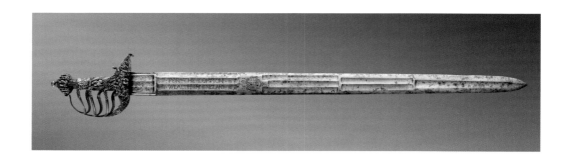

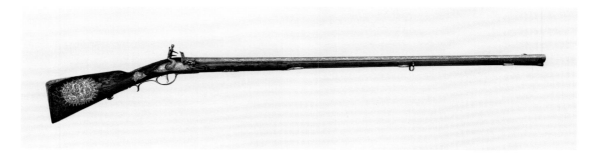

Broadsword
England, 1650
Steel, wood, silver, copper; L. 38⅛ in. (96.8 cm) overall
Bequest of Carl Otto Kretzschmar von Kienbusch, 1977-167-620

Used by both royalist and parliamentarian horsemen during the English civil wars, fought between 1641 and 1652, broadswords generally were fearsome, strictly utilitarian weapons. In contrast to the majority of surviving examples, this sword comprises a very finely embossed and chiseled hilt, and a blade that bears on each side the date of 1650, the unusual inscription "For the Commonwealth of England," and a shield enclosing the heraldic arms of England and Ireland. Long believed to have belonged to English military leader Oliver Cromwell, it conceivably might have been presented to him following his victory over the Scots at the battle of Dunbar in September 1650. PT

Tula arms factory (Tula, Russia, 1712–present)
Flintlock Gun, c. 1740
Wood, steel, gold, silver; L. 56⅛ in. (142.5 cm)
Bequest of Carl Otto Kretzschmar von Kienbusch, 1977-167-838

During the eighteenth century, the arms manufactory of Tula, founded in 1712 by Czar Peter the Great for the production of military weapons, became the source of fine hunting guns for the imperial Russian court. Whereas from the 1760s onward such guns generally were designed according to the fashionable French style, this earlier example reflects native Russian traditions. The barrel, butt plates, and lock are encrusted with intricate ornaments of chased silver, and the stock is adorned with plaques of cast silver, one of which features a Russian hunter in traditional dress, armed with a longbow. PT

Giovanni Benedetto Castiglione (Italian, 1609–1664)
Melancholia, mid-1640s
Brush and dry pigments in oil on laid paper, sheet: 11⅛ × 16⅛ in. (28.3 × 41 cm)
The Muriel and Philip Berman Gift, acquired from the Matthew Carey Lea bequest of 1898 to the Pennsylvania Academy of the Fine Arts, with funds contributed by Muriel and Philip Berman and the Edgar Viguers Seeler Fund (by exchange), 1984-56-39

At a time when draughtsmanship was key to the success of an artist—from mastering the human figure to creating full-blown compositional studies—Giovanni Benedetto Castiglione was known for "brush drawings" such as this, executed in a technique he invented combining linseed oil with dry pigment to produce highly finished works that resemble small paintings on paper. This image of the dejected figure of Melancholy surrounded by objects of artistic

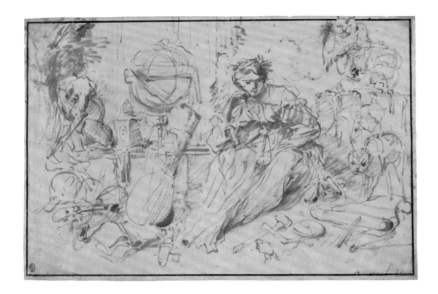

and scientific achievement represents the Museum's notable holdings of old master drawings, the foundation of which is a combination of the collections of two nineteenth-century Philadelphians, Matthew Carey Lea and John S. Phillips, that came to the institution by way of the Pennsylvania Academy of the Fine Arts. AP

François Girardon (French, 1628–1715)

Apollo, modeled c. 1675, cast c. 1715
Bronze, H. 27½ in. (69.9 cm)
Purchased with the Fiske Kimball Fund and the Marie Kimball Fund, 1976-39-1

Among the artistic achievements of the reign of Louis XIV, sculpture particularly flourished. This statue represents the ancient sun god Apollo, a symbol of the king who provided most of François Girardon's commissions. Conceived during Girardon's influential mature period, the bronze provides evidence of the royal sculptor's working practice, as its size and detail suggest it records a terracotta scale model created for his patron's approval. A print of c. 1709 depicting sculpture in Girardon's possession illustrates the terracotta, which probably was cast in bronze toward the end of the sculptor's life. Never executed on a large scale, *Apollo* nonetheless exemplifies the dignified manner of the courtly art of Louis XIV's palace at Versailles. JH/DW

Chair
England, c. 1710
Walnut, cut-velvet upholstery; H. 51½ in. (130.8 cm)
Gift of Mrs. John D. McIlhenny, 1936-3-1

This is one of a set of four early eighteenth-century English chairs in the Museum's collection, each of which retains its original Italian velvet upholstery. Such chairs, with their sumptuous fabrics and trimmings, were made for aristocratic or wealthy clients, who would have placed them in the most important rooms in their homes. The slightly fantastical architectural motif consisting of two towers surmounted by a dome on the chair back also appears in flocked wallpaper from around the same period and in a printed advertisement of about 1720 for the Blue Paper Warehouse in London. DC

De Drie Porceleyne Flessies (Delft, The Netherlands, 1661–1777)

Vase with Lid, c. 1710–20
Earthenware with tin glaze and polychrome decoration, H. 22½ in. (57.2 cm)
Purchased with the Fiske Kimball Fund, contributions from Ida Schaap Schmertz, Martina Schaap Yamin, Aletta Schaap, William T. Justice and Mary Anne Dutt Justice in honor of Ella B. Schaap, and with the gifts (by exchange) of Emmeline Reed Bedell, Edward W. Bok, Mrs. Francis P. Garvan, Jane A. Goldberg, Mrs. Frederick Graff, Commander and Mrs. John Harrison, Mrs. Taylor D. McLafferty, Mrs. Richard Waln Meirs, and John W. Pepper, 2008-92-1a,b

In the early eighteenth century, large vases like this often decorated vacant fireplaces in Dutch homes during the summer months, as confirmed by contemporary records that describe such vessels as "chimney flowerpots." This example's floral ornament is in the "cashmere pattern," so named by European merchants in the nineteenth century, probably in reference to the wool shawls imported from India that were popular at the time. Delft ceramics decorated with colors inspired by famille verte porcelains from China (see, for example, the vase on p. 58) had been extremely popular during the first two decades of the eighteenth century, but by 1720 fashions had changed and factories had almost ceased production of these decors. MADJ

Nanny goat modeled by and billy goat probably modeled by **Johann Joachim Kändler** (German, 1706–1775); made by **Meissen porcelain factory** (Meissen, Germany, 1710–present)

Nanny Goat (left) and *Billy Goat* (right), c. 1732
Porcelain, H. (nanny goat) 18¾ in. (47.6 cm), H. (billy goat) 21¾ in. (55.2 cm)
Bequest of John T. Dorrance, Jr., 1989-22-1,2

These magnificent life-size goats were among the hundreds of porcelain animals ordered by Augustus the Strong, king of Poland and elector of Saxony, from the Meissen factory beginning around 1730. The figures were for the menagerie he envisioned for his palace in Dresden, which was intended for the display of his vast porcelain collection. Records indicate that between 1732 and 1736 the manufactory received orders for sixteen goats—eight females and eight males. However, only eleven of the goats, including the present examples, were delivered to the palace before the project, one of the most ambitious and important commissions of the eighteenth century, was abandoned in the late 1730s. DC

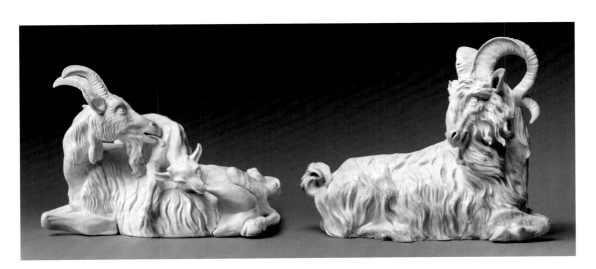

Noël-Nicolas Coypel (French, 1690–1734)

The Abduction of Europa, 1727
Oil on canvas, 50¼ × 76⅜ in. (127.6 × 194 cm)
Acquired with the kind assistance of John Cadwalader, Jr.,
through the gift of Mr. and Mrs. Orville Bullitt (by exchange),
the Edith H. Bell Fund, and other Museum funds, 1978-160-1

In 1727 Noël-Nicolas Coypel entered this work in a
competitive exhibition sponsored by Louis XV of
France. Although it did not win, observant critics
recognized the painting's gay abandonment of the
formal conventions of traditional classical painting as
a precursor of a new age in French taste and sensibility.
The subject comes from a tale in Ovid's *Metamorphoses*
in which the god Jupiter transforms himself into a
bull and abducts the princess Europa. In 1815 Joseph
Bonaparte, exiled brother of Napoleon, brought
this and other paintings (see p. 153) with him to
Philadelphia, where in 1829 he presented the canvas
to General Thomas Cadwalader, in whose family it
descended. JJR

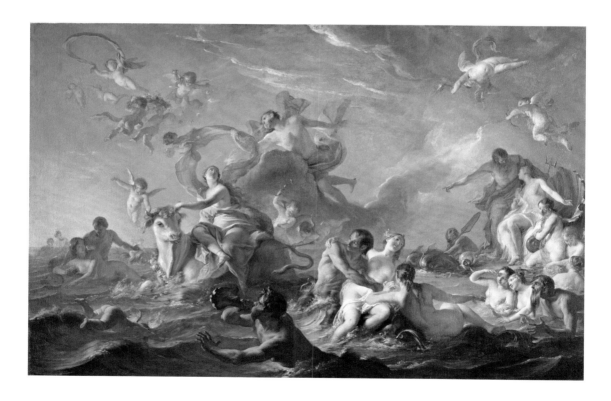

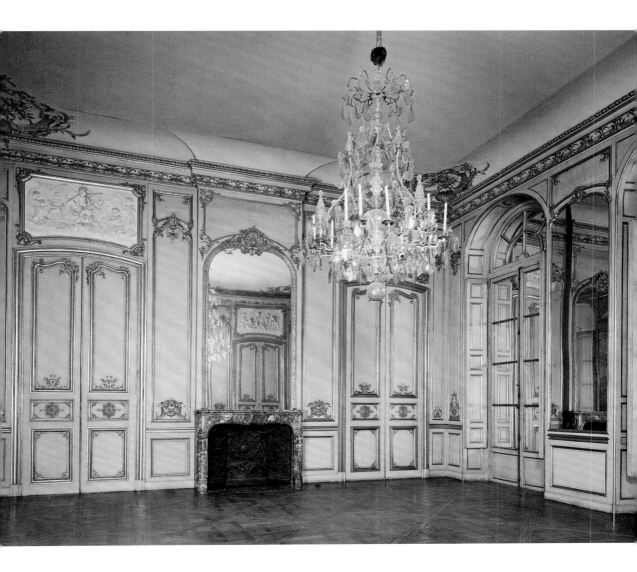

Grand Salon from the Château of Draveil

France, c. 1735
Purchased with Museum funds, 1928-58-1

Purchased in 1928 for the Museum's new building on Fairmount to represent the French Rococo style, this grand salon was once the centerpiece of a magnificent château that Marin de la Haye built at Draveil, a municipality about twelve miles south of Paris. De la Haye's lucrative office of chief tax collector to Louis XV provided him with the means to decorate this formal reception room in the latest and most luxurious Parisian fashion. The large plates of mirror glass inserted into the carved and gilded paneling, for example, were difficult and therefore expensive to make. Not only did these mirrors reflect day- and candlelight to great effect, they displayed the faces and finery of de la Haye's distinguished company. KBH

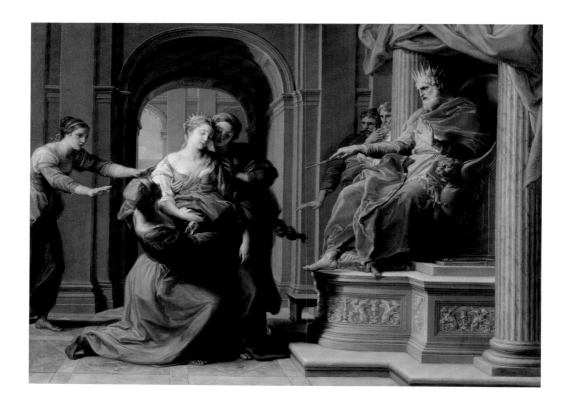

Pompeo Girolamo Batoni (Italian, 1708–1787)

Esther before Ahasuerus, 1738–40
Oil on canvas, 29⅛ × 39⁹⁄₁₆ in. (74 × 99.2 cm)
Purchased with funds contributed by the Women's Committee
of the Philadelphia Museum of Art in honor of their 100th
anniversary, 1982-89-1

Pompeo Girolamo Batoni was the dean of painting
in eighteenth-century Rome, then the artistic center
of Europe. This is a splendid example of the art-
ist's use of discretion and restraint in both color and
expression to describe an event. According to the Old
Testament, it was forbidden by penalty of death to
enter unsummoned the presence of King Ahasuerus.
But his wife Esther, seeking his aid in thwarting the
plot to destroy her own people, the Jews, defied the
order and entered the throne room dressed in her fin-
est robes. First stunned, and then overwhelmed by her
beauty and heroism, the king forgave her and later
joined her in destroying her enemy Haman. JJR

Designed by **François Boucher** (French, 1703–1770); woven at **Beauvais tapestry factory** (Beauvais, France, 1664–present)

Tapestry Showing Psyche and the Basketmaker,
1741–42
Wool, silk; 9 ft. 10⅛ in. × 7 ft. 7⁵⁄₁₆ in. (3 × 2.32 m)
Bequest of Eleanore Elkins Rice, 1939-41-30c

Much of the success of the Beauvais tapestry factory from the 1730s to the 1750s was due to the splendid Rococo designs of François Boucher. This tapestry, designed in 1739, is one of five illustrating scenes from the ancient myth of Psyche. Reflecting fashionable literary and theatrical tastes, Boucher's elegant conception of the story challenged the factory's weavers to attain the highest level of atmospheric and textural effects. In the twentieth century, four tapestries from the set were installed in the paneled drawing room of Eleanore Elkins Rice's New York town house, a setting now preserved as a period room in the Museum (on the Elkins family, see pp. 164–65). JH

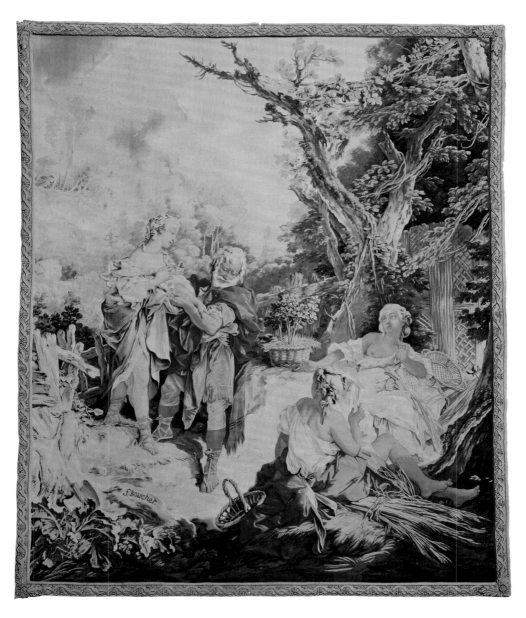

Canaletto (Italian, 1697–1768)

The Bucintoro at the Molo on Ascension Day,
c. 1745
Oil on canvas, 45¼ × 64 in. (114.9 × 162.6 cm)
The William L. Elkins Collection, E1924-3-48

Canaletto was famous for his views of Venice, which were especially popular with British visitors to the city. Here the *Bucintoro*, the ceremonial barge of the doge, the ruler of the Venetian republic, is moored alongside the pier (*molo*) near the city's main square. Every year on Ascension Day, the doge and other officials, who are shown lining the dock as they prepare to board, set out on the vessel as part of a ritual marriage of Venice and the sea. The painting can be dated by the jagged edge of the bell tower, which was struck by lightning in 1745. CBS

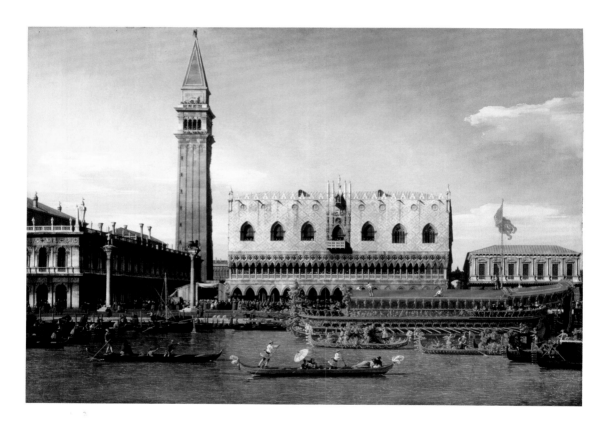

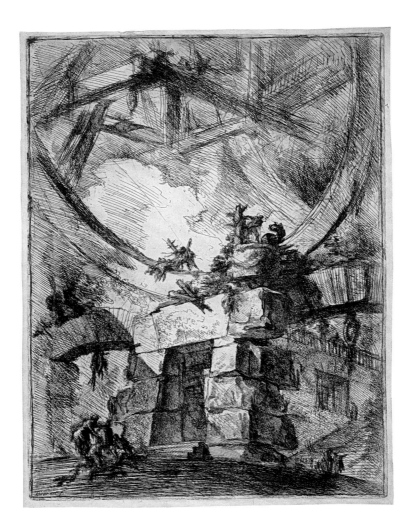

Giovanni Battista Piranesi (Italian, 1720–1778)

The Giant Wheel, c. 1749
Etching and engraving, plate: 21⁷⁄₁₆ × 15¹⁵⁄₁₆ in. (54.4 × 40.5 cm)
The Muriel and Philip Berman Gift, acquired from the John S.
Phillips bequest of 1876 to the Pennsylvania Academy of the Fine
Arts, with funds contributed by Muriel and Philip Berman, gifts
(by exchange) of Lisa Norris Elkins, Bryant W. Langston, Samuel
S. White 3rd and Vera White, with additional funds contributed
by John Howard McFadden, Jr., Thomas Skelton Harrison, and
the Philip H. and A. S. W. Rosenbach Foundation, 1985-52-1306

Only a master mason's son schooled in stage design
could have conjured up this giant freestanding oculus
set above a monolithic doorway seen from below, as
if from the audience. Shortly after settling in Rome
in 1747, Giovanni Battista Piranesi etched this and
thirteen other copperplates of imaginary prisons filled
with such theatrical effects. Although he later won
acclaim for his series of prints of ancient Roman ruins
and Baroque architecture, his suite of prison etch-
ings remains his most haunting work. The Museum's
exceedingly rare first edition of these prints was issued
before Piranesi made corrections on the title plate to
his publisher's last name, Bouchard, which he had mis-
spelled as "Buzard." JI

George Stubbs (English, 1724–1806)

Hound Coursing a Stag, c. 1762

Oil on canvas, 39⅜ × 49½ in. (100 × 125.7 cm)
Purchased with the W. P. Wilstach Fund, the John D. McIlhenny
Fund, and gifts (by exchange) of Samuel S. White 3rd and Vera
White, Mrs. R. Barclay Scull, and Edna M. Welsh, w1984-57-1

An inveterate observer of animals and a dedicated
painter of sporting subjects, here George Stubbs has
captured the dramatic moment of a hunting dog

catching up to its prey, an exhausted and panting stag.
Despite the terror witnessed in the deer's bulging eyes,
the scene, set in a silvery landscape devoid of human
activity, is imbued with elegance and dignity. The
sleek forms and vigorous movements of the animals
suggest careful anatomical study, although Stubbs may
have been inspired by antique sculptures of hunting
subjects he encountered during his trip to Rome in
1754. JAT

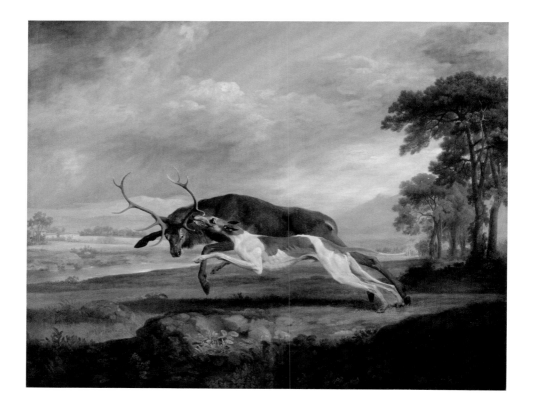

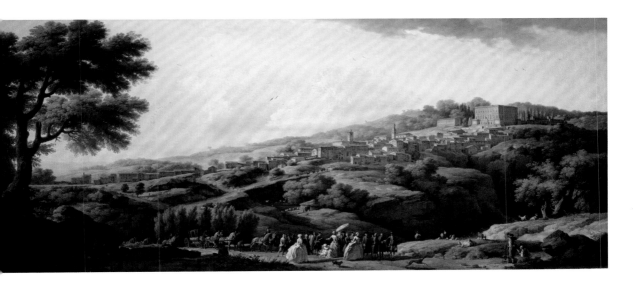

Claude-Joseph Vernet (French, 1714–1789)

Villa at Caprarola, 1746

Oil on canvas, 4 ft. 4³⁄₁₆ in. × 10 ft. 1¹³⁄₁₆ in. (1.33 × 3.09 m)
Purchased with the Edith H. Bell Fund, 1977-79-1

In 1745 Cardinal Acquaviva, Spanish ambassador to Rome, commissioned this work from Claude-Joseph Vernet, one of the most celebrated landscape painters of the eighteenth century, as a gift for Elizabeth Farnese, the queen of Spain. Here the monarch, accompanied by the cardinal and a royal entourage, pauses during her trip to the Villa Farnese, situated above the village of Caprarola near Rome. The hills abound with goats, whose presence alludes to the town's name (*capra* meaning "goat" in Italian), and peasants watch the grand parade. In 1815 Joseph Bonaparte, king of Spain, brought this and other pictures (see p. 146) to Philadelphia, where he lived in exile after the fall of his brother Napoleon. JJR

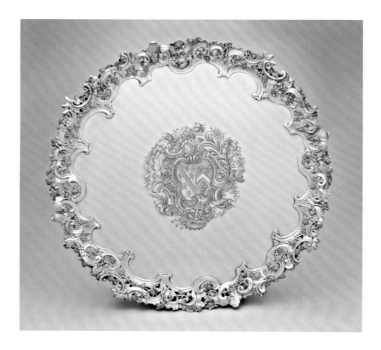

James Shruder (English, active 1737–49)

Salver, 1743–44
Silver, DIAM. 25¼ in. (64.1 cm)
Purchased with funds from the proceeds of the sale of deaccessioned works of art; gift (by exchange) of Carolyn Skelly Burford and an anonymous donor, 2010-200-1

This monumental salver is engraved with the coat of arms of Philadelphia merchant David Franks and his wife, Margaret Evans. Franks, an Ashkenazi Jew born in New York in 1720, moved at the age of twenty to Philadelphia, where he became highly successful. In addition to the salver, Franks owned an elaborate English Rococo silver tea service, components of which also bear his arms. Both the salver and tea service probably were wedding presents from Franks's family in London. Because large salvers such as this often were supplied with wooden stands, they are referred to as "tea tables" in eighteenth-century documents. DC

Gown, Stomacher, and Petticoat

France, c. 1755–60
Chinese export silk
Purchased with the John D. McIlhenny Fund, the John T. Morris Fund, the Elizabeth Wandell Smith Fund, and with funds contributed by Mrs. Howard H. Lewis and Marion Boulton Stroud, 1988-83-1a–c

The eighteenth-century arts of dress and deportment involved mastering restrictive garments and artificial conventions in order to appear at ease. While this gown would have been supported by rigid, boned stays and a hoop petticoat, it nevertheless manages to appear delicate and airy. The luminous, meandering floral brocade, woven in China for export and made up in France, is shown off by the elegant back pleats of this fashionable sacque, or *robe à la française*. From the three-dimensional, serpentine trim to the fluttering fringe and sleeve ruffles, every detail of this gown emphasizes Rococo frivolousness and femininity. HKH

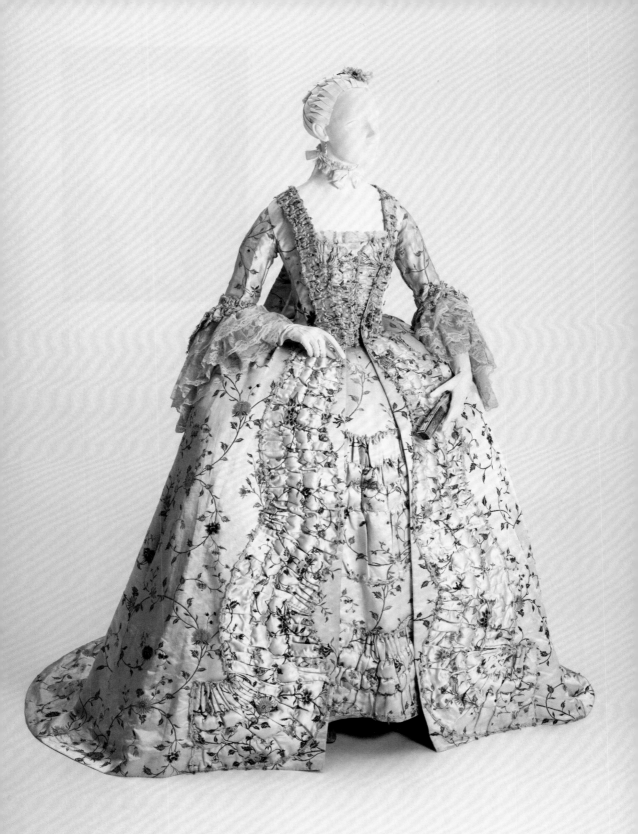

Stomacher and Collar
Possibly Italy, c. 1730–40
Silk with silk and gilt thread
Purchased with funds contributed by an anonymous donor,
1996-148-1a,b

In the eighteenth century, the conical shape of
women's torsos was echoed by decorative triangular
panels, called stomachers, that filled in the open bod-
ices of fashionable, full-skirted gowns. This exquisitely
embroidered example has an unusual matching collar
that framed the wearer's face and further emphasized
the taper of her torso. Colored silks worked in split
stitch create delicately nuanced shading in the pastoral
scene of a shepherdess crowning her gallant with a
floral wreath and in the surrounding decorative flow-
ers and fruits. The idyllic, playful imagery and the
lavish metallic scrolling shapes represent the height of
Rococo refinement. HKH

Design attributed to **Thomas Chippendale** (English,
1718–1779)

Chest of Drawers, c. 1755–60
Mahogany, brass; w. 55 in. (139.7 cm)
Purchased with the John D. McIlhenny Fund, 1941-73-1

This chest of drawers, its form and decoration
awash in scrolls and curves, is a masterpiece of mid-
eighteenth-century English Rococo. The chest's
innovative design is based on a "French commode
table" illustrated in Thomas Chippendale's highly
influential pattern book *The Gentleman and Cabinet-
Maker's Director*, first published in 1754. The chest has
a history of ownership at Raynham Hall in Norfolk,
England, the country house of the aristocratic
Townshend family, and its provenance may date back
to George, fourth Viscount Townshend. The high
quality of the craftsmanship suggests the chest was
made by a skilled cabinetmaker; however, it remains
unclear if that was Chippendale himself. DC

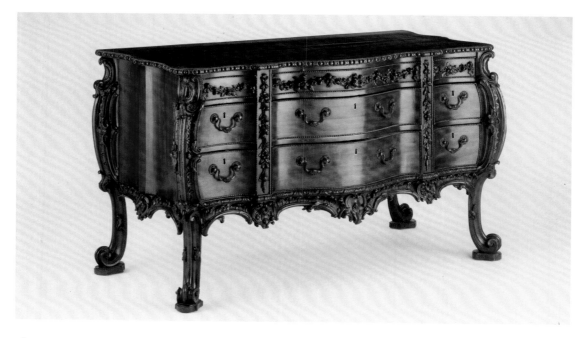

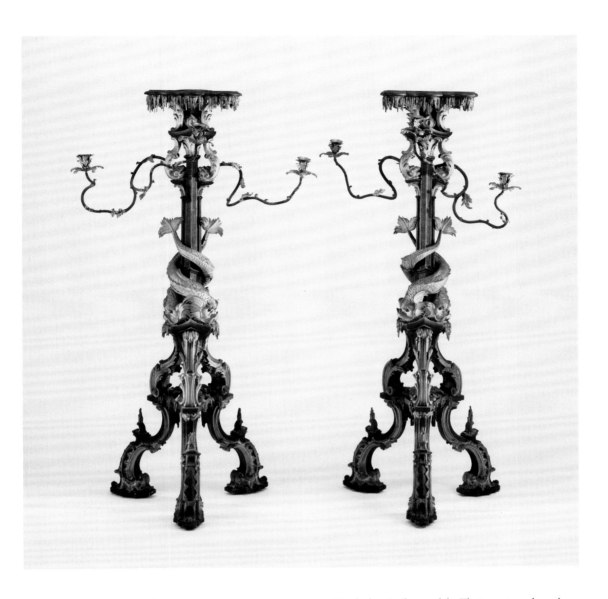

After a design by **Thomas Johnson** (English, 1723–1799)

Pair of Candlestands, c. 1757

Limewood with gilded, stained, and painted decoration; iron; wood; gilded brass; H. 62½ in. (158.8 cm) each
Purchased with Museum funds, 1950-83-3,4

Made for the gallery at Hagley Hall, the fashionable country house of George, first Baron Lyttelton, in Worcestershire, England, these candlestands were based on a design by influential carver Thomas Johnson, whose collection of patterns published in 1758 includes similar models. Their rustic style and that of the room's other furnishings, including four elaborate wall sconces in the Museum's collection, would have harmonized with the landscaped park visible through the gallery's windows. With their asymmetrical, branch-like arms and carved motifs of dolphins, stalactites, stalagmites, and a grotto, the candlestands represent English Rococo at its most exuberant. DC

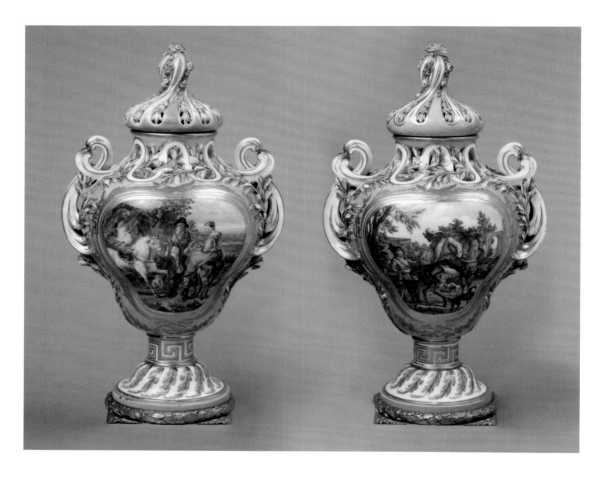

Model attributed to **Jean-Claude Duplessis** (French, active 1748–74); made by **Sèvres porcelain factory** (Sèvres, France, 1756–present)

Pair of Potpourri Vases, c. 1761
Porcelain with enamel and gilt decoration, H. (1939-31-39Aa,b) 15¾ in. (40 cm), H. (1939-41-39Ba,b) 15¹⁵⁄₁₆ in. (40.5 cm)
Bequest of Eleanore Elkins Rice, 1939-41-39Aa,b;Ba,b

Part of the distinguished group of French porcelain bequeathed to the Museum in 1939 by Eleanore Elkins Rice (on the Elkins family, see pp. 164–65), these exquisitely painted and lavishly gilded vases exemplify the production of the Sèvres factory, the preeminent porcelain manufactory in Europe in the second half of the eighteenth century. The factory's name for the vases, *potpourri feuilles de mirte*, and the molded decoration on the vessels' shoulders reference the leaves of the myrtle plant, a common ingredient in potpourri at the time. Reflecting the contemporary French fashion for seventeenth-century Dutch and Flemish art, the hunting scenes depicted on the vases are based on paintings by Flemish artist Carel van Falens. DC

Loosdrecht porcelain factory (Loosdrecht, The Netherlands, 1774–84)

Tureen with Lid and Saucer, 1774–80
Porcelain with enamel and gilt decoration, H. (tureen) 6 in. (15.2 cm)
Bequest of Rita Markus in memory of Frits Markus, 2005-105-31a–c

In the eighteenth century, porcelain wares were ubiquitous in Dutch households, and a number of local factories, including that founded by Johannes de Mol in Loosdrecht in 1774, were established to fulfill the market's demand. Although Loosdrecht porcelains were admired for their delicate decoration, such as the paintings of local birds on this Rococo-style tureen and saucer, the firm's extensive variety of models and patterns ultimately precluded its financial success. Established in 1913, the Museum's small but important collection of Dutch porcelain was enhanced in 2005 by the generous bequest of twenty-six pieces, including this, from the collection of Rita and Frits Markus. MADJ

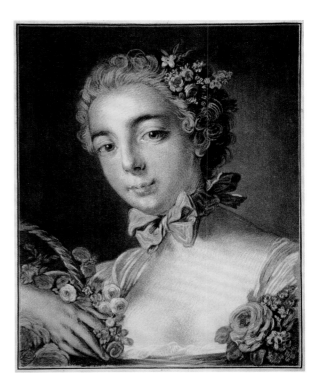

Louis-Marin Bonnet (French, 1736–1793), after
François Boucher (French, 1703–1770)

Head of Flora, 1769
Pastel-manner engraving, image: 16⅟₁₆ × 12¹³⁄₁₆ in. (40.8 × 32.5 cm) including black border
Acquired with The Philip and Muriel Berman Gift (by exchange) and with the gifts (by exchange) of Lisa Norris Elkins, Bryant W. Langston, Samuel S. White 3rd and Vera White, and with funds (by exchange) contributed by John Howard McFadden, Jr., Thomas Skelton Harrison, and the Philip H. and A. S. W. Rosenbach Foundation, 2003-193-1

For this masterful print, one of several rare color engravings in the Museum's important collection of French eighteenth-century prints, Louis-Marin Bonnet reproduced a pastel drawing of 1757 by François Boucher, first painter to Louis XV and favorite artist of the king's chief mistress, Madame de Pompadour. To imitate the soft and powdery effect of pastel, Bonnet invented a secret printing method using multiple plates inked with delicate colors, including a special white ink he developed himself. This impression was owned by brothers Edmond and Jules de Goncourt, whose writings were credited with reviving interest in pre-Revolution French art in the late nineteenth century. JW

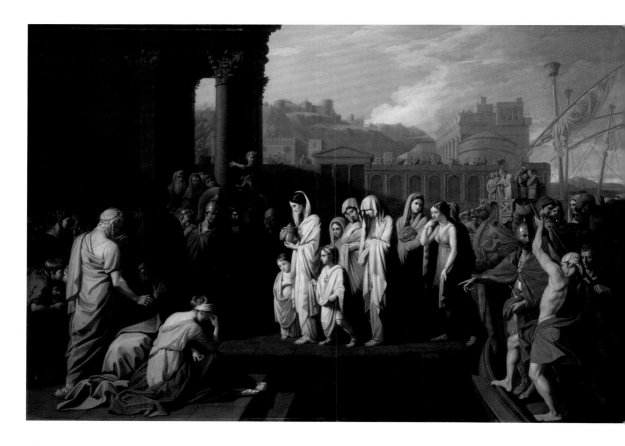

Benjamin West (English, born United States, 1738–1820)

Agrippina Landing at Brundisium with the Ashes of Germanicus, 1770
Oil on canvas, 65 × 94 in. (165.1 × 238.8 cm)
Purchased with the George W. Elkins Fund, E1972-1-1

In 1767 the archbishop of York invited Benjamin West, a promising young artist from Pennsylvania then living in London, to paint the story of the widow Agrippina returning to Italy with her children and the ashes of her husband, Roman general Germanicus, to seek justice for his wrongful death. Based on the histories of Tacitus, this tale of courtly intrigue and nobility allowed the artist to compose a large-scale history painting dominated by toga-clad figures and classical architecture. The canvas was exhibited in London in 1768; two years later, the Earl of Exeter commissioned West to make this second version. JAT

Giovanni Battista Tiepolo (Italian, 1696–1770)

Venus and Vulcan, c. 1765
Oil on paper on canvas, 27⁵⁄₁₆ × 34⁵⁄₁₆ in. (69.1 × 87.2 cm)
John G. Johnson Collection, cat. 287

The subject of this painting comes from an episode in Virgil's *Aeneid* in which the goddess Venus convinces her husband, Vulcan, to make weapons for her son, Aeneas, who was at war. In Virgil's poem, Venus's seduction of Vulcan takes place in the couple's bedroom, but here the goddess appears at his forge, her nude figure reclining on a cloud. Although the picture is an independent painting, it relates to the artist's ceiling decoration showing the apotheosis of Aeneas, which was painted in 1765 for the guardroom in the royal palace in Madrid. CBS

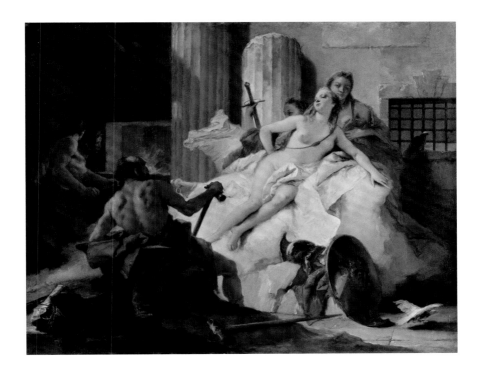

Jean-Honoré Fragonard (French, 1732–1806)

The Useless Resistance, c. 1770–73
Brush and ink and watercolor over black chalk on laid paper,
sheet: 9⅛ × 13⅝ in. (23.2 × 34.6 cm)
125th Anniversary Acquisition. Gift of George M. Cheston,
2010-210-2

The Museum's holdings of French old master drawings were enhanced greatly in 2010 by the gift of this superb work by Jean-Honoré Fragonard, which added not only a telling example of French Rococo esprit but also a tour de force creation by one of the supreme draughtsmen of European art. Prolific and inventive, Fragonard was known for private decorative commissions and easel paintings intimate in scale. This sheet relates closely to a small number of wash drawings of boudoir subjects that are notable in his oeuvre for their lightness, wit, and apparent ease of execution. AP

Designed by **Robert Adam** (Scottish, 1728–1792); painted by **Antonio Zucchi** (Italian, 1726–1795) and **Giovanni Battista Cipriani** (Italian, 1727–1785); gilded by **Joseph Perfetti** (Italian, active 1760–78)

Drawing Room from Lansdowne House, London, c. 1766–75
Gift of Graeme Lorimer and Sarah Moss Lorimer in memory of George Horace Lorimer, 1931-104-1

This room's fanciful wall and ceiling decoration of figures and foliage in antique style is the most important example of the work of Scottish architect Robert Adam outside Britain and represents the most stylistically advanced interior decoration of its time. Designed for the second Earl of Shelburne, the Neoclassical ornaments were hand-painted on paper by Italian artist Antonio Zucchi; fellow Italian Giovanni Battista Cipriani contributed mythological canvases for the ceiling and alcove. These embellishments provided a grand setting for Shelburne, who, as British prime minister, helped negotiate the end of the American Revolution and was made first Marquis of Lansdowne for his services. Lansdowne House descended successively in his family until 1929, when the sixth marquis sold it to a group of investors. Seeking a distinguished eighteenth-century English period room for the Museum's new building, Director Fiske Kimball made immediate inquiries, and by 1931 the drawing room, darkened with age and overpainted, arrived in Philadelphia, although due to depression and war, it was not installed until 1945. After the room suffered water damage in 1977–78, the Museum's conservators studied the background surfaces of Zucchi's painted decorations, discovering through hundreds of cross-section samples that the original ground colors were primarily pinks and greens, as were those of the baseboard, dado, and wall from chair rail to frieze. The room's restoration, completed in 1986, captures the light and festive appearance of Adam's original design. KBH

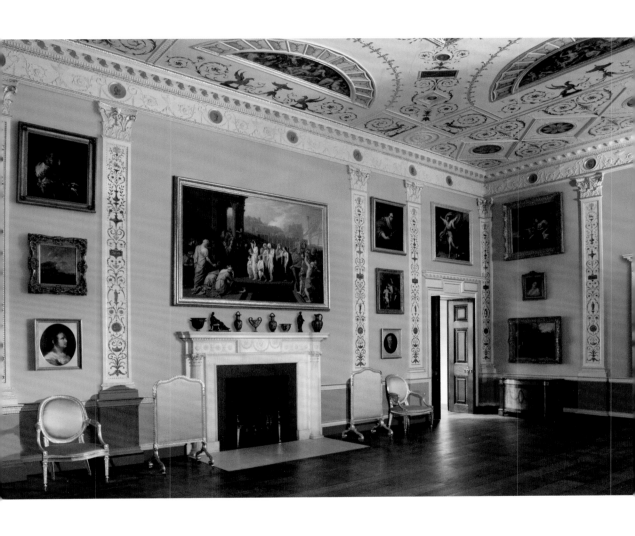

THE ELKINS FAMILY

Among the most generous benefactors to the Museum are four generations of the Elkins family. A self-made man, William L. Elkins (1832–1903) began his career as a grocer's clerk, and gradually invested in supermarkets and early refrigeration technology. He later established the first American oil refinery and partnered with businessman P. A. B. Widener in streetcar, railway, and electrical enterprises that proved vital to the infrastructure of Philadelphia. Elkins had an adept eye for art, and on trips to Europe he bought paintings of exceptional quality, from seventeenth-century Dutch and Flemish landscapes and genre scenes, such as Gerard ter Borch's richly described image of two soldiers in a guard room (right, bottom; see also p. 133), to eighteenth-century Italian views, or *vedute* (see p. 150), English portraits, and Barbizon and Impressionist paintings (see p. 188). On his death, he entrusted ninety-eight works from his collection to his eldest son, George W. Elkins (1858–1919), an esteemed financier and philanthropist.

Like his father, George Elkins was attracted to eighteenth- and nineteenth-century paintings, and he would acquire thirty-two choice works by artists such as Sir Lawrence Alma-Tadema (right, top), Jean-Baptiste-Camille Corot, Thomas Gainsborough, Winslow Homer (p. 304), and Anton Mauve (p. 197). In 1919 the collections of father and son were given to the city of Philadelphia and were among the first paintings shown at the Museum's new building on Fairmount when it opened. In subsequent years, the ample acquisition fund left by George Elkins allowed the Museum to acquire masterpieces by Paul Cézanne, Charles Willson Peale, and Nicolas Poussin (pp. 218, 287, 128, respectively).

In 1939 William's daughter Eleanore Elkins Rice (1861–1937) bequeathed the Museum the magnificent drawing room of her New York town house and its contents, a distinguished collection of French eighteenth-century decorative arts that included splendid tapestries, porcelains, and furniture, such as the writing desk made by the German-born cabinetmaker Martin Carlin in his Paris workshop (left; see also pp. 138, 149, 158, 167).

Several members of the next generation of the family—notably William McIntire Elkins and his wife, Lisa Norris Elkins; Stella Elkins Tyler; George W. Elkins, Jr.; Louise Elkins Sinkler; and George D. Widener—have made substantial gifts to the Museum and participated in the institution's leadership. Period rooms, including the drawing room from Philadelphia's Powel House (p. 262), important American paintings (see pp. 267, 285), eighteenth-century English silver, Indian paintings and sculptures (see pp. 11, 17), and Impressionist lithographs are among the more than forty thousand objects that the Museum has acquired over the last century through the incredible generosity of the Elkins family, an astonishing legacy of connoisseurship. JAT

Made by **Martin Carlin** (German, c. 1730–1785); plaques
made by **Sèvres porcelain factory** (Sèvres, France,
1756–present); plaques painted by **Vincent Taillandier**
(French, 1736–1790) and **Jean-Baptiste Tandart** (French,
active 1754–1800)

Writing Desk, c. 1777–80
Oak with satinwood, tulipwood, and mahogany veneers; gilded
bronze; porcelain with enamel and gilt decoration; H. 39 in.
(99.1 cm)
Bequest of Eleanore Elkins Rice, 1939-41-6

Sir Lawrence Alma-Tadema (English, born The
Netherlands, 1836–1912)

A Reading from Homer, 1885
Oil on canvas, 36⅛ × 72¼ in. (91.8 × 183.5 cm)
The George W. Elkins Collection, E1924-4-1

Gerard ter Borch (Dutch, 1617–1681)

Officer Writing a Letter, with a Trumpeter,
c. 1658–59
Oil on canvas, 22⅜ × 17¼ in. (56.8 × 43.8 cm)
The William L. Elkins Collection, E1924-3-21

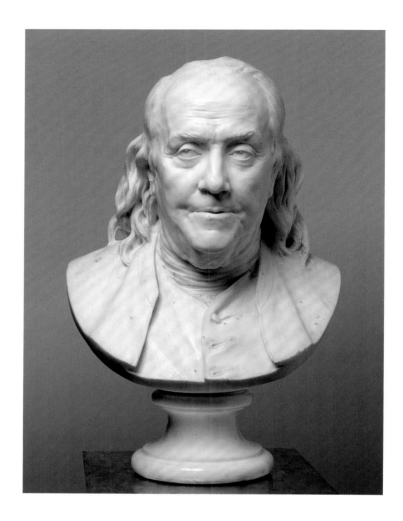

Jean-Antoine Houdon (French, 1741–1828)

Bust of Benjamin Franklin, 1779

Marble, H. 21 in. (53.3 cm) with base
125th Anniversary Acquisition. Purchased with a generous grant from The Barra Foundation, Inc., matched by contributions from the Henry P. McIlhenny Fund in memory of Frances P. McIlhenny, the Walter E. Stait Fund, the Fiske Kimball Fund, and with funds contributed by Mr. and Mrs. Jack M. Friedland, Hannah L. and J. Welles Henderson, Mr. and Mrs. E. Newbold Smith, Mr. and Mrs. Mark E. Rubenstein, Mr. and Mrs. John J. F. Sherrerd, the Women's Committee of the Philadelphia Museum of Art, Marguerite and Gerry Lenfest, Leslie A. Miller and Richard B. Worley, Mr. and Mrs. John A. Nyheim, Mr. and Mrs. Robert A. Fox, Stephanie S. Eglin, an anonymous donor, Mr. and Mrs. William T. Vogt, and with contributions from individual donors to the Fund for Franklin, 1996-162-1

In December 1776 Benjamin Franklin arrived in Paris as minister for the American colonies, tasked with obtaining financial and military support for the Revolutionary War. Already well known as a scientist, thinker, and political leader, he created a sensation, generating huge demand for portraits. In Jean-Antoine Houdon, Franklin's genius arguably met its most able interpreter. The leading portrait sculptor of his day, Houdon imbued his subjects with an astonishing yet restrained naturalism, apparent in the intently described, mobile features of this bust—the finer of two versions carved in costly marble. Given Franklin's taciturnity, the choice of expression—his mouth slightly open as if about to speak—is daring, and underlines the sculptor's thoughtful characterization of his sitter. Houdon's success with Franklin led to opportunities to depict other American patriots, most notably Thomas Jefferson and George Washington. JH

Designed by **François-Joseph Bélanger** (French, 1744–1818); made by **Pierre Gouthière** (French, 1732–1813)

Pair of Andirons, c. 1780
Patinated and partially gilded bronze, H. 17½ in. (44.4 cm) each
Bequest of Eleanore Elkins Rice, 1939-41-25a,b

These andirons, each decorated with an eagle and a salamander (symbolizing the elements of air and fire, respectively), originally were modeled by metalworker Pierre Gouthière for the Duchess of Mazarin's sumptuous Paris town house. Following a design by François-Joseph Bélanger, Gouthière supplied models in earthenware, wax, and wood to be cast in bronze. He then chased and gilded the casts for an extraordinary 5,500 pounds, resulting in the most expensive pair of andirons produced in the eighteenth century. Gouthière was celebrated for the varied surface textures on his cast bronzes, an effect seen on the bases and torches of this slightly less costly variant of his original model. KBH

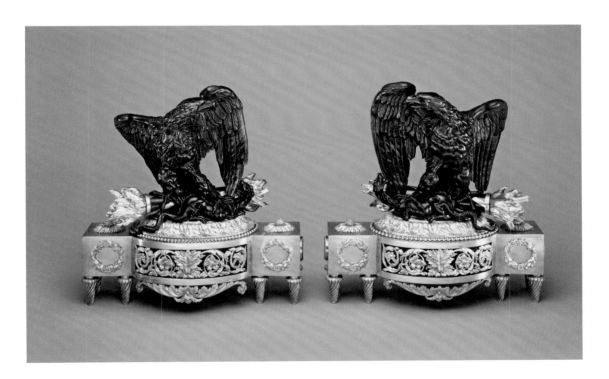

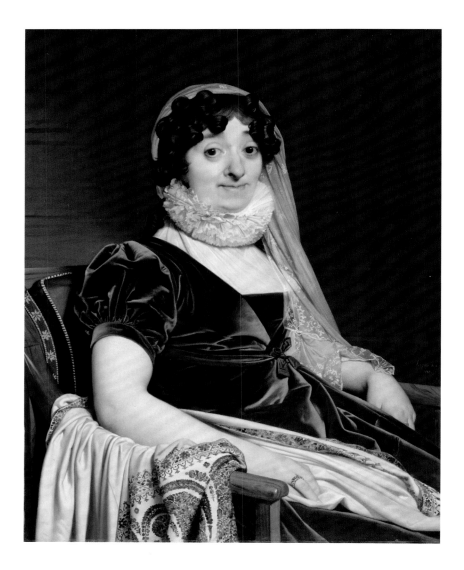

Jean-Auguste-Dominique Ingres (French, 1780–1867)

Portrait of the Countess of Tournon, 1812
Oil on canvas, 36⅜ × 28¹³⁄₁₆ in. (92.4 × 73.2 cm)
The Henry P. McIlhenny Collection in memory of Frances P. McIlhenny, 1986-26-22

Jean-Auguste-Dominique Ingres arrived in Rome in 1806. Although he desired to work in the grand tradition of history painting, he turned to portraiture as a financial necessity, thereby producing some of the greatest achievements of his early career. Here Ingres has found his equal in terms of wit and sophistication in his sitter, the Countess of Tournon, who is unapologetic in her command of the situation. The countess had moved to Rome in 1809 to join her son, who, as prefect of the city, would oversee important archaeological excavations that sparked an artistic resurgence throughout the ancient capital. JJR

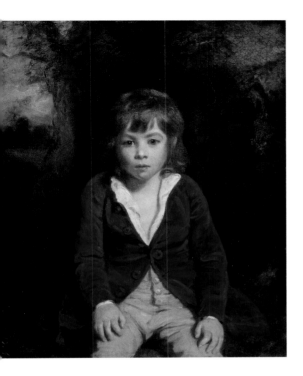

Bertel Thorvaldsen (Danish, 1770–1844)

Bust of the Honorable Mrs. Pellew, 1817
Marble, H. 22⅛ in. (56.2 cm) with base
Purchased with funds from the bequest of Walter E. Stait, 1994-1-1

Bertel Thorvaldsen, the most sought-after portrait sculptor in early nineteenth-century Europe, worked in Rome for most of his career and carved this bust when the sitter, a celebrated English beauty, came to Italy on her wedding trip. Thorvaldsen was influenced by ancient Roman portraits, but here, with hallmark linear elegance and subtle handling of the marble's surface, he transcended specific references to antiquity and achieved a natural likeness corresponding to the fashion of the day. This bust belongs to a rare category of his work in which he attained an image of ineffable ideal beauty and a timelessness that describes the highest aims of the Neoclassical style. JH/DW

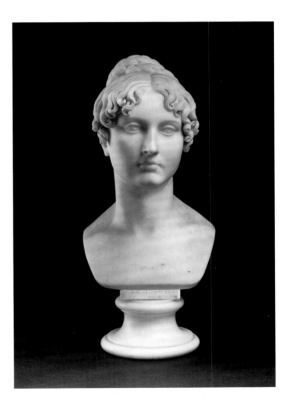

Sir Joshua Reynolds (English, 1723–1792)

Portrait of Master Bunbury, 1780–81
Oil on canvas, 30⅛ × 25⅛ in. (76.5 × 63.8 cm)
The John Howard McFadden Collection, M1928-1-29

One of England's greatest portrait painters, Sir Joshua Reynolds has captured three-year-old Henry Edward Bunbury in a moment of rapt attention, his eyes wide and his mouth slightly open. The artist reportedly regaled the child, his godson, with fairy tales in order to quiet and enthrall the active young boy. Often credited with elevating the prestige and stature of painting in Great Britain, Reynolds is celebrated for his deeply original portraits of noble, aristocratic, and even youthful sitters. Young Bunbury's likeness, which was exhibited to great acclaim at the Royal Academy in London in 1781, was kept by the artist throughout his life. JAT

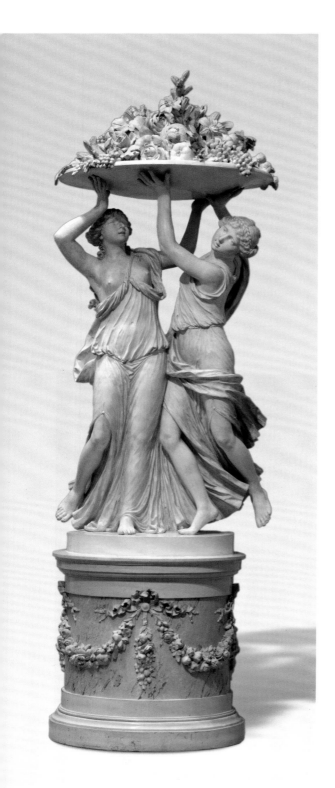

Clodion (French, 1738–1814)

Nymphs Holding Aloft a Platter Charged with Fruit, c. 1785–93

Plaster, H. 95¼ in. (241.9 cm) without base
Gift of Eva Roberts Stotesbury in memory of Edward T. Stotesbury, 1938-24-6

Dining rooms became fashionable in France during the second half of the eighteenth century. Along with its pendant in the Museum and an identical pair in the Musée des Art Décoratifs in Paris, this sculpture was created for the corner niches of the lavish dining room of the Count of Botterel-Quintin's Parisian town house. A masterpiece of its time, the room was decorated in the popular Neoclassical style. Clodion's mastery is apparent in the graceful movement and lightly erotic charm of these life-size figures. JH/DW

Designed by **Jean Baptiste Marie Huet** (French, 1745–1811); printed by **Oberkampf factory** (Jouy-en-Josas, France, 1760–1843)

Detail of *"The Offering to Love"* Printed Textile, c. 1795

Copperplate print on cotton, 79 × 75½ in. (200.7 × 191.8 cm)
Purchased with the Art in Industry Fund from the Henri Clouzot Collection, 1937-11-56

In the 1920s and 1930s the Museum's collection of textiles was enriched by the acquisition of 354 printed fabrics and swatches from the collection of French scholar Henri Clouzot. This example is typical of designs by renowned engraver Jean Baptiste Marie Huet, famous for his romanticized rural scenes. The design shares many similarities with the artist's 1780 cartoon *The Offering to Love*, which he created for the Beauvais tapestry factory. LLC

Séguin et Cie (Lyon, France, 1806–24)

Textile, 1811

Silk, 14⅞ × 38¾ in. (37.8 × 98.4 cm)
Purchased with the Bloomfield Moore Fund, 1943-18-2

Intended for wall hangings or *portières* (over-door hangings), this textile was created for Napoleon's apartments in Versailles; however, it was used instead in 1819 in the salon of the Duchess of Angoulême's château in the western environs of Paris. Decorated with hollyhocks and oak leaves, symbols of fertility and strength, the panel is one of two upholstery fabrics originally made for Napoleon in the Museum's collection; the other is adorned with hollyhocks and lilacs, harbingers of spring. LLC

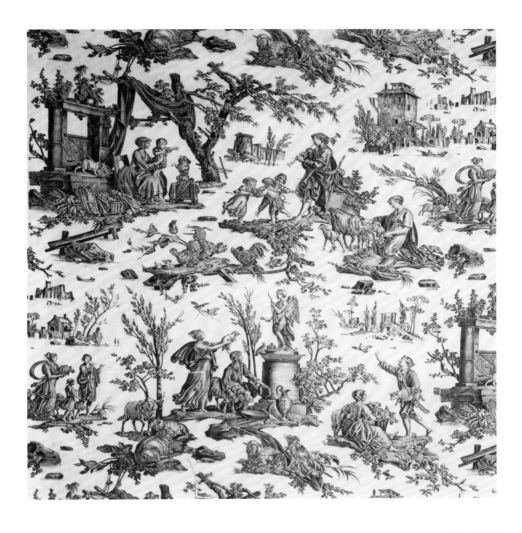

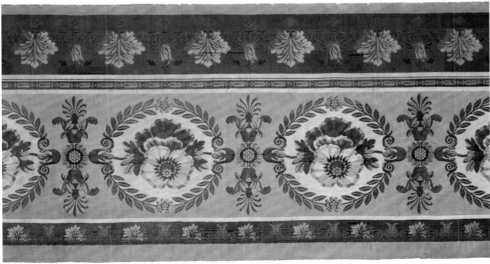

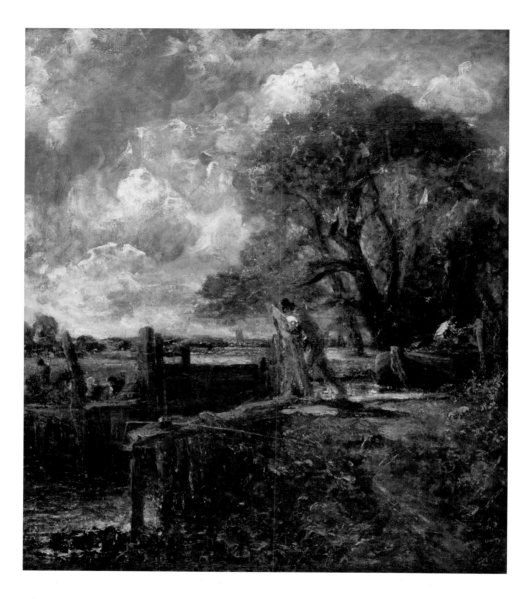

John Constable (English, 1776–1837)

Sketch for "A Boat Passing a Lock," 1822–24
Oil on canvas, 55½ × 48 in. (141 × 121.9 cm)
The John Howard McFadden Collection, M1928-1-2

The son of a mill owner, John Constable grew up along the banks of the river Stour and became fond of the region's weather, scenery, and rhythms. In 1822 he began to prepare a canvas for submission to the Royal Academy in London of a red-vested navigator, or navvy, who has set aside his fishing pole in order to open the canal's lock gates and allow a barge to pass downstream. In this full-size preparatory study for his exhibition picture, Constable used a palette knife and brush freely to suggest the blustery day and give the sketch a remarkably loose, impressionistic character. JAT

Thomas Gainsborough (English, 1727–1788)

Pastoral Landscape, c. 1783

Oil on canvas, 40⅜ × 50⅜ in. (102.6 × 128 cm)
The John Howard McFadden Collection, M1928-1-9

The gentle hills, lush wooded glens, and broad rivers of the English countryside provided Thomas Gainsborough plentiful inspiration for his landscapes, but in the final years of his life he favored more dramatic scenery, including the rugged mountains, deep gorges, and lonely shepherds seen here. He had encountered such views on a trip to the Lake District in 1783, but he may have constructed this scene in this studio; contemporaries reported that he on occasion would create imaginary landscape models by piling together bits of bark, sand, stones, and twigs. When illuminated with candles or magnified with a glass, these fabricated tableaux evoked wild, craggy, and picturesque terrain. JAT

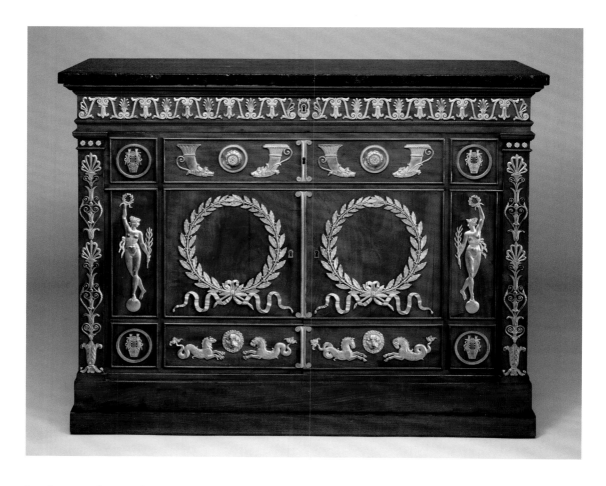

Jacob-Desmalter et Cie (Paris, 1803–13)

Writing Cabinet, 1810–13
Mahogany, oak, marble, gilded bronze; w. 60 in. (152.4 cm)
The Henry P. McIlhenny Collection in memory of Frances P.
McIlhenny, 1986-26-86

Stamped with the maker's mark for the firm of
François-Honoré-Georges Jacob-Desmalter and his
father, Georges Jacob, this cabinet was purchased
by Philadelphia collector Henry P. McIlhenny in
1973 (on the McIlhenny family, see pp. 190–91). The
Jacob-Desmalter workshop filled many orders for
Napoleon's household as well as for those of his sister
Pauline Borghese and his first wife, Josephine; this
cabinet's lavish gilded-bronze mounts suggest a possi-
ble imperial commission. Eager for his empire to draw
comparison to those of ancient Greece and Rome,
Napoleon adopted as symbols such classical motifs of
victory and ceremony as the goddesses, laurel wreaths,
lyres, sea horses, and drinking vessels seen here. KBH

Wedgwood factory (Etruria, England, 1759–present)

Vase, c. 1790
Stoneware (basalt ware) with encaustic decoration, H. 36 in.
(91.4 cm)
Gift of Charlotte and David E. Zeitlin in honor of Susan Z. Baer,
1992-40-1

This vase, one of the largest models produced by the
Wedgwood factory in the eighteenth century, is a
copy of a fourth-century-BC Apulian volute krater that
was in the famed collection of Sir William Hamilton,
British ambassador to the Kingdom of Naples from
1764 to 1800. The ancient vase was illustrated in the
catalogue of Hamilton's collection, one of the most
sumptuous publications produced in the eighteenth
century and a fertile source for Wedgwood's ceramic
designs. The decoration on the present example,
which might have been made for display in the fac-
tory's London showrooms, imitates the style, but not
the technique, of the red-figure painting practiced by
ancient Greek potters. DC

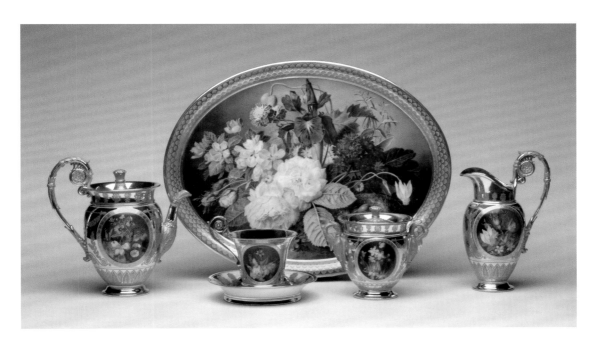

Made by **Sèvres porcelain factory** (Sèvres, France, 1756–present); painted by **Georgius Jacobus Johannes van Os** (Dutch, 1782–1861) and **Denis-Désiré Riocreux** (French, 1791–1872); gilded by **Denis-Joseph Moreau** (French, born 1772) and **Charles-Marie-Pierre Boitel** (French, 1774–1822)

Tea Service, 1814–17
Porcelain with enamel and gilt decoration, H. (teapot) 8¼ in. (21 cm)
Gift (by exchange) of Mrs. William S. Lasdon, 2003-180-1–8

This ornate tea service was one of five created for Napoleon and his second wife, the empress Marie-Louise, as official gifts. It was conceived by Alexandre Brongniart, who, as administrator of the Sèvres porcelain factory, revitalized the firm's production with new scientific and marketing directives. Producing these services on speculation allowed him to keep his best artists employed, notably the flower and fruit painter Georgius Jacobus Johannes van Os. One such service was given to Napoleon's sister Pauline Borghese; the present example was offered by the emperor to the papal envoy Costantino Patrizi Naro on September 20, 1817, and is the only one of the five known services to survive. KBH

Karl Friedrich Schinkel (German, 1781–1841)

Predjama Castle near Krajina, Slovenia, 1816
Lithograph, image: 15⅜ × 12½ in. (39.1 × 31.8 cm)
Purchased with the Alice Newton Osborn Fund, 2011-173-1

Karl Friedrich Schinkel is most famous today as the
leading architect in Berlin of his time, but he also left
a legacy as a city planner, furniture designer, painter,
and printmaker. As an architect Schinkel clearly was
fascinated by the unusual setting of Predjama Castle
in Slovenia. He made a number of sketches of it on
his way to Italy in 1803, which he put to good use
thirteen years later to make this lithograph. It is one
of many rare treasures in the Museum's outstanding
collection of German Romantic prints, the largest and
richest in this country. JI

William Henry Fox Talbot (English, 1800–1877), possibly
in collaboration with **Calvert Richard Jones** (Welsh,
1802–1877); probably printed by **Nicolaas Henneman**
(Dutch, 1813–1898)

Group of Persons Selling Fruit and Flowers, 1845
Salted paper print from a paper negative, image: 6¾ × 8⁵⁄₁₆ in.
(17.1 × 21.1 cm)
Purchased with the Robert A. Hauslohner Fund, 1967-48-4

One of the most important pioneers in the inven-
tion of photography in the 1830s and 1840s, William
Henry Fox Talbot developed a process using paper
negative prints from which multiple positives could
be generated. This photograph, made after years of
experimentation and refinement, demonstrates one
of the key qualities of this new medium: the ease of
composing and producing group portraits, hereto-
fore one of the most arduous artistic undertakings.
Although in 1845 Talbot lamented that, even with
photography, candid scenes were impossible to make,
this engaging albeit carefully posed group represents
one of his finest efforts to capture the immediacy of
an observed slice of life. PB

Jean-Baptiste-Camille Corot (French, 1796–1875)

House and Factory of Monsieur Henry, 1833
Oil on canvas, 32¹⁄₁₆ × 39½ in. (81.4 × 100.3 cm)
Purchased with the W. P. Wilstach Fund, W1950-1-1

One of Jean-Baptiste-Camille Corot's best documented and most loved early landscapes, this painting, commissioned by textile manufacturer Monsieur Henry in 1833, shows the patron's country residence and factory, a former monastery, in the small city of Soissons in northern France. Corot spent most of that summer in Soissons working on this canvas and its pendant, now in the Rijksmuseum Kröller-Müller in Otterlo, The Netherlands. The clarity and measure of Corot's landscapes, effects influenced by the controlled balance of blunt and limpid observation he had learned during his three-year sojourn to Italy, earned him the admiration of fellow artists Paul Cézanne and Camille Pissarro. JJR

William Blake (English, 1757–1827)

A Destroying Deity, c. 1820–25
Pen and brush and ink, watercolor, and graphite on paper; sheet:
8⅛ × 11¾ in. (20.6 × 29.8 cm)
Gift of Mrs. William Thomas Tonner, 1964-110-7

Notably opposed to the contemporary academic art establishment, painter and poet William Blake promoted an international style of Romantic Neoclassicism that eschewed the copying of nature and illusionistic representation, and instead celebrated the pure linear outline and flowing contours of Greek vase painting and the heroic, muscular nudity of the human body. In his work backgrounds often are abstracted and naturalistic space is flattened or suppressed, as in this example, the subject of which has never been exactly identified. In 1964 Mrs. William Thomas Tonner gave the Museum this and nine other important sheets by Blake, a transformative addition to the collection's then small holdings of British drawings. AP

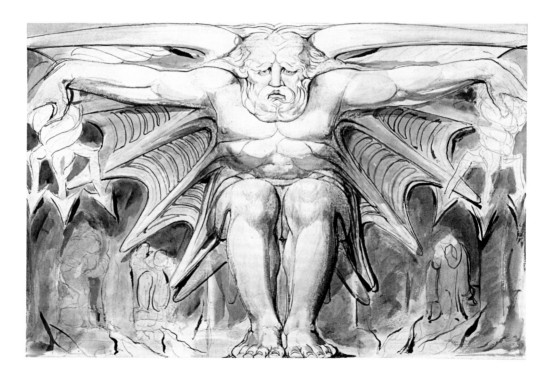

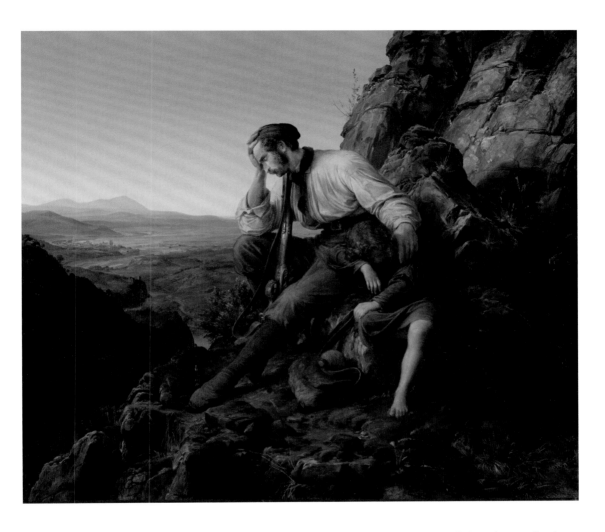

Karl Friedrich Lessing (German, 1808–1880)

The Robber and His Child, 1832
Oil on canvas, 16⅝ × 19⅛ in. (42.2 × 48.6 cm)
The W. P. Wilstach Collection, bequest of Anna H. Wilstach,
W1893-1-65

A popular character in nineteenth-century German Romantic art and literature, the "noble robber" was a man driven to a life of crime by circumstances, rather than depravity. Here Karl Friedrich Lessing shows the robber as a caring father who is isolated from society and defeated. The canvas, representative of the Düsseldorf school with its crisp lines and careful attention to details, was owned by Philadelphia businessman William P. Wilstach and his wife, Anna. Bequeathed after her death in 1892 and installed the next year at Memorial Hall, the Museum's first home, the Wilstach Collection formed one of the city's first public galleries of European paintings. JAT

Joseph Mallord William Turner (English, 1775–1851)

The Burning of the Houses of Lords and Commons, 1834–35

Oil on canvas, 36¼ × 48½ in. (92.1 × 123.2 cm)
The John Howard McFadden Collection, M1928-1-41

On the evening of October 16, 1834, the medieval buildings that comprised the Houses of Parliament in London went up in flames, having been set alight by a careless attendant charged with burning old tally sticks. Joseph Mallord William Turner was among the thousands of spectators who watched the venerable structures burn overnight. In the company of artists and students from the Royal Academy, he witnessed the conflagration from a boat on the river Thames and made sketches of the scene that later formed the basis for two canvases documenting the event. The Philadelphia picture shows the crowds gathered on the south bank of the river near the old Westminster Bridge, its brilliant white stone reflecting the fierce oranges and reds of the burning buildings. The artist's fascination with sublime events—shipwrecks, smoke-filled battles, and violent storms—was matched perfectly by the destructive force of the fire. Turner reportedly completed the canvas days before it was to be exhibited in London, in February 1835, by adding waxes and pigments in great flourishes to create a surface rich with impasto and nuances of color. The painting was acquired in the early twentieth century by John Howard McFadden of Philadelphia and immediately became one of the highlights of his extraordinary collection of British paintings, many of which have filled the Museum's English period rooms since 1928. JAT

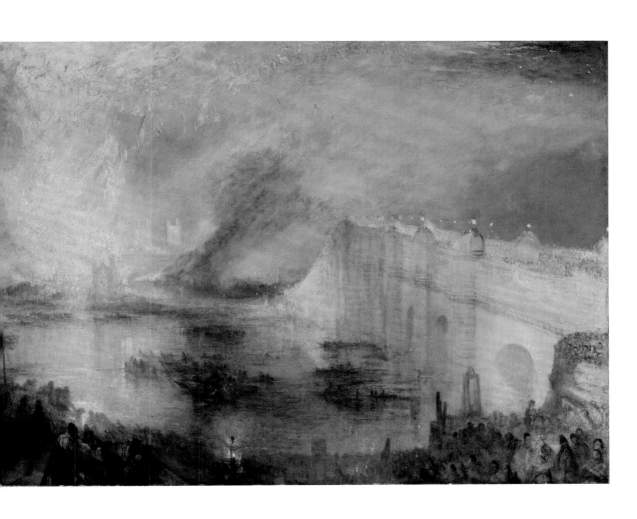

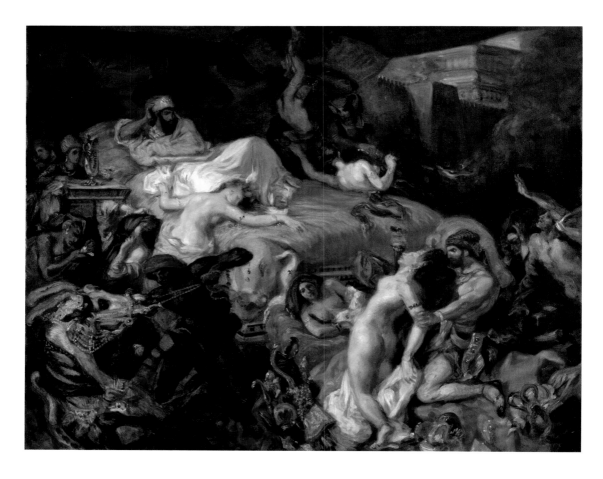

Ferdinand-Victor-Eugène Delacroix (French, 1798–1863)

The Death of Sardanapalus, 1844
Oil on canvas, 29 × 32⅞ in. (73.7 × 82.4 cm)
The Henry P. McIlhenny Collection in memory of Frances P. McIlhenny, 1986-26-17

When Eugène Delacroix showed his huge painting inspired by Lord Byron's play about the demise of the Assyrian king Sardanapalus in the Paris Salon of 1827–28, he changed the history of art. The canvas brought back the splendor and opulence of Baroque painting, putting to question the restraint and clarity that had been revered as classical truths, and marking the coming of age of Romanticism. It is thought that before selling the canvas in 1846 Delacroix made this quickly worked smaller version as a reprise, perhaps reflecting on his audacious youth. JJR

Gustave Courbet (French, 1819–1877)

Spanish Woman, 1855
Oil on canvas, 31⅝ × 25½ in. (80.3 × 64.8 cm)
John G. Johnson Collection, inv. 2265

In the fall of 1854, a young woman of Spanish descent cared for Gustave Courbet while he was recovering from cholera in Lyon. This sensual portrait, thought to have been painted from memory after Courbet returned to Paris, shows the woman leaning languidly on her hand, her hair falling loosely over her arm. When it was exhibited in 1855, the picture attracted more attention—much of it negative—than did any of the artist's other paintings on display. Critics disapproved of Courbet's realism, questioning what grievances he held against Spain to make his sitter appear so unnecessarily ugly. JAT

Jean-Baptiste Carpeaux (French, 1827–1875)

Princess Mathilde, 1862
Plaster, H. 37 in. (94 cm)
Purchased with the Fiske Kimball Fund and with funds contributed by the Friends of the Philadelphia Museum of Art, 1978-113-2

As the cousin and official hostess of Louis-Napoleon Bonaparte, who declared himself emperor of France in 1852, Princess Mathilde became the country's second most powerful woman and, by virtue of her interest in the visual arts, a great force in the making of taste and artists' reputations. Her request that Jean-Baptiste Carpeaux sculpt her portrait in 1861 was therefore a critical step in his official ascendancy, and laid the foundation for him to receive a series of commissions from the imperial family and the state. Breaking with the conservative classicism of sculptural portraiture of the time, here Carpeaux returned to the full-blown representationalism of seventeenth-century French sculpture—aloof and splendid and tremendously alive. JJR

Designed by **Jean-Jacques Feuchère** (French, 1807–1852);
made by the firm of **P.-H.-Émile Froment-Meurice**
(French, 1837–1913)

Centerpiece, 1860
Silver, H. 27⅝ in. (70 cm)
Gift of Dr. and Mrs. Joseph Sataloff, 1980-41-1

One of the most important examples of mid-
nineteenth-century French silver sculpture, this
massive centerpiece belongs to a thirty-two-piece
decorative table ensemble commissioned by the Duke
of Medinaceli of Spain. Numerous designers, sculp-
tors, and silversmiths fashioned the candelabra and
vessels, now in the collection of the Palacio Real in
Madrid, that accompanied Jean-Jacques Feuchère's
centerpiece. Each component is decorated with
aquatic imagery, the centerpiece notably with figures
of Amphitrite, Neptune, and Venus, who stand under
a boat-shaped dish. The service was manufactured in
Paris by the firm of P.-H.-Émile Froment-Meurice,
which enjoyed a clientele that included members of
the French court of Napoleon III as well as Italian and
Spanish nobility. KBH

Designed by **Édouard Muller** (Swiss, 1823–1876); made by
the firm of **Jules Desfossé** (French, died 1889)

"Garden of Armida" Wallpaper, c. 1855
Block-printed paper, 12 ft. 8 in. × 11 ft. (3.86 × 3.35 m)
Gift (by exchange) of Julia G. Fahnestock in memory of her
husband, William Fahnestock, 1988-57-1a–e

Determined to raise the production of wallpaper to
a fine art, manufacturer Jules Desfossé chose subjects
from celebrated literary works and employed rec-
ognized artists, such as the flower painter Édouard
Muller, to illustrate them. This example, the center-
piece of a three-part panoramic wallpaper, depicts the
magical garden of the enchantress Armida, described
by the Renaissance poet Torquato Tasso in his mas-
terwork, *Jerusalem Delivered* (1575). For his efforts,
Desfossé won a first-class medal at the 1855 Universal
Exposition in Paris, where a version of this wallpaper
was displayed. An example also was featured in the
Museum's 1978 exhibition *The Second Empire: Art in
France under Napoleon III*. KBH

LA GUERRE

LA PAIX

Pierre Puvis de Chavannes (French, 1824–1898)

War (top) and *Peace* (bottom), 1867
Oil on canvas, *War*: 43⅛ × 58¾ in. (109.5 × 149.2 cm), *Peace*:
42⅞ × 58½ in. (108.9 × 148.6 cm)
John G. Johnson Collection, cats. 1062, 1063

By the late nineteenth century, Pierre Puvis de
Chavannes was among the most celebrated French
artists. These two canvases are reduced versions of
Puvis's large murals, completed in 1861, in the Musée
de Picardie in Amiens, France. The historical vague-
ness of their subjects is intentional: *War* suggests a
nonspecific northern Druidic or Gallic setting, while
Peace recalls an Arcadian golden age. Although Puvis's
association with convention has obscured his artistic
innovations, the subtle and understated color, poetic
unity, and flat pictorial effect of his works profoundly
influenced progressive artists, including Paul Cézanne
and Paul Gauguin, and lifted decorative painting to a
new level. JJR

Pierre-Auguste Renoir (French, 1841–1919)

The Large Bathers, 1884–87
Oil on canvas, 46⅜ × 67¼ in. (117.8 × 170.8 cm)
The Mr. and Mrs. Carroll S. Tyson, Jr., Collection, 1963-116-13

In Paris in May 1887, after four years of work and
more than twenty preparatory studies, Pierre-Auguste
Renoir exhibited this ambitious canvas with the title
Bathers, an Essay in Decorative Painting. Evoking
seventeenth- and eighteenth-century French rep-
resentations of female bathers lounging playfully
outdoors, the picture, which Renoir later described
as his masterwork, marked a bold departure from his
Impressionist manner with its reliance on strong con-
tours and its smooth, dry surface reminiscent of por-
celain or the frescoes he recently had admired in Italy.
This canvas, along with Vincent van Gogh's *Sunflowers*
(1888 or 1889; p. 200), is part of the superb collec-
tion of European paintings given to the Museum by
Philadelphia painter Carroll S. Tyson, Jr., and his
wife, Helen Roebling Tyson, in 1963. JAT

Jean-François Millet (French, 1814–1875)

Bird's-Nesters, 1874
Oil on canvas, 29 × 36½ in. (73.7 × 92.7 cm)
The William L. Elkins Collection, E1924-3-14

A work of haunting beauty, painted in somber, earthen tones with especially fluid and vibrant brushwork, Jean-François Millet's canvas describes the violent yet ancient practice of bird's-nesting, as a peasant holding a flaming torch disorients a flock of wild pigeons so his companions can stun the birds with clubs and gather their struggling bodies. Millet, who recalled witnessing such nocturnal hunts during his childhood in Normandy, painted the scene from memory at the end of his life, perhaps in recognition of his own ill health and frailty. By the 1870s, the artist was widely praised for his faithful representations of rural life and its fading traditions. JAT

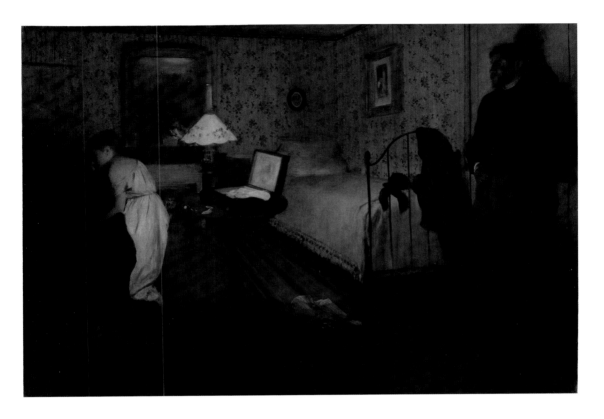

Hilaire-Germain-Edgar Degas (French, 1834–1917)

Interior, 1868 or 1869
Oil on canvas, 32 × 45 in. (81.3 × 114.3 cm)
The Henry P. McIlhenny Collection in memory of Frances P.
McIlhenny, 1986-26-10

An annotation in a notebook used by Edgar Degas during this period provides a clue to his intentions in this enigmatic painting: "work a great deal on nocturnal effects, lamps, candles, etc." Diffused light from a table lamp and a fire contributes to the intimacy of the setting, while also dividing the couple and casting them into shadow. Although the artist made numerous preparatory studies for the room and its figures in order to create a powerful psychological mood, the tense encounter between two lovers so far has resisted a convincing narrative explanation. JAT

THE McILHENNY FAMILY

John D. McIlhenny (1866–1925) and his son Henry P. McIlhenny (1910–1986) rank among the most important figures and generous benefactors in the Museum's history. The son of an Irish immigrant who invented the gas meter, the elder McIlhenny served as president of the Museum from 1918 until his death, playing a major role in the planning for

the institution's Fairmount building and the hiring of its formative director Fiske Kimball. He and his wife, Frances Galbraith McIlhenny (1869–1943), were enthusiastic collectors of Oriental carpets, and their superb collection, including a magnificent early sixteenth-century Turkish "Lotto" rug (right), was bequeathed to the Museum in 1943.

In many ways, therefore, Henry—who would serve as the Museum's curator of decorative arts from 1939 to 1964 and as chairman of the board for the last ten years of his life—came by his collector's instinct and commitment to civic responsibility naturally. While a student at Harvard in the 1930s, he began to collect in earnest, with Jean-Baptiste-Siméon Chardin's *Still Life with a Hare* (c. 1730; left, top) being his first major purchase.

Yet his greatest love was nineteenth-century French painting and drawing, and he assembled masterworks by, among others, Edgar Degas, Eugène Delacroix, Jean-Auguste-Dominique Ingres, Pierre-Auguste Renoir, Georges Seurat, Henri de Toulouse-Lautrec, and Vincent van Gogh, whose painting of a wheat field during a rainstorm was made during his stay at the clinic of Saint-Paul-de-Mausole in southern France (left, bottom; see also pp. 168, 182, 189, 193, 199, 203). These and other works were displayed with European furniture and decorative arts (see pp. 140, 141, 174, 241) in Henry's house on Rittenhouse Square in Philadelphia, which he opened freely to visitors. Although he never ventured too far into twentieth-century art, he bought for his sister Bernice ("Bonnie") McIlhenny Wintersteen (1903–1986), a collector herself who led the Museum's board from 1959 to 1964, Henri Matisse's *Woman in Blue* (1937; p. 246), one of the artist's greatest works of the 1930s.

Henry shared his happy and privileged life very openly, and his legacy continues through his bequest of his magnificent collection of paintings, drawings, furniture, and decorative arts to the Museum that he and his family helped form. His collection is a cornerstone of the Museum's holdings, and the largesse of the McIlhenny family lives on in spirit throughout the galleries. J J R

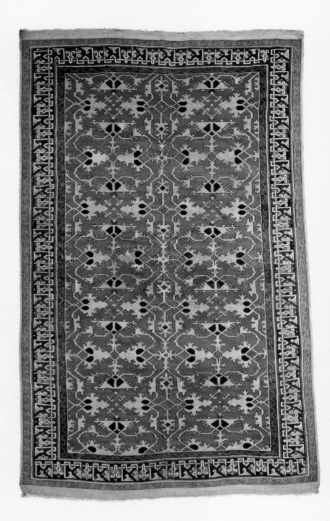

Jean-Baptiste-Siméon Chardin (French, 1699–1779)

Still Life with a Hare, c. 1730
Oil on canvas, 25⅝ × 32 in. (65.1 × 81.3 cm)
Gift of Henry P. McIlhenny, 1958-144-1

Vincent van Gogh (Dutch, 1853–1890)

Rain, 1889
Oil on canvas, 28⅞ × 36⅜ in. (73.3 × 92.4 cm)
The Henry P. McIlhenny Collection in memory of Frances P. McIlhenny, 1986-26-36

"Lotto" Carpet
Turkey, possibly Anatolia, Konya, early 16th century
Wool and possibly goat hair; 92 × 56 in. (233.7 × 142.2 cm)
The John D. McIlhenny Collection, 1943-40-68

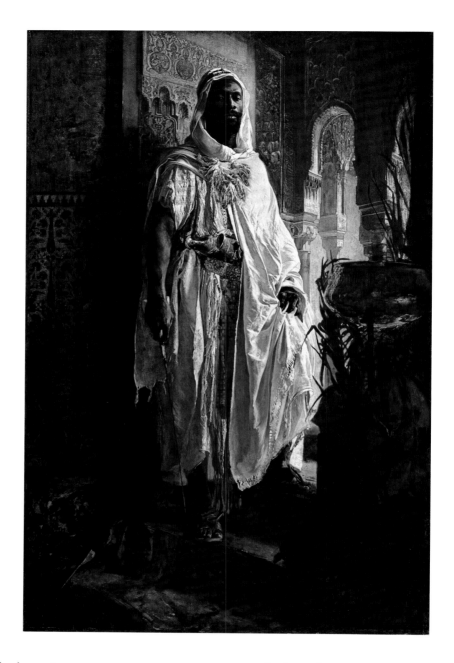

Eduard Charlemont (Austrian, 1848–1906)

The Moorish Chief, 1878
Oil on panel, 59⅛ × 38½ in. (150.2 × 97.8 cm)
John G. Johnson Collection, cat. 951

Born and trained in Vienna, Eduard Charlemont
spent thirty years in Paris, where he became a success-
ful figure in the official circle of the Salons. A nimble
eclectic, Charlemont was known for his charming

anecdotal, usually interior, genre scenes, but by the
1850s his paintings of so-called Orientalist subjects,
featuring images drawn from North Africa and the
Middle East, had become a clear specialty. Here and
in a handful of smaller works that seem to use the
same handsome model, his work instills in its subject
a true dignity and a powerful, theatrical presence. JJR

Pierre-Auguste Renoir (French, 1841–1919)

Portrait of Mademoiselle Legrand, 1875
Oil on canvas, 32 × 23½ in. (81.3 × 59.7 cm)
The Henry P. McIlhenny Collection in memory of Frances P.
McIlhenny, 1986-26-28

Pierre-Auguste Renoir painted this captivating portrayal of the hesitant six-year-old Delphine Legrand early in his career, when he depended on portrait commissions to support himself and build his reputation. Set in a modest room, the painting is uncluttered with details, yet dominated by the rich colors and virtuoso brushwork of the black pinafore, the brilliant blue scarf knotted at the girl's neck, and the shimmering green curtain behind her. The shy, earnest sitter was the daughter of an art dealer, and her parents were friends with many young artists, including Renoir. JAT

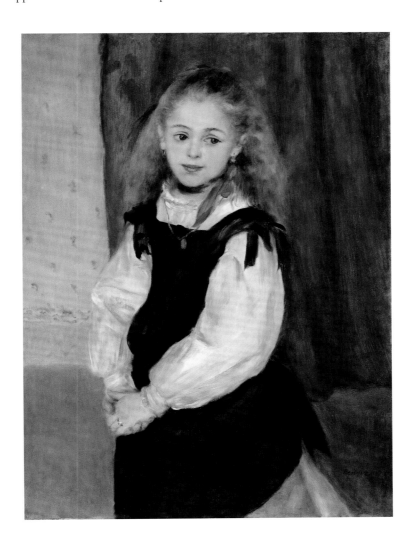

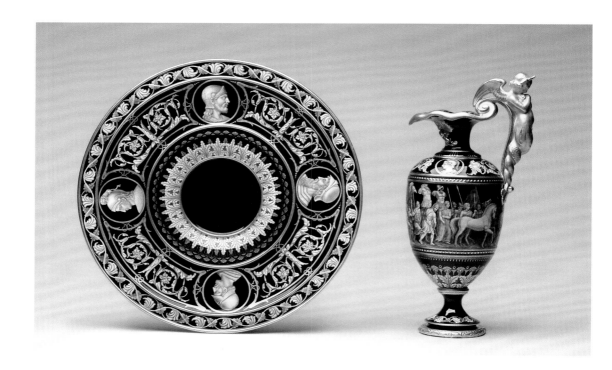

Decorated by **Thomas John Bott, Jr.** (English, 1854–1932); made by **Worcester porcelain factory** (Worcester, England, 1751–present)

Ewer and Stand, 1875
Porcelain with enamel and gilt decoration, H. (ewer) 11¼ in. (28.5 cm), DIAM. (stand) 12 in. (30.5 cm)
Purchased with Museum funds, 1876-1623,1624

Among the first objects to enter the Museum's collection, this ewer and stand were purchased from London retailer A. B. Daniell and Son at the 1876 Centennial Exhibition in Philadelphia. The elaborate decoration, exquisitely executed by Thomas John Bott, Jr., mimics the grisaille technique of sixteenth-century Limoges enamels. Bott's father had been instrumental in developing this style at the Worcester porcelain factory, and a ewer and stand decorated by him and of similar shape to the present examples were exhibited in Paris in 1855. The ewer's processional scene, identified by the inscription as "The Triumph of Scipio" after sixteenth-century Italian artist Perino del Vaga, likely was taken from an engraved source. DC

Probably designed by **Jean Brandely** (French, active 1867–73); made by the firm of **Charles-Guillaume Diehl** (French, 1811–c. 1885)

Jewelry Cabinet, c. 1867
Wood, gilded bronze; H. 63⅜ in. (161 cm)
Purchased with funds from the gift of Mrs. William S. Lasdon and with the Henry P. McIlhenny Fund in memory of Frances P. McIlhenny, 1996-65-1

The scale, fine colored-wood marquetry, gilded-bronze mounts, and clever construction of Charles-Guillaume Diehl's imposing jewelry cabinet made it a showpiece at the 1867 Universal Exposition in Paris. Critics praised the originality of its conception and the perfect execution of its Greek-inspired decoration, from the intricately inlaid scene on the central panel to the mythical griffins on the supports. Hidden springs open the front door for access to interior drawers, and an innovative mechanism pops up the top to reveal a panel for the display of the day's selection of jewelry. When acquired in 1996, this was the first piece of international exhibition furniture to enter the Museum's European collections in over a century. KBH

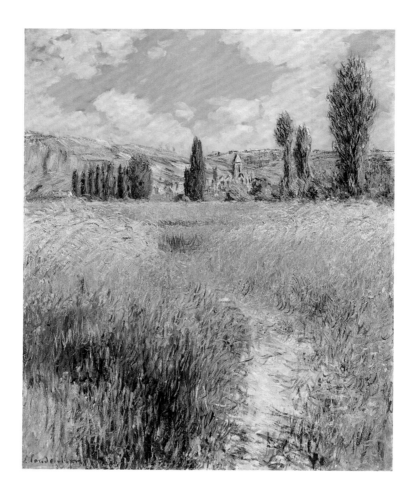

Claude Monet (French, 1840–1926)

Path on the Island of Saint Martin, Vétheuil, 1881
Oil on canvas, 29 × 23½ in. (73.7 × 59.7 cm)
125th Anniversary Acquisition. Gift of John C. Haas and Chara C.
Haas, 2011-58-2

In September 1879 Claude Monet moved with his ail-
ing wife, Camille, to the village of Vétheuil, in north-
western France. The next two years were catastrophic
for the artist: Camille died in September 1879, leaving
him with two young sons, and he suffered great finan-
cial difficulties. By early 1881, however, his fortunes
started to turn, as demand for his work began to rise.
The present landscape is a wonderful declaration of
this optimistic moment, radiant in its delineation
of the path winding through the verdant meadow
toward the medieval village, where Monet would
return years later, in 1903, as an established (and rich
and famous) artist. JJR

Charles Aubry (French, 1811–1877)

Group of Leaves on a Tulle Background, 1864
Albumen silver print, image and sheet: 19⅛ × 15⅛ in.
(48.6 × 38.4 cm)
Purchased with funds contributed by the American Museum of
Photography, 1971-4-124

A designer of textiles and wallpapers, Charles Aubry
produced a series of still-life photographs in the early
1860s to be used as models in the classroom training
of young artists and designers. After dipping leaves
in plaster to preserve and enhance their forms and
structures, he photographed them individually or in
elegant arrangements, achieving his extraordinary
results with a large-format camera and long expo-
sures. Although his images were never used for the
educational purposes he had envisioned, the surviving
prints are treasured examples of nineteenth-century
photography and mark a high point in the medium's
application to the period's industrial design. PB

Anton Mauve (Dutch, 1838–1888)

The Return of the Flock, Laren, c. 1886–87
Oil on canvas, 39⁷⁄₁₆ × 63½ in. (100.2 × 161.3 cm)
The George W. Elkins Collection, E1924-4-21

Despite the high regard Vincent van Gogh had for his cousin Anton Mauve (whose work strongly influenced Van Gogh's early style), Mauve and his fellow Hague school painters only recently have regained some of the great reputation they enjoyed in their own day. The Museum owns an important and representative collection of these artists' works, with Mauve's canvases being among the most affecting. As this landscape so convincingly demonstrates, his ability to use gentle, nearly monochromatic tones without losing a sense of time or place puts him in direct comparison with the two French artists he most admired: Jean-Baptiste-Camille Corot and Jean-François Millet. JJR

Henri-Julien-Félix Rousseau (French, 1844–1910)

Carnival Evening, 1886
Oil on canvas, 46⅜ × 35¼ in. (117.3 × 89.5 cm)
The Louis E. Stern Collection, 1963-181-64

Although untrained as a painter, Henri Rousseau was celebrated by many collectors and avant-garde artists of the early twentieth century, including Pablo Picasso and members of the Surrealist movement. His imaginative, stylized scenes, often informed by motifs found in illustrated books, evoke realms of innocent wonder disturbed by an unexpected, perhaps threatening presence. In this painting, a couple dressed in festive carnival costumes stands before a forest of barren trees. Backlit by the glimmer of twilight and a full moon, the figures appear to glow radiantly. Unbeknownst to them, a face peers out from the hut-like structure behind them, introducing a narrative that furthers the painting's mystery. JV

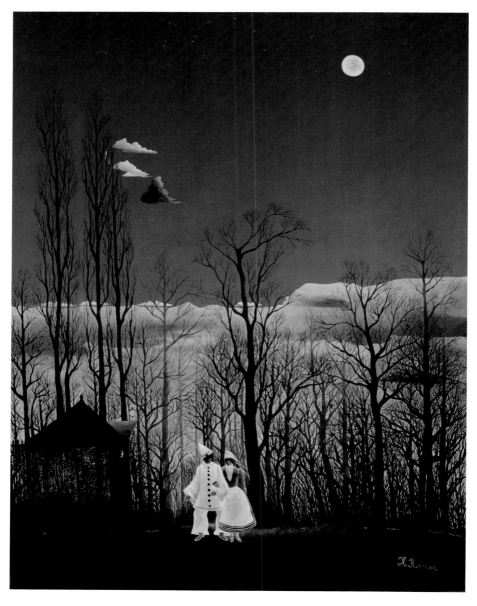

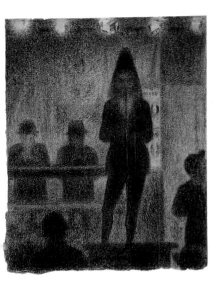

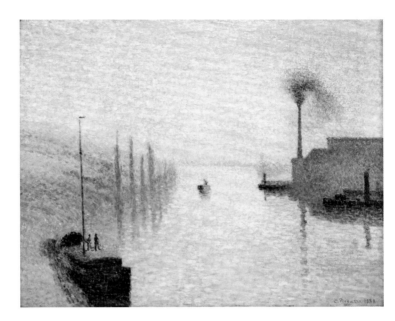

Georges Seurat (French, 1859–1891)

Trombonist (Study for "Circus Side Show"),
1887–88
Conté crayon and white chalk on laid paper, sheet: 12¼ × 9⅜ in.
(31.1 × 23.8 cm)
The Henry P. McIlhenny Collection in memory of Frances P.
McIlhenny, 1986-26-31

Purchased in 1932 by renowned Philadelphia collector
Henry P. McIlhenny while a student at Harvard (on
the McIlhenny family, see pp. 190–91), this drawing
is a study for George Seurat's first nocturnal painting,
Circus Side Show (1887–88; Metropolitan Museum of
Art, New York). The immobile figures paradoxically
suggest silence rather than music, while the emphatic
placement of every element gives the composition
a strange weight and timelessness. In this and other
drawings, Seurat used black conté crayon on tex-
tured paper to create a luminous ambience against
which objects appear silhouetted. The white of the
paper generally produces the highlights, but the art-
ist occasionally employed white chalk to accentuate
significant elements, as here with the trombone's long
slide. IHS

Camille Pissarro (French, 1830–1903)

L'Île Lacroix, Rouen (The Effect of Fog), 1888
Oil on canvas, 18⅜ × 22 in. (46.7 × 55.9 cm)
John G. Johnson Collection, cat. 1060

The oldest of the Impressionists, Camille Pissarro was
a versatile and experimental artist who in the mid-
1880s adopted the new style popularized by Georges
Seurat and others of using small dabs of color to
create pictures of breathtaking effect. The pointillist
technique enabled Pissarro to render this foggy view
of factories and barges on a river in Rouen with subtle
beauty in a delicate range of colors. The artist's shift
in style was accompanied by a change in working
methods; Pissarro painted this labor-intensive picture
in his studio from drawings and etchings rather than
en plein air. JAT

Vincent van Gogh (Dutch, 1853–1890)

Sunflowers, 1888 or 1889
Oil on canvas, 36⅜ × 28 in. (92.4 × 71.1 cm)
The Mr. and Mrs. Carroll S. Tyson, Jr., Collection, 1963-116-19

Few artists have been associated with specific subjects as closely as Vincent van Gogh was to sunflowers. They represented for him something deeply personal, and he frequently praised them as symbols of reverie, loyalty, and joy. After moving to Paris in 1866, Van Gogh, encouraged by his first encounters with Impressionism, continued to experiment with color, focusing on still lifes of flowers, including his 1887 series of paintings of cut sunflowers arrayed on a flat surface. It was during the next two years, in 1888–89, that Van Gogh, then living in Arles in the south of France, became almost obsessed with sunflowers, repeatedly painting bouquets of them arranged in a simple earthenware vase. Seven of these canvases, including this one, survive. Initially, they were conceived as a series to decorate the room that Paul Gauguin would occupy when he visited Van Gogh in Arles, at his so-called Studio of the South. Later versions were intended as altarpiece-like wings to flank Van Gogh's portrait of Augustine Roulin, wife of the artist's friend and postman in Arles, rocking the cradle in which her child sleeps (1889; Metropolitan Museum of Art, New York). Some of these paintings seem to have been made as variants of earlier versions, an exercise in repetition that Van Gogh practiced quite often. The Museum's picture, for example, is in closest kinship with the versions in Munich and London. JJR

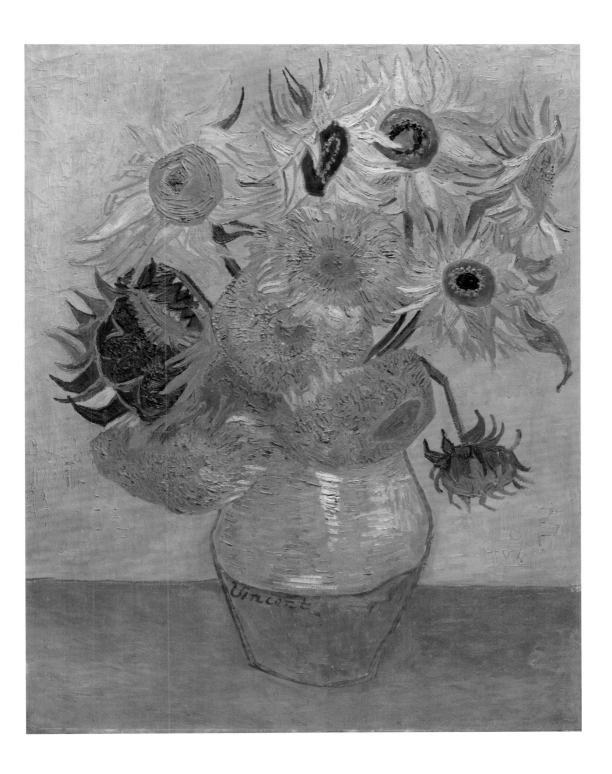

Charles Frederick Worth (English, 1825–1895)

Evening Dress, c. 1886–87
Silk, lace, rhinestones
Gift of Mr. and Mrs. Owen Biddle, 1978-2-1a,b

This evening dress was designed by the first great couturier, Charles Frederick Worth, an Englishman working in Paris who is credited with elevating fashion to an art form through his creativity and promotional skills. Featuring diverse colors and textures and distinctive textiles, such as the floral brocade seen here, his designs elicited veneration, as well as extravagant sums, from aristocratic and nouveaux riches clients around the world. He made this opulent gown for an American, Mrs. Ernest Fenollosa, who might have worn it for presentation at the Japanese imperial court. Restrictive, impractical, and decorative, it exemplifies late nineteenth-century concepts of feminine status and beauty. HKH

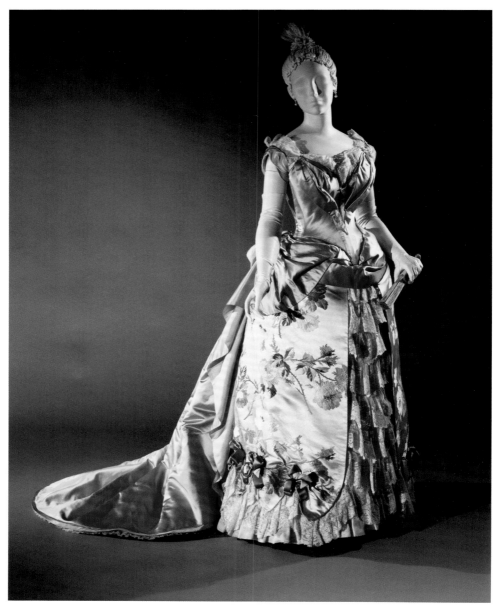

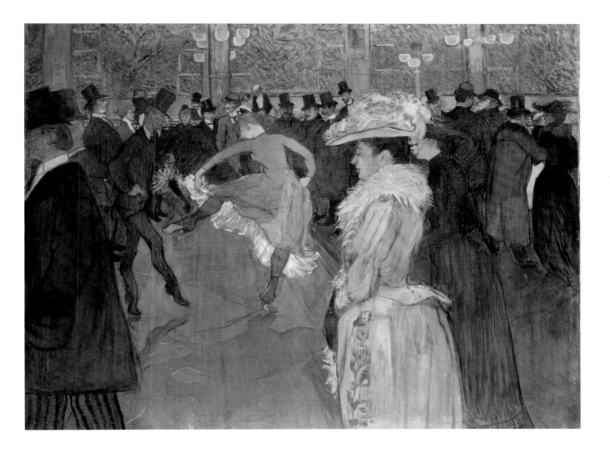

Henri de Toulouse-Lautrec (French, 1864–1901)

At the Moulin Rouge: The Dance, 1890
Oil on canvas, 45½ × 59 in. (115.6 × 149.9 cm)
The Henry P. McIlhenny Collection in memory of Frances P.
McIlhenny, 1986-26-32

With flat, silhouetted forms, dark outlines, and
strident colors, Henri de Toulouse-Lautrec skillfully
chronicled the ostentatious performances and gaslit
interiors of dance halls and nightclubs in fin de siècle
Paris. Here the profiles of men and women passing
through the main hall of the Moulin Rouge cabaret
frame the evening's entertainment: the top-hatted
male dancer with extraordinarily flexible limbs, who
was known as Valentin le Désossé (literally, "the
boneless one"). According to an inscription in the
artist's hand on the reverse of the painting, Valentin is
instructing his partner, a woman in red stockings, in a
new dance. JAT

Designed by **George Washington Jack** (American, 1855–1932); made by **Morris and Company** (London, 1861–1940)

"Secretary Cabinet," c. 1889

Mahogany with hardwood inlays, w. 55½ in. (141 cm)
Purchased with funds contributed by the Friends of the Philadelphia Museum of Art and with the gift (by exchange) of Julia G. Fahnestock in memory of her husband, William Fahnestock, 1986-128-1a,b

A masterwork of High Victorian design, this cabinet on stand, modified as a writing desk with drawers and pigeonholes behind a fall front, is the most important example of nineteenth-century British furniture in the Museum's collection. Among the most elaborate and costly pieces ever made by Morris and Company, the cabinet is decorated inside and out with exotic woods inlaid in geometric and naturalistic patterns. Wealthy Englishman Ralph Radcliffe Whitehead purchased the cabinet about 1891, bringing it with him when he and his American wife moved to the United States the following year. KBH

Designed by **William Morris** (English, 1834–1896); printed by **Morris and Company** (London, 1861–1940)

Detail of *"Brer Rabbit" Printed Textile,* 1882

Cotton, 13 ft. × 3 ft. 1½ in. (3.96 × 0.95 m)
Gift of Mr. and Mrs. Richard Hartshorne Kimber, 1964-183-1a,b

For this textile's pattern, influential designer and writer William Morris was inspired by Brer Rabbit, the mischievous character from *Uncle Remus*, a collection of short stories, songs, and folktales of the American South published in 1881. As a major figure of the Arts and Crafts movement in England, Morris advocated for traditional methods of craftsmanship in reaction to the increasing use of mass production. The complex design of this fabric was produced by discharge printing, one of the earliest techniques for decorating textiles, in which the dyed ground was bleached with patterned blocks. Morris's design firm, Morris and Company, used the Brer Rabbit motif for both textiles and wallpapers. LLC

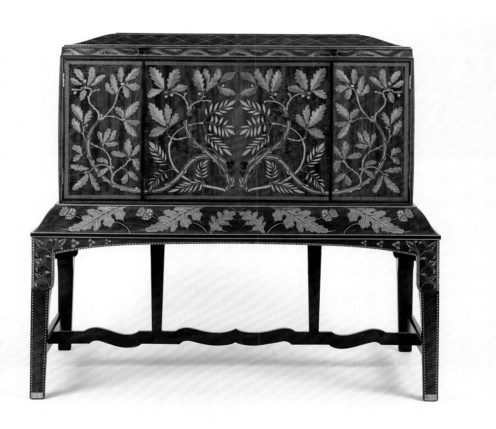

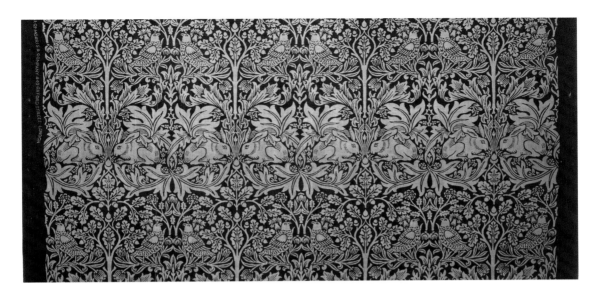

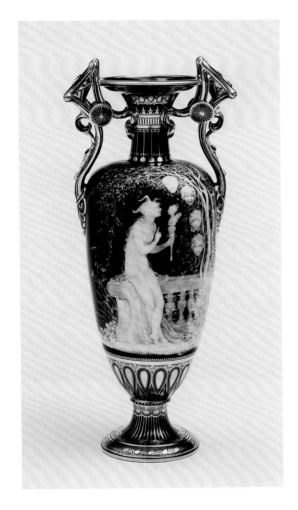

Designed and decorated by **Marc-Louis-Emmanuel Solon** (French, 1835–1913); made by **Minton, Ltd.** (Stoke-on-Trent, England, 1793–1968)

"Jester" Vase, 1894
Parian ware with *pâte-sur-pâte* and gilt decoration, H. 23⅞ in. (60.7 cm)
Purchased with the Joseph E. Temple Fund, 1898-95

The very first purchases made by the Museum included parian porcelains decorated by Marc-Louis-Emmanuel Solon in thin layers of transparent white slip known as *pâte-sur-pâte* (paste on paste), a time-consuming technique that he had brought to England when he emigrated from France in 1870. *Pâte-sur-pâte* became the most admired porcelain decoration of the late nineteenth century, and Solon its foremost practitioner. His wares were sold at international exhibitions and at retailers such as Philadelphia's Bailey, Banks and Biddle, where in 1898 the Museum purchased this extravagant "Jester" vase (named for the main character in its design), which Director William Platt Pepper considered the best "specimen" in the United States. KBH

Paul Gauguin (French, 1848–1903)

The Sacred Mountain (Parahi Te Marae), 1892
Oil on canvas, 26 × 35 in. (66 × 88.9 cm)
Gift of Mr. and Mrs. Rodolphe Meyer de Schauensee, 1980-1-1

Paul Gauguin made his first trip to Tahiti in 1891, but soon retreated, sick and broke, to Paris, where he showed this and other works, with little success. With time, however, came public awareness of Gauguin's great imaginative power, evident in the magical world he invented after his encounter with the civilizations of the South Seas. Here, although the fence decorated with skulls, the idol on the hill, and the evocation of sacrifice in the thread of smoke ascending before the god have no basis in Tahitian culture, Gauguin has created a mythical paradise with his opulent color and splendid sensuality. JJR

Claude Monet (French, 1840–1926)

Poplars, 1891
Oil on canvas, 36⅝ × 29³⁄₁₆ in. (93 × 74.1 cm)
The Chester Dale Collection, 1951-109-1

In 1891 Claude Monet painted a series of canvases showing a stand of poplar trees lining the river Epte near his home at Giverny. These paintings, like the artist's earlier series of grain stacks (1890–91), capture the shifting light and seasonal changes of the French countryside. With the haystacks, however, Monet had focused on the raking light and the shadows cast by the solid, grounded forms, whereas with the poplars he delighted in the changing light's diverse effects on the landscape. Some fifteen canvases from the series, including this one, were exhibited to great acclaim at the Galerie Durand-Ruel in Paris in February 1892. JJR

Odilon Redon (French, 1840–1916)

Sea Monster, c. 1895
Pastel with charcoal on blue laid paper, sheet: 20¾ × 17⅝ in.
(52.7 × 44.8 cm)
Gift of C. K. Williams, II, 2011-171-4

Created around 1895, *Sea Monster* dates to the
extremely generative period when Symbolist artist
Odilon Redon shifted from drawing and printmaking
exclusively in black and white to working with exu-
berant colors. Seen by his contemporaries as the leader
of the Symbolist movement, Redon depicted dreams,
myths, fantasies, and the enigmatic worlds explored
by contemporary writers. This drawing relates to sev-
eral lithographs from his third series of prints based
on French novelist Gustave Flaubert's *Temptation of
Saint Anthony* (1874). The Museum owns a second
printing of this portfolio, which focuses on Flaubert's
evocative description of the underwater world, full of
mysterious sea creatures. AJ

Édouard Vuillard (French, 1868–1940)

Self-Portrait with Sister, c. 1892
Oil on paper on cardboard, 9 × 6½ in. (22.9 × 16.5 cm)
The Louis E. Stern Collection, 1963-181-76

As a member of the group of experimental young
artists called the Nabis, Édouard Vuillard developed
a painting style that incorporated broad areas of
flat color, stylized forms, and the decorative play of
elegant line. His works of the 1890s often bear unset-
tling intimations of psychological, moral, and spiritual
complexity, as in this small, jewellike painting of the
artist and his elder sister, Marie. The strange melding
of their bodies in an awkward embrace hints at a trou-
bling ambiguity in the dynamics of family life. In later
years, Vuillard's family and friends remained constant
subjects for his art, but rarely in scenes as haunting
and ambivalent as this. CR/JV

Georges Seurat (French, 1859–1891)

Moored Boats and Trees, 1890
Oil on wood, 6⁵⁄₁₆ × 9¹³⁄₁₆ in. (16 × 25 cm)
Gift of Jacqueline Matisse Monnier in memory of Anne
d'Harnoncourt, 2008-181-1

Georges Seurat often painted plein air studies of
nature on small panels of wood, even cigar-box lids.
Some he used as preparations for larger landscapes;
others, including this view of a quay, he intended
as independent analyses of how best to transform
observed shapes into grand and lasting impressions
with his precise and refined manipulation of color. It
is no surprise to learn that Henri Matisse acquired this
small picture, an object of remarkable authority and
potency, in 1916 and kept it for the rest of his life. JJR

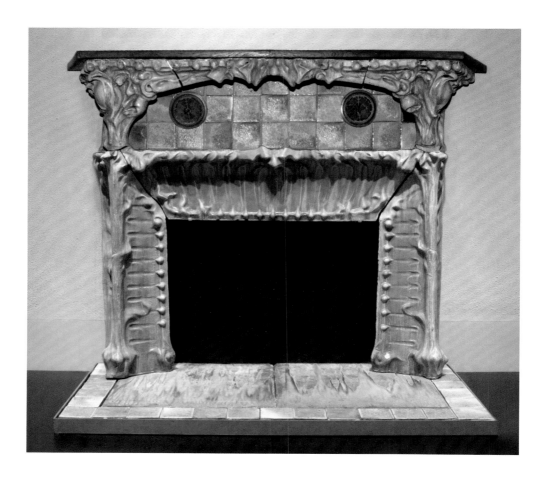

Designed by **Hector Guimard** (French, 1867–1942); made by the firm of **Alexandre Bigot** (French, 1862–1927)

Fireplace, designed c. 1895
Glazed stoneware, wood, metal; H. 47¼ in. (120 cm)
Purchased with the Henry P. McIlhenny Fund in memory of
Frances P. McIlhenny, 2004-87-1

Best known for his fantastical entrances to Paris metro stations, architect-designer Hector Guimard was a leading proponent of French Art Nouveau, relying on abstracted forms drawn from the natural world, as seen in the robust stalk-like shapes of this fireplace. Guimard originally designed this model for his largest and ultimately most important architectural project, a block of flats in Paris known as the Castel Béranger, and he subsequently employed it in at least one other building. At Béranger and elsewhere, he embraced the contemporary fashion for architectural ceramics, using them in the interiors and on the exteriors of his buildings. DC

Designed by **J. Jurriaan Kok** (Dutch, 1861–1919); made by **N. V. Haagsche Plateelfabriek Rozenburg** (The Hague, The Netherlands, 1883–1917); decorated by **Wilhelmus Petrus Hartgring** (Dutch, 1874–1940)

Tea Service, 1900
Eggshell porcelain with enamel decoration, H. (teapot) 7½ in. (19.1 cm) with lid
Purchased with the Fiske and Marie Kimball Fund, 1975-18-1–5

As director of the Rozenburg factory, Jurriaan Kok developed an innovative process for the production of an extremely thin ceramic known as eggshell porcelain. Rather than separately casting and later attaching a vessel's spout or handles, his method allowed such parts to be cast with the body to form a seamless entity. The decoration of exotic birds and flora reflects Kok's interest in the art of Java, then a Dutch colony, and the fine painting recalls Japanese color woodcuts. At the 1900 Universal Exposition in Paris, Rozenburg's almost weightless porcelains were praised for their remarkable shapes and decoration. MADJ

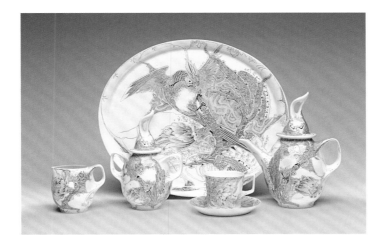

Gebrüder Thonet (Vienna, 1853–present)

Chaise Lounge, 1887
Beechwood, caning; H. 45 in. (114.3 cm)
Purchased with the Director's Discretionary Fund, 1970-237-1

Although Gebrüder Thonet, Vienna's pioneering bentwood furniture manufacturer, exhibited at the 1876 Centennial Exhibition in Philadelphia, the Museum purchased nothing from the firm's display. Nearly a century later, curator Calvin Hathaway redressed this omission by acquiring thirteen Thonet chairs, including this example. The firm developed an innovative process of steam-bending wood into standardized, lightweight curvilinear shapes; furniture thus produced could be shipped unassembled and joined with screws upon arrival, making it affordable to a broad range of consumers. This elaborate model, with scrolled curves and an adjustable back, was first exhibited in London in 1887 and illustrated in Thonet's sale catalogue the following year. KBH

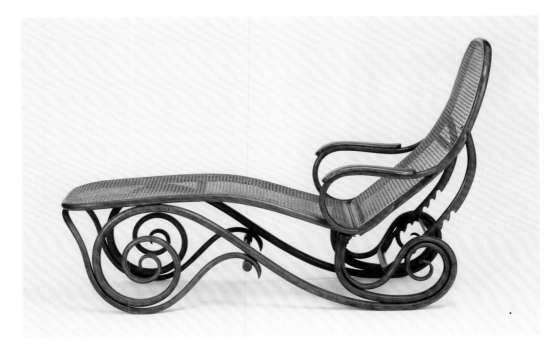

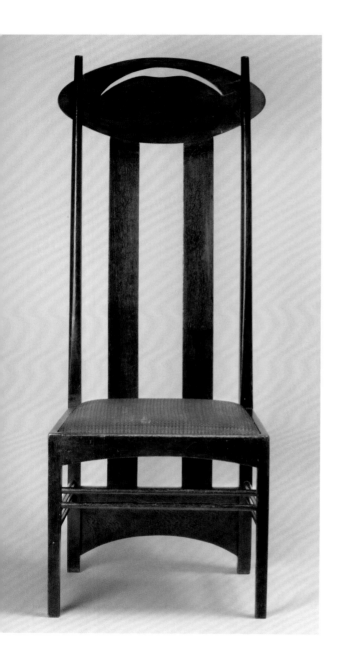

Designed by **Charles Rennie Mackintosh** (Scottish, 1868–1928); probably made by **Herbert Smith and Son** (Glasgow, active c. 1900)

Chair, 1897
Stained oak, caning, horsehair; H. 53⅞ in. (136.9 cm)
Purchased with the Fiske Kimball Fund and the Thomas Skelton Harrison Fund, 1987-71-1

This high-back chair with its unusually tall rectangular slats and oval backrail exemplifies the use of geometric forms that made Scottish architect and designer Charles Rennie Mackintosh a pioneer of modern design. Created for the luncheon room of the Argyle Street Tearooms in Glasgow, the chair was Mackintosh's first major interior-design commission. Arranged in facing pairs, the chairs enclosed the space at each table, providing a sense of privacy for guests. Mackintosh used this model in his own home and included it in the Vienna Secession exhibition of 1900, where it inspired a generation of European and American avant-garde architects and designers. KBH

Edvard Munch (Norwegian, 1863–1944)
Detail of *Mermaid,* 1896
Oil on canvas, 3 ft. 3½ in. × 18 ft. 1½ in. (1 × 5.53 m)
Gift of Barbara B. and Theodore R. Aronson, 2003-1-1
© 2014 The Munch Museum / The Munch-Ellingsen Group / Artists Rights Society (ARS), NY

Designed to fit under the sloping rafters of the Oslo home of Norwegian industrialist Axel Heiberg, Edvard Munch's trapezoidal painting shows a beguiling mermaid lingering on a moonlit beach. The half-human, half-sea creature evokes Norse myths of mermaids as melancholic beings who love men but cannot live comfortably on land. Munch painted this canvas, his first large-scale decorative mural, in Paris in the summer of 1896, a time when he, like other avant-garde artists associated with the international Symbolist style, was exploring how to express the invisible emotions and fears of the human psyche in his art. JAT

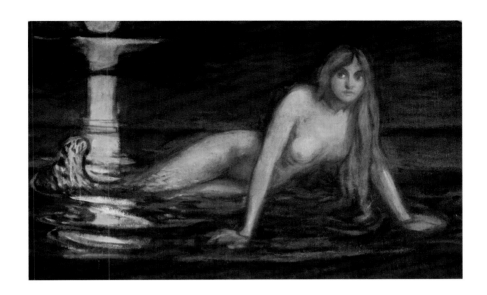

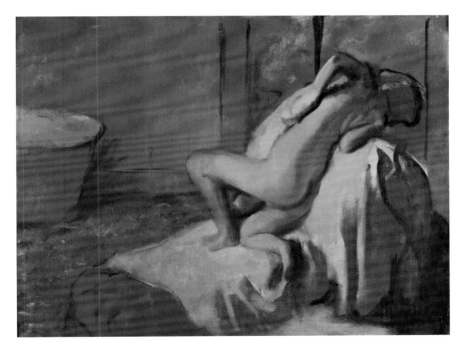

Hilaire-Germain-Edgar Degas (French, 1834–1917)

After the Bath (Woman Drying Herself), c. 1896
Oil on canvas, 35¼ × 46 in. (89.5 × 116.8 cm)
Purchased with funds from the estate of George D. Widener,
1980-6-1

In this nearly monochromatic picture, completed pre-dominantly in tones of red, one of the artist's favorite colors, Edgar Degas rubbed red-ocher and burnt-sienna paints into the canvas, giving the scene a disquieting evenness. An amateur photographer, Degas made a bromide print of a nude in the exact pose shown in this painting, presumably to assist him since a model would be unable to hold the awkward position for long. Feelings of vulnerability and exhaustion can be found in the artist's late nudes, which often concentrate, as here, on the back of the bather. JAT

RODIN MUSEUM

In September 1924 American cinema magnate Jules Mastbaum (1872–1926) visited the Musée Rodin in Paris for the first time. Captivated by the French sculptor's use of the human figure to express inner passions and thoughts, Mastbaum, a Philadelphia native, acquired his first bronze by Rodin that day. Over the next two years, he purchased more than 150 sculptures by the artist. Most were bronzes, original works cast from Rodin's plasters under the authority granted to the Musée Rodin by the artist's will, but Mastbaum also scoured the art market to acquire intimate and revealing pieces, such as the bust of Victor Hugo that the sculptor had presented to his friend the painter Henri Fantin-Latour (far right).

Within months of beginning his collection, Mastbaum was considering how to share it with his fellow Philadelphians. As the owner of the Stanley Company of America, the largest operator of cinemas in the country, he initially intended to place iconic works like *The Thinker* (below) in the lobbies of his ornate theaters or in public squares in Philadelphia, but he soon decided they would best be shown in a dedicated museum on the Benjamin Franklin Parkway. At his request, French architects Paul Philippe Cret and Jacques Gréber designed a unique venue for the collection, one that evokes Parisian gardens and provides an elegant setting—both indoors and outdoors—for the sculptures (see fig. 7). The museum's entrance recreates the facade of a seventeenth-century château that Rodin had reassembled on the grounds of his home in Meudon, outside Paris, and beyond it lie a reflecting pool, a

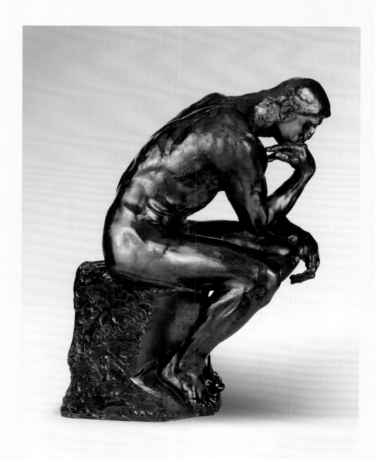

formal garden filled with monumental bronzes, and a Beaux-Arts building at the center of which stands the first cast of *The Gates of Hell* (modeled 1880–1917, cast 1926–28; p. 216).

Mastbaum died of complications following an appendectomy before the museum was built, but his widow and three daughters carried out his wishes and the Rodin Museum opened in November 1929, a gift to the city of Philadelphia that is administered by the Philadelphia Museum of Art. The collection continues to grow through extraordinary gifts, such as the touching *Young Mother in the Grotto* (below), and remains, as Mastbaum intended, an enthralling place for the study and appreciation of Rodin. JAT

Auguste Rodin (French, 1840–1917)

The Thinker, modeled 1880–81, cast 1924
Bronze, H. 27⅛ in. (68.9 cm)
Bequest of Jules E. Mastbaum, F1929-7-15

Young Mother in the Grotto, modeled 1885, carved 1891
by **Jean Escoula** (French, 1851–1911)
Marble, H. 27⅞ in. (70.8 cm)
Gift of Brook J. Lenfest, 2010-11-1

Victor Hugo, modeled 1883, cast 1886
Plaster, H. 22¼ in. (56.5 cm)
Bequest of Jules E. Mastbaum, F1929-7-85

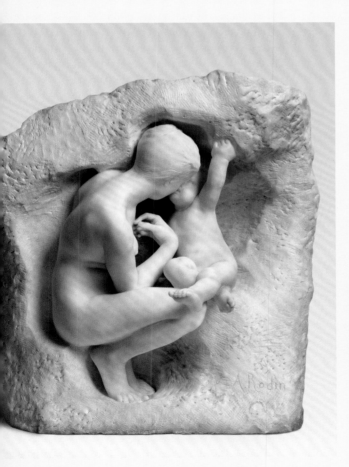

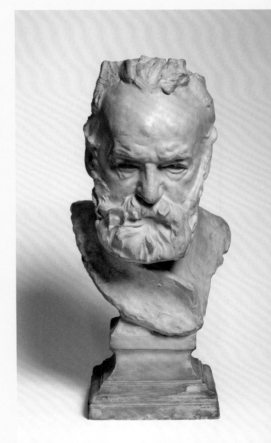

Auguste Rodin (French, 1840–1917)

The Gates of Hell, modeled 1880–1917, cast 1926–28
Bronze, H. 20 ft. 10¾ in. (6.37 m)
Bequest of Jules E. Mastbaum, F1929-7-128

The monumental bronze doors that stand in the entrance portico of the Rodin Museum reflect nearly forty years of experiment and revision. Auguste Rodin began work on them in 1880, shortly after receiving a commission to create a portal for a new museum in Paris devoted to the decorative arts. The subject—more than two hundred tormented figures caught in the chaos of hell—was selected by the artist, who was inspired in part by the journey through hell described in Dante Alighieri's *Divine Comedy*. Rodin initially based his designs on Renaissance art, such as Lorenzo Ghiberti's *Doors of Paradise* (1425–52) for the baptistery in Florence and Michelangelo's painting of the Last Judgment (1536–41) in the Sistine Chapel, but he soon moved beyond his early plans to create a weightless, disorderly world noted for its sweeping voids and lack of gravity. The restless energy and twisting poses of the men and women reveal the artist's genius for using the human body to express powerful emotions such as pain, suffering, or regret. The Paris museum for which the doors were intended never came to fruition, but Rodin continued to make adjustments to them for decades. Near the end of his life, he contemplated having the piece, his seminal work, cast in bronze, but he died before this was realized. In 1925, eight years after the sculptor's death, the Philadelphia motion-picture magnate Jules Mastbaum (see pp. 214–15) paid for the first two casts of *The Gates of Hell*, one for Philadelphia and one for the Musée Rodin in Paris. JAT

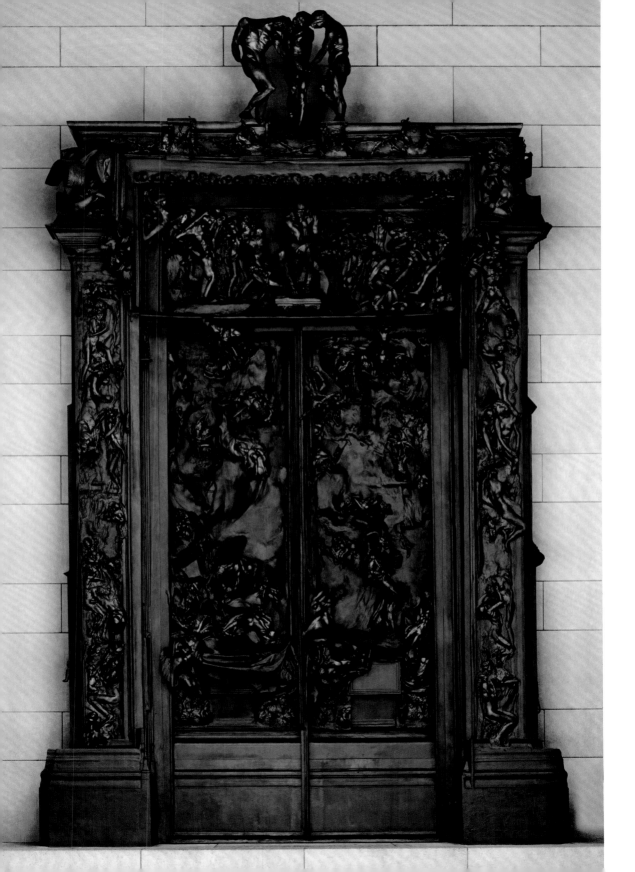

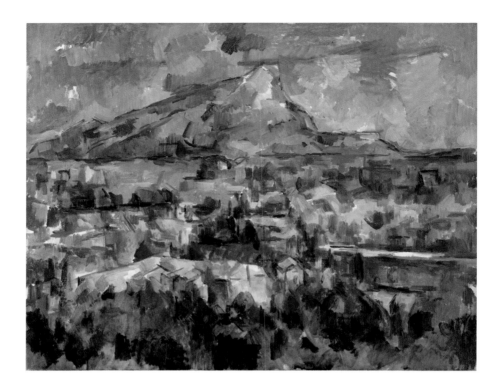

Paul Cézanne (French, 1839–1906)

Mont Sainte-Victoire, 1902–4
Oil on canvas, 28¾ × 36⁵⁄₁₆ in. (73 × 91.9 cm)
The George W. Elkins Collection, E1936-1-1

In 1899, due to the settlement of his mother's estate, Paul Cézanne was forced to leave his childhood home, the grand villa called the Jas de Bouffan, located on the outskirts of Aix-en-Provence. As a result of his dislocation, the artist built a large new studio on a ridge north of Aix from which he enjoyed a stunning view of Mont Sainte-Victoire in raising profile. Over the next decade, he would represent this image some sixty times, allowing viewers to trace his tremendously complete relationship with the mountain and the surrounding landscape. JJR

Frederick H. Evans (English, 1853–1943)

Kelmscott Manor: Attics, 1896
Platinum print, image and sheet: 6¹⁄₁₆ × 7⅞ in. (15.4 × 20 cm)
Gift of the artist, 1932-40-1

Shortly before his death in 1896, Arts and Crafts movement leader William Morris invited Frederick H. Evans to photograph Kelmscott Manor, the designer's cherished sixteenth-century country house in Oxfordshire, England. For this print, one of the first photographs to enter the Museum's collection, Evans used soft, natural light to highlight the striking geometry of the room's handcrafted beams and rafters, the dramatic angles of which recall the soaring arches depicted in his famous views of Gothic cathedrals. With more than two hundred photographs by Evans, the Museum is home to one of the most extensive holdings of his work. ANB

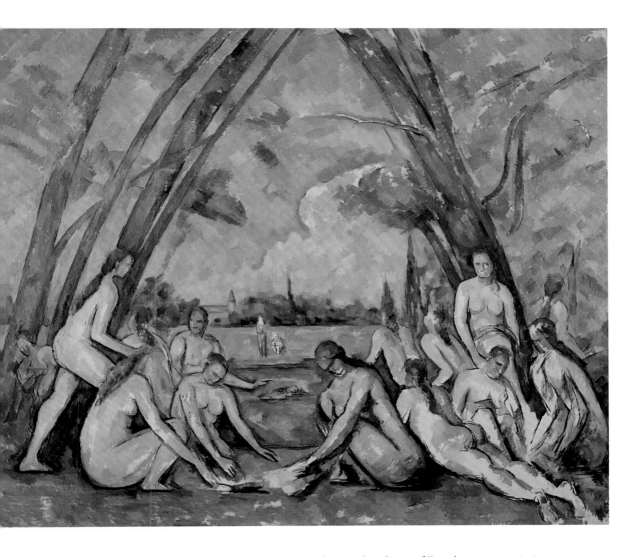

Paul Cézanne (French, 1839–1906)

The Large Bathers, 1900–1906
Oil on canvas, 82⅞ × 98¾ in. (210.5 × 250.8 cm)
Purchased with the W. P. Wilstach Fund, W1937-1-1

Near the end of his life, Paul Cézanne painted three large canvases of female nudes disporting in a landscape. They derive in part from pastoral images of female bathers, such as the goddess Diana and her maidens, long favored in French art. For many, these works represent the culmination of Cézanne's lifetime of exploration of the nude, his final testament within the grand tradition of French narrative painting on the ancient theme of Arcadia. The three canvases (the others are in the Barnes Foundation, Philadelphia, and the National Gallery, London) differ greatly from one another. This version, in large part due to its unfinished state, is both the most exalted and the most serene. The women command a grand stage, resembling goddesses in an opera production, with the arched trees serving as the proscenium. They are completely at ease, imparting a profound sense of calm and rectitude. JJR

Designed by **Josef Hoffmann** (Austrian, 1870–1956); made by the firm of **Jacob Kohn** (Austrian, 1791–1868) and **Josef Kohn** (Austrian, 1814–1884)

Chair, c. 1904
Beechwood, leather; H. 39 in. (99.1 cm)
Purchased with the Bloomfield Moore Fund, 1969-136-7

Architect Josef Hoffmann designed this chair to reflect the rectangular structure and straight ceiling beams of the dining room in his building for the Purkersdorf Sanatorium near Vienna, founded around 1890 by psychiatrist Richard von Krafft-Ebing to treat nervous disorders. Hoffmann's interest in rationalized geometric forms, first fully realized in his plans for Purkersdorf, became a hallmark of progressive Viennese design of the early twentieth century. The sanatorium's environment of strict formal simplicity, with decoration limited to geometric patterns such as rows of windows or the circular perforations on this chair back, was thought to have a calming effect on patients. KBH

Émile Gallé (French, 1846–1904)

"Dragonfly" Vase, 1903
Glass with applied decoration and metal foil, H. 11½ in. (29.2 cm)
Purchased with the Joseph E. Temple Fund, 1905-46

Representing the latest and most advanced of Émile Gallé's dazzling decorative techniques, this dragonfly-adorned glass vase was purchased at the 1904 Saint Louis World's Fair by trustee John T. Morris on behalf of the Museum. Gallé's studies in botany, horticulture, and mineralogy are evident in the impressionistic, naturalistic style he invented. To create a realistic effect, Gallé applied the dragonfly to the surface of the vase in partial relief—its eyes glinting from gold and silver foil backings, its engraved wings mottled with ash. Gallé favored this motif, once inscribing in French a similarly decorated vase, "Made by the lover of quivering dragonflies." KBH

Designed by **Dagobert Peche** (Austrian, 1887–1923); made by **Wiener Werkstätte** (Vienna, 1903–32)

Detail of *"Glacier Flower" Printed Textile,* 1911–13
Screen print on silk with hand painting, 16¾ × 27 in. (42.5 × 68.6 cm)
Gift of the Friends of the Philadelphia Museum of Art, 1988-7-6

Founded in 1903 by Josef Hoffmann and Koloman Moser, the Wiener Werkstätte (Vienna Workshops) was a community of architects, artists, and designers committed to creating objects of practical design and use. The geometric style of their work—evident here in Dagobert Peche's design of gradating, horizontal stripes and stylized flowers—was in contrast to the curved, organic forms of Art Nouveau. In 1917 Viennese fashion magazine *Die Damenwelt* advertised clothing made from Wiener Werkstätte fabrics, including a skirt from this textile, designed by Otto Lendecke, the journal's artistic director. Peche's textile also was used for dresses, cushion covers, and umbrellas. LLC

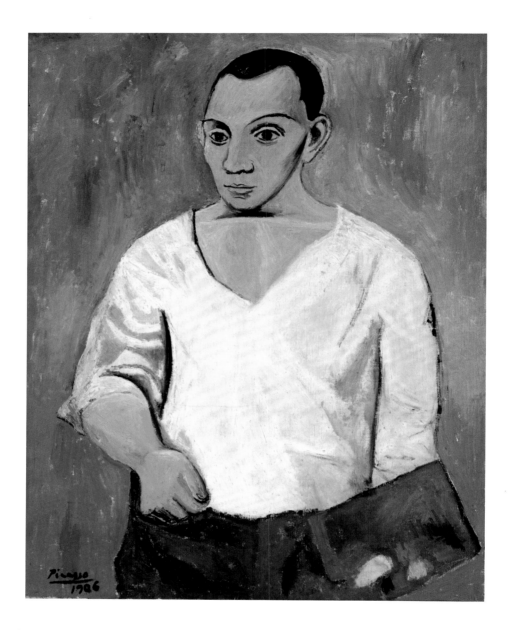

Pablo Picasso (Spanish, 1881–1973)

Self-Portrait with Palette, 1906
Oil on canvas, 36⅗₆ × 28⅞ in. (91.9 × 73.3 cm)
A. E. Gallatin Collection, 1950-1-1

In this picture, his first explicit self-portrait since 1901, Pablo Picasso cast himself as a fearless and determined artist. He stands with the solidity of a column that is immovable and enduring, and his stark white shirt, opened at the neck and pulled up at the sleeve, reveals his athletic build. The wide eyes of his inexpressive, mask-life face stare unflinchingly ahead, suggesting the concentrated focus of an artist at work. Yet, while his left hand clutches a palette, his right is empty. The conspicuous absence of a brush, which Picasso had included in preliminary drawings for the composition, evokes the young artist's confidence in the boundless potential of the creative mind and spirit. JV

André Derain (French, 1880–1954)

Portrait of Henri Matisse, c. 1905
Oil on canvas, 13 × 16⅛ in. (33 × 41 cm)
A. E. Gallatin Collection, 1952-61-22
© 2014 Artists Rights Society (ARS), New York / ADAGP, Paris

In July 1905 André Derain visited Henri Matisse
in Collioure, a coastal village in southern France
known for its brilliant natural light. There the artists
embarked on a shared quest for pure, liberated color
that later yielded the Fauvist style. A souvenir of that
summer, this vibrant painting consists of horizontal
bands of sky, sea, sand, and shadow, animated by
rhythmic brushstrokes and cut off by the tilted edge
of an open doorway. In the middle sits Matisse,
Derain's mentor, whose pose appropriately suggests
both relaxation and reflective thought. JV

Max Beckmann (German, 1884–1950)

Self-Portrait, 1918
Drypoint, plate: 12 × 9⅞ in. (30.5 × 25.1 cm)
Print Club of Philadelphia Permanent Collection, 1951-59-8
© 2014 Artists Rights Society (ARS), New York / VG Bild-Kunst, Bonn

From 1900 to 1950, during a half-century of war,
chaos, and exile, Max Beckmann made more than
eighty self-portraits. None is more revealing than
this unflinching attempt to confront the anguish he
endured as a volunteer in World War I field hospitals.
Beckmann likely printed this unique proof to review
the changes he was making to the composition; in
later states, the dark curving lines in the upper right
are transformed into a billowing curtain at a window.
The Museum's distinguished collection of prints by
German Expressionist artists was established in the
1940s by curator Carl Zigrosser, who published one
of the first English-language surveys of their work
in 1957. JI

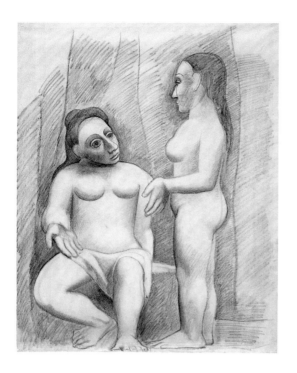

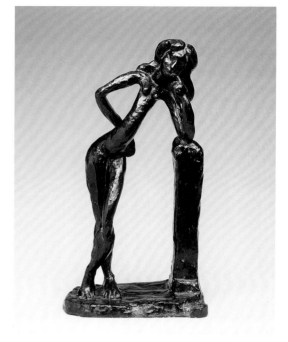

Pablo Picasso (Spanish, 1881–1973)

Seated Nude and Standing Nude, 1906

Charcoal and crayon on laid paper, sheet: 25¹⁄₁₆ × 18¹³⁄₁₆ in. (63.7 × 47.8 cm)

The Louise and Walter Arensberg Collection, 1950-134-162

© 2014 Estate of Pablo Picasso / Artists Rights Society (ARS), New York

Created only a few months before beginning his groundbreaking painting *Les demoiselles d'Avignon* (1907; Museum of Modern Art, New York), this large charcoal drawing epitomizes the moment when Pablo Picasso, inspired by ancient sculptural styles he had encountered in Paris, entered a phase of austere and monumental classicism, stripping his work of sentiment or narrative expression. The masklike faces of these squat yet statuesque women originated from Iberian sculptures, while the figures' severe planar poses and hieratic gestures recall archaic and classical Greek reliefs, particularly funerary examples in which the mourners stand or sit in shallow, curtained spaces. IHS

Henri Matisse (French, 1869–1954)

The Serpentine, 1909

Bronze, H. 21½ in. (54.6 cm)

Gift of R. Sturgis and Marion B. F. Ingersoll, 1963-210-1

© 2014 Succession H. Matisse / Artists Rights Society (ARS), New York

This lithe, coiling figure presents a stunning exploration of spatial rhythm and linear form. Henri Matisse derived the sculpture's pose from a magazine photograph, but elongated the original model's rounder build. By thinning her arms, legs, and torso, he created airy voids framed by delicate contours that morph, then vanish, and finally reappear as the figure is seen in the round. As in his drawings and paintings—including his portrait of Mademoiselle Yvonne Landsberg (p. 238), executed five years later—these graceful arabesques imbue the stationary subject with a sense of continuous motion. JV

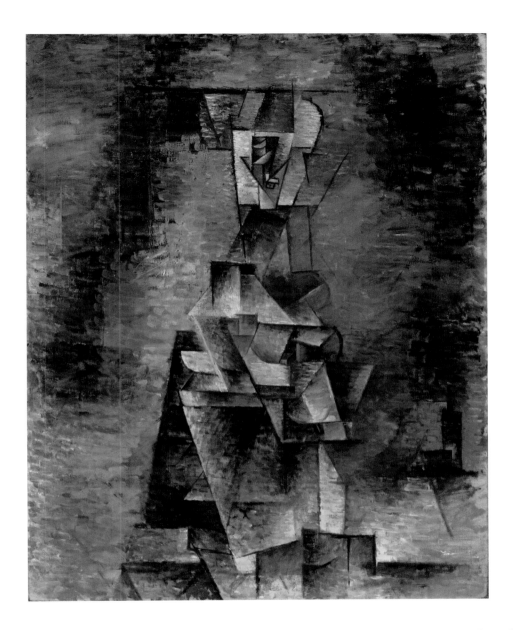

Pablo Picasso (Spanish, 1881–1973)

Female Nude, 1910
Oil on canvas, 39⅞ × 30⁹⁄₁₆ in. (101.3 × 77.6 cm)
The Louise and Walter Arensberg Collection, 1950-134-166
© 2014 Estate of Pablo Picasso / Artists Rights Society (ARS), New York

Pablo Picasso painted *Female Nude* in the summer of 1910, as the development of Analytic Cubism began to yield increasingly radical results. Here his subject is transformed into a cipher of lines and planes loosened from their traditional mimetic roles. Volume and depth, suggested by abrupt tonal shifts, exist in seeming opposition to the unifying brushstrokes that merge the figure with her surroundings and flatten the space. Yet she is present: She sits in profile, her rounded shoulders slouched over a downward-pointing breast; her right arm, bent at the elbow, rests on a table, as she languidly handles a glass and turns her head to face the viewer. JV

František Kupka (Czech, 1871–1957)

Disks of Newton (Study for "Fugue in Two Colors"), 1912

Oil on canvas, 39½ × 29 in. (100.3 × 73.7 cm)

The Louise and Walter Arensberg Collection, 1950-134-122

© 2014 Artists Rights Society (ARS), New York / ADAGP, Paris

The title of this painting refers to the seventeenth-century English physicist Sir Isaac Newton, who discovered that sunlight comprises all seven colors of the visible spectrum. František Kupka's radiant composition thus incorporates circular bands of burning, vibrating color that overlap and interpenetrate one another to create a sense of spinning movement. Given the artist's fascination with cosmology and astronomy, these whirling concentric rings may relate to images of planets in orbit. Yet another analogy is suggested by the word "fugue" in the second part of the painting's title, which evokes Johann Sebastian Bach's polyphonic musical arrangements that Kupka so admired. MT/JV

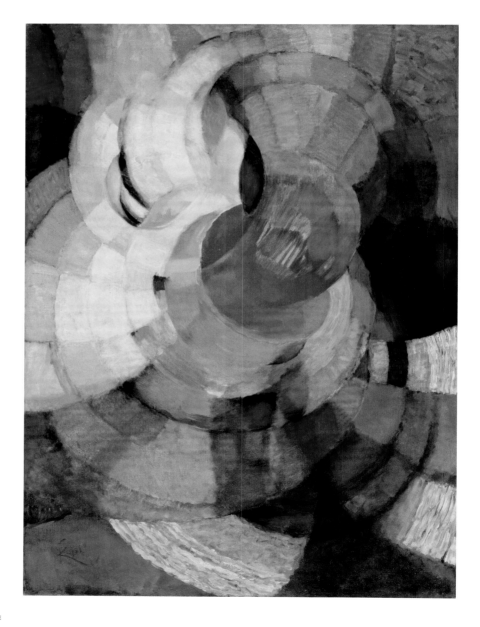

Vasily Kandinsky (French, born Russia, 1866–1944)

Little Painting with Yellow (Improvisation), 1914
Oil on canvas, 31 × 39⅝ in. (78.7 × 100.6 cm)
The Louise and Walter Arensberg Collection, 1950-134-103
© 2014 Artists Rights Society (ARS), New York / ADAGP, Paris

Vasily Kandinsky, a cofounder of the Munich-based Der Blaue Reiter (The Blue Rider) group of Expressionist artists, advanced the development of abstract art in both his writings and paintings. His abstract compositions, which he called "improvisations," are considered to be among the first nonfigurative paintings. Deploying amorphous shapes of lively color to convey emotional and spiritual content, these works evoke in name the abstract qualities of music that Kandinsky, as well as artists such as František Kupka (see, for example, p. 226), sought to communicate visually. Created shortly before the outbreak of World War I, this canvas shows how the artist deliberately juxtaposed forms of contrasting colors, depth, rhythm, or weight to reveal the sublime turbulence of an ineffable force. JV

Georges Braque (French, 1882–1963)

Still Life, 1912–13

Charcoal, black chalk, and collage of cut colored and printed
papers on laid paper; sheet: 24½ × 19 in. (62.2 × 48.3 cm)
The Louise and Walter Arensberg Collection, 1950-134-24
© 2014 Artists Rights Society (ARS), New York / ADAGP, Paris

In the formative years of Cubism, Georges Braque
and Pablo Picasso strove to make paintings that would
not be perceived as illusionistic renditions of reality.
Accordingly, forms became shifting planes, and color
was all but eliminated. Braque's solution to the prob-
lem came in late 1912, when he made the first Cubist
collage by adhering strips of colored wallpaper to a
charcoal drawing, thereby allowing color and form to
exist independently in a composition. In this example,
the charcoal forms of a guitar hover around three
paper planes pasted at subtle angles to indicate a slight
shifting. The Museum's Arensberg and Gallatin collec-
tions (see pp. 236–37, 242–43) boast seven of Braque's
and Picasso's early collages. IHS

Jacques Villon (French, 1875–1963)

Yvonne Duchamp in Profile, 1913

Drypoint, plate: 21½ × 16⅛ in. (54.6 × 41 cm)
Gift of The Judith Rothschild Foundation in honor of Innis
Howe Shoemaker, 2003-50-1
© 2014 Artists Rights Society (ARS), New York / ADAGP, Paris

In addition to the world's richest holdings of works by
Jacques Villon's youngest brother, Marcel Duchamp
(see pp. 342–43), and an important group of sculp-
tures by their middle brother, Raymond Duchamp-
Villon (see, for example, p. 229), the Museum has one
of the greatest public collections of Villon's Cubist
prints, thanks to the transformative gift of thirty-four
works by this master printmaker in 2001. In this bril-
liant impression of the rare second state of Villon's
drypoint portrait of his sister Yvonne, he translated
color values into a linear language of black and white.
Yvonne was the subject of several of Villon's works in
1912 and 1913, including the painting *Young Girl* (1912)
in the Museum's Arensberg Collection. IHS

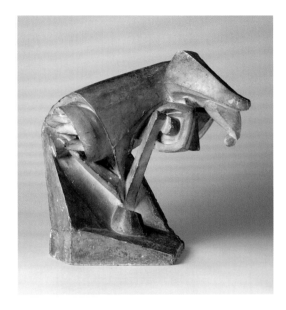

David Bomberg (English, 1890–1957)

Acrobats, 1913–14
Charcoal with erasing and crayon on laid paper, sheet:
18½ × 22⅞ in. (47 × 57 cm)
Purchased with the Lola Downin Peck Fund and the Fiske
Kimball Fund, 1981-21-1
© 2014 Artists Rights Society (ARS), New York / DACS, London

Although he received a diploma in traditional life
drawing from the Slade School in London in 1912,
David Bomberg already had developed a simpli-
fied and dynamic abstract style, in part inspired by
Cubism and Italian Futurism. His compositions of
figures, derived from the steel forms of the modern
city and from the heightened gestures he observed in
Jewish theatrical performances in London, established
his reputation as a leader of the English avant-garde.
This important example of early British modernism
acquires broader significance when viewed in the
context of the Museum's distinguished collection of
early twentieth-century European drawings by artists
such as Georges Braque and Pablo Picasso (see, for
example, pp. 228, 224, respectively). IHS

Raymond Duchamp-Villon (French, 1876–1918)

Horse, 1914
Plaster, H. 17½ in. (44.5 cm)
Gift (by exchange) of Miss Anna Warren Ingersoll, 1999-5-1

Raymond Duchamp-Villon, together with his brothers
Jacques Villon and Marcel Duchamp, helped advance
the Cubist movement begun in Paris by Pablo Picasso
and Georges Braque. A former student of medicine,
Duchamp-Villon turned to sculpture around 1900,
and his early figures reveal the influence of Auguste
Rodin. In this and other studies for *Horse*, the final
version of which was posthumously cast in bronze,
the vitality of Duchamp-Villon's mature work is
apparent in the fusion of the animal's energy with the
streamlined forms of a machine. Tragically, his career
as a sculptor was cut short by his death from typhoid
fever during World War I. CB

Marc Chagall (French, born Russia, 1887–1985)

Half-Past Three (The Poet), 1911
Oil on canvas, 77⅛ × 57 in. (195.9 × 144.8 cm)
The Louise and Walter Arensberg Collection, 1950-134-36
© 2014 Artists Rights Society (ARS), New York / ADAGP, Paris

One of the masterpieces Marc Chagall created during his first trip to Paris—where he arrived from Saint Petersburg in May 1911 and stayed for three years—this painting of the Russian poet Mazin, a fellow resident at the La Ruche studios in Montparnasse, demonstrates the artist's ambitious adaptation of Cubist methods. Prismatic planes of blue, white, and red swirl throughout the composition, fragmenting the scene and lifting its protagonists from reality. The poet's upside-down head, the attentive feline muse, and the book of verse, which doubles as a painter's palette, suggest the passionate artistic inspiration that Chagall himself no doubt experienced. JV

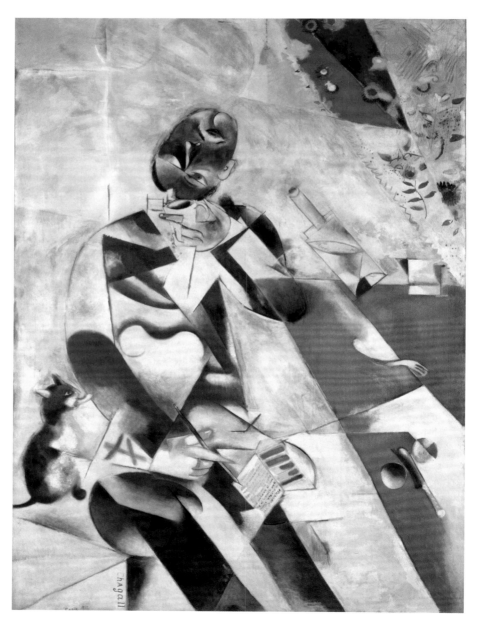

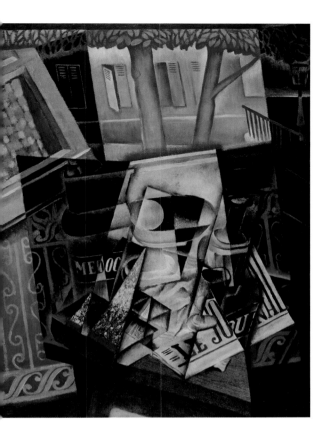

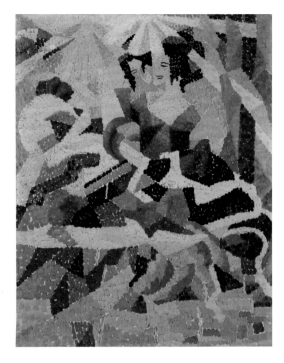

Juan Gris (Spanish, 1887–1927)

Still Life before an Open Window, Place Ravignan, 1915
Oil on canvas, 45⅝ × 35 in. (115.9 × 88.9 cm)
The Louise and Walter Arensberg Collection, 1950-134-95

In *Place Ravignan*, Juan Gris wed interior and exterior, still life and landscape, even day and night. The title refers to the artist's Paris address, and the painting presumably presents his daily view from his studio. Traditional elements of still life—newspaper, glass, carafe, compote, bottle, and book—are arranged on a table, but refracted in great shafts of light from the window, which bring the neighboring trees and houses into the composition. The umbrella of foliage on the trees and the balcony's wrought-iron designs gather background and foreground into a dreamlike sweep that revels in intense color, evoking the artist's close association with Henri Matisse. AT/AVa

Gino Severini (Italian, 1883–1966)

The Milliner, 1910–11
Oil on canvas, 25½ × 19 in. (64.8 × 48.3 cm)
Gift of Sylvia and Joseph Slifka, 2004-45-2
© 2014 Artists Rights Society (ARS), New York / ADAGP, Paris

Italian artist Gino Severini painted *The Milliner* in Civray, a small town in southwest France, where he spent the summers of 1910 and 1911. It was around this time that he departed from his former Neo-Impressionist style and began to experiment with Cubism, seen here in the flat, shifting planes that compose the hatmaker and her surroundings. Severini showed this work in the first Futurist exhibition in Paris, held at the Galerie Bernheim-Jeune in 1912. Conveying a sense of dizzying motion through the repeated elements of the subject's body, the painting speaks to Futurism's celebration of the speed, fragmentation, and sensory overload of modernity. MT/JV

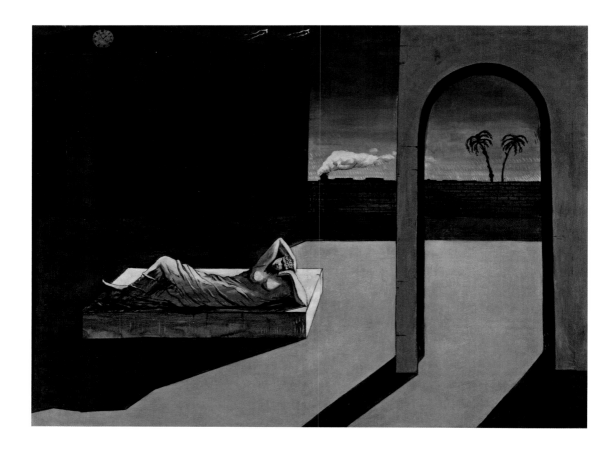

Giorgio de Chirico (Italian, born Greece, 1888–1978)

The Soothsayer's Recompense, 1913
Oil on canvas, 53⅜ × 70⅞ in. (135.6 × 180 cm)
The Louise and Walter Arensberg Collection, 1950-134-38
© 2014 Artists Rights Society (ARS), New York / SIAE, Rome

Giorgio de Chirico's use of exaggerated perspective and sharp realism combine to create the troubling, dreamlike atmosphere of this enigmatic picture, part of the artist's series of melancholy cityscapes painted shortly before World War I. Dominating the foreground is an antique statue of the sleeping Ariadne, who in Greek mythology was abandoned by her lover Theseus after aiding his escape from the Minotaur's labyrinth. De Chirico's juxtaposition of the sculpture with the puffing steam engine in the background produces the scene's disturbingly ambiguous sense of time and place in which the ancient and modern worlds collide. MT/JV

Fernand Léger (French, 1881–1955)

The City, 1919
Oil on canvas, 7 ft. 7 in. × 9 ft. 9½ in. (2.31 × 2.98 m)
A. E. Gallatin Collection, 1952-61-58
© 2014 Artists Rights Society (ARS), New York / ADAGP, Paris

Created at the close of World War I, Fernand Léger's
The City (below and fig. 13) is a synthesis of the world
that just ended and a vision of disquieted exhilaration
with another being born. Here Léger reinvented pre-
war Cubism as a fount of creative energy to rival that
of the modern metropolis. Glimpses of a cityscape—
billboards, billows of smoke, scaffolding, traffic
signs—are set within a framework of vivid hues and
clashing shapes, producing an effect of intensity, like
the sensory assault of an urban street. Evoking cin-
ematic montage, the graphic language of print, theat-
rical backdrops, and murals, the painting challenges
the constraints of its medium and is a landmark in the
history of modern art. AVa

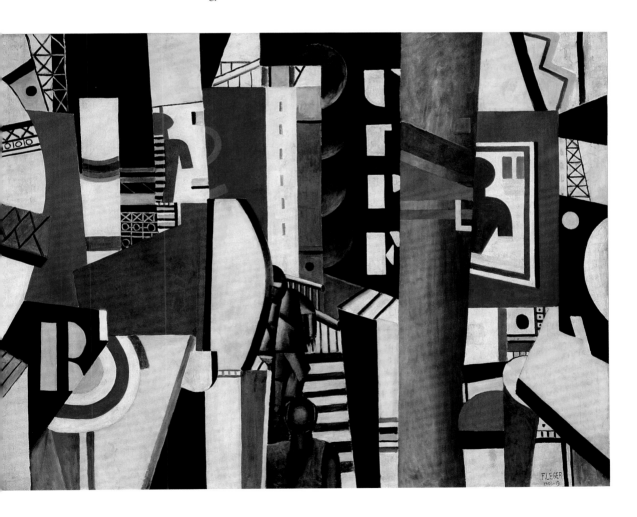

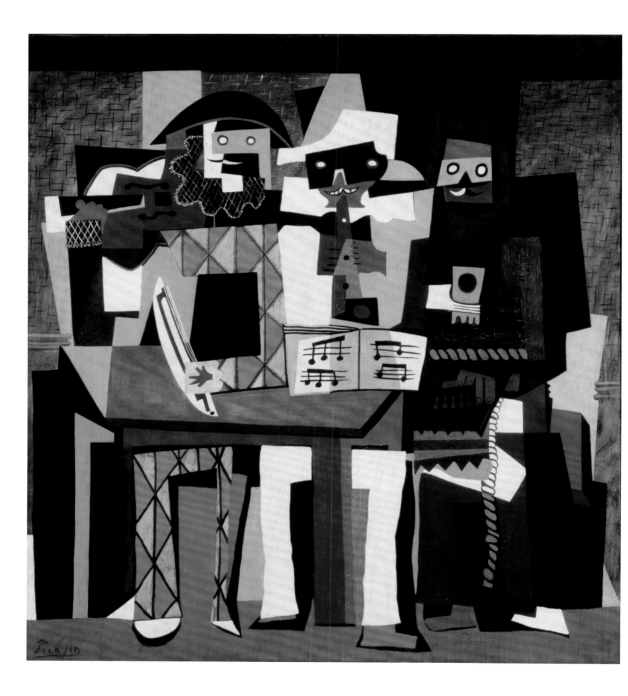

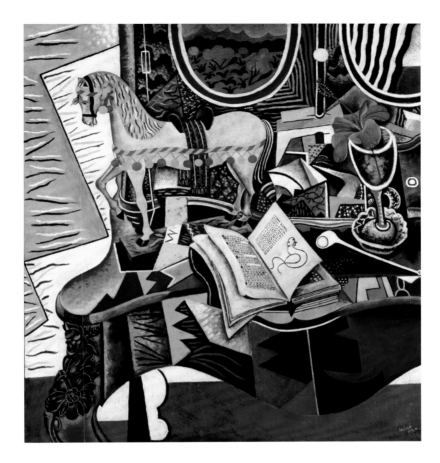

Pablo Picasso (Spanish, 1881–1973)

Three Musicians, 1921
Oil on canvas, 80½ × 74⅛ in. (204.5 × 188.3 cm)
A. E. Gallatin Collection, 1952-61-96
© 2014 Estate of Pablo Picasso / Artists Rights Society (ARS), New York

Three Musicians (left and fig. 10) provides a grand
summation of Pablo Picasso's decade-long exploration
of Synthetic Cubism, with its flat shapes echoing the
cut-and-pasted papers of his collages. Music was a
favorite Cubist theme, and here Harlequin is
equipped with a violin, Pierrot with a recorder, and
the monk with an accordion. These characters, which
figure importantly in the history of painting and in
Picasso's earlier work, come from Italian, French, and
Spanish popular theater and carnival traditions. Likely
a portrayal of Picasso himself (Harlequin) with his
friends Guillaume Apollinaire (Pierrot) and Max
Jacob (the monk), the painting presents an allegory
of the artist as performer, a major theme throughout
Picasso's highly autobiographical oeuvre. AT/JV

Joan Miró (Spanish, 1893–1983)

Horse, Pipe, and Red Flower, 1920
Oil on canvas, 32½ × 29½ in. (82.6 × 74.9 cm)
Gift of Mr. and Mrs. C. Earle Miller, 1986-97-1
© Successió Miró / Artists Rights Society (ARS), New York / ADAGP, Paris 2014

Joan Miró painted *Horse, Pipe, and Red Flower* at his
home in the Catalan village of Montroig shortly after
his first visit to Paris in 1920. The exuberant color,
clamorous patterning, and crowded composition are
characteristic of his earlier work, but the complex
configuration of forms, the unconventional vantage
point, and the background's resemblance to Cubist
collage prove the young artist's close attention to
the avant-garde paintings he had seen on his trans-
formative trip abroad. The book on the table, Jean
Cocteau's *Le coq et l'arlequin,* features illustrations by
Pablo Picasso, whom Miró had met that spring. By
audaciously incorporating Picasso's drawing in his
own painting, Miró proudly announced his position
among the international avant-garde. JV

THE LOUISE AND
WALTER ARENSBERG COLLECTION

Louise and Walter Arensberg's extraordinary gift to the Museum, together with that of A. E. Gallatin (see pp. 242–43), forms the cornerstone of the institution's modern art collection. Early in the twentieth century Louise (1879–1953) and Walter Arensberg (1878–1954) were a patrician couple living in Cambridge, Massachusetts, where Walter had studied at Harvard University. Their path to becoming collectors was set in 1913 after a visit to the legendary Armory Show in New York. The exhibition proved a fateful encounter—above all, with Marcel Duchamp's notorious *Nude Descending a Staircase (No. 2)* (1912; below), which the couple later would acquire. The Arensbergs moved to New York the following year, and in 1915 they eagerly opened their home to Duchamp himself, who had just arrived from Paris, inaugurating a forty-year friendship and collaboration between the artist and the collectors (see fig. 9).

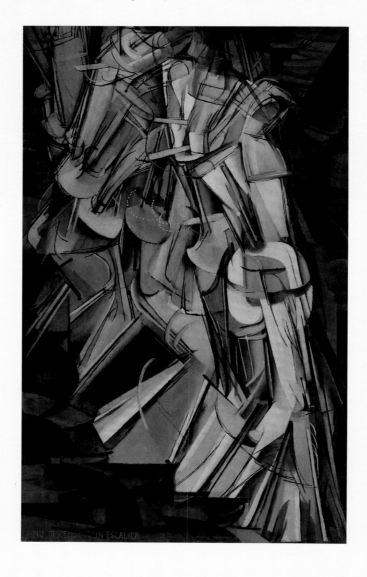

The Arensbergs' apartment became a hub of New York artistic and intellectual life, and by the end of the decade, their burgeoning collection numbered more than seventy works, chosen with remarkable acuity and often on Duchamp's advice. This perspicacity is evident throughout their collecting career, from early acquisitions such as Henri Matisse's haunting portrait of Mademoiselle Yvonne Landsberg (p. 238) to later purchases like Marc Chagall's monumental Cubist canvas *Half-Past Three (The Poet)* (1911; p. 230)—each an unusual experiment within the respective artist's oeuvre, and each a masterpiece.

In 1921 the couple moved to California, and their Hollywood home soon grew crowded with outstanding works by, among others, Georges Braque, Giorgio de Chirico, Salvador Dalí, Juan Gris, Vasily Kandinsky, Paul Klee (below, right), František Kupka, and Pablo Picasso, as well as the largest collection of Constantin Brancusi's sculpture outside Paris (below and p. 240; see also pp. 224–28, 231, 232, 248). Like those of many artists they admired, the Arensbergs' interests extended beyond Western art, and their distinguished holdings of pre-Columbian art (see pp. 252, 254–55) were displayed alongside contemporary works. Above all and with a singular passion, the couple amassed the foremost collection of Duchamp's work in the world, which has made the Museum a place of pilgrimage for generations of artists and art-lovers. AVa

Marcel Duchamp (American, born France, 1887–1968)
Nude Descending a Staircase (No. 2), 1912
Oil on canvas, 57⅞ × 35⅛ in. (147 × 89.2 cm)
The Louise and Walter Arensberg Collection, 1950-134-59
© Succession Marcel Duchamp / ADAGP, Paris / Artists Rights Society (ARS), New York 2014

Constantin Brancusi (French, born Romania, 1876–1957)
The Kiss, 1916
Limestone, H. 23 in. (58.4 cm)
The Louise and Walter Arensberg Collection, 1950-134-4
© 2014 Artists Rights Society (ARS), New York / ADAGP, Paris

Paul Klee (Swiss, 1879–1940)
Fish Magic, 1925
Oil and watercolor on canvas on panel, 30⅜ × 38¾ in. (77.1 × 98.4 cm)
The Louise and Walter Arensberg Collection, 1950-134-112

Henri Matisse (French, 1869–1954)

Mademoiselle Yvonne Landsberg, 1914
Oil on canvas, 58 × 38⅜ in. (147.3 × 97.5 cm)
The Louise and Walter Arensberg Collection, 1950-134-130
© 2014 Succession H. Matisse / Artists Rights Society (ARS), New York

For Henri Matisse, this portrait of Yvonne Landsberg, the nineteen-year-old daughter of a Brazilian financier, was no ordinary commission. Matisse started with a naturalistic likeness but fully reworked the composition during each sitting, deindividualizing the face and simplifying both the body and the space it occupies. In the final session he used a sharp tool to incise curves radiating from the figure's shoulders and hips, creating a startling expansion of his sitter's form. Seeking creative latitude, Matisse allowed the Landsbergs to see the finished picture before deciding whether to make an offer to purchase. They declined. Collectors Louise and Walter Arensberg (see pp. 236–37) acquired the portrait at the artist's first solo exhibition in New York in 1915. MA

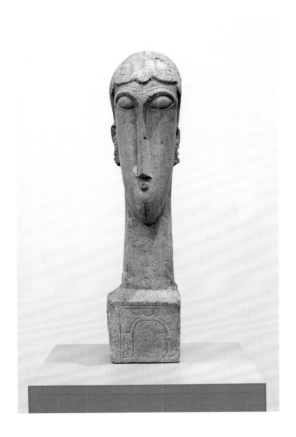

Amedeo Modigliani (Italian, 1884–1920)

Head of a Woman, 1912
Limestone, H. 27¾ in. (70.5 cm)
Gift of Mrs. Maurice J. Speiser in memory of her husband,
1950-2-1

Known for his elegant, reductive painted portraits
of fellow artists and notable patrons of the Parisian
avant-garde, Amedeo Modigliani created roughly two
dozen sculptures between 1909 and 1915. A remark-
able example from that period, *Head of a Woman*
displays the graceful lines, elongated composition,
and geometrically stylized features that character-
ize the artist's work. Having moved to Paris in 1906,
Modigliani learned the techniques of direct carving
from Constantin Brancusi. Yet his own approach to
sculpture, as with painting, combined modernism
with a prodigious interpretation of the art forms of
other places and times, from ancient Egypt and the
Cyclades to Renaissance Italy. JV

Eugène Atget (French, 1857–1927)

Versailles—Faun, 1921–22
Albumen silver print, image and sheet (irregular): 8¹¹⁄₁₆ × 7¹⁄₁₆ in.
(22 × 18 cm)
125th Anniversary Acquisition. The Lynne and Harold
Honickman Gift of the Julien Levy Collection, 2001-62-267

With the thoroughness of a historian and the eye
of a novelist, Eugène Atget photographed Paris and
its environs for more than three decades, producing
nearly ten thousand images that form an unparalleled
statement about his time and place. As he often did
with his photographs of statues, he enlivened this
image by shooting the sculpted faun from an elevated
angle to animate the figure's dynamic energy. Atget
photographed trees as ambitiously as sculptures, and
in this view the trunk of an established chestnut
vies with the statue, providing the faun with a fit-
ting woodland bower and directing our gaze into
the receding grove beyond. This is one of 361 Atget
prints from the Julien Levy Collection, which came
to the Museum in 2001 and comprises a total of 2,500
photographs—including modernist masterworks
and Levy's personal trove of Surrealist found photo-
graphs—which he exhibited at his groundbreaking
New York gallery in the 1930s and 1940s. PB

Constantin Brancusi (French, born Romania, 1876–1957)
Bird in Space (Yellow Bird), 1923–24
Marble with marble, limestone, and oak base; H. 8 ft. 7 in.
(2.62 m) with base
The Louise and Walter Arensberg Collection, 1950-134-19
© 2014 Artists Rights Society (ARS), New York / ADAGP, Paris

Born in Romania but living in Paris after 1904,
Constantin Brancusi developed an absolutely mod-
ern sculptural idiom. Seeking inspiration in ancient,
folk, and exotic precedents, he arrived at simplified
forms and hand-carving techniques that moved his
work beyond the verisimilitude exemplified by the
popular sculpture of Auguste Rodin (see, for example,
pp. 214–16). This elegant sculpture is one of four in
the Museum's collection representing Brancusi's life-
long obsession with the theme of the bird, a subject
he explored in more than thirty marble and bronze
sculptures. The bird epitomized the artist's search for
an ideal form that triumphs over the imperfections
of earthly existence. Here all the parts of the creature
become one soaring movement, with an elegance
resulting from its slightly swelling chest and graceful,
slender footing. Brancusi considered bases integral to
his sculpture, and their contribution to the principles
of balance, proportion, and combination are central
to his aesthetic. The pedestal's rough textures and vari-
ety of shapes provide a counterpoint to the smooth
unity of the marble bird. JV/AT

Designed by **René Lalique** (French, 1860–1945); made by
René Lalique et Cie (Wingen-sur-Möder and Combs-la-
Ville, France, 1909–present)

"Whirlwinds" Vase, 1926
Glass with enamel decoration, н. 8 in. (20.3 cm)
The Henry P. McIlhenny Collection in memory of Frances P.
McIlhenny, 1986-26-146

Although the Museum purchased nothing from
the great 1925 International Exposition of Modern
Industrial and Decorative Arts in Paris, several
avant-garde designers represented there found clients
among Philadelphia's cosmopolitan elite, including
Frances P. McIlhenny, who, in August 1928, bought
this masterwork from René Lalique's showroom in
Paris. Lalique had served as president of the glass jury
at the 1925 exhibition, where he displayed in his own
pavilion press-molded glassware in the new abstract,
Cubist-inspired style. This dynamic vase—decorated
in deep relief, its faceted swirls heightened with black
enamel—demonstrates the technical mastery that
made Lalique's work so appealing to fashionable
modernists. KBH

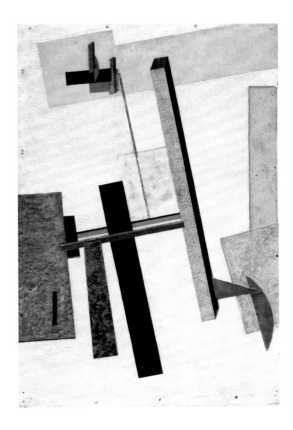

El Lissitzky (Russian, 1890–1941)

Proun 2, 1920
Oil, paper, and metal on panel; 23⁷⁄₁₆ × 15¹¹⁄₁₆ in. (59.5 × 39.8 cm)
A. E. Gallatin Collection, 1952-61-72

El Lissitzky made the series of works called *Prouns*
between 1919 and 1923, in the climate of cultural
experimentation and utopian anticipation that fol-
lowed the Russian Revolution of 1917. "Proun," an
acronym for the Russian phrase "Project for the
Establishment of the New," expresses the idea that
society can be revolutionized through the transforma-
tion of perception. Here the abstract composition of
floating shapes evokes a futuristic city seen in aerial
perspective, but the laws of gravity and the conven-
tions of orientation and relative size that govern our
understanding of space have been suspended. This is a
vertiginous glimpse or visionary diagram of a new life
to come. AVa

THE A. E. GALLATIN COLLECTION

The Museum is distinguished among American encyclopedic museums by its history of exceptional commitment to collecting the art of its time. This endeavor was bolstered in the early 1950s with the acquisition through bequest of the collections of Albert E. Gallatin (1881–1952) and Louise and Walter Arensberg (see pp. 236–37), two of the most significant private holdings of avant-garde art formed during the early twentieth century in the United States.

Heir to a banking fortune, Gallatin was born in Villanova, Pennsylvania, but spent most of his life in New York and Paris. His early interests revolved around the work of James Abbott McNeill Whistler and the American Impressionists, but by the 1920s he was a frequent visitor to the Paris studios of Georges Braque, Fernand Léger, Piet Mondrian, and Pablo Picasso. One of only a handful of American collectors of vanguard European art, in 1927 he opened his Gallery (later Museum) of Living Art in a study area of a New York University building.

Announced as the first public collection in the world devoted exclusively to contemporary art, the gallery was a beacon for many young American artists, including Philip Guston and Jackson Pollock. Visitors encountered the extraordinary juxtaposition of Léger's *The City* (1919; p. 233) and Picasso's *Three Musicians* (1921; p. 235), the crown jewels of Gallatin's collection, along with a rotating display of works by, among others, André Derain, Juan Gris, and El Lissitzky (see pp. 223, 241). Gallatin's range is demonstrated by such acquisitions as Joan Miró's mystical and poetic canvas *Dog Barking at the Moon* (right, bottom) and Mondrian's austerely abstract *Schilderij (Picture) No. 1: Composition with Two Lines and Blue* (below), both of 1926. *Glass of Absinthe* (1914; right, top), one of Picasso's extraordinarily rare early sculptures, is a testament to the collector's acumen.

When in 1942 New York University terminated its lease of Gallatin's gallery space, Museum Director Fiske Kimball persuaded him to loan his collection to Philadelphia. The inaugural display of Gallatin's holdings opened at the Museum in May 1943 (see fig. 10), and the more than 160 objects entered the collection after Gallatin's death in 1952. AVa

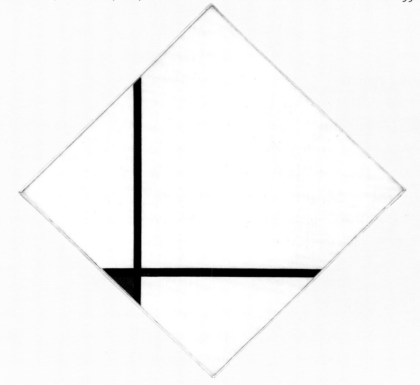

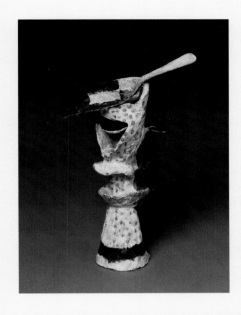

Piet Mondrian (Dutch, 1872–1944)

Schilderij (Picture) No. 1: Composition with Two Lines and Blue, 1926
Oil on canvas, 24¹/₁₆ × 24¹/₁₆ in. (61.1 × 61.1 cm)
A. E. Gallatin Collection, 1952-61-87
© 2014 Mondrian / Holtzman Trust c/o HCR International USA

Pablo Picasso (Spanish, 1881–1973)

Glass of Absinthe, 1914
Painted bronze with silver-plated spoon, H. 8⅞ in. (22.5 cm)
A. E. Gallatin Collection, 1952-61-114
© 2014 Estate of Pablo Picasso / Artists Rights Society (ARS), New York

Joan Miró (Spanish, 1893–1983)

Dog Barking at the Moon, 1926
Oil on canvas, 28¾ × 36¼ in. (73 × 92.1 cm)
A. E. Gallatin Collection, 1952-61-82
© Successió Miró / Artists Rights Society (ARS), New York / ADAGP, Paris 2014

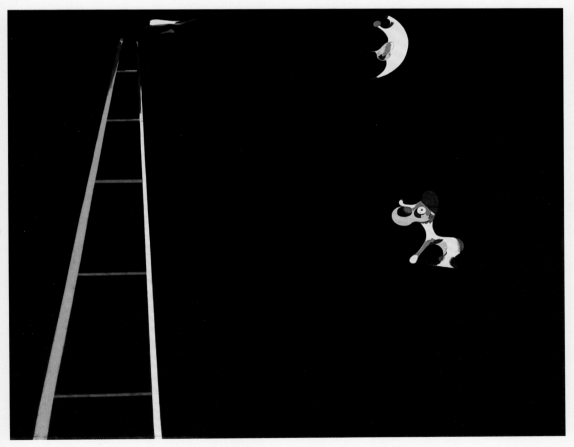

Designed by **Ludwig Mies van der Rohe**
(American, born Germany, 1886–1969); made by **Berliner Metallgewerbe Josef Müller** (Berlin) or **Bamberg Metallwerkstätten** (Berlin-Neukölln)

Armchair and Stool, designed 1927, made c. 1931
Chrome-plated steel, lacquered caning; H. (armchair) 32½ in. (82.6 cm), H. (stool) 18½ in. (47 cm)
Gift of Collab: The Group for Modern and Contemporary Design at the Philadelphia Museum of Art, in memory of Roland Gallimore, 1978-116-1,2

Bent tubular-steel furniture was the most technologically advanced in the world when Bauhaus instructor Marcel Breuer and Dutch architect Mart Stam introduced it separately around 1925. Taking advantage of the strength and spring quality of steel tubes, Ludwig Mies van der Rohe designed this chair as a cantilever, with the frame and attached arms curving out in front of a U-shaped base in what appears to be a continuous loop. This revolutionary model and its accompanying side chair, first shown at the influential exhibition *Die Wohnung* (The Dwelling) in Stuttgart, Germany, in 1927, defined twentieth-century modernism with their industrial material and sleek, minimal design. KBH

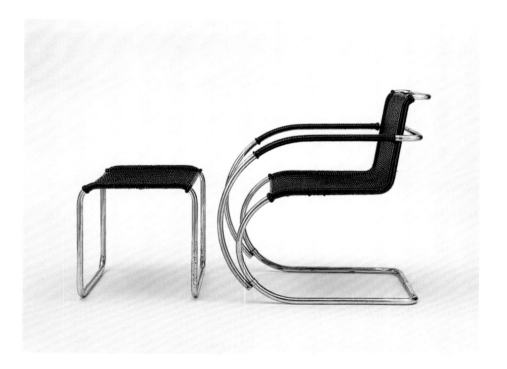

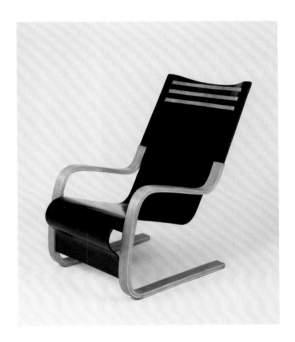

Designed by **Alvar Aalto** (Finnish, 1898–1976); made by
Oy Huonekalu-ja Rakennustyötehdas AB (Turku,
Finland, 1910–present)

Armchair, c. 1931–32
Birch-faced plywood, laminated birch, leather; H. 37½ in.
(95.3 cm)
Purchased with funds contributed by Collab: The Group for
Modern and Contemporary Design at the Philadelphia Museum
of Art, in honor of Cynthia W. Drayton, and with the Fiske
Kimball Fund, 1985-67-1

Wholly innovative in its form and the technology
required to produce it, this armchair, a rare variant of
Alvar Aalto's popular "standard" chair, is a centerpiece
of the Museum's modern design collection. It is built
as a free cantilever, with the seat and back formed
from one long, curved panel of springy, molded ply-
wood suspended between two laminated U-shaped
loops. Put into production in the 1930s after extensive
experimentation, Aalto's plywood chairs were unprec-
edented in their audacious manipulation of wood,
and many critics considered them more comfortably
"human" than the cold, hard metal cantilever chairs
of the designer's contemporaries (see, for example,
p. 244). KBH

Jacques-Émile Ruhlmann (French, 1879–1933)
Writing Desk and Chair, c. 1925
Desk: Macassar ebony with ivory inlay; suede; chair: rosewood,
upholstery; H. (desk) 44½ in. (113 cm), H. (chair) 31⅞ in. (81 cm)
Gift of Collab: The Group for Modern and Contemporary
Design at the Philadelphia Museum of Art, 1976-227-1 (desk).
Purchased with funds from Collab: The Group for Modern and
Contemporary Design at the Philadelphia Museum of Art, and
with the gifts (by exchange) of Mrs. Newell J. Ward and Dorothy
Reed, 2006-77-1 (chair)

Collab, the Museum's affiliate for modern and
contemporary design (see pp. 408–9), supported the
purchases of this desk and chair to commemorate
the institution's centennial in 1976 and opening of
the Perelman Building in 2007, respectively, thereby
associating the group's name with Jacques-Émile
Ruhlmann, the foremost French luxury furniture
designer of the twentieth century. Known for his use
of rare and costly materials and exquisite craftsman-
ship, Ruhlmann was compared by contemporaries to
great historical cabinetmakers. While acknowledging
traditional forms, as in this writing desk and elegantly
curved chair inspired by eighteenth-century models,
he created an original modern style defined by clean
outlines, simple veneers, and spare ornament. KBH

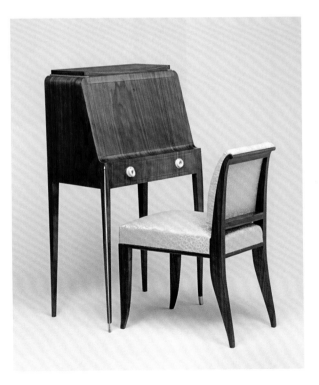

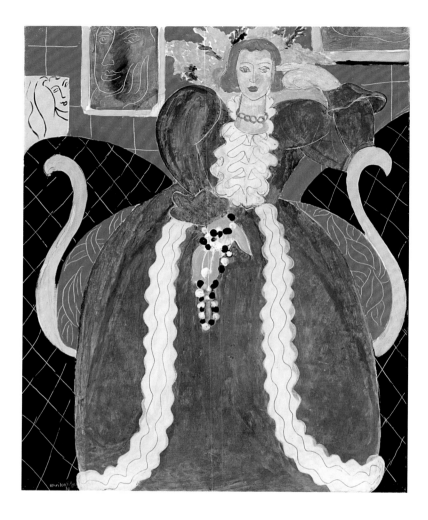

Henri Matisse (French, 1869–1954)

Woman in Blue, 1937
Oil on canvas, 36½ × 29 in. (92.7 × 73.7 cm)
Gift of Mrs. John Wintersteen, 1956-23-1
© 2014 Succession H. Matisse / Artists Rights Society (ARS), New York

For this portrait of Russian émigré Lydia Delectorskaya, Henri Matisse focused on his model's costume and surroundings rather than her personal appearance. The simplicity of the composition is striking, with a basic palette and a seemingly casual harmony of curves and grids. Many of the lines, in fact, were scraped out from the wet ground—a technique the artist first used in his portrait of Yvonne Landsberg (p. 238). Yet photographs taken over the three months that Matisse worked on this painting show how it began as a relatively naturalistic portrayal, full of depth and detail, and only gradually evolved into a flattened picture with exaggerated proportions. These photographs, as well as Delectorskaya's blue silk skirt, also are part of the Museum's collection. AT/JV

Designed by **Elsa Schiaparelli** (French, born Italy, 1890–1973) in collaboration with **Salvador Dalí** (Spanish, 1904–1989)

"Lobster" Dress, 1937
Silk organza, synthetic horsehair
Gift of Mme Elsa Schiaparelli, 1969-232-52

In the 1930s Elsa Schiaparelli's collaborations with artists changed the face of fashion. One of her most famous designs, this evening dress adorned with an oversize printed lobster was among her many collaborative projects with Salvador Dalí, who in 1934 had begun employing this shellfish as a motif in his work. Like many of Schiaparelli's designs from the late 1920s through the 1930s, the gown combines the aesthetics of modernism with the polemics of Surrealism. Heiress Daisy Fellowes, a frequent patron of the designer, wore the dress, and a version was purchased for American socialite Wallis Simpson's trousseau of eighteen Schiaparelli garments for her marriage to the Duke of Windsor in 1937. The present example, from the designer's personal wardrobe, was among the seventy-one original models she gave to the Museum in 1969. Her gift included another iconic collaboration with Dalí, the *Tear* dress (1938), and garments created with French artist and writer Jean Cocteau. DB

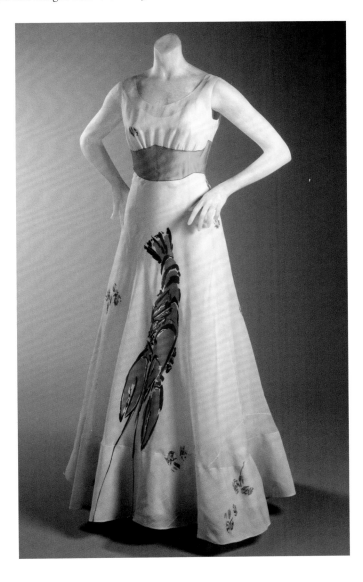

Salvador Dalí (Spanish, 1904–1989)

*Soft Construction with Boiled Beans
(Premonition of Civil War),* 1936

Oil on canvas, 39⁵⁄₁₆ × 39³⁄₈ in. (99.9 × 100 cm)
The Louise and Walter Arensberg Collection, 1950-134-41
© Salvador Dalí, Fundació Gala-Salvador Dalí / Artists Rights Society (ARS),
New York 2014

Gruesome, bizarre, and excruciatingly meticulous in technique, Salvador Dalí's paintings rank among the most compelling portrayals of the unconscious mind. For this canvas—a highlight of the Museum's extensive Surrealist holdings—the artist turned his attention to the impending Spanish Civil War, which began in 1936 with Francisco Franco's nationalist insurrection against the country's democratic government.

In painting, sculpture, photography, and film, the Surrealists reveled in the desecration of the human body, but few descended to the depth of tortuous anatomy found in this picture. Dalí's monstrous human-like figure deliriously tears itself apart in a premonitory allegory of the bloody conflict that would befall Spain. Its ecstatic grimace, taut neck muscles, elasticized torso, and petrifying fingers and toes create a vision of disturbing fascination.

So persuasive is this terrifying construction that it appears to be an authentic natural phenomenon rather than an imagined apparition. By draping the limp phallic shape over the truncated hip, Dalí deployed his signature device of "soft" form, while the scattered beans of the title exemplify the bizarre incongruities of scale used to conjure the workings of an unconscious mind. The artist paid homage to Sigmund Freud, whose work inspired him to embrace such nightmarish visions, with a tiny portrait of the psychoanalyst inspecting the gnarled hand at lower left. MT/JV

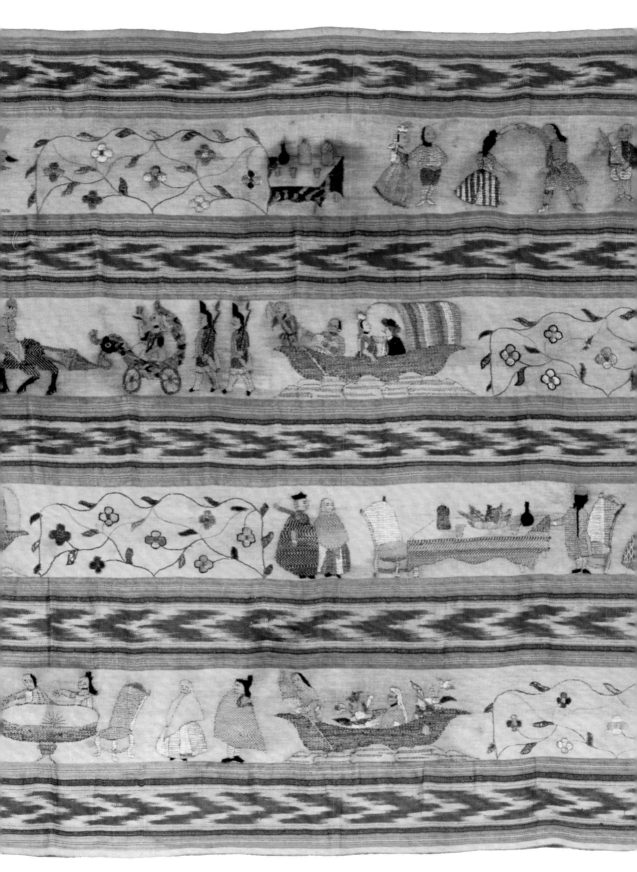

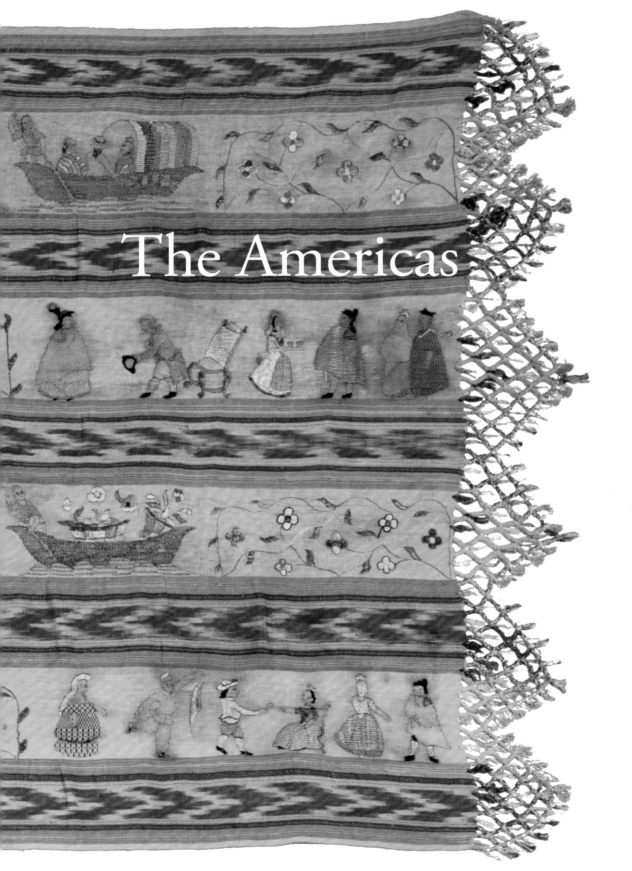

The Americas

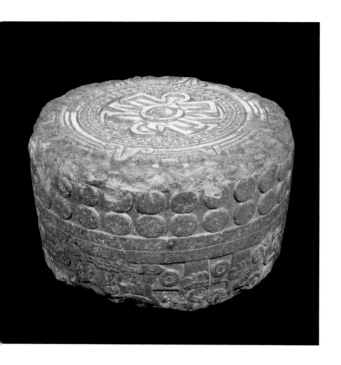

Attributed to **Damián Hernández** (Mexican, born Spain, documented 1607–53)

Jar with Handles, mid-17th century
Earthenware with tin glaze, H. 18½ in. (47 cm)
Purchased with funds contributed by Mrs. John Harrison, 1907-295

Located some sixty miles southeast of Mexico City, Puebla de los Angeles was colonial Mexico's principal center for glazed pottery from the late 1500s. The mark "he" on this jar and on a nearly identical example at the Hispanic Society of America in New York is attributed to Damián Hernández, a master potter and cofounder of the Puebla potter's guild. Informed by diverse artistic influences of Western, Islamic, and Asian origin (Mexico was on Spain's trade route with China), the decoration on this outstanding example of Puebla ware includes a European woman in a chariot, Chinese figures, and human and animal forms filled with dots, a motif first introduced to Spain by Muslim potters. JH

Sacrificial Stone
Mexico, Aztec, 1300–1500
Greenstone, DIAM. 33 in. (83.8 cm)
The Louise and Walter Arensberg Collection, 1950-134-403

According to sixteenth-century Spanish chroniclers, the Aztecs used sacrificial stones such as this, called *temalacatls*, as altars during important rituals, particularly coronation ceremonies. The precious greenstone and sophisticated decoration of this example, one of several pre-Columbian sculptures from the collection of Louise and Walter Arensberg (see pp. 236–37), suggest it might have been made in the Aztec capital of Tenochtitlan. The *ollin* (literally "movement") symbol carved on the stone's central panel signifies the era of Aztec rule as well as the fifth, and final, sun in Aztec creation mythology. Its curved outer edge features carvings of two rows of dots, perhaps representing stars, and the mask of the water deity Tlaloc surrounded by obsidian knives, possibly in reference to the object's function as a sacrificial altar. MAC

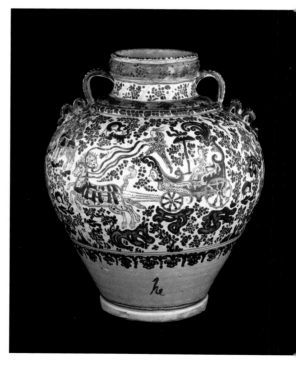

Cristóbal de Villalpando (Mexican, c. 1649–1714)

Saint Francis Defeats the Antichrist, c. 1691–92
Oil on canvas, 65⅜ × 60¾ in. (166.1 × 154.3 cm)
Purchased with funds contributed by Barbara B. and Theodore R. Aronson, 2008-6-1

This canvas belongs to a series of paintings illustrating the life of Saint Francis of Assisi by Cristóbal de Villalpando, the preeminent artist in seventeenth-century Mexico. The violent confrontation between Francis and the Antichrist originally was echoed by a heavenly battle between angels and demons, but the top of the canvas was later trimmed, leaving visible only the figures' legs. Representations of this scene, which is not described in the biographies of the famously peaceful saint, have been found only in Mexico. This painting is an important example of the inventiveness of Spanish colonial artists, who adapted and created imagery to serve their patrons. MAC

LATIN AMERICAN ART

The Museum has exhibited and collected Latin American art throughout its history, over time building extensive holdings representing a range of cultures, periods, and mediums. Among the earliest public displays of this material in the United States occurred in 1888 at the Museum's first home, Memorial Hall, with the exhibition of Mexican colonial paintings from the collection of Robert H. Lamborn. In 1895 Lamborn, a railroad engineer and metallurgist, bequeathed to the institution seventy-five of these works, including Juan Rodríguez Juárez's

tender image of the Virgin and Child (below), painted on an unfinished copper printing plate from a children's textbook. Further enriching the institution's holdings of Mexican colonial art are significant examples of decorative arts and textiles, including an important group of Mexican majolica assembled in the early twentieth century by curator Edwin AtLee Barber, such as the jar attributed to Puebla potter Damián Hernández (p. 252). These collections have continued to grow through important purchases and generous gifts, including the recent promise of Andean colonial paintings from Roberta and Richard Huber, broadening the collection into South America (see, for example, p. 256).

In 1950 the major gift of Louise and Walter Arensberg's collection of modern art included several important pre-Columbian sculptures representing

Goddess Figure (Chalchiuhtlicue)
Central Mexico, Teotihuacan, c. 250–650
Volcanic stone with traces of pigment, H. 36¼ in. (92.1 cm)
The Louise and Walter Arensberg Collection, 1950-134-282

Juan Rodríguez Juárez (Mexican, c. 1675–1728)
Virgin and Child, c. 1700
Oil on copper, 11 × 8½ in. (27.9 × 21.6 cm)
The Dr. Robert H. Lamborn Collection, 1903-878

the complex indigenous past of Latin America (see p. 252; on the Arensberg Collection, see pp. 236–37). The sculpture of the Aztec goddess Chalchiuhtlicue (far left), for example, evokes traditions of mural painting and ceramics from the ancient city of Teotihuacan.

Twentieth-century art, especially from Mexico, forms a significant part of the Museum's collection. Through curator Henry Clifford and others, the Museum acquired paintings by the period's leading artists, such as Diego Rivera (p. 323); David Alfaro Siqueiros (p. 328); and Rufino Tamayo, whose 1943 painting *The Mad Dog* (below) captures the anxiety and fear surrounding World War II. A substantial

collection of prints, drawings, and photographs (see, for example, p. 322)—largely the result of the efforts of curator Carl Zigrosser—provides a comprehensive representation of the vibrancy of Mexican Modernism.

The Museum has continued its commitment to the field, expanding its collection to include works by contemporary Latino artists, such as Gabriel Orozco (p. 410), and by artists of the Latin American diaspora, such as Felix Gonzalez-Torres (p. 404). **MAC**

Rufino Tamayo (Mexican, 1899–1991)

The Mad Dog, 1943
Oil on canvas, 32 × 43 in. (81.3 × 109.2 cm)
Gift of Mrs. Herbert Cameron Morris, 1945-2-1
Art © Tamayo Heirs / Mexico / Licensed by VAGA, New York

Gaspar Miguel de Berrío (Bolivian, 1706–after 1764)

Our Lady of Mount Carmel with Bishop Saints,
1764
Oil on canvas, 38¾ × 33¹⁄₁₆ in. (98.5 × 84 cm)
Promised gift of the Roberta and Richard Huber Collection

The city of Potosí was a major artistic center in colonial Bolivia, and Gaspar Miguel de Berrío was among its most celebrated painters. Vibrant colors and richly detailed figures are characteristic of Berrío's style, which inspired painters throughout the region. Here the Virgin Mary is shown as Our Lady of Mount Carmel, a popular devotion of the Discalced Carmelites, whose emblem appears on her brown habit and on the scapular she holds in her right hand. Her voluminous cape, carried by angels, shelters two saints, possibly Fermin of Amiens and Bernard of Clairvaux. MAC

José Campeche y Jordán (Puerto Rican, 1751–1809)

The Divine Shepherdess, late 18th century

Oil on mahogany panel, 22⅟₁₆ × 16¹⁵⁄₁₆ in. (56 × 43 cm)
Purchased with funds contributed by Bruce and Robbi Toll,
Maude de Schauensee, Barbara B. and Theodore R. Aronson,
Mrs. Willem K. Dikland, Martha Hamilton Morris and I.
Wistar Morris III, Mr. and Mrs. Charles E. Mather III, Bayard
and Frances Storey, Mickey Cartin, Harriet and Ronald Lassin,
Angelica Z. and Neil L. Rudenstine, Mr. Philip C. Danby,
Roberta and Richard Huber, and David and Margaret Langfitt,
and with the Edith H. Bell Fund, the J. Stogdell Stokes Fund, the
Audrey Helfand Acquisition Fund, and the Edward and Althea
Budd Fund, 2013-1-1

José Campeche, the leading painter of colonial San
Juan, Puerto Rico, specialized in portraits but also
produced religious images, such as this charming
scene, for churches and private patrons. Here the
Virgin Mary is depicted as a simple shepherdess sur-
rounded by her flock and holding the Christ child in
her lap. In the distance a lost sheep being chased by a
wolf calls out "Ave Maria," a plea for the Virgin's help,
and is saved by the Archangel Michael, who strikes
down the predator. Campeche's painting accentu-
ates the tender protection offered by the Virgin, who
keeps watch over the faithful just as a shepherdess
shelters her flock. MAC

Fall from a Balcony

Mexico, c. 1803
Oil on canvas, 33¾ × 24½ in. (85.7 × 62.2 cm)
The Louise and Walter Arensberg Collection, 1950-134-492

On February 22, 1803, a servant named Barbara Rico
accidentally fell through a balcony, dropping the
child she was holding to the stone floor below. As the
inscription at the bottom of the painting explains, the
child was unhurt, a miracle attributed to the interces-
sion of the Virgin Mary, whom Barbara had invoked
as she fell. Popular throughout Latin America,
ex-votos such as this were produced as offerings of
gratitude for miraculous events. In 1950 modern art
collectors Louise and Walter Arensberg (see pp. 236–
37) donated an important collection of nineteenth-
century Mexican ex-votos to the Museum. MAC

John Head (American, born England, 1688–1754)

High Chest of Drawers and Dressing Table, 1726
Walnut, yellow pine, cedar, brass; H. (high chest) 64½ in.
(163.8 cm), H. (dressing table) 28¾ in. (73 cm)
Gift of Lydia Thompson Morris, 1928-7-12,13

The parents of Catherine Johnson of Germantown, Pennsylvania, commissioned this high chest and dressing table from furniture maker John Head for her marriage to Philadelphia merchant Caspar Wistar in 1726. Born and trained as a joiner in England, Head made the pieces in the latest English style. The pair's slender legs, turned in the shape of a trumpet, are supported by horizontal stretchers, which curve to mirror the arched bottom rail. The locally sourced walnut, specifically chosen for its swirling grain, is solid, not veneered, a distinctive feature on furniture made by and for Quakers, who objected to the use of deceptive facades. AAK

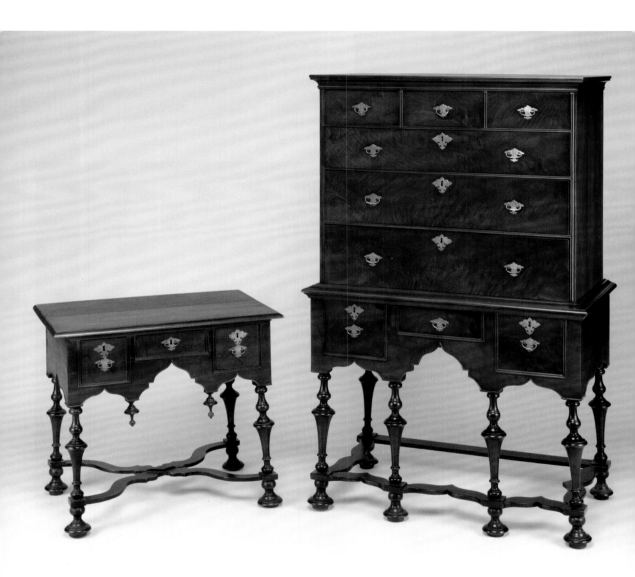

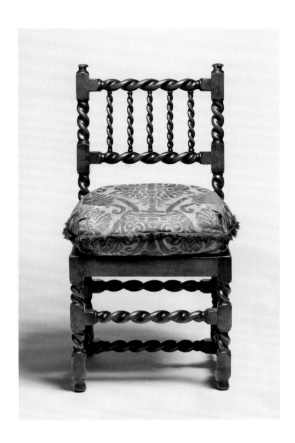

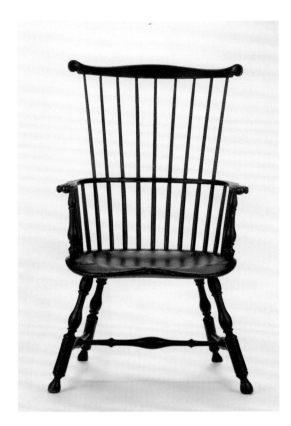

Side Chair

Probably Philadelphia, 1685–1710
Walnut, H. 39 in. (99.1 cm)
Purchased with Museum and Subscription Funds from the
Charles F. Williams Collection, 1923-23-53

One of the earliest surviving pieces of furniture made
in the Philadelphia region, this chair features double-
twist turnings popular in England and its colonies
after 1660. These sophisticated turnings, based on
continental European prototypes, probably were
made by a London-trained immigrant working in
Philadelphia. Designed to have a squab (cushion)
on the board seat, such a stylish chair would have
conveyed its owner's familiarity with current London
fashions. According to a nineteenth-century history,
the chair originally belonged to a family in Burlington
County, New Jersey, across the Delaware River from
Philadelphia. DLB

Windsor Armchair

Philadelphia, 1750–70
Painted hardwoods, H. 43 in. (109.2 cm)
Gift of Lydia Thompson Morris, 1928-7-111

Distinguished by their turned vertical supports,
saddle-shaped board seats, and painted surfaces,
Windsor chairs were first imported from Britain to
the American colonies in the 1740s. Philadelphia
furniture makers soon dominated their stylistic
development and production in the colonies, helping
them become nearly ubiquitous in eighteenth- and
nineteenth-century American households. On this
early example, the broad, horizontal rail counterbal-
ances the chair back's high and narrow design. The
curled shape of the handholds, based on the scroll
volutes of an Ionic column capital, often is found on
more formal mahogany or walnut armchairs (see, for
example, p. 261). AAK

THE MᴄNEIL AMERICANA COLLECTION

Chemist and pharmaceutical executive Robert L. McNeil, Jr. (1915–2010), had a lifelong passion for the arts and history of Philadelphia, and his most prized acquisitions combined outstanding aesthetic quality with great historical significance. A prime example is the rare Rococo sauceboat made in 1770–72 by the American China Manufactory, the city's first porcelain factory (p. 263). One of his early purchases,

an armchair attributed to William Savery (below), exemplifies Philadelphia's unique interpretation of the late Baroque style, and its ownership in the family of glassmaker Caspar Wistar enhances its importance. With a scholar's focus, McNeil put together comprehensive holdings in several categories. He gathered a stellar survey of paintings by the Peale family, from the work of its patriarch Charles Willson

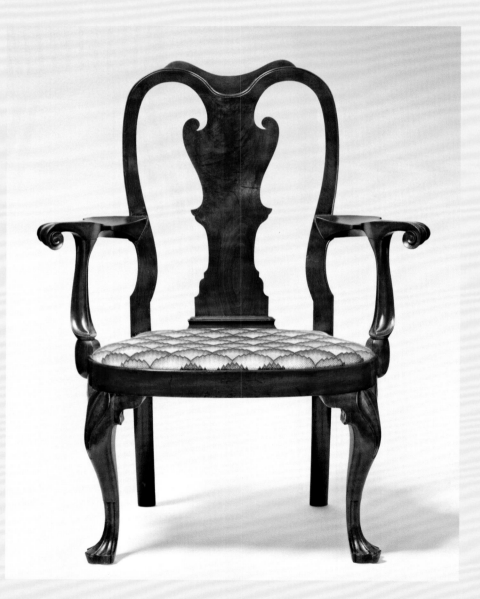

Peale to the creations of his myriad descendants, including his son Rubens's exuberant depiction of cut flowers (p. 287). He formed a reference collection comprising examples by a majority of Philadelphia's early silversmiths, many represented by exquisite objects such as the engraved Neoclassical tea caddy by the Richardson brothers (right, top).

Over a half century, McNeil assembled a spectacular survey of American art in many mediums. His broader interests included superb oil portraits by Gilbert Stuart and Thomas Eakins, as well as an important group of Hudson River school landscapes, such as Frederic Edwin Church's *Pichincha* (1867; p. 283). A fascination with early American statesmen led to his purchase of a porcelain plate owned by George Washington, which became the first piece of his collection of American presidential china, the most comprehensive group of White House tablewares outside Washington, DC. Among its treasures is the covered sugar bowl from the first official State Service, commissioned by President James Monroe in 1817 (right, bottom).

A trustee for more than four decades, McNeil left a legacy that established the Museum as a premier repository of American art. He donated and bequeathed his personal collection, and supported the purchase of objects with outstanding local significance, such as the Tucker factory's vases depicting the Fairmount Water Works, Eakins's *Gross Clinic*, and Jean-Antoine Houdon's bust of Benjamin Franklin (pp. 283, 294, 166, respectively). He endowed six curatorial positions in American art and funded

catalogues and galleries for the permanent collection. The immense educational value of the Museum's American holdings inspired McNeil to create the Center for American Art, which supports the institution's exhibitions, programming, and scholarship for present and future generations. **DLB/KAF**

Possibly by **William Savery** (American, 1722–1787)

Armchair, 1745–50
Walnut, oak, pine, yellow poplar; H. 42 in. (106.7 cm)
Promised gift of the McNeil Americana Collection

Partnership of **Joseph Richardson** (American, 1752–1831) and **Nathaniel Richardson** (American, 1754–1827)

Tea Caddy, c. 1780–90
Silver, H. 4⅝ in. (11.7 cm)
Gift of the McNeil Americana Collection, 2005-68-81a,b

Dagoty and Honoré (Paris, 1816–20)

Covered Sugar Bowl, 1817
Porcelain with printed, enamel, and gilt decoration; H. 6⅛ in. (15.6 cm)
Gift of the McNeil Americana Collection, 2006-3-50a,b

Ceiling plasterwork attributed to **James Clow** (American, born Scotland, active c. 1763–72); carving attributed to **Hercules Courtenay** (American, 1744–1784), **James Reynolds** (American, c. 1739–1794), **Nicholas Bernard** (American, born France, active 1762–89), and **Martin Jugiez** (American, active from 1762, died 1815)

Parlor from the Powel House, 1769–70
Gift of Mr. and Mrs. Wolf Klebasky, 1925. Gift of Mr. and Mrs. George D. Widener, 1926. Gift of H. Louis Duhring, 1926 (1925-61-1 . . 1927-76-1)

The elegant second-floor front parlor of the house of Philadelphia mayor Samuel Powel and his wife, Elizabeth Willing, was the venue for many special occasions, including George and Martha Washington's twentieth wedding-anniversary celebration. Here the architectural woodwork that survives from the Powel's parlor exemplifies British colonial artists'

interpretation of sixteenth-century Italian architect Andrea Palladio's bold classical style, embellished with Rococo ornaments—including flower, leaf, and scroll motifs, and the trophies of music—and the carved scene from Aesop's fables on the mantel.

Much of the art and furniture installed in this room at the Museum were made for another distinguished Philadelphia couple, John and Elizabeth Lloyd Cadwalader, who commissioned their house's interior furnishings from the same artisans who fashioned the Powel's parlor. Although the Cadwaladers' house was demolished in 1816, displayed here are examples of its lavish carved furniture and family portraits—ultimate symbols of wealth and prestige in colonial America—by Charles Willson Peale (see the card table and portrait, p. 266). AAK

American China Manufactory (Philadelphia, 1770–72)

Sauceboat, 1770–72

Porcelain with lead glaze and underglaze blue decoration,
H. 4⅝ in. (11.7 cm)
125th Anniversary Acquisition. Gift of the McNeil Americana
Collection, 2007-45-1

Admired for its hardness, resonance, and translucence, porcelain was a luxury good in the eighteenth century, and American and European manufacturers attempted to duplicate original Chinese prototypes. English pottery maker Gousse Bonnin and American entrepreneur George Anthony Morris established a porcelain manufactory in the Southwark section of Philadelphia in 1770, following closely on the success of a similar operation in South Carolina. This sauceboat, one of very few surviving wares from their factory, imitates contemporary English porcelains with its fluted edges, dotted diamond border, and Chinese-style landscape. A sauceboat of such diminutive size was intended for serving sweet cream or icing in the dessert course of a formal meal. AAK

Made by **Richard Humphreys** (American, born Tortola, 1750–1832); engraved by **James Smither** (English, 1741–1797)

Hot Water Urn, 1774

Silver, H. 21½ in. (54.6 cm)
Purchased with funds contributed by The Dietrich American
Foundation, 1977-88-1

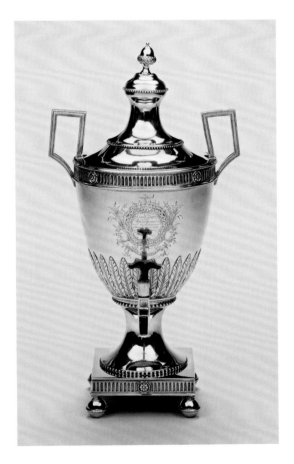

Among the Museum's unrivaled collection of Philadelphia silver is this impressive urn by Richard Humphreys. Used for dispensing hot water for tea, it is the earliest documented object made in colonial America in the Neoclassical style. While the urn's overall shape, arcade and bead moldings, and rosette and laurel-leaf decorations were based on contemporary English prototypes in the distinctive Neoclassical style of Scottish architect Robert Adam, the curvilinear, organic ornament of its engraved cartouche reflects the Rococo style still popular in the colonies in the 1770s. The First Continental Congress presented the urn to Charles Thomson, its secretary, in 1774, perhaps intending the vessel's classical style to evoke the ancient Roman Republic as a model for the fledgling American government. In the decade following the end of the Revolutionary War, Neoclassicism became the preferred style for silver made in Philadelphia and other American cities. DLB

Clockwise from top left:

Benjamin Wynkoop (American, 1675–1751)
Brandywine Bowl, 1698–1710
Silver, w. 11 in. (27.9 cm)
On permanent deposit from The Dietrich American Foundation
Collection

American brandywine bowls, such as this example
from The Dietrich American Foundation's superla-
tive collection of silver, were made exclusively in New
York, primarily for clients of Dutch ancestry, who
used them for traditional celebrations of births and
weddings. This bowl by Benjamin Wynkoop origi-
nally was owned by Nicholas and Heyltje Roosevelt,
married in 1682. As with other Dutch-inspired objects
made a generation or more after the English took
control of New York in 1665, Wynkoop's bowl departs
from European prototypes with its low foot and
boldly chased floral decoration, creating a distinctive,
local interpretation of the late Mannerist style. DLB

Philip Syng, Jr. (American, born Ireland, 1703–1789)
Coffeepot, 1750–55
Silver, wood; h. 11⅞ in. (30.2 cm)
Purchased with the John D. McIlhenny Fund, 1966-20-1

This coffeepot is an outstanding example of American
silver in the Rococo style that first became popular in
Philadelphia around 1750 due to the influx of objects
and craftsmen from Europe. To suit the prevailing
local taste for plain surfaces, most of the silver made
in the Philadelphia workshop of Philip Syng, Jr.,
lacked ornament such as the sumptuous repoussé
decoration of C-scrolls, flowers, and shells seen here.
The client who commissioned this coffeepot, Joseph
Galloway, clearly preferred furnishings in the latest
London fashion. A loyalist to the British Crown, he
fled to England in 1778, bringing this coffeepot with
him. DLB

Paul Revere, Jr. (American, 1735–1818)
Teapot, 1765–70
Silver, wood; h. 5¾ in. (14.6 cm)
On permanent deposit from The Dietrich American Foundation
Collection

Better known as a patriot during the American
Revolution, Paul Revere was the most prolific
and accomplished silversmith in late eighteenth-
century Boston. His shop produced domestic and

ecclesiastical objects for a clientele belonging to the
same civic, military, political, and religious organiza-
tions as Revere. With its inverted pear shape and
engraved ornament of C-scrolls, foliage, and shells,
the teapot epitomizes the Rococo style of his early
career. As a talented engraver of bookplates, magazine
illustrations, political prints, and trade cards, Revere
presumably executed the decoration himself. The
teapot featured in John Singleton Copley's famous
portrait of the silversmith (1768; Museum of Fine
Arts, Boston) might be this example. DLB

Benjamin Harbeson (American, 1728–1809)
Coffeepot, c. 1765–75
Copper, brass, wood; h. 9½ in. (24.1 cm)
Purchased with the Joseph E. Temple Fund, the J. Stogdell Stokes
Fund, and the John T. Morris Fund, 1977-113-1

Coffeepots of this type were popular in England
during the second half of the eighteenth century. The
wide base provided space for coffee grounds to collect,
and the extended wooden handle and incurving
profile protected the user from contacting the heated
pot. This is the only such coffeepot marked by a colo-
nial American coppersmith, Benjamin Harbeson of
Philadelphia, whose trade card declared, "My work
is all Stampt [stamped]," and included an image of a
similar pot that he made and sold. DLB

William Ball (American, 1729–1810)
Two-Handled Covered Cup, 1762
Silver, h. 12¼ in. (31.1 cm)
Purchased with contributions from Robert L. McNeil, Jr.,
H. Richard Dietrich, Jr., and with the Richardson Fund,
2005-40-3a,b

This magnificent covered cup by William Ball
was commissioned by the First Baptist Church of
Philadelphia with a legacy from the Reverend Jenkin
Jones, its pastor for fourteen years. Its double-dome
cover and wide double-scroll handles echo English
prototypes in the Baroque style. This cup is the only
Philadelphia example of this form, which was popular
as a presentation piece in Boston and New York, as
well as the only American example made for a reli-
gious purpose (serving wine during the Eucharist).
It is the earliest of the eleven silver cups and waiters
from First Baptist that the Museum acquired as a
group in 2005. DLB

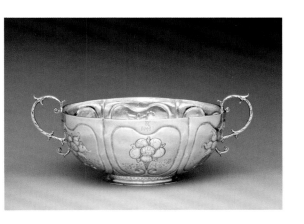

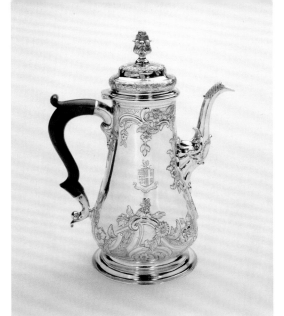

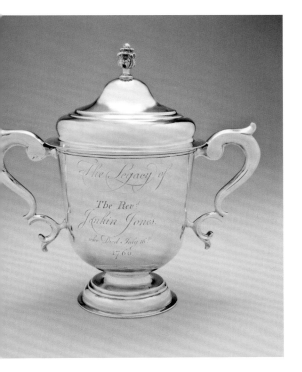

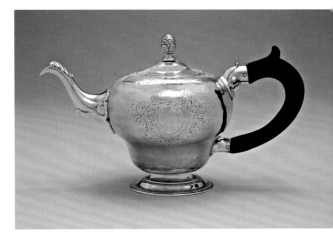

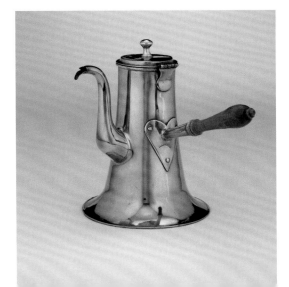

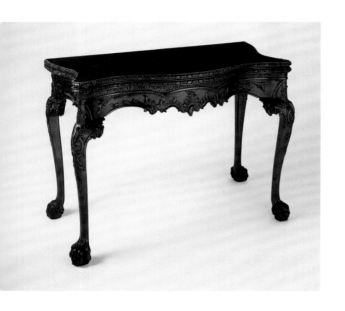

Charles Willson Peale (American, 1741–1827)

Portrait of John and Elizabeth Lloyd Cadwalader and Their Daughter Anne, 1772

Oil on canvas, 50½ × 41¼ in. (128.3 × 104.8 cm)
Purchased for the Cadwalader Collection with funds contributed by the Mabel Pew Myrin Trust and the gift of an anonymous donor, 1983-90-3

Successful Philadelphia merchant John Cadwalader, holding his hat and walking stick at his side, gently offers a ripe peach, a symbol of honor and virtue, to his firstborn child, Anne, while his wife, Maryland heiress Elizabeth Lloyd, gazes at him affectionately. In 1770 Cadwalader commissioned five family portraits, including this one, from Charles Willson Peale to adorn the sumptuous parlor of his new Philadelphia town house. Peale took great care in describing the luxurious fabrics, jewelry, and carved Rococo-style furniture (left) that were among the family's possessions. CES

Thomas Affleck (American, born Scotland, 1740–1795)

Commode Card Table, 1771

Mahogany, yellow pine, yellow poplar, oak; H. 28⅞ in. (73.3 cm)
Purchased for the Cadwalader Collection with funds contributed by the Mabel Pew Myrin Trust and with the gift of an anonymous donor, 1984-6-1

The sinuous lines and sumptuous carving of this mahogany card table, which is one of a pair, demonstrate the capability of colonial Philadelphia furniture makers and carvers to match or even exceed the quality of similar pieces made in London. Trained in his native Scotland, cabinetmaker Thomas Affleck oversaw the production of furniture commissioned for the lavish Philadelphia house of merchant John Cadwalader and his wife, Elizabeth Lloyd, whose portrait by Charles Willson Peale is in the Museum's collection (right). The table's Rococo-style carved ornament, including the boldly articulated hairy-paw feet, was designed to complement its commode, or curved, profile and echo the elaborate woodwork in the Cadwaladers' house. AAK

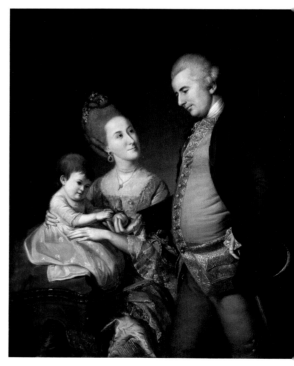

John Singleton Copley (American, 1738–1815)

Portrait of Mr. and Mrs. Thomas Mifflin (Sarah Morris), 1773

Oil on ticking, 61⅝ × 48 in. (156.5 × 121.9 cm)

125th Anniversary Acquisition. Bequest of Mrs. Esther F. Wistar to The Historical Society of Pennsylvania in 1900, and acquired by the Philadelphia Museum of Art by mutual agreement with the Society through the generosity of Mr. and Mrs. Fitz Eugene Dixon, Jr., and significant contributions from Stephanie S. Eglin, and other donors to the Philadelphia Museum of Art, as well as the George W. Elkins Fund and the W. P. Wilstach Fund, and through the generosity of Maxine and Howard H. Lewis to the Historical Society of Pennsylvania, EW1999-45-1

In 1773 Philadelphia merchant Thomas Mifflin, a firebrand of the American Revolution and later the first governor of Pennsylvania, convened in Boston with like-minded rebels. While there, he and his wife, Sarah ("Sally") Morris, posed for this portrait by John Singleton Copley, the best painter in the colonies. The couple's radical politics may be suggested by Sally's work on a portable loom, weaving her own decorative fringe to demonstrate support of the boycott of highly taxed imported English goods. Copley's masterpiece, immediately recognized as one of his finest and most complex portraits, captures his sitters' plain but elegant Quaker style as well as their affectionate partnership. KAF

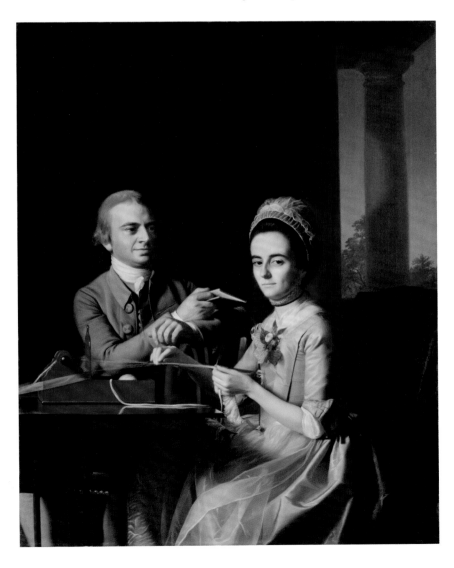

High Chest of Drawers and Dressing Table
Philadelphia, 1765–75

Mahogany, yellow poplar, white cedar, yellow pine, brass; H. (high chest) 96¾ in. (245.7 cm), H. (dressing table) 29⅞ in. (75.9 cm)
Gift of Mrs. Henry V. Greenough, 1957-129-1 (high chest).
Purchased with funds contributed by Leslie A. Miller and Richard B. Worley, Mrs. J. Maxwell Moran, Kathy and Ted Fernberger, Marguerite and Gerry Lenfest, Sarah Miller Coulson, Donna C. and Morris W. Stroud II, Dr. and Mrs. Robert E. Booth, Mr. and Mrs. Frederick Vogel III, Jr., Peggy Cooke, Hannah L. Henderson, Lawrence H. and Julie C. Berger, Hollie and Jamie Holt, George M. and Linda H. Kaufman, David and Margaret Langfitt, Richard Wood Snowden, Dr. Salvatore M. Valenti, and other generous individuals and with funds from the proceeds of the sale of deaccessioned works of art and other Museum funds, 2012-59-1 (dressing table)

This stately mahogany high chest and its corresponding dressing table, each featuring a dynamically carved scene from Aesop's fables, would have been the focal points of a bed chamber in colonial Philadelphia and integral to the room's architectural framework. Although conceived as a unit, the chest, the waist molding of which is positioned slightly higher than a room's chair rail, and the table, which would have fit just below the rail, are foils in size. While the swirling grain of the mahogany gives liveliness to the broad expanses of the pieces' drawers, it is the lavish carving that adds a playful Rococo whimsy to the bold Baroque forms. The exuberant woodwork culminates with the carved image on the bottom middle drawer of both the chest and the table, depicting the climactic scene from Aesop's tale "The Fox and the Grapes," in which the proud fox, unable to reach the succulent grapes hanging high on the vine, decries the fruit as unripe and thus refrains. Carved by one of the many London-trained woodworkers who arrived in Philadelphia in the late 1740s, the composition is based on an illustration in English carver Thomas Johnson's 1758 book of furniture designs. During this period, incorporating scenes from Aesop's fables into the decoration of carved interiors and furnishings was popular among Americans and Europeans who, influenced by the rationalism of the Enlightenment and classical thought, identified useful moral teachings in these ancient tales (see also p. 262). AAK

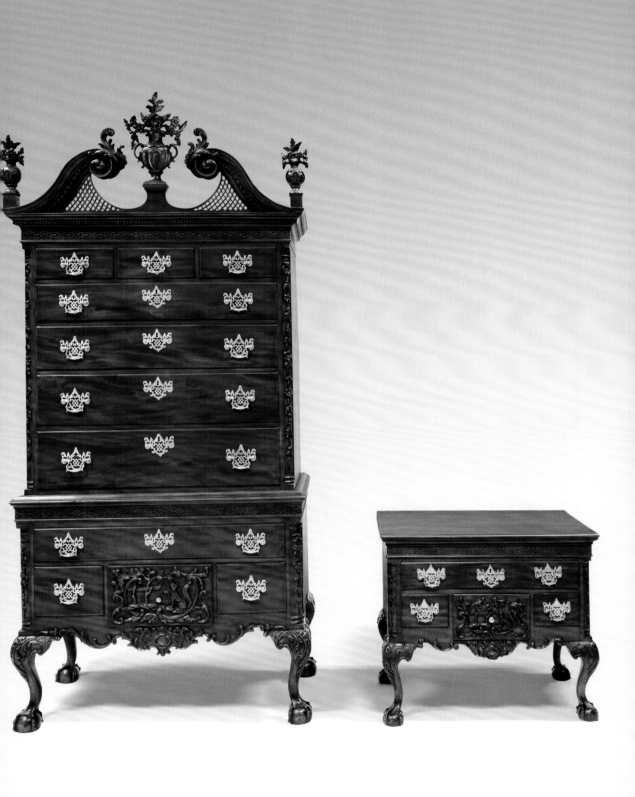

RURAL PENNSYLVANIA

After the English settled the colony of Pennsylvania in 1682, German-speaking Protestant immigrants moved into its rural areas, seeking fertile farmland and religious tolerance. As the Museum's preeminent Pennsylvania German holdings illustrate, their art remained distinct from English-influenced work, even as it diverged from European antecedents. In the 1890s curator Edwin AtLee Barber began acquiring slip-decorated redware pottery for the Museum, and the institution subsequently received major gifts of Pennsylvania German art from the collections of Titus C. Geesey (see p. 275), J. Stogdell Stokes, and Ralph Beaver and Mae Bourne Strassburger. More recently, the collection has been enhanced by Joan and Victor Johnson's promised gift of more than two hundred fraktur (see, for example, p. 273).

Immigrant craftsmen were the primary agents for introducing continental European styles and forms to Pennsylvania. Johann Christopher Heyne trained as a pewterer in Saxony before working as a journeyman in Stockholm and immigrating in 1742 to Pennsylvania with his Moravian congregation, for which he served as a schoolteacher and minister. His sophisticated understanding of the German Baroque style is reflected in the tall proportions, bold moldings, and flared cup of the chalice seen at far right. Most of Heyne's pewter wares were for ecclesiastical purposes, suggesting the church's central role in preserving cultural identity.

Language was another important means of maintaining traditions, as seen in the German text extolling the potter's craftsmanship inscribed

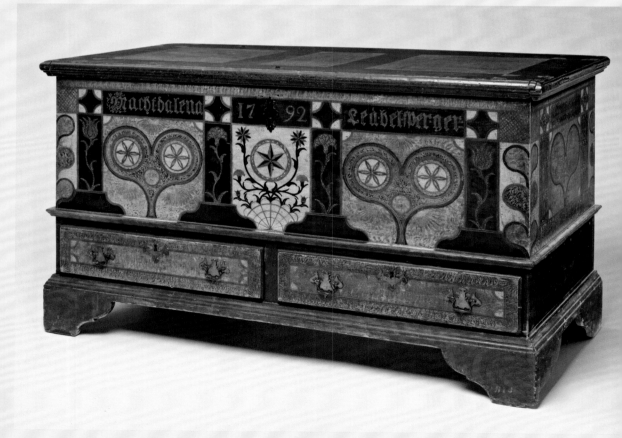

around the border of George Hübener's dish (below; translated, "Catarina Raeder, her dish. From the earth with skill the potter makes everything"). Born in Montgomery County, Hübener was the grandson of immigrants from Silesia, in Central Europe, and his pottery represents the vitality of Germanic artistic traditions at a remove of several generations. He made this richly ornamented plate using the sgraffito technique, cutting the design through a slip coating to expose the red clay underneath.

The chest attributed to John Bieber of Lehigh County (left) offers evidence of increasing influence of English styles on objects made in German-speaking enclaves. Its bracket feet and moldings were based on Georgian design; the brass hardware was imported from England; and the geometric, abstract decoration reflects the influence of English Neoclassical veneer and inlay. Yet, the vibrant painted ornament of the chest, like that of the Museum's monumental wardrobe (p. 274), features traditional Germanic motifs of compass-designed hearts and stars, freehand drawings of flowers, and sponged backgrounds. DLB

Attributed to **John Bieber** (American, 1768–1825)

Chest over Drawers, 1792
Yellow poplar, white and yellow pine, painted and inlaid decoration, brass, iron; w. 53 in. (134.6 cm)
Purchased with the Thomas Skelton Harrison Fund, the Fiske Kimball Fund, and the Joseph E. Temple Fund, 1982-68-1

George Hübener (American, 1757–1828)

Dish, 1786
Earthenware with lead glaze and slip and copper-oxide decoration, DIAM. 12⅝ in. (32.1 cm)
Gift of John T. Morris, 1900-21

Johann Christopher Heyne (American, born Germany, 1715–1781)

Covered Chalice, c. 1756–80
Pewter, H. 10⅞ in. (27.6 cm)
Purchased with the Lynford Lardner Starr Fund, 2008-110-1a,b

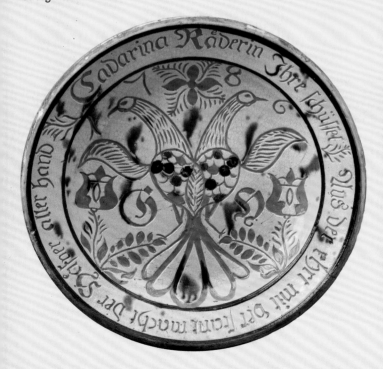

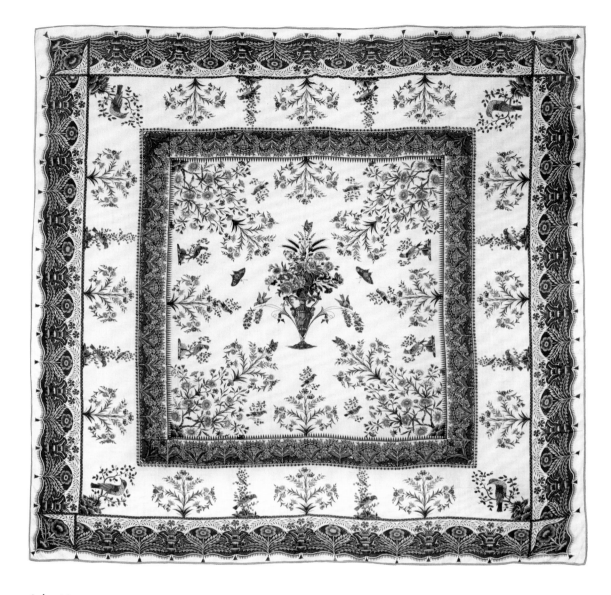

John Hewson (American, 1745–1821)

Bedcover, c. 1790–1810

Cotton, 8 ft. 6 in. × 8 ft. 5 in. (2.59 × 2.57 m)
Purchased with the Costume and Textiles Revolving Fund, the Phoebe W. Haas Fund for Costume and Textiles, the Thomas Skelton Harrison Fund, the John D. McIlhenny Fund, the Joseph E. Temple Fund, and funds contributed by Barbara B. and Theodore R. Aronson, Mr. and Mrs. Robert A. Fox, Maxine S. and Howard H. Lewis, Mrs. Samuel M. V. Hamilton, Barbara Y. Tiffany, Dr. and Mrs. Paul Richardson, Mrs. William H. Clausen III, Mr. and Mrs. Howard H. Lewis, Jr., David A. Schwartz, friends of the Department of Costume and Textiles, and the Women's Committee of the Philadelphia Museum of Art, 2011-101-1

John Hewson, a preeminent figure in American textile history, worked in the Kensington neighborhood of Philadelphia from 1774 to 1810 after emigrating from England, where he had apprenticed at several leading textile print works. Elaborately patterned with drapery swags, floral borders, and a center square with a flower-filled urn, this rare block-printed bedcover is Hewson's masterwork. Of the three known versions, two are in the Museum's collection: This example, in nearly pristine condition, preserves the integrity and vitality of the original color palette; the other belonged to Hewson himself. The third version is in the Winterthur Museum in Wilmington, Delaware. DB

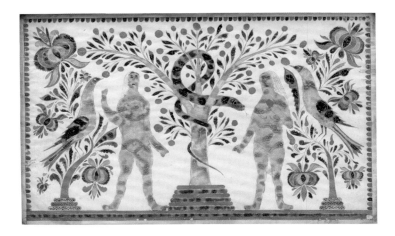

Attributed to **Samuel Gottschall** (American, 1808–1898)

Adam and Eve, c. 1834–35

Watercolor and ink on paper, sheet: 8 × 12½ in. (20.3 × 31.8 cm)
125th Anniversary Acquisition. Promised gift of Joan and
Victor Johnson

Images of Adam and Eve have a long history in
Germanic art and were popular subjects for fraktur,
hand-decorated religious and secular documents made
in Pennsylvania German communities in the eigh-
teenth and nineteenth centuries. This lively drawing
attributed to the Bucks County schoolteacher Samuel
Gottschall likely was created as an award of merit or
a religious lesson for a prized student. A masterwork
of its kind, it is one of over two hundred fraktur in
the promised gift from Joan and Victor Johnson that
will elevate the Museum's holdings of this genre to
a level comparable to its outstanding collections of
Pennsylvania German redware and painted furniture
(see pp. 270–71). SRL

Shawl

Mexico, late 18th century
Silk with silk and gilt thread, 30 × 90 in. (76.2 × 228.6 cm)
Gift of Mrs. George W. Childs Drexel, 1939-1-19

Shawls such as this, known as *rebozos*, were used
throughout Mexican society during the colonial
period. Although primarily utilitarian, a *rebozo*
often was given to a young woman to mark a special
occasion, such as her entrance into a convent. This
luxurious example, which would have been worn
by a woman from the Spanish aristocracy, features
resist-dyed patterning and embroidered decorations of
figures—clergy members, Indian women, and Creole
and Spanish elites—engaged in a variety of popular
pastimes, including boating, carriage riding, dancing,
and promenading. DB

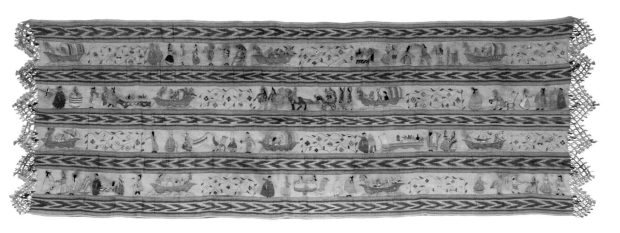

Wardrobe

Lancaster County, Pennsylvania, 1779
Black walnut, yellow pine, red oak, yellow poplar, sulfur inlay,
brass, iron; H. 81⅛ in. (206.1 cm)
Purchased with Museum funds, 1957-30-1

The exaggerated cornice and base, classical dentils and
guttae, and convex-molded panels of this wardrobe,
or *Kleiderschrank*, impart an architectural quality that
is reinforced by the object's monumental scale. It is
the most elaborately ornamented example of furniture
decorated with the sulfur-inlay technique, in which
molten sulfur is poured into incised channels, that
originated in Lancaster County in imitation of light-
wood inlay. The images of flowering vines, lovebirds,
crowns, and swastikas (for good fortune) suggest that
the wardrobe was made for a marriage. However,
George Huber, whose name is inscribed on the chest's
doors, married Barbara Oberholtzer in Lancaster in
1780, a year after this chest was made. DLB

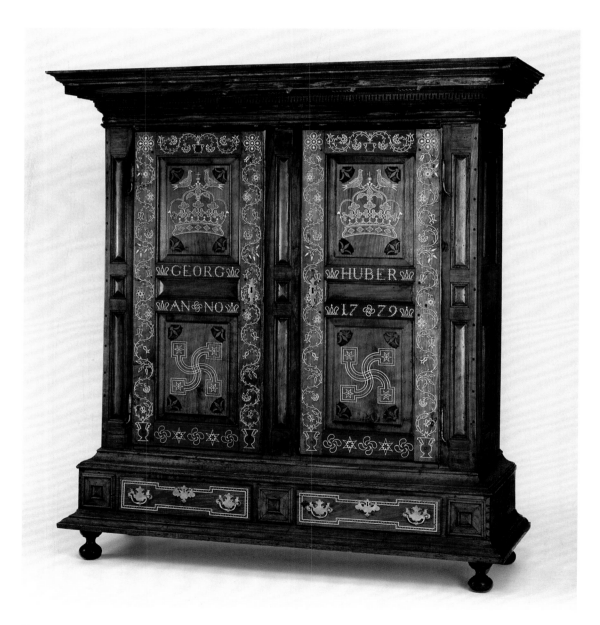

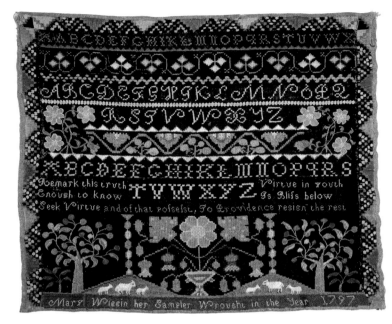

Door Hinge

Pennsylvania, 1720–1800
Wrought iron, H. 19⅞ in. (50.5 cm)
Titus C. Geesey Collection, 1953-125-11k

By the third quarter of the eighteenth century, Pennsylvania led the American colonies in iron production. Pennsylvania German blacksmiths tended to be full-time craftsmen, unlike potters or weavers who engaged in their trades during the winter break from farming. Although the majority of iron objects were utilitarian, blacksmiths occasionally had the opportunity to demonstrate their artistry on fireplace tools and architectural hardware, such as this exceptional hinge, one of a pair in the Museum's renowned collection donated by Titus C. Geesey. Composed of abstracted, scrolling foliage, the design follows a form created by German craftsmen in the sixteenth and seventeenth centuries, representing a continuation of that long tradition by immigrants to America. DLB

Mary Wiggin (American, born 1780)

Sampler, 1797

Linen with silk, 18¼ × 21⅜ in. (46.4 × 54.3 cm)
Whitman Sampler Collection, gift of Pet, Incorporated, 1969-288-18

Mary Wiggin likely completed this sampler while attending boarding school in Newbury or Newburyport, Massachusetts, in the late eighteenth century. The embroidered filling stitches, originally black but now dark brown, that almost completely cover the textile's ground are characteristic of samplers made in these New England communities, as are many of its motifs, in particular the flowering fruit tree and checkered sawtooth border, which are worked in shades of green, pink, tan, white, and yellow. Yet the sampler's especially dense embroidery makes it one of the most unusual examples in the Museum's extensive collection. This is one of several hundred American and European samplers dating from the seventeenth through the twentieth century that were given to the Museum in 1969 by Pet, Incorporated, then the parent company of Philadelphia-based confectionery Whitman's, famous for its popular "sampler" boxes of assorted chocolates. LLC

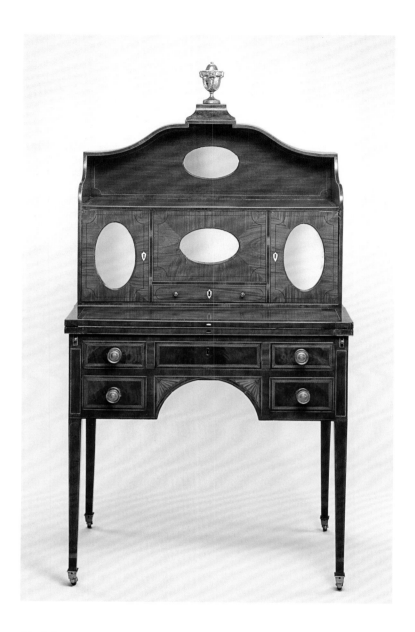

Possibly by **William Sinclair** (American, 1775–1852)

Lady's Cabinet and Writing Table, 1801–6
Mahogany, satinwood, white pine, yellow poplar, ivory, silvered glass; H. 59⅟₁₆ in. (150 cm)
Bequest of Miss Fanny Norris in memory of Louis Marie Clapier, 1940-46-2

French-born Philadelphia merchant Louis Marie Clapier ordered this cabinet and writing table for his wife, Maria Heyle, shortly after they married in 1801. The oval mirrors, ivory keyholes, and brass pulls of the table's central section suggest separate compartments; however, it is a single panel that can be raised to reveal an elegant interior with gilded columns, marquetry decoration, a mirrored back, and slots for storing documents. The hinged desktop unfolds to provide a generous writing surface. The urn that crowns the cabinet retains its original gilded surface and is a familiar ornament on Neoclassical arts of the early 1800s. AAK

Thomas Sully (American, born England, 1783–1872)

Portrait of Colonel Jonathan Williams, 1815
Oil on canvas, 81 × 58 in. (205.7 × 147.3 cm)
Gift of Alexander Biddle, 1964-111-1

In 1801 Colonel Jonathan Williams, grandnephew and former private secretary of Benjamin Franklin, became the first superintendent of the United States Military Academy at West Point. In this richly painted canvas by renowned Philadelphia portraitist Thomas Sully, the colonel, seated at a table on which his folded bicorne hat and gilded sword are placed, turns his attention and steady gaze toward the viewer. Behind him is a view of Castle Williams, the fort on Manhattan's Governors Island that, as the commander of the Army Corps of Engineers, he designed and built to defend New York against naval attack. CES

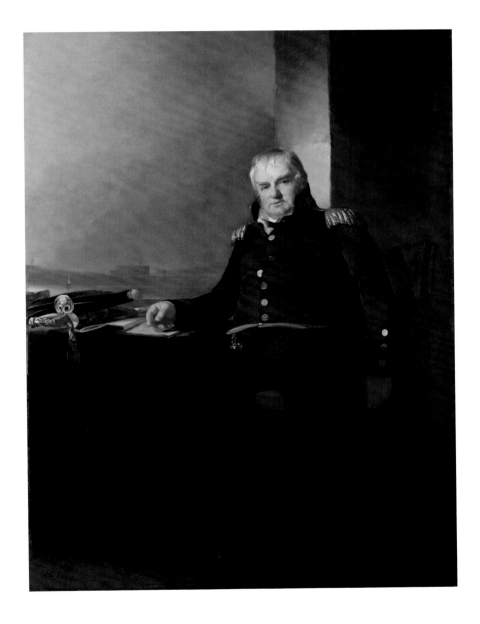

Made in the **Shaker community of Enfield, New Hampshire** (organized 1793, disbanded 1923)

Bench, c. 1825–50
Maple, hickory, pine; w. 61 in. (154.9 cm)
Gift of Mr. and Mrs. Julius Zieget, 1963-160-29

Shakers used benches instead of pews in their meetinghouses so the floors could be cleared for their ritual dances, the shaking movements of which inspired the sect's name. Originally painted red, this bench epitomizes the spare design favored by Shakers and illustrates their practice of simplifying common forms (here the arms and cross stretchers were eliminated from the traditional design of a Windsor bench). The back is a masterful combination of curved, tapered spindles and a trapezoidal crest rail. The donors of this piece assembled a large collection of Shaker artifacts in the early twentieth century, as communities like that of Enfield, New Hampshire, disbanded and consolidated. DLB

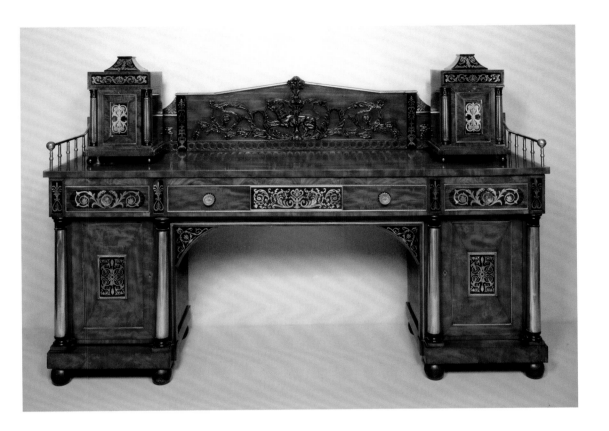

Sideboard, Knife Cases, and Wine Cooler

Philadelphia, 1825–30
Mahogany, ebony, brass, white pine, yellow poplar, unidentified
hardwoods, lead; w. (sideboard) 91 in. (231.1 cm), H. (knife cases)
21⅝ in. (54.9 cm) each, H. (wine cooler) 29½ in. (74.9 cm)
Bequest of Miss Elizabeth Gratz, 1909-2a–c (sideboard and knife
cases). Gift of Simon Gratz in memory of Caroline S. Gratz,
1925-76-2 (wine cooler)

The strong architectonic presence of this imposing
sideboard with knife cases, commissioned for the din-
ing room of Philadelphia merchant Simon Gratz, is
conveyed through the interplay of the various decora-
tive elements—the carved hunt scene, the European-
made brass and ebony marquetry panels, and the
central arch spanning the space between the two cases.
The shape of the wine cooler, fittingly carved with
robust grapevines, follows a tradition of such cases
being fashioned after ancient Roman sarcophagi.
Featuring a lead liner to hold ice water and a spigot
for draining, the cooler stands on castors for ease of
serving. AAK

Thomas Fletcher (American, 1787–1866)

The Maxwell Vase, 1829

Silver, H. 24³⁄₁₆ in. (61.4 cm)
Purchased with funds from the bequest of Lynford Lardner Starr,
2010-5-1a,b

New York merchants commissioned this vase from
local retailer Baldwin Gardiner for District Attorney
Hugh Maxwell, as an expression of gratitude for
his prosecution of corrupt financiers. To execute
the order, however, Gardiner secretly contracted

Philadelphia silversmith Thomas Fletcher, then the
foremost maker of presentation silver. Inspired by the
so-called Warwick Vase, an ancient Roman marble
urn, Fletcher responded with this spectacular example
of the classical revival style, which he had studied in
England in 1815. The sculptural quality of the vessel's
paw feet and sphinx supports is without parallel in
contemporary American silver, and anticipates work
from the later nineteenth century. DLB

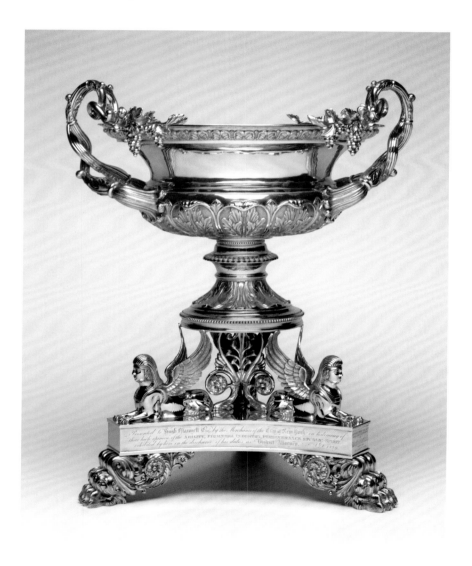

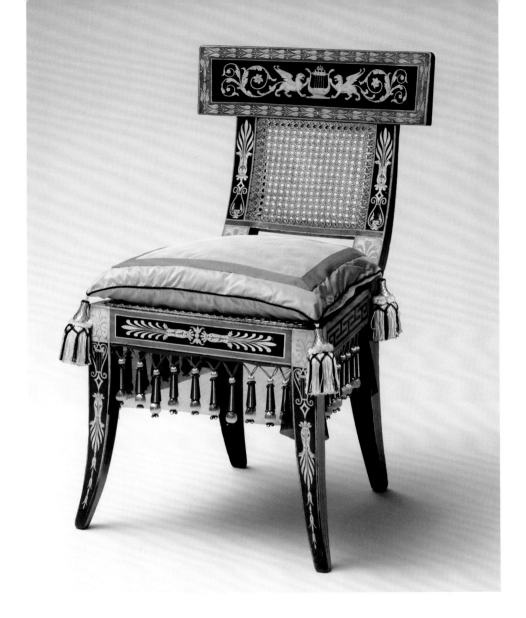

Designed by **Benjamin Henry Latrobe** (American, born England, 1764–1820); made by **John Aitken** (American, born Scotland, died 1839); decorated by **George Bridport** (American, born England, 1783–1819)

Side Chair, 1808

Gessoed, painted, and gilded yellow poplar and maple; H. 34¼ in. (87 cm)

Purchased with the gift (by exchange) of Mrs. Alex Simpson, Jr., and A. Carson Simpson, and with funds contributed by Mr. and Mrs. Robert L. Raley and various donors, 1986-126-6

In 1808 the construction of the Philadelphia house of merchant William Waln and his wife, Mary Wilcocks, was completed, and the interiors were furnished to the specifications of the building's architect, Henry Latrobe, who designed this chair and other furniture, all made by Philadelphia cabinetmaker John Aitken, for the main drawing room. The chair's inward curving legs identify it as a *klismos*, an ancient Greek seating form known through depictions found in classical art, including painted pottery and sculptural reliefs. George Bridport continued the theme by decorating the piece with classical symbols and motifs, and, at Latrobe's request, painting the room's walls with scenes from Homer's *Iliad* and *Odyssey*. AAK

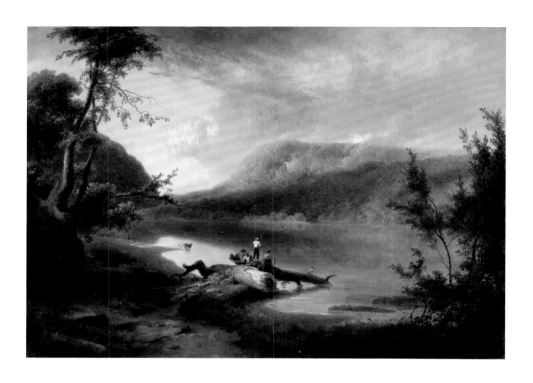

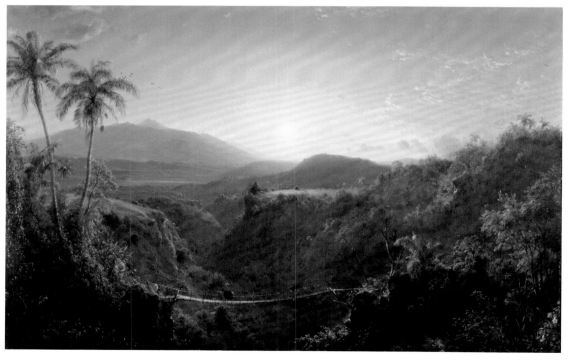

Thomas Doughty (American, 1793–1856)

Delaware Water Gap, 1827
Oil on canvas, 23⅜ × 32⅜ in. (59.4 × 82.2 cm)
Gift of the family of J. Welles Henderson in honor of Robert L.
McNeil, Jr., 2007-57-1

In the early nineteenth century, the natural landscape
of the United States inspired the country's first artis-
tic movement, led by Philadelphia native Thomas
Doughty and English-born Thomas Cole. In this
serene view of the Delaware Water Gap, a key gateway
through Pennsylvania's Pocono Mountains to the
nation's interior, Doughty captured the beauty of the
landscape's natural features, here enlivened by a dra-
matic play of light and atmosphere. In the distance,
the sun rises beyond the gap, illuminating the sky and
its vaporous clouds, and drawing the cowherds' atten-
tion to the quiet majesty of their surroundings. MDM

Frederic Edwin Church (American, 1826–1900)

Pichincha, 1867
Oil on canvas, 31 × 48³⁄₁₆ in. (78.7 × 122.4 cm)
125th Anniversary Acquisition. Gift of the McNeil Americana
Collection, 2004-115-2

Suffused with radiant light, Frederic Edwin Church's
view of the Ecuadorean Andes, with the volcano of
Pichincha rising in the background, conveys the sub-
lime power of nature in a moment of relative peace.
Church had visited the site in 1857, a decade before
completing this painting, following in the footsteps of
acclaimed German naturalist Alexander von Humboldt,
whose earlier illustrations of the volcano influenced
the composition of this canvas. Both Church and
Humboldt admired the microcosmic ability of views
such as this to capture the landscape's range of natural
features, from valleys populated by verdant rainforests
to snow-covered mountain peaks. MDM

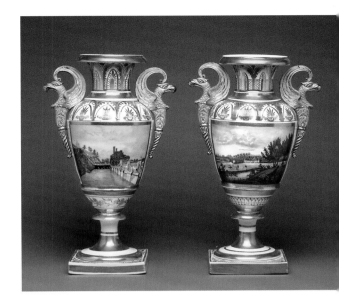

Made by **Tucker factory** (Philadelphia, 1826–38); decoration
attributed to **Thomas Tucker** (American, 1812–1890)

Pair of Vases, 1833–38
Porcelain with enamel and gilt decoration; patinated brass;
H. 21⅛ in. (53.7 cm) each
Purchased with the Baugh-Barber Fund, the Thomas Skelton
Harrison Fund, the Elizabeth Wandell Smith Fund, funds given
in memory of Sophie E. Pennebaker, and with funds contributed
by the Barra Foundation, Inc., Mrs. Henry W. Breyer, Mr. and
Mrs. M. Todd Cooke, The Dietrich American Foundation, Mr.
and Mrs. Anthony N. B. Garvan, the Philadelphia Savings Fund
Society, and Andrew M. Rouse, 1984-160-1,2

The size and resplendent decoration of these vases
make them monumental achievements of the por-
celain factory established by William Ellis Tucker in
Philadelphia in 1826 and continued by his brother,
Thomas, into the late 1830s. Wares produced at
their factory rivaled in quality European examples,
and often featured distinctive enamel paintings of
local historical figures and landscapes, contempo-
rary literary narratives, or old master paintings. The
extraordinary images on these vases proudly celebrate
Philadelphia's Fairmount Water Works, completed
in the 1820s and still standing near the Museum as a
testimony to the engineering triumph that brought
prosperity to the city by providing its residents with
a reliable water supply. The patina of the splendid
brass eagle handles gives them the appearance of
gilding. AAK

Rebecca Scattergood Savery (American, 1770–1855)

Quilt, 1839
Cotton, 9 ft. 7 in. × 9 ft. 11 in. (2.92 × 3.02 m)
Gift of Sarah Pennell Barton and Nancy Barton Barclay, 1975-5-1

Philadelphia Quaker Rebecca Scattergood Savery, who made at least six quilts for her family and friends during her lifetime, completed this bedcover in 1839 for her granddaughter Sarah Savery, who was born that year. Measuring nearly ten feet by ten feet, it is composed of almost four thousand pieces cut from forty-seven different small-patterned, roller-printed cottons. Individual pieces were basted to paper templates before being whipstitched together; the diamond-patterned quilting probably was done at a quilting bee. This piecework bedcover is one of the most important in the Museum's large and diverse quilt collection, which is especially rich in examples from the Philadelphia area. HKH

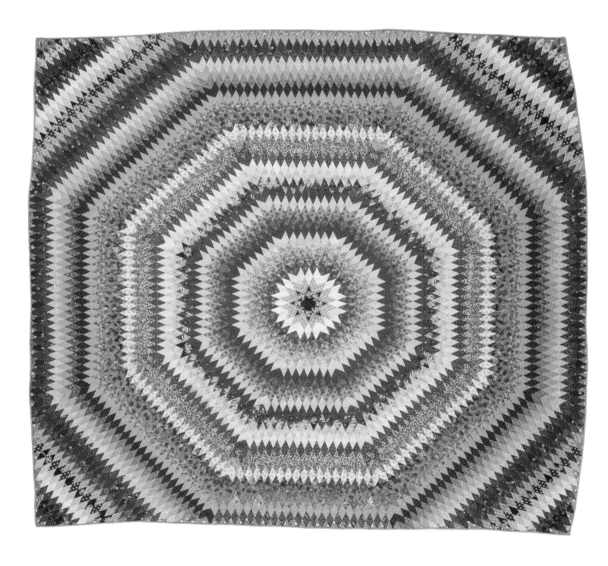

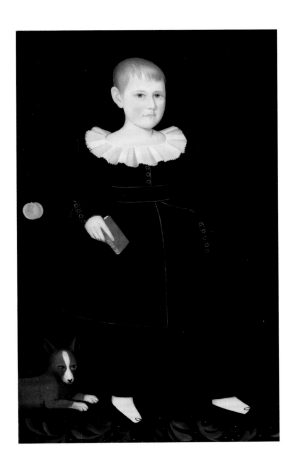

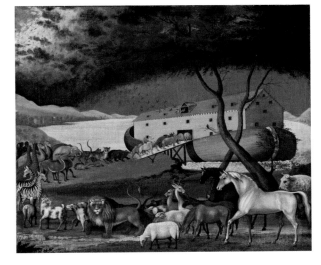

Ammi Phillips (American, 1788–1865)

Blond Boy with Primer, Peach, and Dog, c. 1836
Oil on canvas, 48⅜ × 30 in. (122.9 × 76.2 cm)
125th Anniversary Acquisition. Estate of Alice M. Kaplan,
2001-13-1

Young Aaron Smith's parents, who likely commissioned this work, were wealthy members of their northwestern Connecticut community and could afford to hire any portraitist from New York to Boston to paint their son's likeness. They chose itinerant artist Ammi Phillips, whose plain style combined compositional elements of academic portraiture with the frank expression, flat color, bold contrast, and incisive design that distinguished the region's vernacular tradition. Until the mid-nineteenth century, taste was determined locally; as Phillips moved from town to town, he regularly adapted his style to suit. MDM

Edward Hicks (American, 1780–1849)

Noah's Ark, 1846
Oil on canvas, 26⁵⁄₁₆ × 30⅜ in. (66.8 × 77.1 cm)
Bequest of Lisa Norris Elkins, 1950-92-7

Quaker minister Edward Hicks is best known for his portrayals of Pennsylvania as the peaceable kingdom prophesied in the book of Isaiah. By contrast, this painting is the artist's only extant depiction of the apocalyptic flood described in the Old Testament. Inspired by an 1844 lithograph of Noah's ark by Nathaniel Currier, Hicks dramatically transformed the composition by adding a broad sweep of landscape and sky, menacing storm clouds, and vivid color. The ominous arc of the dark clouds foreshadows the rainbow that would herald the storm's end. Despite Quaker belief forbidding its practice, Hicks felt that his art was an integral part of his faith. MDM

THE PEALE FAMILY

The Peale family of Philadelphia was the first American artistic dynasty. Thanks to the generous gifts of Robert L. McNeil, Jr., the Museum's collection features a wide range of works—including portraits, still lifes, landscapes, miniatures, drawings, and prints—by eleven Peale family members over three generations.

The Staircase Group by Charles Willson Peale, the family's patriarch, is among his most celebrated paintings (far right). A trompe l'oeil picture of his sons Raphaelle and Titian Ramsay, it was created at a moment of keen international interest in life-like wax sculpture and illusionistic painting. Designed to surprise viewers and to impress them with his technical skills, the picture features a frame in the form of a doorway with an actual step at its base. After its debut in May 1795 at the inaugural exhibition of the nation's first art academy, the Columbianum in Philadelphia, the canvas was installed in the city's museum of art and natural sciences that Peale had founded in 1786.

In 1819 Peale added to his museum's collections his portrait of eighty-three-year-old Yarrow Mamout (right), an African American Muslim who won his freedom from slavery and established himself by buying a home and investing his savings. An extraordinarily rare representation of ethnic and religious diversity in early America, this portrait is an outstanding example of the artist's late naturalistic style and his direct and sympathetic encounter with the sitter, who represented for Peale the triumph of perseverance over adversity.

In the last decade of his life, beginning in the mid-1850s, Charles's son Rubens, who had spent his career managing the family's museums in Baltimore, New York, and Philadelphia, turned to still-life painting, such as his exuberant 1856 canvas *From Nature in the Garden* (below). Primarily a self-taught artist, he had a gift for pictorial design, which, together with his bold forms and color, earned his work a place alongside the naturalistic compositions of his elder brother, Raphaelle, and his uncle, James, who were founders of the American still-life tradition. The inscription on the reticulated porcelain bowl, which appears in several pictures by Peale family artists, indicates it was presented to Rubens's eldest son, Charles Willson, who was his grandfather's namesake. CES

Rubens Peale (American, 1784–1865)

From Nature in the Garden, 1856
Oil on canvas, mounted on panel; 18¾ × 24¾ in.
(47.6 × 62.9 cm)
Gift of the McNeil Americana Collection, 2010-70-3

Charles Willson Peale (American, 1741–1827)

Portrait of Yarrow Mamout, 1819
Oil on canvas, 24 × 20 in. (61 × 50.8 cm)
Purchased with the gifts (by exchange) of R. Wistar Harvey,
Mrs. T. Charlton Henry, Mr. and Mrs. J. Stogdell Stokes,
Elise Robinson Paumgarten from the Sallie Crozer Hilprecht
Collection, Lucie Washington Mitcheson in memory of Robert
Stockton Johnson Mitcheson for the Robert Stockton Johnson
Mitcheson Collection, R. Nelson Buckley, the estate of Rictavia
Schiff, and the McNeil Acquisition Fund for American Art and
Material Culture, 2011-87-1

Charles Willson Peale (American, 1741–1827)

The Staircase Group, 1795
Oil on canvas, 89½ × 39⅜ in. (227.3 × 100 cm)
The George W. Elkins Collection, E1945-1-1

Severin Roesen (American, born Germany, 1816–c. 1872)

Flower Still Life with Bird's Nest, 1853

Oil on canvas, 40 × 32 in. (101.6 × 81.3 cm)

Purchased with support from the Henry P. McIlhenny Fund in memory of Frances P. McIlhenny, Mr. and Mrs. Robert L. McNeil, Jr., the Edith H. Bell Fund, Mrs. J. Maxwell Moran, Marguerite and Gerry Lenfest, the Center for American Art Acquisition Fund, Donna C. and Morris W. Stroud II, Dr. and Mrs. Robert E. Booth, Jr., Frederick LaValley and John Whitenight, Mr. and Mrs. John A. Nyheim, Charlene Sussel, Penelope P. Wilson, and the American Art Committee, and with the gift (by exchange) of Theodore Wiedemann in memory of his wife, Letha M. Wiedemann, 2010-6-1

Upon arriving in New York in 1848, German immigrant Severin Roesen introduced an ambitious new approach to still-life painting with his lavish depictions of fruit and flowers. In this profuse tabletop arrangement, the densely packed, vividly colored flowers at the bouquet's brightly lit center are balanced by the sinuous, silhouetted stems that extend toward the shadowy edges of the composition. Topped by a red crown imperial and including daylilies, irises, lilacs, morning glories, nasturtiums, roses, and tulips, the arrangement is crowded with blooms from all seasons and satisfied an emergent taste for sensuous scenes of natural abundance. MDM

Made by **William Forbes** (American, 1799–after 1882) for
Ball, Tompkins and Black (New York, 1839–51)

Hot Water Kettle on Stand, 1839–51
Silver, ivory; H. 17⅜ in. (44 cm) overall
Purchased with the Richardson Fund, funds contributed in
memory of Sophie E. Pennebaker, the Center for American Art
Acquisition Fund, and with funds contributed by the Levitties
Family, 2011-99-1a,b

Beginning in the 1830s Americans embraced the
Gothic Revival as a picturesque, romantic alterna-
tive to Neoclassicism. Domestic silver hollowware
in this style is exceptionally rare; fewer than a dozen
examples are known, of which this kettle on stand is
the largest. Like many American interpreters of the
Gothic Revival, William Forbes took a form for serv-
ing tea that was unknown in the Middle Ages and
embellished it with medieval architectural details,
such as the trefoil handle, quatrefoil sockets, fleur-
de-lis ornaments, pointed arches, and foliate finial.
The stand similarly combines the shape of a tower or
baptismal font with piercings reminiscent of window
tracery. DLB

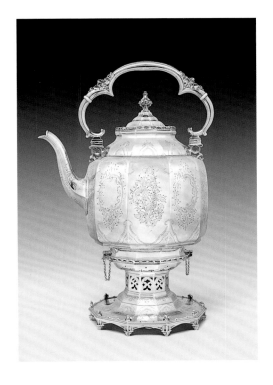

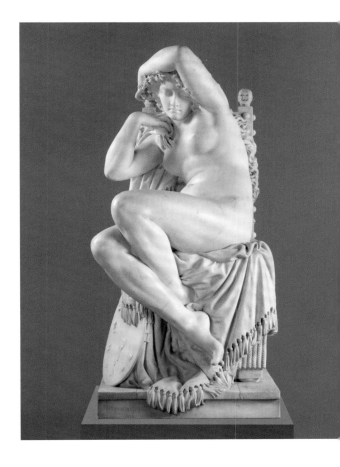

Howard Roberts (American, 1843–1900)

La première pose, 1873–76
Marble, H. 51¼ in. (130.2 cm)
Gift of Mrs. Howard Roberts, 1929-134-1

Howard Roberts, like his fellow Philadelphian
Thomas Eakins, trained in Paris and mastered the
French academic style of portraying the human
figure. Unlike Eakins, however, Roberts returned
to France to work on major projects such as this
sculpture, which he submitted to the 1876 Centennial
Exhibition in Philadelphia. Praising the work for
the subtle realism of its modeling, critics declared it
a triumph of American sophistication and a match
in technique for any French sculpture. However, its
subject—a young model overcome with shyness at
posing nude for the first time—drew criticism as
being "too French" and merely an excuse to revel in
the figure's sensuality. KAF/DS

James Abbott McNeill Whistler (American, 1834–1903)

Purple and Rose: The Lange Leizen of the Six Marks, 1864
Oil on canvas, 46⁹⁄₁₆ × 34⅜ in. (118.3 × 87.3 cm) with frame
John G. Johnson Collection, cat. 1112

An enthusiastic collector of Asian art, James Abbott McNeill Whistler has envisioned an elegant European woman painting a vase in a shop filled with exotic objects. Unconcerned with realistically depicting the decoration of Chinese ceramics, Whistler instead created a painting about painting, one that suggests beauty and refinement lie behind all great works of art. The Dutch phrase *lange leizen* (commonly translated as "long ladies") of the title refers to the elongated figures that adorn the vase the woman is decorating, and the gilded frame, which Whistler designed, is embellished with six Chinese characters referring to the Kangxi period (1662–1722) during which this style of blue and white porcelain became popular. JAT

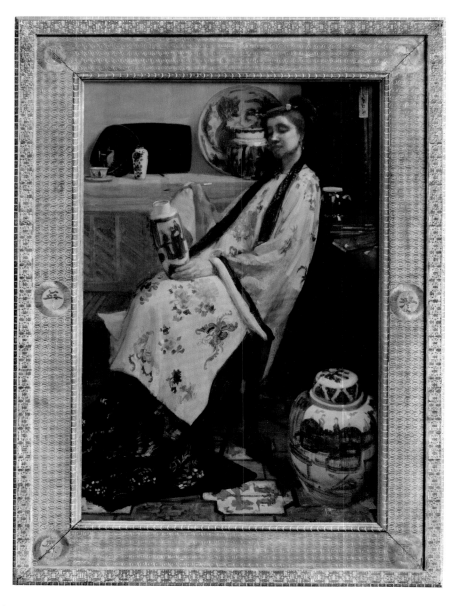

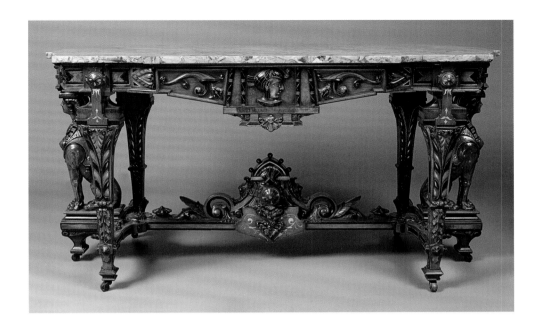

Attributed to **Allen and Brother** (Philadelphia, 1835–96)

Center Table, 1865–80
Walnut and Circassian walnut veneer with ebonized and gilt
decoration; brass; marble; w. 58½ in. (148.6 cm)
Purchased with the bequest of Margaret McKee Breyer, the Titus
C. Geesey Collection, Mrs. C. E. Warner, J. Stogdell Stokes,
the estate of Dr. Charles Koder, the Haas Community Funds,
Mr. and Mrs. George B. Emeny, Mrs. Elizabeth Titus, and Mrs.
Xavier von Erdberg (by exchange), 2002-79-1

The exuberant form, ornament, and decoration of this
table, designed as the centerpiece for a lavish parlor,
give it a sculptural presence. The figure of an ancient
sphinx proudly stands between the legs at each end,
and the exaggerated, organic curves of the stretcher
resemble the lobed form of classical Greek anthemia.
This fusion of styles was typical of furniture made in
Philadelphia around the time of the 1876 Centennial
Exhibition, which featured art from around the
world. At the Allen and Brother firm where this table
likely was made, cabinetmakers continued the art
of custom-made furniture, even as mass-produced
examples became increasingly available. AAK

Designed by **Edward C. Moore** (American, 1827–1891);
made by **Tiffany and Company** (New York, 1853–present)

"Moresque" Tea Service, 1866–67
Silver with parcel-gilt decoration; ivory; H. (teapot) 8½ in. (21.6 cm)
Gift of the Friends of the Philadelphia Museum of Art,
1973-94-8a–c

Edward Moore designed this tea service for Tiffany
and Company's internationally acclaimed display
at the 1867 Universal Exposition in Paris, for which
the firm became the first American manufacturer
to receive an award for silver craftsmanship. An
early product of Moore's forty-year association with
Tiffany, this service, in a style the manufacturer called
"Moresque," reflects the widespread enthusiasm for
non-Western art in late nineteenth-century America.
The vessels' chased and gilded patterns were inspired
by the Islamic decorations of the Alhambra, an ancient
Moorish palace in Spain, and the design of the exqui-
site interlaced handles was based on examples of
Persian metalwork. DLB

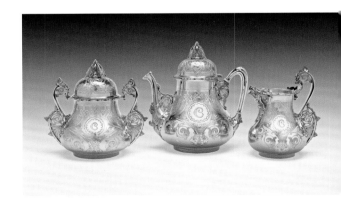

THE THOMAS EAKINS COLLECTION

Thomas Eakins, Philadelphia's greatest artist, spent his lifetime painting the people and landscapes of his native city. From 1862 to 1866, Eakins, who had been a star pupil at the city's prestigious Central High School, attended classes at the Pennsylvania Academy of the Fine Arts, where he developed a devotion to studying the human figure. He then traveled to Paris, where he studied at the École des Beaux-Arts from 1866 to 1869, returning to Philadelphia in 1870 after an extended visit to Spain. In 1876 he began to teach at the Pennsylvania Academy, where he soon became a professor and in 1882 was appointed director, reforming the school's curriculum to reflect his belief in the importance of the study of anatomy; the nude, as evident in the drawing below; perspective; and sculpture (see, for example, below, right).

These principles, drawn in part from his experiences with contemporary French painting and the old masters, were applied to his own art in subjects from modern American life, particularly the local sports he loved best: boxing, hunting, sailing, and swimming. Painting sunlit scenes on the Schuylkill and Delaware Rivers, he captured the characteristic postures of athletes and fishermen (see right, top) with a complex method that included plein air sketching, figure study, perspective drawing, and photography. With the same rigor, he made portraits of his family and friends, as well as a wider circle of distinguished contemporaries, including the city's artists, musicians (see right, bottom), doctors, and professors. Sometimes unsparing and occasionally shocking, as in his monumental portrait of Dr. Samuel D. Gross (p. 294), Eakins's paintings earned a reputation for blunt realism and psychological insight.

Although his career was marred by scandals, mostly related to his use of nude models and his own obstinate behavior, Eakins lived to see his work hailed as definitively American. A decade after the artist's death in 1916, his widow began conversations with Fiske Kimball, director of the Museum, to create a memorial gallery in the institution's new building on Fairmount. Susan Macdowell Eakins's many gifts to the Museum in 1929 and 1930 established the most important collection of Thomas Eakins's paintings, drawings, sculptures, and photographs in the world. KAF

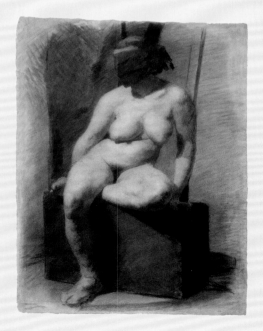

Thomas Eakins (American, 1844–1916)

Study of a Seated Nude Woman Wearing a Mask, 1863–66
Charcoal and crayon with stumping on paper, sheet: 24¼ × 18⅝ in. (61.6 × 47.3 cm)
Gift of Mrs. Thomas Eakins and Miss Mary Adeline Williams, 1929-184-49

Knitting, 1882–83, cast 1886
Sand-cast bronze, H. 18⁷⁄₁₆ in. (46.8 cm)
Gift of Charlene Sussel in memory of her husband, Eugene Sussel, 1992-4-1

Mending the Net, 1881
Oil on canvas, 32⅛ × 45⅛ in. (81.6 × 114.6 cm)
Gift of Mrs. Thomas Eakins and Miss Mary Adeline Williams, 1929-184-34

The Concert Singer, 1890–92
Oil on canvas, 75⅛ × 54¼ in. (190.8 × 137.8 cm)
Gift of Mrs. Thomas Eakins and Miss Mary Adeline Williams, 1929-184-19

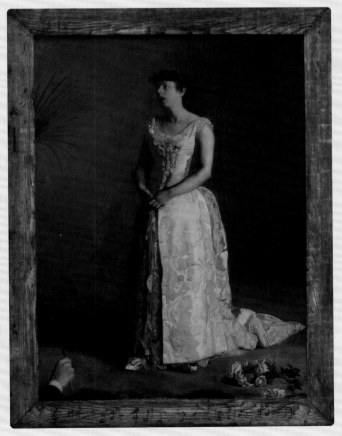

Thomas Eakins (American, 1844–1916)

Portrait of Dr. Samuel D. Gross (The Gross Clinic), 1875
Oil on canvas, 96 × 78 in. (243.8 × 198.1 cm)
Gift of the Alumni Association to Jefferson Medical College in 1878 and purchased by the Pennsylvania Academy of the Fine Arts and the Philadelphia Museum of Art in 2007 with the generous support of more than 3,600 donors, 2007-1-1

Thomas Eakins's masterpiece, acclaimed as the greatest American painting of the nineteenth century and the centerpiece of the Museum's outstanding collection of his work (see pp. 292–93), depicts the famed surgeon Samuel D. Gross instructing students during an operation at Jefferson Medical College in Philadelphia. The procedure, removing infected sections from the thighbone of a boy suffering from osteomyelitis, was not life-threatening; rather, the elegantly simple, minimally invasive treatment represented the newest understanding of anatomy and pathology. Eakins, born in Philadelphia and a student at Jefferson, wished to celebrate his professor and the city's illustrious medical community. He also hoped, at the age of thirty-one, to establish his reputation as a realist artist. Drawing on his training at the Pennsylvania Academy of the Fine Arts in Philadelphia and in Europe, Eakins composed a majestic painting that wedded modern naturalism to the technique and impact of the old masters. Painted expressly for the 1876 Centennial Exhibition in Philadelphia, the picture and its bloody detail shocked the art jury; ultimately, it was displayed among the US Army's medical exhibits at the fair. When the painting was shown at subsequent art exhibitions in Philadelphia and New York, critics admired the artist's masterful handling of light and dark and his creation of astonishing illusionism, but were repulsed by the canvas's gory subject. Medical professionals revered the painting, however, and ultimately viewers recognized the work's heroic modernity as well as its artistry. Jointly owned by the Pennsylvania Academy and the Museum, *The Gross Clinic* appears alternately at each institution. KAF

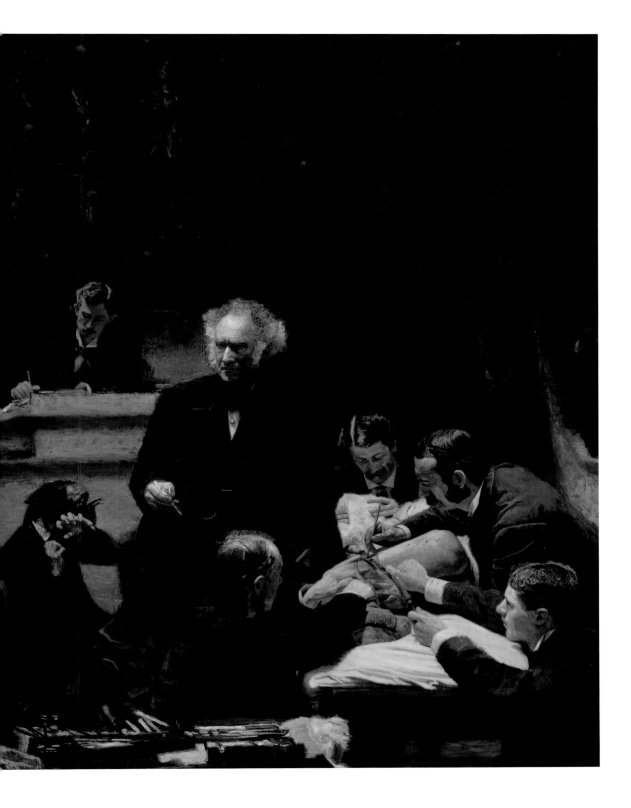

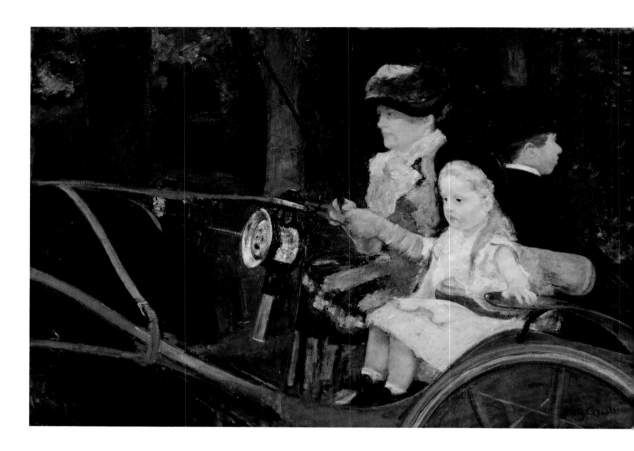

Mary Stevenson Cassatt (American, 1844–1926)

A Woman and a Girl Driving, 1881

Oil on canvas, 35⁵⁄₁₆ × 51³⁄₈ in. (89.7 × 130.5 cm)
Purchased with the W. P. Wilstach Fund, W1921-1-1

The striking similarity of the intent gazes of the woman and the child in this work suggest a family relationship, but the driver of the horse-drawn carriage is Lydia Cassatt, the artist's younger sister, and the girl seated stiffly beside her is Odile Fèvre, niece of the painter Edgar Degas. The Pennsylvania-born Mary Cassatt excelled in capturing quiet, quotidian moments such as this carriage ride through the Bois de Boulogne, a park on the outskirts of Paris. A friend and close colleague of Degas's, she may have borrowed from him the dramatic cropping of the horse and buggy, which suggests the movement of the vehicle. JAT

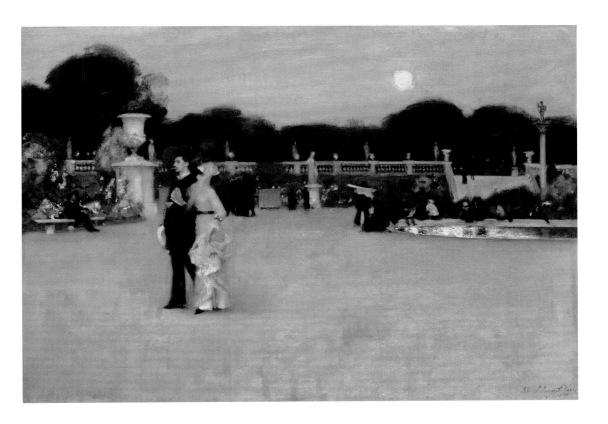

John Singer Sargent (American, 1856–1925)

In the Luxembourg Gardens, 1879

Oil on canvas, 25⅞ × 36⅜ in. (65.7 × 92.4 cm)

John G. Johnson Collection, cat. 1080

In the 1870s John Singer Sargent, like many other artists, lived in the Latin Quarter of Paris, not far from the Luxembourg Gardens, which had recently been landscaped with new formal paths, fountains, and sculptures. In this twilight scene, a fashionably dressed yet dispassionate couple walks arm in arm. Their detachment is echoed by other figures in the garden, all absorbed in their own activities: sitting on a bench, reading a newspaper, or playing with a toy sailboat. The soft brushwork and the urban life depicted in this canvas, which was first exhibited in New York in 1879, appealed to American critics and collectors. JAT

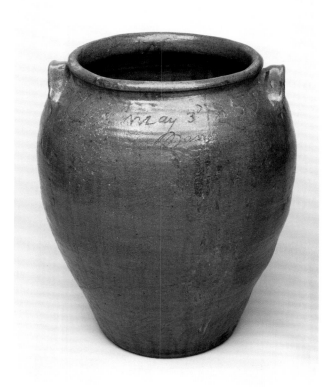

Made by **David Drake** (American, 1800–c. 1870) at **Lewis J. Miles Pottery (Stoney Bluff Manufactory)**
(Edgefield District, South Carolina, 1840–67)

Storage Jar, 1859
Stoneware with alkaline glaze, H. 26½ in. (67.3 cm)
125th Anniversary Acquisition. Purchased with funds contributed by Keith and Lauren Morgan and with the gifts (by exchange) of John T. Morris, Mrs. John D. Wintersteen, and the bequest of Maurice J. Crean, and with the Baugh-Barber Fund, the Haas Community Fund, and other Museum funds (by exchange), 1997-35-1

Over a forty-year career, enslaved potter David Drake made many large utilitarian vessels for a succession of masters. A skilled and literate craftsman, he often incised text on his ceramics. Here the inscription ("Good for lard or holding fresh meat, / blest we were when Peter saw the folded sheet") refers to Saint Peter's vision in Acts 10:9–16 of a heaven-sent sheet holding animals whose meat is forbidden to Jews, and the command to eat, declaring, "Do not call impure anything that God has made clean" (10:15). Preserved in fired clay, Drake's commentaries represent an exceptional legacy of the musings of an enslaved African American. DLB

Susan Frackelton (American, 1851–1932)
Covered Jar on Stand, 1893
Stoneware with salt glaze and underglaze blue decoration, H. 25 in. (63.5 cm)
Gift of John T. Morris, 1893-309a–c

Beginning in the late 1870s, women were leaders of the American art pottery movement, which promoted ceramics as art and emphasized handwork over industrial production. Susan Frackelton began her career as a china painter and moved on to making vessels around 1890. Created from local Milwaukee clay, this exceptional covered jar won a gold medal at the 1893 Chicago World's Fair, where curator Edwin AtLee Barber acquired it for the Museum. Although Frackelton intended the salt glaze and cobalt decoration to evoke colonial American stoneware, the jar's simplified shape, subdued colors, and naturalistic olive branches were inspired by contemporary Arts and Crafts aesthetics. DLB

Made by **Rookwood Pottery** (Cincinnati, 1880–1960); decorated by **Kitaro Shirayamadani** (American, born Japan, 1865–1949)

Vase, 1899
Glazed stoneware (Black Iris glaze), H. 17⅜ in. (44.1 cm)
Gift of John T. Morris, 1901-15

Inspired by the sleek shapes and innovative glazes of the Japanese ceramics exhibited at the 1876 Centennial Exhibition in Philadelphia, Ohio heiress Maria Longworth Nichols established Rookwood Pottery in Cincinnati in 1880. There artists created elegant ceramic vessels—so-called art pottery—such as this majestic vase. Kitaro Shirayamadani drew on the aesthetic sensibilities of his native Japan for the vessel's decoration of delicate thorny-stemmed roses on a brilliant black ground. At the urging of Museum curator Edwin AtLee Barber, trustee John T. Morris purchased the vase in 1900 at the Universal Exposition in Paris, one of the many international exhibitions at which Rookwood ceramics received high honors. AAK

Designed by **Louis Comfort Tiffany** (American, 1848–1933); made by **Tiffany Glass and Decorating Company** (Corona, New York, 1892–1902)

"Cypriote" Vase, c. 1900
Glass, H. 9⅜ in. (23.8 cm)
Purchased with the Joseph E. Temple Fund, 1901-63

Inspired by the iridescent and irregular surfaces of ancient blown glass from Cyprus that he had seen exhibited in New York in 1880, Louis Comfort Tiffany invented the so-called Cypriote technique using chemical reactions to achieve similar effects on glass produced by his firm. This vase was exhibited at the 1900 Universal Exposition in Paris, where trustee John T. Morris, who together with curator Edwin AtLee Barber was instrumental in expanding the Museum's collections of decorative arts, purchased it, as well as the Rookwood vase decorated by Kitaro Shirayamadani (left), on behalf of the institution. ERA

Designed by **Frank Furness** (American, 1839–1912); made by
Daniel Pabst (American, born Germany, 1826–1910)

Desk, 1870–71
Walnut, walnut veneer, rosewood, brass, iron, steel, glass globes
(not original); H. 77½ in. (196.9 cm)
Gift of George Wood Furness, 1974-224-1

Architect Frank Furness, an innovative force in late
nineteenth-century Philadelphia, rejected popular
historical designs in favor of the forms and materials
of the Industrial Revolution. Made for his brother's
library, this massive desk is a fine example of Furness's
use of bold, unorthodox juxtapositions of architec-
tural elements. The horseshoe arch inspired by Islamic
architecture, the stylized patterns, and the dynamic
interplay of intaglio and relief carvings are characteris-
tic details of his buildings, as well as of furniture made
by Philadelphia cabinetmaker Daniel Pabst, who
executed this desk and the library's woodwork. DLB

Herter Brothers (New York, 1865–1906)

Wardrobe, c. 1880
Ebonized cherry, red cedar, light and dark wood marquetry,
silvered glass, brass; H. 8 ft. 8 in. (2.64 m)
Gift of Mrs. William T. Carter, 1928-121-1d

Herter Brothers supplied Philadelphia iron and coal
magnate William Thornton Carter and his wife,
Cornelia, with a seven-piece suite of bedroom furni-
ture, probably in 1880 when the couple acquired their
town house on Walnut Street. Herter was renowned

for its costly, superbly crafted furniture that attracted
elite clients, including railroad magnates William
Henry Vanderbilt and Mark Hopkins, Jr. Instead of
the gilded or veneered surfaces and high-relief carving
popular during the 1870s, this wardrobe's rectilin-
ear profile, low-relief carving, and ebonized facade
accented with light wood marquetry reflect the influ-
ence of Japanese art as interpreted by contemporary
English furniture designers. DLB

José Maria Velasco (Mexican, 1840–1912)

Valley of Oaxaca, 1888
Oil on canvas, 41⅞ × 63¼ in. (106.4 × 160.7 cm)
Gift of the Mauch Chunk National Bank, 1949-56-1

José Maria Velasco, the most famous academic painter in nineteenth-century Mexico, produced a large body of works focusing on the spectacular natural scenery of his homeland. Trained at the Academy of San Carlos in Mexico City, where he was later a professor, Velasco based this work on a painting he had made a year earlier on a trip to the Valley of Oaxaca. Here Mexico's long history is evoked through such details as the colonial-era wooden cross, the ruins of recently abandoned fortifications, and the colorfully dressed Zapotec Indians who gather traditional white flowers from a *casahuate* tree. MAC

Thomas Moran (American, born England, 1837–1926)

Grand Canyon of the Colorado River, 1892/1908
Oil on canvas, 53 × 94 in. (134.6 × 238.8 cm)
Gift of Graeme Lorimer, 1975-182-1

The majestic Grand Canyon is among the most recognized natural wonders of the world, partly thanks to the artistic vision of Thomas Moran. After his first trip to the American West in 1871, he began producing enormous panoramic views of the region's landscape, which were exhibited around the country and made him a celebrity. By capturing the nation's attention, his paintings played an important role in encouraging the federal government to establish national parks to preserve the country's pristine natural beauty. Here Moran's vast composition explores the dramatic color range and terrifying depth of the gorge, thrusting the viewer out over the chasm without a ledge to stand on. MDM

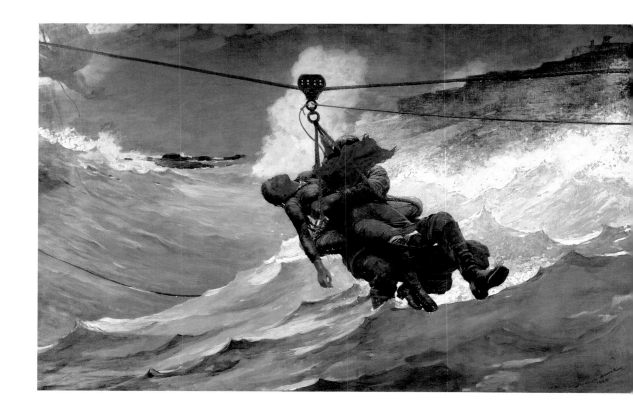

Winslow Homer (American, 1836–1910)

The Life Line, 1884
Oil on canvas, 28⅝ × 44¾ in. (72.7 × 113.7 cm)
The George W. Elkins Collection, E1924-4-15

This stirring depiction of a rescue at sea was a popular and critical success from its first appearance in 1884, and it has remained one of Winslow Homer's best-known works. Boldly cropping his subject to isolate the romance of two strangers thrown together by disaster, Homer merely hints at the shipwreck to the left, the coastline on the right, and the unseen brigade assisting on the shore. An old-fashioned story of heroic knight and fair lady, the narrative swings modern to highlight the state-of-the-art technology of the breeches buoy that carries the pair. Contemporary pride in the recently reformed United States Life Saving Service and the emergence of a new American hero, the so-called surf man, added to the thrill of the subject. Yet, Homer hid the rescuer's identity by painting a billowing red scarf over his face, making the figure anonymous and mysterious, and centering attention on the damsel in distress. KAF

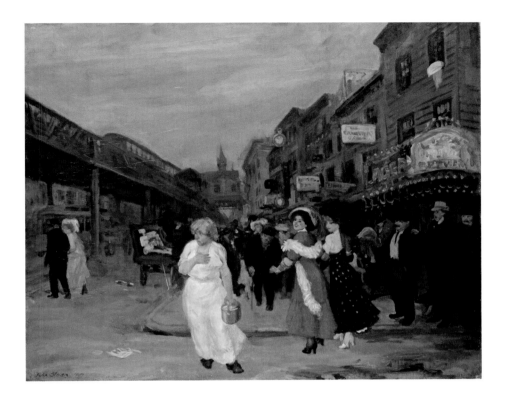

John Sloan (American, 1871–1951)

Sixth Avenue and Thirtieth Street, New York, 1907
Oil on canvas, 24¼ × 32 in. (61.6 × 81.3 cm)
Gift of Meyer P. Potamkin and Vivian O. Potamkin, 1964-116-5
© 2014 Delaware Art Museum / Artists Rights Society (ARS), New York

In New York's Tenderloin neighborhood, an area notorious for illicit activities of all sorts, a disheveled woman carrying a pail of beer steps unsteadily into the street. Her disoriented appearance has attracted the attention of onlookers, including that of two smirking, gaudily dressed women. Behind them, the elevated train and commercial thoroughfare converge at the distinctive silhouette of the Jefferson Market Courthouse. In capturing the atmosphere and the emotions of the Tenderloin, John Sloan exemplified the expressive and documentary approach he shared with his fellow members of the Ashcan school. Like Sloan, many of these artists were trained in Philadelphia, where they learned to capture the vitality and energy of modern urban life, as seen in the Museum's many paintings and prints by his contemporaries William J. Glackens, Robert Henri, Ernest Lawson, George B. Luks, and Everett Shinn. CMB

Henry Ossawa Tanner (American, 1859–1937)

The Annunciation, 1898
Oil on canvas, 57 × 71¼ in. (144.8 × 181 cm)
Purchased with the W. P. Wilstach Fund, W1899-1-1

The Bible tells the story of the angel Gabriel's announcement to Mary of the forthcoming birth of her son, Jesus. Here Henry Ossawa Tanner has given this familiar narrative unconventional treatment by weaving together ancient and modern, and spiritual and material threads into his compelling image.

Raised in Philadelphia and trained by Thomas Eakins at the Pennsylvania Academy of the Fine Arts from 1879 to 1883, Tanner followed his teacher's example and pursued art studies in Paris, where he ultimately settled. Like Eakins, Tanner absorbed an academic tradition that prized important figural subjects, fine drawing, and careful study from life. Both artists grounded their work in realist observation, seeking authentic detail.

Informed by his trip to the Holy Land in 1897, Tanner imagined the Virgin as a Palestinian teenager, in the context of a Middle Eastern home. His choices make the biblical past feel fresh and contemporary; Mary becomes a believable young woman, stunned by the apparition that appears before her. Tanner expressed his spirituality in the striking visualization of the angel as a column of light, the dematerialized representation of illumination and revelation itself.

A success at the Paris Salon in 1898, the painting was shown the next year in Philadelphia, where it was purchased for the Museum. Among the first contemporary American paintings acquired for the collection, it was also the first of Tanner's works to enter a museum in the United States and the foundation of the Museum's distinguished survey of work by African American artists. KAF

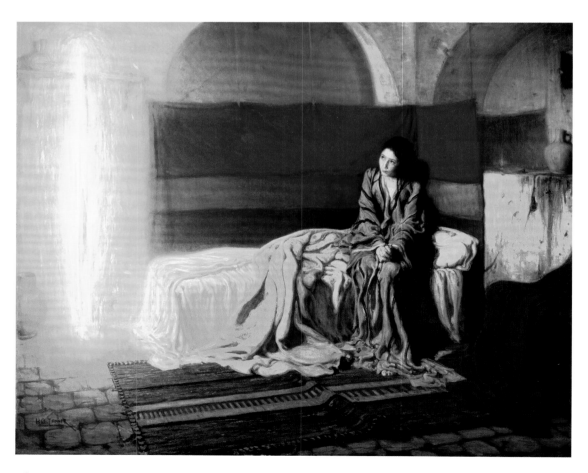

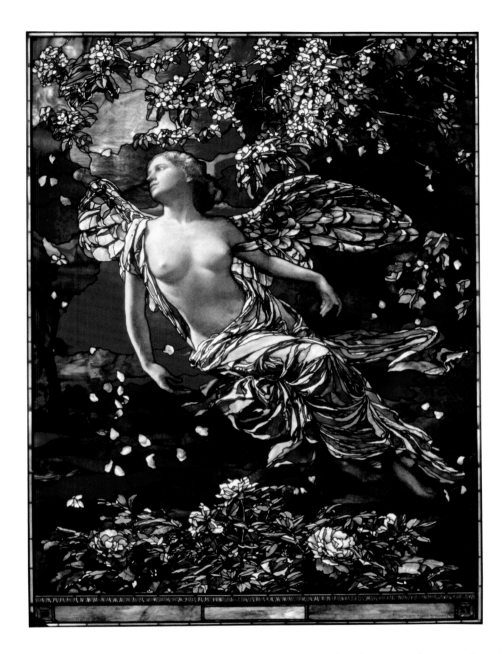

Designed by **John La Farge** (American, 1835–1910); made
by **Thomas Wright** (American, born England, 1856–1918);
painted by **Juliette Hanson** (American, active c. 1881–1910)

Spring, 1900–1902
Opalescent and painted glass, lead; H. 8 ft. 4 in. (2.54 m)
Gift of Charles S. Payson, 1977-33-1

John La Farge created this window for a country
house on Long Island designed by renowned architect
Stanford White. One of the artist's last major works,

it represents the culmination of a career of continual
experimentation. The figure's face and torso, painted
by Juliette Hanson, were fired on a single sheet of
glass, the largest La Farge ever used. The remainder of
the window is composed entirely of opalescent glass,
which he had pioneered in the late 1870s. La Farge
intended the rich variety of colors and shadings to
evoke the medium of painting; he called this window
a "picture work in glass." DLB

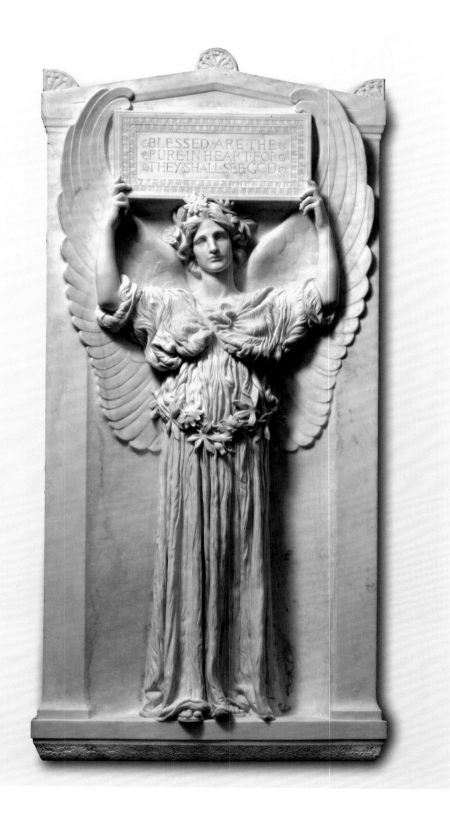

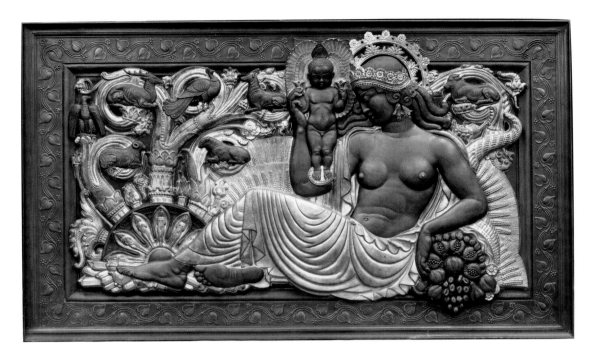

Augustus Saint-Gaudens (American, born Ireland, 1848–1907)

The Angel of Purity (Maria Mitchell Memorial), 1902
Marble, H. 96 in. (243.8 cm)
Purchased with the Annenberg Fund for Major Acquisitions and with the gifts of Mr. and Mrs. Wharton Sinkler and Mrs. T. Charlton Henry (by exchange), and with funds contributed by the Margaret Dorrance Strawbridge Foundation of Pennsylvania II, Inc., 2005-2-1

Beautiful and solemn, this sculpture remembers Maria Mitchell, a young woman who died in 1898 at the age of twenty-two. Her bereft parents turned to Augustus Saint-Gaudens, the most versatile and imaginative American sculptor of his day, to create a monument in her honor for Saint Stephen's Episcopal Church in Philadelphia. For this luminous work, the last and finest in the artist's series of related sculptures of angelic figures begun in 1885, Saint-Gaudens refreshed the tradition of Renaissance and classical art with a graceful modern naturalism. The glowing marble and delicate carving make this his most moving statement of sorrow and serenity. KAF

Paul Manship (American, 1885–1966)

The Four Elements: Earth, 1914
Bronze, 37½ × 68¾ in. (95.3 × 174.6 cm)
Gift of Marguerite and Gerry Lenfest in honor of Ruth and Raymond G. Perelman, 2006-40-1
© Estate of Paul Manship

Architect William Welles Bosworth commissioned these four bronze panels to adorn the facade of the new headquarters of the American Telephone and Telegraph (AT&T) Company at the corner of Broadway and Fulton Streets in New York. Exceptional examples of Paul Manship's early decorative style, they reflect an important shift in the artist's work, uniting his interest in archaic Greek and Renaissance sculpture with a new passion for Chinese, Indian, and other non-Western art forms, evident in the highly ornamental treatment of the clouds, flames, plants, and water. In 2007 the panels were permanently installed in the library reading room in the Museum's Perelman Building, which opened that year. JV/EH

Samuel Yellin (American, born Russia, 1884–1940)

Lock, Key, and Handle, 1911
Wrought iron, w. (lock) 19¾ in. (50.2 cm)
Purchased with the Joseph E. Temple Fund, 1911-237a–e

An example of virtuoso ironwork, this beautifully designed and executed lock with corresponding key and handle raised Samuel Yellin's profile as a craftsman in Philadelphia when it was exhibited at the Museum in 1911. That same year he won a commission from the New York architectural firm of C. Grant LaFarge for wrought-iron gates for the Long Island estate of J. P. Morgan, Jr., making 1911 a turning point in his career. Inspired by medieval examples, Yellin maintained a collection of historical ironwork for his assistants to study; fifty-one of the finest pieces were sold to the Museum in 1931. ERA/DLB

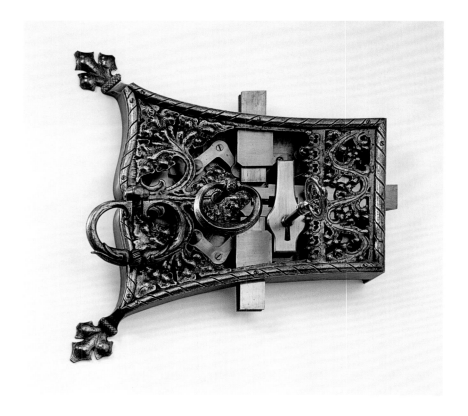

Maxfield Parrish (American, 1870–1966)

No-To-Bac, 1896
Color relief print, sheet: 42 1/16 × 29 1/8 in. (106.8 × 74 cm)
The William H. Helfand Collection, 1981-114-36
Art © Maxfield Parrish Family, LLC / Licensed by VAGA, New York

By 1913, when he declined an invitation to head the art department at Yale University, Maxfield Parrish was already famous for his whimsical murals in hotels all across the country, from *Old King Cole* in New York to *The Pied Piper of Hamelin* in San Francisco. He began his career as a commercial artist, designing award-winning posters while a student at the Pennsylvania Academy of the Fine Arts in

Philadelphia in the mid-1890s, a period of poster mania in Europe and the United States that heralded the advertising age. Parrish was among the artists for whom poster-making offered instant recognition as they created the constantly changing promotions for competing products, such as No-To-Bac's promise of a cure for smoking. This poster is part of the William H. Helfand Collection, which forms a substantial segment of the Museum's renowned Ars Medica Collection (see also p. 354), comprising more than 3,500 prints, posters, illustrated books, ephemera, and drawings covering a broad array of medical topics. JI

Quilt

Arthur, Illinois, c. 1915–20
Wool, 85 × 70 in. (215.9 × 177.8 cm)
Purchased with the Katherine Levin Farrell Fund and the
Joseph E. Temple Fund, 1996-163-1

Amish quilts can be identified by the distinctive
variations found in each community's quilts. The
strong colors, fine materials, and meticulous crafts-
manship in this example are typical of those made
in the Old Order Amish settlement in Arthur,
Illinois. The alternating fan pattern and turkey-track
embroidery stitches show the influence of the nearby
Indiana Amish community and Victorian crazy quilts,
so called for their irregularly shaped, overlapping
patches. Although it was common for Amish women
to purchase fabrics for quilts, this one was pieced from
scraps or recycled textiles. It was likely a Sunday best
quilt, possibly made for a bride by her mother. DB

Marsden Hartley (American, 1877–1943)

Painting No. 4 (A Black Horse), 1915
Oil on canvas, 39¼ × 31⅝ in. (99.7 × 80.3 cm)
The Alfred Stieglitz Collection, 1949-18-8

Filled with organic symbols and patterns derived
from Native American art and German modernism
and folk traditions, *Painting No. 4* embodies Marsden
Hartley's reaction to the devastation he witnessed
while living in Berlin during the first years of World
War I. According to Hartley, the work represents his
reflections on America as a place of peace and rever-
ence for nature. As fish swim in blue water, a black
horse with a white mane and tail sits inside a teepee,
and light radiates from the sun, providing nourish-
ment for the plant forms that reach upward from
both land and water. MDM

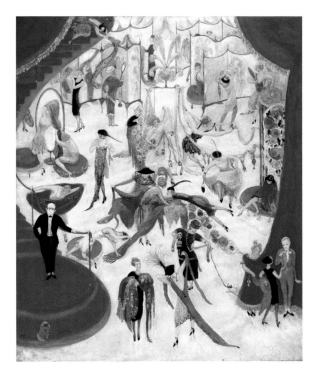

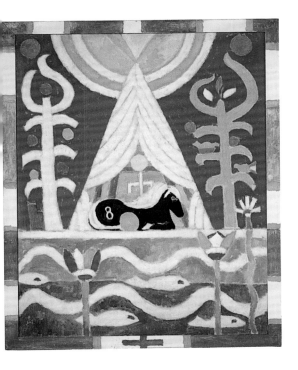

Florine Stettheimer (American, 1871–1944)

Spring Sale at Bendel's, 1921
Oil on canvas, 50 × 40 in. (127 × 101.6 cm)
Gift of Miss Ettie Stettheimer, 1951-27-1

Florine Stettheimer was a fixture among Manhattan's
elite during the 1910s and 1920s. In paintings such
as this, in which upper-class women grapple for
discounted couture at Bendel's, a luxury retailer,
Stettheimer used her insider status to poke fun at
spectacles of high society and consumerism. Arranged
like a stage set, complete with a gold-fringed curtain,
the scene reveals a balletic chorus of slim, elegant
figures whose frenzied, self-absorbed behavior is more
characteristic of a common street brawl. Adding to
the subject's irreverence, Stettheimer signed the paint-
ing by including her initials on the monogrammed
sweater worn by the lapdog in the lower left. BAS

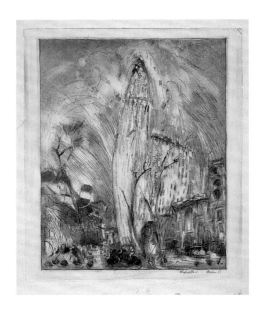

John Marin (American, 1870–1953)

Woolworth Building, No. 1, 1913
Etching with monotype inking, plate: 11¹³⁄₁₆ × 9⅞ in. (30 × 25.1 cm)
The J. Wolfe Golden and Celeste Golden Collection of Marin Etchings, 1969-81-86
© 2014 Estate of John Marin / Artists Rights Society (ARS), New York

After five years of study in Europe, John Marin returned to New York in 1910 in time to witness work begin on what would be the world's tallest skyscraper, the Woolworth Building. In 1913, the year construction was completed, he showed four watercolors depicting the structure's shimmering tower surging skyward at the legendary exhibition of modern art at the Armory in New York. In this etching of the same year, the building appears to glisten in the rainy night, an effect the artist achieved by covering the plate with a lustrous wash of ink, called plate tone, and then wiping highlights on the inky surface with fingertip and dauber before printing. This rare print is part of the Museum's master set of Marin's prints, comprising seventy-one of his printing plates and all but four of his 181 etchings. JI

Georgia O'Keeffe (American, 1887–1986)

No. 15 Special, 1916–17
Charcoal on laid paper, sheet: 18⅞ × 24⅜ in. (47.9 × 61.9 cm)
125th Anniversary Acquisition. Purchased with the gift (by exchange) of Dr. and Mrs. Paul Todd Makler, with funds contributed by Mr. and Mrs. John J. F. Sherrerd, the Alice Newton Osborn Fund, and the Lola Downin Peck Fund, and the gift of The Georgia O'Keeffe Foundation, 1997-39-1
© 2014 Georgia O'Keeffe Museum / Artists Rights Society (ARS), New York

Georgia O'Keeffe and photographer Alfred Stieglitz inscribed the title *Special* on thirty-three of her works completed between 1915 and 1934, but its meaning has never been clarified. Created at the moment when O'Keeffe began incorporating personal shapes and ideas into her art, this composition was inspired by her walks in the precipitous Palo Duro Canyon in Texas. In 1917 Stieglitz included it in the first exhibition of O'Keeffe's work at his New York gallery known as 291. The drawing clearly was special to him: He used it the next year as the background for several of his photographic portraits of O'Keeffe, two of which are in the Museum's collection. IHS

Charles Sheeler (American, 1883–1965)

Stairway to the Studio, 1924
Conté crayon and opaque watercolor on laid paper; sheet:
25⅜ × 19¾ in. (64.5 × 50.2 cm)
Bequest of Mrs. Earl Horter in memory of her husband, 1985-59-1

In the course of his fifty-year career as a painter and
photographer, which spanned the 1910s through the
1950s, Philadelphia native Charles Sheeler became
widely regarded as an important American modern-
ist. He was among the artists who developed a style
known as Precisionism, which was characterized by
sharp pictorial definitions and contrasts, extreme
realism or Cubist-derived abstraction, and a focus on
American regional landscapes or cityscapes. One of
five drawings by Sheeler in the Museum's collection,
this example, depicting the stairs to his studio in New
York, is typical of his mature architectural subjects in
its strict simplicity. AP

Alfred Stieglitz (American, 1864–1946)

From My Window at the Shelton, North, 1931
Gelatin silver print, image and sheet: 9½ × 7½ in. (24.1 × 19.1 cm)
The Alfred Stieglitz Collection, 1949-18-70
© 2014 Georgia O'Keeffe Museum / Artists Rights Society (ARS), New York

In 1944 the Museum mounted an exhibition of works
by Alfred Stieglitz and the artists he championed,
such as Marsden Hartley and John Marin. Five
years later, Stieglitz's widow, artist Georgia O'Keeffe,
donated an important group of such works, includ-
ing sixty-two of her husband's photographs, a nucleus
that was greatly enhanced in the ensuing decades by
the major gift of the Dorothy Norman Collection (see
p. 351). Among the Museum's distinguished holdings
of Stieglitz's photography is this brooding view of the
modernizing city, one of eleven prints in the collec-
tion from the artist's celebrated series of photographs
taken from his apartment in the Shelton Hotel in
New York. PB

Daniel Garber (American, 1880–1958)

Tanis, 1915
Oil on canvas, 60 × 46¼ in. (152.4 × 117.5 cm)
Purchased with funds contributed by Marguerite and Gerry
Lenfest, 2011-60-1
© Daniel Garber

A father's love radiates from this iridescent painting
of sunlight and youth. Trained as an academic figure
painter and drawn to Impressionist landscape sub-
jects, Daniel Garber merged disciplined observation
with his passion for color and light. Shaped by the
realist tradition of Thomas Eakins at the Pennsylvania
Academy of the Fine Arts, Garber traveled in Europe
for two years before returning in 1907 to Philadelphia,
settling in the countryside north of the city. From
his farm in Bucks County, he harmoniously merged
nature, art, and domestic life. In this portrait of
his daughter Tanis, light from the garden outside
his studio renders her smock translucent, while the
composition's serene geometry captures the shimmer
of an endless summer afternoon. A principal of the
New Hope art colony, Garber and his colleagues
William Langson Lathrop and Edward Willis Redfield
led the school of Pennsylvania Impressionists, who are
well represented in the Museum's collection. KAF

Edward Hopper (American, 1882–1967)

Evening Wind, 1921
Etching, plate: 6¹⁵⁄₁₆ × 8¼ in. (17.6 × 21 cm)
Purchased with the Thomas Skelton Harrison Fund, 1962-19-30

Evening Wind presents one of Edward Hopper's
signature subjects—solitary figures who turn away
from the viewer or otherwise are obscured, set in
stark, dramatically illuminated environments that
capture the isolation and anonymity that were increas-
ingly part of the modern urban experience. Many dis-
tinctive aspects of Hopper's highly successful paintings

that feature such intimate portrayals of American life were first developed in prints that he created between 1915 and the mid-1920s. His innate talent as a printmaker is revealed in his masterful manipulation of line, with which he created striking contrasts between densely worked passages and sparsely etched areas that heighten the emotional tenor of the scene. As the world's most comprehensive collection of Hopper's prints, the Museum's holdings include 117 of his etchings and drypoints, more than half of which are progressive proofs that document various states of his images as he developed and refined the etching plates. The Museum owns impressions of each state of *Evening Wind*, including the seventh (and final) state seen here. SRL

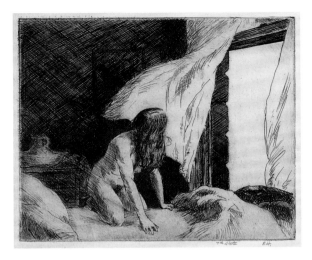

Arthur B. Carles (American, 1882–1952)

Abstract of Flowers, c. 1922
Oil on canvas, 21¼ × 25½ in. (54 × 64.8 cm)
The Samuel S. White 3rd and Vera White Collection, 1967-30-14
© Arthur B. Carles Estate, by permission of Alex Matter

The radiant color and vital energy of *Abstract of Flowers* exemplify the mature work of Arthur B. Carles, who was Philadelphia's leading modernist in the early twentieth century. The painting's rhythmic movement conveys the musicality for which the artist was admired during the 1920s, when he helped bring still life to the forefront of American art. Captivated by the lyrical palette of Henri Matisse and the expressive abstraction of Vasily Kandinsky, Carles introduced contemporary European aesthetics to the Pennsylvania Academy of the Fine Arts, where as an instructor he inspired generations of young painters to embrace the spirit of modernism. MDM

Donald Deskey (American, 1894–1989)

Screen, c. 1929–31
Leather with gold and silver decoration (front), painted canvas (reverse); H. (largest panel) 77½ in. (196.9 cm)
Purchased with the Thomas Skelton Harrison Fund, 1975-62-1

In the late 1920s and 1930s, before launching a successful career as an industrial designer, Donald Deskey designed furnishings, such as this screen, and luxurious apartment interiors for wealthy New York clients. The influence of 1920s modernist architecture, especially the exciting new skyscrapers, is evident in the stepped profile of this screen, which once adorned the apartment of New York socialite Muriel Vanderbilt. Its bold, flat geometric patterns were created with aluminum foil, a recently introduced industrial material that was a marvel of modern technology for many contemporary designers. ERA

Designed by **Eugene Schoen** (American, 1880–1957); made by **Schmieg, Hungate and Kotzian** (New York, 1924–33)

Buffet with Base, 1927
Macassar ebony, rosewood, walnut, and imbuia burl veneers; rosewood, bubinga, walnut, cherry, oak, oak plywood, light and dark wood inlay, brass; w. 72 in. (182.9 cm)
Gift of the Modern Club of Philadelphia, 1929-45-1a,b

The 1925 International Exposition of Modern Industrial and Decorative Arts in Paris had a profound influence on American design in what became known as the Art Deco style. After visiting the fair, New York architect Eugene Schoen opened a gallery selling modern European objects, along with his own designs. Inspired by Austrian and French furniture, Schoen composed this buffet from simple, abstract shapes ornamented with contrasting exotic woods and inlays. Rejecting the nineteenth-century practice of using sideboards for the display of silver and other tablewares, he intended the buffet's massive size to conceal dining accouterments. Given to the Museum in 1929, it was the first piece of contemporary American furniture to enter the collection. DLB

THE PAUL STRAND COLLECTION

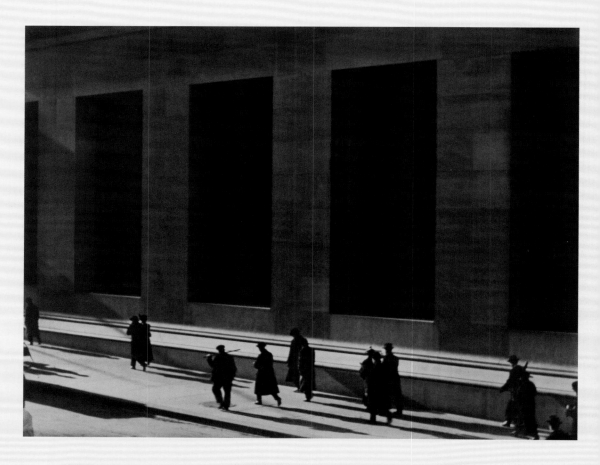

In 2010 the Museum committed to acquire through purchase and gift more than three thousand photographs from the Paul Strand Archive, significantly enhancing its existing collection of more than six hundred of Strand's prints, many of which were featured in the Museum's 1971 retrospective of his work. These combined holdings, comprising all his early glass positives and master prints from every decade of his career, are the definitive representation of his life's work. Together with the Museum's extensive holdings of works by Thomas Eakins and Marcel Duchamp (see pp. 292–93, 342–43, respectively), the Paul Strand Collection is a major foundational element of its important modernist collections.

Having come of age in the New York photography scene spearheaded by Alfred Stieglitz, Strand helped establish the medium's significance as a modern art form. His groundbreaking efforts with formal abstraction and candid street photography are represented in the collection by twenty of his most important platinum and gelatin silver prints of such images, including *Wall Street, New York* (1915; above), his iconic picture of modern city life.

He continued to explore the camera's potential as a modernist tool throughout the 1920s, both in experimental film and in his remarkable investigations of the eight-by-ten view camera's optical power through portraits and studies of machines and natural forms. Strand's beloved picture *Toadstool and Grasses, Georgetown, Maine* (1928; right), for example, demonstrates his attention to the interdependence and structural harmony of diverse elements.

Through his formal pictorial investigations, engagement with the work of other artists, and

political thinking, Strand gradually arrived at a much broader ambition for modernist photography and film, which he elaborated in an unparalleled series of projects from the 1930s onward. These included photographic journeys in Mexico, New England, Europe, and Africa, which resulted in complex and moving portraits of twentieth-century experience. His picture of a cobbler in rural northern Italy (far right), one of many he took of the inhabitants of a village in the Po Valley, reflects his desire to represent a community's everyday life, an endeavor inspired by such literary models as Edgar Lee Masters's *Spoon River Anthology* (1915) and Sherwood Anderson's *Winesburg, Ohio* (1919). **PB**

Paul Strand (American, 1890–1976)

Wall Street, New York, 1915
Platinum print, image: 9¾ × 12¹¹/₁₆ in. (24.8 × 32.2 cm)
The Paul Strand Retrospective Collection, 1915–1975, gift of the estate of Paul Strand, 1980-21-2

Toadstool and Grasses, Georgetown, Maine, 1928
(negative), 1950s (print)
Gelatin silver print, image: 9⅝ × 7⅝ in. (24.4 × 19.4 cm)
The Paul Strand Collection, purchased with funds contributed by Lois G. Brodsky and Julian A. Brodsky, 2014-8-8

Cobbler, Luzzara, Italy, 1953
Gelatin silver print, image and sheet: 5⅞ × 4⅝ in. (15 × 11.8 cm)
The Paul Strand Collection, gift of Marjorie and Jeffrey Honickman, 2012-181-62

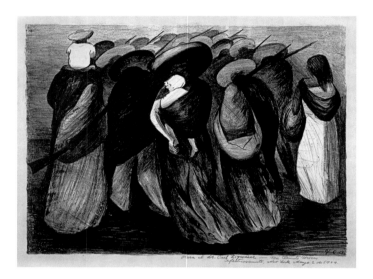

Tina Modotti (Mexican, born Italy, 1896–1942)

Mother and Child, Tehuantepec, Oaxaca, Mexico,
c. 1929
Gelatin silver print, image and sheet: 8¹⁵⁄₁₆ × 6⅛ in. (22.7 × 15.6 cm)
Gift of Mr. and Mrs. Carl Zigrosser, 1968-162-39

In 1913 Tina Modotti emigrated from Italy to the
United States, living in San Francisco and then Los
Angeles. She became a model for American photogra-
pher Edward Weston in 1921, and their affair began
soon after. Two years later they moved to Mexico City,
where Weston instructed her in photography. She
quickly developed her own vision, and after joining
the Mexican Communist Party in 1927, she turned
largely to images of social and political strife. Despite
her prolific output, her work was nearly forgotten. In
1995 the Museum launched the first major exhibition
of Modotti's photography, including such haunting
images of post-revolutionary Mexico as this. NSL

José Clemente Orozco (Mexican, 1883–1949)

Rear Guard, 1929
Lithograph, image: 14 × 18½ in. (35.6 × 47 cm)
Purchased with the Lola Downin Peck Fund from the Carl and
Laura Zigrosser Collection, 1976-97-50
© 2014 Artists Rights Society (ARS), New York / SOMAAP, Mexico City

The Museum owes the richness of its Mexican
modernist print collection to its first curator of prints
and drawings, Carl Zigrosser. Before his appointment
in 1940, Zigrosser was the director of New York's
Weyhe Gallery, an important venue for emerging
international artists. There he published José Clemente
Orozco's increasingly popular lithographs, including
this print based on the artist's series of drawings,
begun in 1926, of the Mexican Revolution. Composi-
tionally, the image relates to Orozco's mural *A Return
to the Battlefields* (1926; Escuela Nacional Preparatoria,
Mexico City), which depicts wives of revolutionary
soldiers carrying both weapons and children. NSL

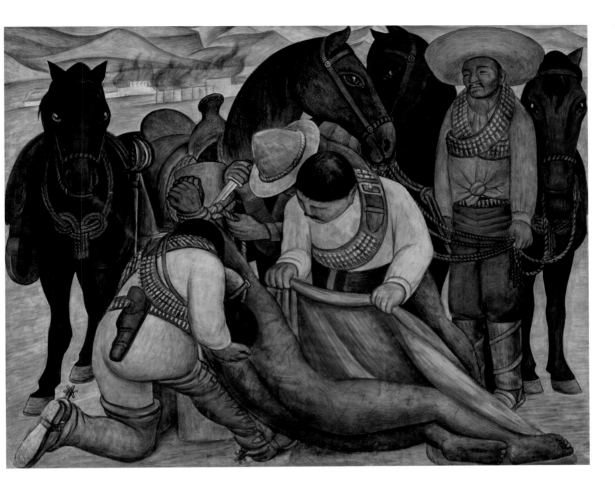

José Diego María Rivera (Mexican, 1886–1957)

Liberation of the Peon, 1931
Fresco, 73 × 94¼ in. (185.4 × 239.4 cm)
Gift of Mr. and Mrs. Herbert Cameron Morris, 1943-46-1
© 2014 Banco de México Diego Rivera Frida Kahlo Museums Trust, Mexico, D.F. /
Artists Rights Society (ARS), New York

A leading figure in the Mexican muralist movement, Diego Rivera sought to illustrate episodes of Mexican history, before and after the revolution of 1911–17, in a clear, straightforward way that could be understood by the masses. To achieve this, he revived the fresco tradition of the Italian Renaissance in which pigments ground in water are applied to a moist lime-plaster surface. For his 1931 retrospective at the Museum of Modern Art in New York, Rivera, keen on fore-grounding the art form for which he was best known, decided to paint a series of movable frescoes, since his most ambitious murals were integral parts of the

buildings that included them. He was given a spacious studio in the Museum of Modern Art building where he completed eight fresco panels, two of which the Philadelphia Museum of Art later acquired.

Liberation of the Peon, one of these two panels, is based on a mural of the same title that Rivera painted in 1923 for the Ministry of Public Education in Mexico City. It symbolizes the struggle to free peasants from a life of unremitting toil, as four revolutionary soldiers release a man who has been flogged and left for dead. Rivera designed his composition to echo scenes of Christ's descent from the cross and the Lamentation. The soldiers attend the naked, lacerated peon—one shares water from his canteen, as another prepares to wrap him in a red robe—while the burning hacienda in the background heralds an end to colonial exploitation. JV

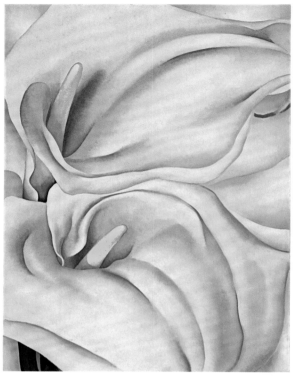

Designed by **Jean G. Theobald** (American, active 1920s–30s) and **Virginia Hamill** (American, 1898–1980); made by **Wilcox Silver Plate Company,** a division of **International Silver Company** (Meriden, Connecticut, 1898–present)

"Dinette" Tea Set, 1928
Pewter, wood; H. (teapot) 3⁵⁄₁₆ in. (8.4 cm)
Purchased with funds contributed by Ruth Nutt, 2006-55-1–4

In the late 1920s American manufacturers endeavored to introduce modern design to a nation that overwhelmingly preferred historical styles. Staff designers at the International Silver Company, for example, created the *Dinette* tea set for the restricted spaces of apartments inhabited by stylish young urbanites. Its radically modern, geometric design reflected the influence of Bauhaus artists such as Marianne Brandt, while its rounded contours foreshadowed the streamlined style of the 1930s. Pewter might have been chosen as the material not only for its traditional appeal but also for its affordability, as pewter sets sold at half the price of silver-plate examples. DLB

Georgia O'Keeffe (American, 1887–1986)
Two Calla Lilies on Pink, 1928
Oil on canvas, 40 × 30 in. (101.6 × 76.2 cm)
Bequest of Georgia O'Keeffe for the Alfred Stieglitz Collection, 1987-70-4
© 2014 Georgia O'Keeffe Museum / Artists Rights Society (ARS), New York

The swelling forms of two calla lilies in flawless bloom convey a poetic sensuality that is enhanced by their delicate pink backdrop. The majesty of Georgia O'Keeffe's oversize flowers commands attention, compelling the viewer to look closely at what might otherwise be overlooked. Working in an art world dominated by men—including her husband, photographer Alfred Stieglitz—and strict gender roles, during the 1920s O'Keeffe struggled against critical dismissal of her flower paintings as erotic allusions. MDM

Wharton H. Esherick (American, 1887–1970)

Fireplace and Doorway from the Bok House,
Gulph Mills, Pennsylvania, 1935–38
White oak, stone, copper, brass; w. 16 ft. (4.88 m)
Acquired through the generosity of W. B. Dixon Stroud, with
additional funds for preservation and installation provided by
Dr. and Mrs. Allen Goldman, Marion Boulton Stroud, and the
Women's Committee of the Philadelphia Museum of Art, 1989-1-2

Born in Philadelphia, where he studied painting at
the Pennsylvania Academy of the Fine Arts, Wharton
Esherick is an iconic figure of the American studio
craft movement. This fireplace and doorway were
made for the library and music room of Curtis and
Nellie Lee Bok's house in Gulph Mills, Pennsylvania.
The commission invited Esherick, renowned for
pushing the limits of his virtuoso woodworking into
a purely sculptural realm, to create an integrated
decorative plan for the building's interiors and fur-
nishings. Considered his greatest artistic achievement,
Esherick's designs for the house were inspired by
Cubism's asymmetrical and angular shapes, and exem-
plify his bold sculptural forms. ERA

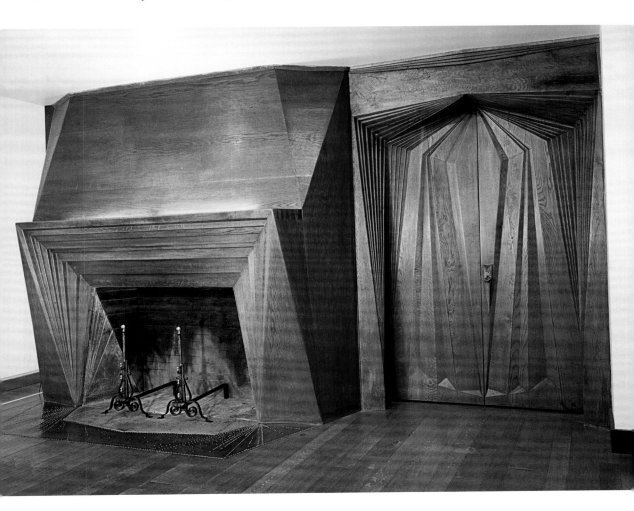

Grant Wood (American, 1891–1942)

Plowing, 1936
Colored pencil and white opaque paint over charcoal on wove
paper, sheet: 23½ × 29½ in. (59.7 × 74.9 cm)
Gift of C. K. Williams, II, 2009-227-1

The principal advocate for American Regionalism's
focus on local subject matter, Iowa native Grant
Wood not only was trained in art and design in
Minneapolis and Chicago, but also studied in Paris
and traveled in Europe. During the Depression, his
idealized landscapes were criticized for portraying a
nostalgia at odds with his home state's collapsing farm
economy. Yet in this drawing, an outstanding example
of the Museum's holdings of works by American
Regionalists, the streamlined curves of undulating
fields recall the simplified forms of contemporary
industrial design, and the plowman's work resembles
that accomplished by modern machinery. IHS

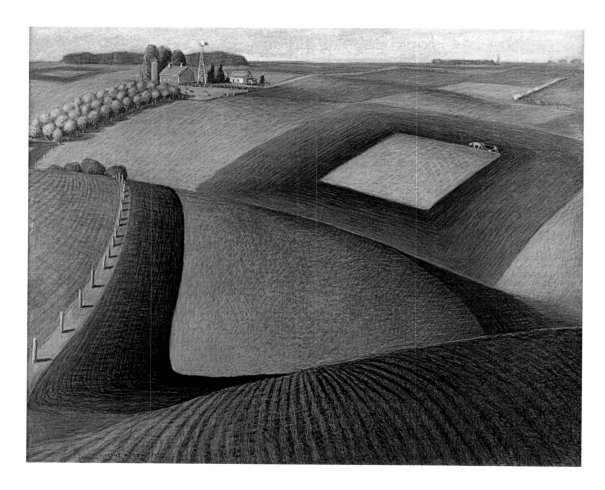

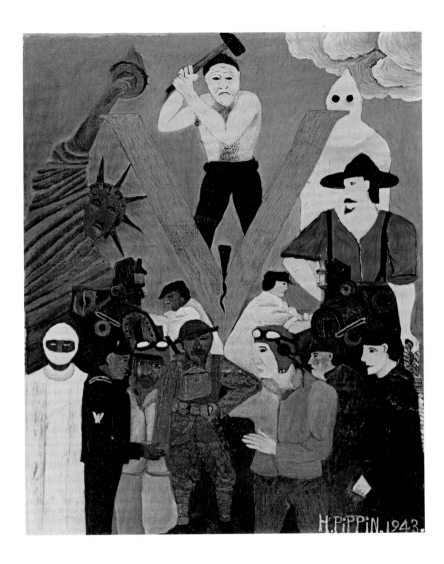

Horace Pippin (American, 1888–1946)

Mr. Prejudice, 1943
Oil on canvas, 18⅛ × 14⅛ in. (46 × 35.9 cm)
Gift of Dr. and Mrs. Matthew T. Moore, 1984-108-1

Wounded, Horace Pippin returned from World War I to be scarred again by the racism that greeted many African American veterans. Twenty-five years later, by then an established artist, he depicted the tensions that flared into riots in 1943 when the United States government attempted to desegregate the defense industry. Here a hooded Klansman and a burly figure holding a noose stand opposite a staggering Statue of Liberty, while the sinister Mr. Prejudice segregates the white and black machinists and servicemen by driving a wedge into the symbolic V of victory. The Museum's rich collection of works by African American artists traces many creative paths, from the ceramics of the enslaved potter David Drake to the Paris Salon paintings of Henry Ossawa Tanner (see pp. 298, 306, respectively). Many were folk, self-taught, or independent artists, such as Sarah Mary Taylor and Bill Traylor; others followed Pippin into the mainstream, including Romare Bearden, Martin Puryear, and Kara Walker (see pp. 387, 348, 378, 397, 424, respectively). KAF

Philip Guston (American, born Canada, 1913–1980)

Bombardment, 1937
Oil on Masonite, DIAM. 42 in. (106.7 cm)
Gift of Musa and Tom Mayer, 2011-2-1
© The Estate of Philip Guston

The atrocities of the Spanish Civil War stoked outrage in many modern artists, including Spaniards Salvador Dalí (see, for example, p. 248) and Pablo Picasso, as well as sympathetic Americans like Philip Guston. *Bombardment* portrays Guston's vision of the war, as informed by news accounts of airborne squadrons laying waste to defenseless civilian towns. The colorful clothing and heroic musculature of the fleeing victims, dynamically foreshortened within a circular tondo, reflect the artist's study of Italian Old Masters.

Combining artistic conventions with the political activism of contemporaneous Mexican muralists, such as Diego Rivera (p. 323) and David Alfaro Siqueiros (see entry below), here Guston has evinced art's emotional power as a vital instrument of protest. JV

David Alfaro Siqueiros (Mexican, 1896–1974)

War, 1939
Duco on two panels, 48⅝ × 63⅞ in. (123.5 × 162.2 cm) overall
Gift of Inés Amor, 1945-84-1a,b
© 2014 Artists Rights Society (ARS), New York / SOMAAP, Mexico City

In 1937 Mexican artist David Alfaro Siqueiros went to Spain to fight for the Republican army in the Spanish Civil War. The two years he spent in this grisly conflict had a lasting effect on the imagery in

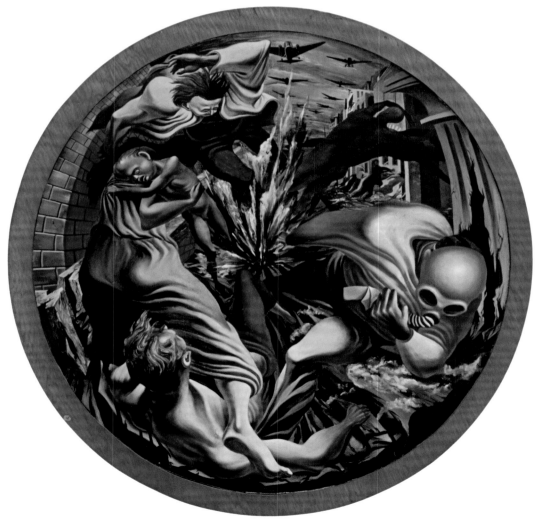

his paintings. This anonymous body, painted when the artist returned to Mexico in 1939, represents the faceless multitudes victimized by war. Its pain is heightened by the deep red of the rumpled cloth on which the figure lies, while the pale left arm suggests necrosis, perhaps signaling a slowly spreading death or a gangrenous limb soon to be amputated. MAC

materials. A version of the poster was shown at the Museum in the 1942 exhibition *Art in Advertising*, which promoted the vital role of American artists in the war effort. A French national (caught here by the war), Carlu became one of America's most important propagandists. KBH

Designed by **Jean Carlu** (French, 1900–1997); printed by **US Government Printing Office, Office for Emergency Management** (Washington, DC, 1940–44)

"America's Answer! Production" Poster, 1941
Offset lithograph, 29⅞ × 39⅝ in. (75.9 × 100.6 cm)
Purchased with funds contributed by Gregory M. Harvey in memory of Merrill P. Harvey, 2003-70-1
© 2014 Artists Rights Society (ARS), New York / ADAGP, Paris

Jean Carlu's powerful image was the first World War II poster commissioned by the United States government. Published for the lend-lease program, through which the US government provided defense supplies to the Allies before the country's official entry into the conflict in late 1941, the poster was designed to encourage American manufacture of military

Man Ray (American, 1890–1976) and **Marcel Duchamp** (American, born France, 1887–1968)

Marcel Duchamp as Rrose Sélavy, c. 1920–21
Gelatin silver print, image and sheet: 8½ × 6¹³⁄₁₆ in. (21.6 × 17.3 cm)
The Samuel S. White 3rd and Vera White Collection, 1957-49-1
© Man Ray Trust / Artists Rights Society (ARS), NY / ADAGP, Paris 2014
© Succession Marcel Duchamp / ADAGP, Paris / Artists Rights Society (ARS), New York 2014

Rrose Sélavy, artist Marcel Duchamp's feminine alter ego, is one of the most complex pieces in the enigmatic puzzle of his oeuvre. First emerging in portraits by photographer Man Ray in New York in the early 1920s, when the two artists were collaborating on a number of conceptual photographic works, Rrose Sélavy lived on through the writings, puns, and works of art that Duchamp attributed to her throughout his career. This print, inscribed in 1924 by Duchamp and Man Ray to the Philadelphia collector Samuel S. White III, is part of the Museum's internationally renowned holdings of works by and about Duchamp. PB/MC

Manuel Álvarez Bravo (Mexican, 1902–2002)

Optic Parable, 1931
Gelatin silver print, image and sheet: 7½ × 8⅜ in. (19 × 21.3 cm)
125th Anniversary Acquisition. The Lynne and Harold Honickman Gift of the Julien Levy Collection, 2001-62-35
© 2014 Artists Rights Society (ARS), New York / ADAGP, Paris

The Museum's holdings from the collection of New York art dealer Julien Levy includes masterpieces by leading photographers of the 1920s and 1930s, such as Manuel Álvarez Bravo, Henri Cartier-Bresson, Walker Evans, and Lee Miller. Among the collection's treasures are ten exhibition prints by Álvarez Bravo, including this image of an optician's shop window in Mexico City, which brilliantly undermines the supposed reliability of vision and demonstrates the artist's affinities with the European Surrealists. Presumably these prints were part of Levy's seminal 1935 exhibition of works by Álvarez Bravo, Cartier-Bresson, and Evans, which helped launch the careers of all three artists, each of whom is among the greatest photographers of the twentieth century. PB

Joseph Cornell (American, 1903–1972)

Untitled (Woodpecker Habitat), 1946
Box construction, H. 13⅝ in. (34.6 cm)
125th Anniversary Acquisition. Partial gift of Mrs. Edwin A.
Bergman, and purchased with the gift (by exchange) of Anna
Warren Ingersoll, 2000-5-2

Ever enigmatic, Joseph Cornell pioneered a unique approach to art, creating evocative collages and enchanting box constructions from materials found in New York junk shops and bookstores. Playfully poetic works like this convey an uncanny realism mingled with nostalgia, here aroused by the naturalist illustrations of birds—one of the artist's favorite subjects—housed within a hypnotic, paint-splattered diorama. Although a strong individualist, Cornell was linked to many Surrealist artists through exhibitions, publications, and mutual appreciation. The ringed disks of this assemblage may suggest Marcel Duchamp's *Rotoreliefs* (1935), cardboard disks meant to be spun on turntables, as Cornell collaborated with the French artist in the 1940s. JV

Milton Avery (American, 1893–1965)

Black Jumper, 1944

Oil on canvas, 54⅜ × 33¾ in. (137.6 × 85.7 cm)
Bequest of Mrs. Maurice J. Speiser in memory of Raymond A.
Speiser, 1968-177-1
© 2014 Milton Avery Trust / Artists Rights Society (ARS), New York

This portrait of the artist's twelve-year-old daughter,
March, exemplifies Milton Avery's mature style, dem-
onstrating his indebtedness to the paintings of Henri
Matisse (see, for example, p. 246) and the impact
of his own work on the younger generation of New
York–based abstractionists. The various elements in
this composition—the red table, the green wall, the
purple blouse, and the yellow screen—stand as dis-
crete, vibrant masses, while simultaneously interacting
with one another to establish pairs of complementary
colors that maximize the painting's visual impact.
Although Avery left his subject's face blank, the por-
trait remains a tender image of his adored daughter. JV

Willem de Kooning (American, born The Netherlands, 1904–1997)

Seated Woman, c. 1940

Oil and charcoal on Masonite, 54⅛ × 36 in. (137.3 × 91.4 cm)
The Albert M. Greenfield and Elizabeth M. Greenfield
Collection, 1974-178-23
© 2014 The Willem de Kooning Foundation / Artists Rights Society (ARS), New York

This is an early example from Willem de Kooning's
extensive series of paintings that constituted one of
the most aggressive revisions of the female figure in
twentieth-century art. Here the artist's rearrangement
of the woman's body is conveyed through the outlines
that emerge from gestural fields of color. The intense,
acidic palette is typical of his work of this time, while
the flattened environment responds to his lifelong
study of the pictorial features of abstraction (see, for
example, p. 393). With her hieratic dreamlike stare,
and the faint suggestion of a crown atop her head, this
voluptuous seated woman suggests the embodiment
of a symbol, like a playing-card queen or a magazine
model, rather than a specific individual. JV/AT

Jackson Pollock (American, 1912–1956)

Male and Female, 1942–43
Oil on canvas, 73¼ × 48¹⁵⁄₁₆ in. (186.1 × 124.3 cm)
Gift of Mr. and Mrs. H. Gates Lloyd, 1974-232-1
© 2014 The Pollock-Krasner Foundation / Artists Rights Society (ARS), New York

This painting was included in Jackson Pollock's 1943 solo exhibition at Art of This Century, legendary art patron Peggy Guggenheim's radically innovative New York gallery. As its title suggests, the work depicts a male figure, embodied in the black column at right covered with mysterious numerical markings, and a curvy, cat-eyed female figure at left. Balanced on tiny triangular feet, these archetypical representations emerge from splashes and smears of paint, conjuring the sense of primal energy that Pollock believed art could reveal or unleash, while also foreshadowing his famous "drip" technique developed later that decade. JV/MT

Roberto Matta (Chilean, 1911–2002)

The Bachelors Twenty Years Later, 1943
Oil on canvas, 38 × 50 in. (96.5 × 127 cm)
Purchased with the Edith H. Bell Fund, the Edward and Althea
Budd Fund, gifts (by exchange) of Mr. and Mrs. William P. Wood
and Bernard Davis, and bequest (by exchange) of Miss Anna
Warren Ingersoll, 1989-51-1
© 2014 Artists Rights Society (ARS), New York / ADAGP, Paris

This painting pays homage to the great allegory of
frustrated desire, *The Bride Stripped Bare by Her
Bachelors, Even (The Large Glass)* by Marcel Duchamp
(1915–23; p. 340), whom Roberto Matta admired for
his explorations of science and eroticism. Twenty years
after the French artist declared his work unfinished,
Matta reenergized the bachelors within an infinite
space full of subtle tonal passages and incisive linear
markings that recall the cracks in Duchamp's origi-
nal. The sexual tension permeating *The Large Glass* is
revived here in the excitement of the lamplike bach-
elors, as their illuminating gas mixes with other nebu-
lous vapors and crystalline elements to produce
a vision of primal chaos. JV/MT

Mark Rothko (American, born Latvia, 1903–1970)

Gyrations on Four Planes, 1944
Oil on canvas, 24 × 48 in. (61 × 121.9 cm)
Gift of the Mark Rothko Foundation, Inc., 1985-19-3
© 1998 Kate Rothko Prizel & Christopher Rothko / Artists Rights Society (ARS),
New York

Spinning and weaving, the two central figures of
Mark Rothko's *Gyrations on Four Planes* move through
space as if they are dancing on a stage, suggesting the
painting's other recorded title, *Horizontal Procession.*
Inspired by Surrealism, he based the forms on micro-
scopic organisms, which he found evocative of the
creatures that haunt the subconscious. Within a few
years, the color planes on which Rothko's fantastical
figures dance and perform became the primary subject
of his luminous abstract works. MDM

Arshile Gorky (American, born Armenia, c. 1902–1948)

Dark Green Painting, c. 1948
Oil on canvas, 43¾ × 55½ in. (111.1 × 141 cm)
Gift (by exchange) of Mr. and Mrs. Rodolphe Meyer de
Schauensee and R. Sturgis and Marion B. F. Ingersoll, 1995-54-1
© 2014 The Arshile Gorky Foundation / Artists Rights Society (ARS), New York

Historically tied to both Surrealism and Abstract
Expressionism, Arshile Gorky emerged as a unique
artistic voice only in the 1940s, producing in a short
span of time an intense, brilliant body of work
steeped in studies of nature and memories of his
homeland. The biomorphic forms of this painting
suggest hidden messages that resist literal decod-
ing. Although the shapes seem freely improvised, an
impression often conveyed in the artist's work, the
meticulously plotted design was based on a gridded
preparatory drawing. One of the very last works cre-
ated before the artist's suicide, in retrospect this canvas
is a somber composition of impenetrable density,
hinting at tragedy. JV/MT

Designed by **Helen Rose** (American, 1904–1985); made by the wardrobe department of **Metro-Goldwyn-Mayer** (Culver City, California, 1924–present)

Grace Kelly's Wedding Dress and Accessories, 1956
Silk, lace, seed pearls
Gift of Her Serene Highness, the Princesse Grace de Monaco, 1956-51-1a–d–4b

Movie actress Grace Kelly, a Philadelphia native, wore this gown for her wedding to Prince Rainier III of Monaco on April 19, 1956. A gift from her studio, Metro-Goldwyn-Mayer, the dress was designed by Academy Award–winning costume designer Helen Rose, who had created the star's wardrobe for four films, including *High Society* and *The Swan*. MGM's wardrobe department constructed it with meticulous care under strict security.

In style and detail the dress was conceived to complement the bride's fairy-princess image. The bell-shaped skirt of ivory faille, supported by three attached petticoats, fans out into a graceful lace train; the high-necked bodice of antique Brussels lace was re-embroidered to render the seams invisible and then accented with seed pearls. Lace embellished with pearls covers the accompanying prayer book, shoes, and cap, which is surmounted by a wreath of orange blossoms. The circular veil was designed specially so as not to obscure the bride's famous face.

As a Hollywood star, Kelly was renowned for her beauty and talent—recognized by her Academy Award for best actress for her role in *The Country Girl* (1954)—and for her understated, classic style that inspired the fashion phenomenon known as the Grace Kelly Look. As a royal bride, her magnificent yet simple ensemble incited intense interest and admiration. Shortly after the wedding, the princess presented the gown to the Museum, where it has become one of the collection's most popular and beloved objects, and continues to serve as the ultimate exemplar of bridal elegance. HKH

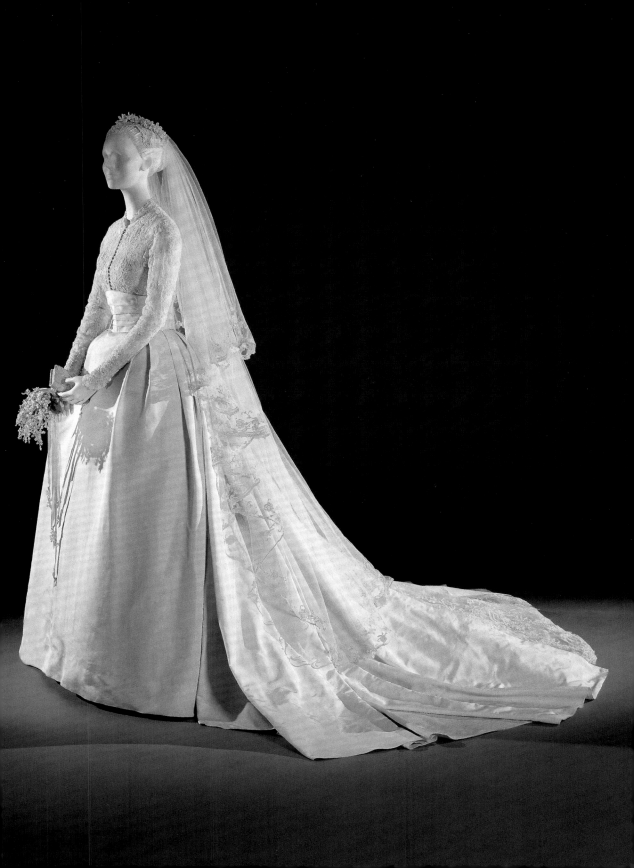

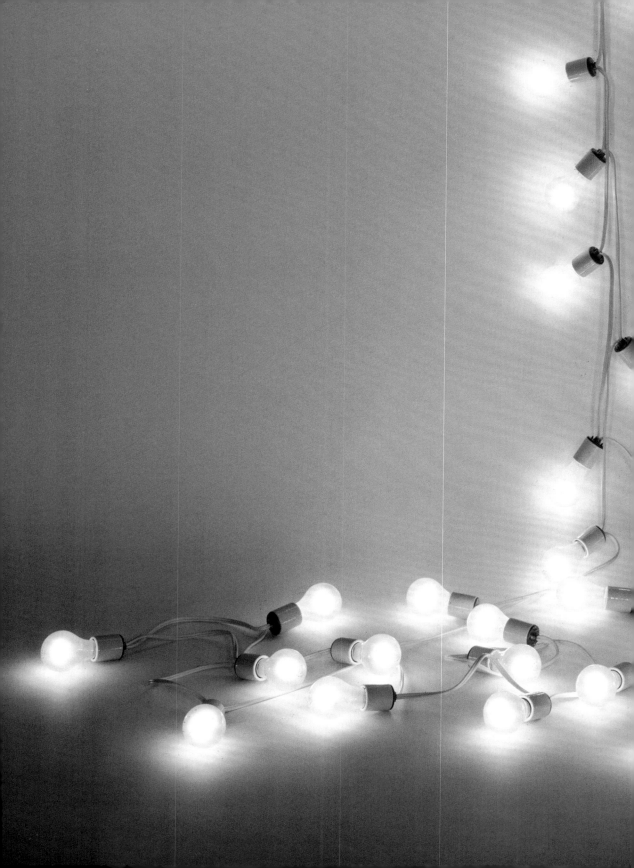

Contemporary

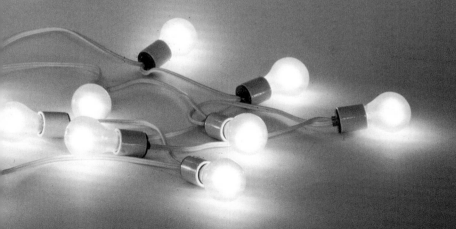

Marcel Duchamp (American, born France, 1887–1968)

The Bride Stripped Bare by Her Bachelors, Even (The Large Glass), 1915–23

Oil, varnish, lead foil, lead wire, and dust on two glass panels; H. 9 ft. 1¼ in. (2.78 m)

Bequest of Katherine S. Dreier, 1952-98-1

© Succession Marcel Duchamp / ADAGP, Paris / Artists Rights Society (ARS), New York 2014

Marcel Duchamp's *The Large Glass* is a work of art to be looked both at and through. Although Duchamp called the *Glass* "a hilarious picture," he took it seriously enough to devote eight years to its intricate execution. As a twenty-seven-year-old newcomer to New York, in 1915 he began to work on this masterpiece, having first conceived of it three years earlier while sojourning in Munich. Each element of the *Glass* is the result of meticulous studies, calculations, and experiments. Accordingly, Duchamp prepared a voluminous body of notes that address the narrative described by the work's full title. In 1934 he published ninety-four of these notes in *The Green Box*, which suggest possible readings of the imagery of the *Glass*, and document in painstaking detail the complex interactions and erotic tension between the enigmatic bride in the upper panel and her nine uniformed bachelors below.

In 1923 Duchamp stopped working on the *Glass*, stating that it was "definitively unfinished." A few years later, while in transit following an exhibition at the Brooklyn Museum in 1926–27, the two panels were shattered. Ten years would pass before Duchamp repaired the glass fragments, laboriously securing them between new panes and housing the fabrication in an aluminum frame. Satisfied with the result and the appearance of the eerily symmetrical cracks in the upper and lower sections of the work, he declared it finished. Occupying the space in the Museum chosen by the artist a half-century ago, *The Large Glass* has become the subject of extensive scholarship, and the object of pilgrimages for countless visitors drawn to its witty, intelligent, and vastly liberating redefinition of what a work of art can be. CB

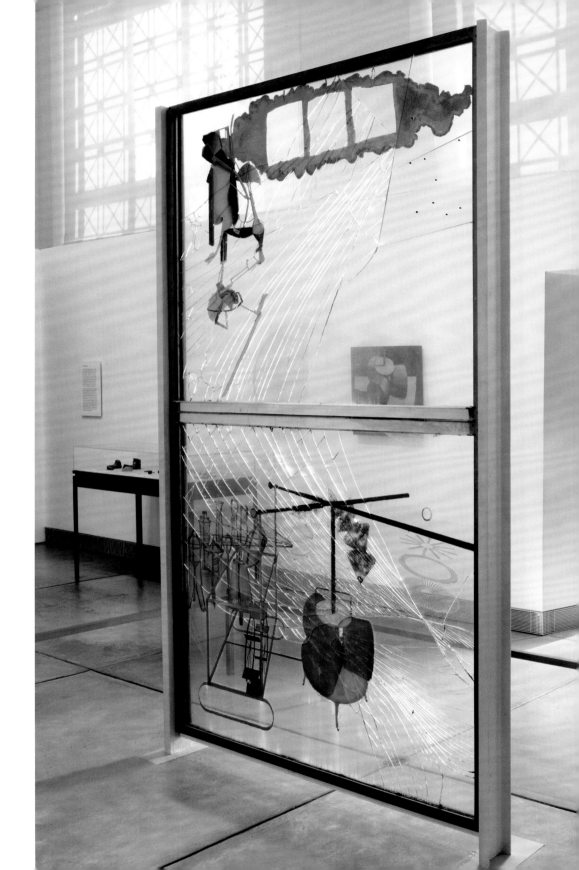

MARCEL DUCHAMP

The Museum is the repository of the world's largest collection of works by Marcel Duchamp, one of the most influential artists of the twentieth century, who was responsible for fundamentally challenging the very notion of what art is. This extraordinary trove of materials includes two of Duchamp's most important masterpieces, *The Large Glass* (1915–23; p. 340) and *Étant donnés* (1946–66; right), all three versions of his celebrated *Nude Descending a Staircase* (see p. 236), and many of his early paintings and drawings, as well as notes, sketches, and first incarnations of his readymades.

Duchamp's *Fountain* (below) is arguably among the most thought-provoking works of art in the history of modernism. In the spring of 1917, Duchamp anonymously submitted the work, a urinal he had acquired at the New York showroom of the J. L. Mott Iron Works and signed "R. Mutt," to the first exhibition of the Society of Independent Artists, of which he was a founding member. When its inclusion was refused by a committee whose authority did not entail such prerogative, he quit. That year he would have the work photographed by Alfred Stieglitz, a celebrated artist and pioneer of modern art, for publication in the second issue of *The Blind Man*, a magazine Duchamp edited with artist Beatrice Wood and writer Henri-Pierre Roché. Since then and for almost a century, *Fountain* has remained at the center of heated arguments, art historical and other, on why it should be considered a work of art. These debates have reshaped the landscape of contemporary art and contributed greatly to the myth of Duchamp, an integral aspect of his work as an artist. Although the urinal first submitted to the Society of Independent Artists has been lost, the work in the Museum's collection is the earliest existing replica.

Duchamp's posthumous masterpiece, the quietly and profoundly perplexing *Étant donnés*, was constructed over a twenty-year period, from 1946 to 1966, during which time it was generally assumed that the artist had given up making works of art. Thus, after his death in 1968, the news that he had discreetly been working on an elaborate final project was greeted with great surprise. Accompanied only by a carefully compiled installation manual, *Étant donnés* shocked Duchamp's champions and detractors alike. In accordance with the artist's wishes, in 1969 it was installed at the Museum in a gallery devoted to his work, where visitors have a unique opportunity to gain insight into the oeuvre of this exceptional artist. CB

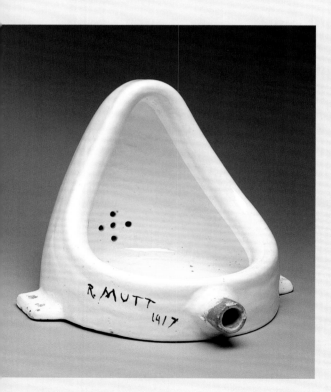

Marcel Duchamp (American, born France, 1887–1968)

Fountain, 1950 (replica of 1917 original)
Porcelain urinal, H. 12 in. (30.5 cm)
125th Anniversary Acquisition. Gift (by exchange) of Mrs. Herbert Cameron Morris, 1998-74-1

Étant donnés: 1° la chute d'eau, 2° le gaz d'éclairage . . . (Given: 1. The Waterfall, 2. The Illuminating Gas . . .), 1946–66
Mixed media assemblage, H. 95½ in. (242.6 cm)
Gift of the Cassandra Foundation, 1969-41-1

Designed by **Charles Eames** (American, 1907–1978) and **Ray Eames** (American, 1912–1988); shell made by **Zenith Plastics Company** (Gardena, California, established 1943); base made by **Herman Miller Furniture Company** (Zeeland, Michigan, 1923–present)

"RAR" Rocking Armchair, designed 1948–50
Molded polyester-fiberglass composite, steel, birch, rubber; H. 26½ in. (67.3 cm)
Gift of Collab: The Group for Modern and Contemporary Design at the Philadelphia Museum of Art, 1985-94-1

Landmarks of modern design, Charles and Ray Eames's molded-shell chairs, including the *RAR* rocker, were among the first pieces of mass-produced furniture made primarily of plastic. Their form evolved from the Eameses' prize-winning proposal to the 1948 International Competition for Low-Cost Furniture Design, sponsored by the Museum of Modern Art in New York. The shell of their winning chair was molded from a single material and could be mounted on a variety of bases, including rockers. They had intended to stamp the shells from metal, but through collaboration with Zenith Plastics they developed a plastic version that was lightweight, durable, colorful, and inexpensive to manufacture. DLB

Designed by **Donald H. Colflesh** (American, born 1932); made by **Gorham Manufacturing Company** (Providence, Rhode Island, 1831–present)

"Circa '70" Tea and Coffee Service, designed 1958 and 1963, made 1960–66
Silver, ebony, Formica; H. (coffee pot) 11⅝ in. (29.6 cm)
Purchased with funds contributed by Marguerite and Gerry Lenfest and the Richardson Fund, 2010-74-1a,b–5

The Soviet Union's launch of the first Sputnik in 1957 is considered the beginning of the modern space age, which proved a ready source of inspiration for American artists. Designed in 1958, Donald Colflesh's *Circa '70* line of hollowware, with its strong vertical forms, was intended to evoke the sense of moving into space. Gorham offered this service, designed with complex contours that required special fabrication as well as ebony handles and finials, as a higher-quality alternative to other industrially produced silverware of the period. The extraordinary tray, introduced in 1963, incorporated Formica, a plastic laminate that became a popular household material after World War II. DLB

Designed by **Joe Colombo** (Italian, 1930–1971); made by **Boffi** (Milan, 1934–present)

Mini-Kitchen, designed 1963
Plastic-coated wood, plastic, stainless steel; H. 37¾ in. (95.9 cm)
Gift of Mr. and Mrs. Benjamin Thompson, 2000-89-1

Only slightly larger than a conventional washing machine, this portable mini-kitchen contains everything necessary for food storage, preparation, and service for six people. Designed for use in a studio apartment, an office, or a garden setting, this compact, all-in-one electrically powered unit is the most famous of the multifunction products that earned Joe Colombo his reputation. An ingenious designer of furniture, glass, interiors, and lighting, Colombo led rationalist Italian design in the 1960s with objects and living units that maximized functions in minimal spaces. This kitchen belonged to American architect Benjamin Thompson, whose Design Research stores introduced avant-garde European furnishings and accessories (see, for example, the Marimekko fabric on p. 409), in the United States. KBH

Ellsworth Kelly (American, born 1923)

Seine, 1951
Oil on wood, 16½ × 45¼ in. (41.9 × 114.9 cm)
Purchased with funds contributed in memory of Anne
d'Harnoncourt and other Museum funds, 2008-228-1
© Ellsworth Kelly

In 1948, following his military service in World War II, twenty-five-year-old Ellsworth Kelly moved to Paris, where he lived for six years before moving to New York in 1954. Kelly made significant changes in his artistic production during this formative period, when he met a number of artists and progressively came into the singular and groundbreaking form of intensely felt abstraction for which he is widely known and celebrated. While in Paris, he abandoned figuration and easel painting, made his first shaped-wood cutout canvases, and embraced white monochrome and then primary colors. It was there that in February 1950 Kelly encountered Jean (Hans) Arp's collages, arranged according to chance, which had a profound impact on the work of the young artist. Chance began to play an increasingly larger role in Kelly's art, with *Seine* an early and accomplished example. In creating the painting—a representation of light flickering on the wavering surface of the Seine, translated into a geometric pattern—the artist incorporated chance into the process, pulling numbers from a box and darkening the corresponding blocks of a modular grid. CB

Lee Krasner (American, 1908–1984)

Composition, 1949
Oil on canvas, 38⅛₆ × 27¹³⁄₁₆ in. (96.7 × 70.6 cm)
Gift of the Aaron E. Norman Fund, Inc., 1959-31-1
© 2014 The Pollock-Krasner Foundation / Artists Rights Society (ARS), New York

Part of Lee Krasner's breakthrough *Little Image* series of the late 1940s, this meticulously crafted and intimately scaled canvas reflects the artist's deft control of innovative, unorthodox painting methods. Krasner—the wife of one of the most celebrated artists in the postwar period, Jackson Pollock—worked the canvas flat on a table, applying pigments with sticks and palette knives or straight from tubes. The picture's overlapping skeins of dripped white paint form small, geometric compartments and convoluted designs atop its densely textured surface. Impenetrable and unreadable, *Composition* celebrates painting as a primal means of communication through an analogy to picture-based writing systems. JV

SELF-TAUGHT ARTISTS

Since 1993 the Museum has been collecting in a relatively new field that, for lack of a better term, is referred to as "outsider art," or work by self-taught artists. First recognized in Europe during the early years of the twentieth century and in the United States by the 1930s, outsider art is created by individuals who have not attended art school, who are not employed professionally as artists, and who work, for the most part, with limited or no contact with the mainstream art world. These artists operate from their own motivations and influences—including dreams, memories, imagination, visions, popular culture, regional character, and religion—rather than from within established conventions.

At present the Museum's holdings comprise more than five hundred outsider works in various mediums, primarily by American artists. Nearly two hundred of these are part of the transformative

Bill Traylor (American, c. 1853–1949)
Runaway Goat Cart, c. 1939–42
Opaque watercolor and graphite on cream card, 14 × 22 in. (35.6 × 55.9 cm)
The Jill and Sheldon Bonovitz Collection

Martín Ramírez (American, born Mexico, 1895–1963)
Long Train, 1953
Crayon, opaque watercolor, and ink on paper; sheet: 2 ft. 5⅝ in. × 9 ft. 2¾ in. (0.75 × 2.81 m)
Gift of Josephine Albarelli in memory of Alphonse Albarelli, 1993-101-1

James Castle (American, 1899–1977)
Untitled (Girl with Bicycle-Wheel Head), n.d.
Cardboard, printed and colored papers, cotton and synthetic string; H. 17¼ in. (43.8 cm)
Gift of the James Castle Collection, L.P., Boise, Idaho, in honor of Ann Percy Stroud, 2007-121-1

promised gift made in 2011 by Philadelphians Jill and Sheldon Bonovitz, which launched the Museum into the top ranks of institutions in the United States that pursue this material. The gift includes thirteen works by Bill Traylor, born a slave on an Alabama plantation, who in a brief but remarkable burst of creativity in his mid- to late eighties produced some 1,200 drawings while living on the streets of Montgomery. Executed on found pieces of paper, works such as his *Runaway Goat Cart* (left) depict—with a distinctive combination of simplified forms and narrative liveliness—animals, events, and people from Traylor's long life in the post–Civil War South.

Equally mysterious impulses spurred Mexican-born Martín Ramírez, who was confined to California mental institutions for much of his adult life. His enigmatic images of animals, horsemen, landscapes, Madonnas, trains (see below), and tunnels have been widely acclaimed by contemporary critics for their unique imagery and unusual spatial configurations.

Born deaf, James Castle never acquired the tools of spoken or written language, presumably could not read, and rarely left his family's rural Idaho farms. Yet he produced an enormous and complex body of work with found and homemade materials, utilizing many different aesthetic and conceptual strategies that range from Surrealist imagery to pop-culture appropriation to collage and assemblage (see right) to text art. The Museum's fifty-six Castles are among the strongest public holdings by this remarkable artist. AP

Andrew Newell Wyeth (American, 1917–2009)

Groundhog Day, 1959

Tempera on panel, 31⅜ × 32⅛ in. (79.7 × 81.6 cm)
Gift of Henry F. du Pont and Mrs. John Wintersteen, 1959-102-1
© Andrew Wyeth

Andrew Wyeth often is seen as existing outside his own time or any particular tradition. In his art, however, he maintained a strong continuity with the painters of the 1930s and 1940s who focused on typically American scenes of daily life. Using the medieval technique of egg tempera, here Wyeth created a sense of great intimacy through his exquisite rendering of his neighbors' light-flooded Pennsylvania farmhouse kitchen. Yet the dryness and restraint of the demanding medium combine with the image of the table's solitary place setting to evoke a mood of overwhelming loneliness. Outside, the wire fence and the steeply rising hill that cuts off any glimpse of sky compound this sense of isolation. JBR/AVa

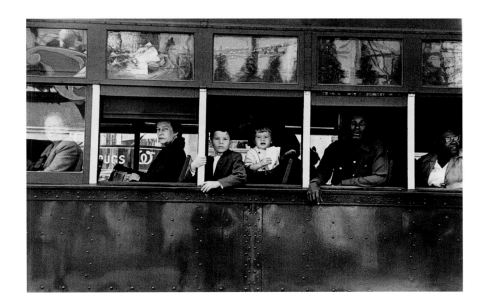

Robert Frank (American, born Switzerland 1924)

Trolley, New Orleans, 1955

Gelatin silver print, image: 12⁵⁄₁₆ × 18¹³⁄₁₆ in. (31.2 × 47.8 cm)
Purchased with funds contributed by Dorothy Norman,
1969-195-55
© Robert Frank, from *The Americans*; courtesy Pace/MacGill Gallery, New York

Robert Frank's influential book *The Americans* (1959),
featuring photographs from his 1955 road trip across
the continental United States, inaugurated a turn to
deadpan documentary style in American photogra-
phy and galvanized a generation of younger artists.
In this scene of a New Orleans trolley car, one of the
iconic images from Frank's series, the spare compart-
mentalization of the subjects suggests the ambiguities
of modern experience while baldly illustrating the
racial segregation of the time and place. This is one of
forty-five works by Frank acquired in 1969 through
the gift of photographer and philanthropist Dorothy
Norman, one year after she founded the Museum's
Alfred Stieglitz Center. PB

Dorothea Lange (American, 1895–1965)

Cable Car, San Francisco, 1956

Gelatin silver print, image: 15½ × 15⁵⁄₁₆ in. (39.4 × 38.9 cm)
Purchased with funds contributed by the Friends of the Alfred
Stieglitz Center, 2010-225-1
© The Dorothea Lange Collection, the Oakland Museum of California, City of
Oakland. Gift of Paul S. Taylor

Dorothea Lange's tightly framed picture of the crossed
legs of a woman seated in a cable car conveys volumes

about American prosperity and urban life after World
War II. An important example of Lange's later work,
the image demonstrates her extraordinary understand-
ing of the expressiveness of the human figure, and its
relaxed confidence contrasts with the sense of anxiety
visible in her earlier photographs documenting the Great
Depression. This print is one of several outstanding
examples among the Museum's holdings of works by
American women photographers, including Berenice
Abbott, Gertrude Käsebier, and Lee Miller. JW

Sam Francis (American, 1923–1994)

Red, 1955–56

Oil on canvas, 10 ft. 2 in. × 6 ft. 2 in. (3.1 × 1.88 m)
125th Anniversary Acquisition. Partial and promised gift of
Dennis Alter, 2000-94-1

This brilliant canvas reveals Sam Francis at the height
of his creativity, when he responded to the natural
world though his distinctive painting language.
Divided into fields of warm and cool tones, the
picture is a tumbling accumulation of cell-like forms,
realized through soaking and dripping paint. While
the artist's dynamic colors and nuanced exploration
of the painting process place him squarely in the
context of Abstract Expressionism, *Red,* which Francis
painted in Paris, also represents his lifelong homage to
Impressionism and Fauvism. Indeed, this unique mar-
riage of elements from American and French painting
traditions remained the hallmark of Francis's work
throughout his career. SR/JV

Franz Kline (American, 1910–1962)

Torches Mauve, 1960
Oil on canvas, 10 ft. ⅛ in. × 6 ft. 9⅛ in. (3.05 × 2.06 m)
Gift of the artist, 1961-223-1
© 2014 The Franz Kline Estate / Artists Rights Society (ARS), New York

Franz Kline is best known for his sweeping black-and-white paintings from the late 1940s and early 1950s that represent some of the purest examples of Abstract Expressionism. By the late 1950s, however, Kline reintroduced color into his work as a way to extend and redefine the essential tension between black and white. Here the atmospheric haze of purple does not mitigate the sense of movement and pressure that arises between the two primary tones, but rather enriches it. Despite its suggestions of an elegiac, flame-lit ceremony, *Torches Mauve* in fact was named for a brand of purple oil paint manufactured by Joseph Torch on Fourteenth Street in New York. JBR/JV

Jess (American, 1923–2004)

The Sun: Tarot XIX, 1960

Collage of lithographic illustrations on wove paper, with
window-shade pull; sheet: 80 × 50 in. (203.2 × 127 cm)
Purchased with the SmithKline Beckman Corporation Fund,
1984-78-1

Chemist and beat-generation artist Jess is known
for his so-called paste-ups in which he combined
hundreds of cut-out images to create scenes of a
mythical reality that he described as matching or
surpassing logic. His imaginative interpretation of the
nineteenth card of the Major Arcana suit in a Tarot
deck juxtaposes large anatomical illustrations with
fantastical images. This monumental work is part of
the Museum's famed Ars Medica Collection (see also
p. 311), comprising works dating from the fifteenth
century to the present that chronicle cultural interest
in human anatomy, health, and medicine. JW

David Smith (American, 1906–1965)

Two Box Structure, 1961

Stainless steel, H. 13 ft. 9 in. (4.19 m)
Gift of Paul and Hope Makler, 1972-130-1
Art © Estate of David Smith / Licensed by VAGA, New York. Photography by
Robert McKeever, courtesy Gagosian Gallery

David Smith was one of the most important sculptors of his generation, defining his work in three dimensions among the painters of Abstract Expressionism while retaining an affinity with early twentieth-century Cubism. Smith composed this sculpture from prefabricated steel elements burnished to a high polish and then welded together, creating a work that is not only imposing in its towering height but also light and elegant in its reflective possibilities. Playing upon the precepts of flatness and depth, as well as abstraction and figuration, *Two Box Structure* can be read as a two-dimensional cut-out or a sculpture in the round, a blending of two bodies or an evocative assemblage of shapes and forms. EFB

James Rosenquist (American, born 1933)

Zone, 1961
Oil on two canvas sections, 95¼ × 96½ in. (241.9 × 245.1 cm) overall
Purchased with the Edith H. Bell Fund, 1982-9-1
Art © James Rosenquist / Licensed by VAGA, New York

James Rosenquist considers this work, created shortly after he quit his job as a billboard artist in New York, his first entirely Pop painting. Working from a preparatory collage made from scraps of magazine advertisements, he transferred his subjects—a model featured in an ad for moisturizer and an up-close photograph of a tomato—onto two large canvases, scaling the pictures to that of sign painting. Divided by a sharp zigzag, this composition of images reveals both jarring juxtapositions and subtle similarities, such as the sinuous tomato leaf echoed in the woman's arched eyebrow. The painting's gray tones unify the canvas and allude to the predominance of newspaper and print media in Pop art. EFB

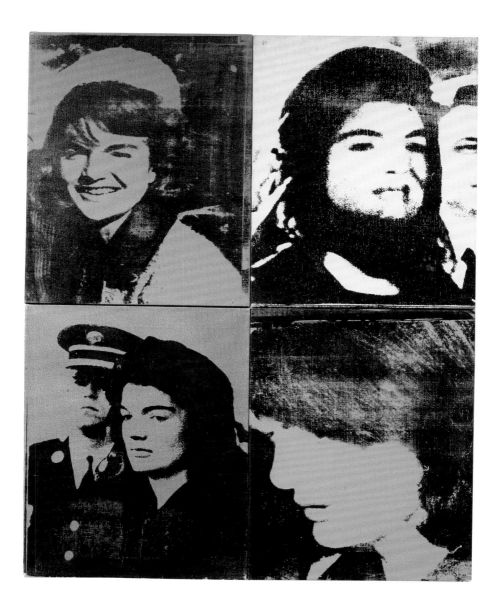

Andy Warhol (American, 1928–1987)

Jackie (Four Jackies) (Portraits of Mrs. Jacqueline Kennedy), 1964

Screenprinted acrylic on four canvas panels, 20 × 16 in. (50.8 × 40.6 cm) each

Gift of Mrs. H. Gates Lloyd, 1966-57-1–4

After the assassination of John F. Kennedy in 1963, Andy Warhol culled photographs that appeared widely in the media following the tragedy, cropping them to focus on the president's widow, Jacqueline.

The artist often employed this unorthodox approach to portraiture, appropriating photographs of celebrities from magazines and newspapers to reinforce an individual's public image rather than creating his own artistic interpretation of a subject's personal character. This combination of four silkscreened photographs intensifies the numbing effects of the mass-media coverage of this nationally experienced tragedy, an impression compounded by Warhol's use of the same images in multiple works. EFB

Jasper Johns (American, born 1930)

Sculpmetal Numbers, 1963
Sculpmetal on canvas, 57⅞ × 43⅞ in. (147 × 111.4 cm)
Centennial gift of the Woodward Foundation, 1975-81-6

In his earliest paintings, Jasper Johns, one of the defining artists of the postwar period, depicted subjects familiar to everyone, such as letters, numbers, targets, and the American flag. But numbers, which Johns first painted in 1955, constitute an uncomplicated subject matter only apparently, for in fact these solid forms represent the ultimate abstractions: conventional signs of universal value for purely mental concepts. Here the numbers are standard commercial stencils used for labels or signage, presented in order from zero to nine according to a grid that seems to proceed inevitably from the format of the canvas. The gray medium is Sculpmetal, a commercial aluminum putty, the use of which exemplifies Johns's investigation of the territorial blurring of narrowly defined mediums, such as sculpture and painting, that has been a leitmotif throughout his long and fruitful career. This painting likewise demonstrates the artist's deliberate removal of the traditional indicators of personal expression: color, brushwork, and narrative. In *Sculpmetal Numbers*, the stencils incorporated onto the canvas render the abstract concrete, and the texture and tones of the putty give a sensuous dimension to the purely conceptual nature of the numerical signs. Typically, Johns has made an entirely literal statement to introduce profound questions about the intimate relationship between image and language, subject and object, matter and thought, painting and seeing. AT/CB

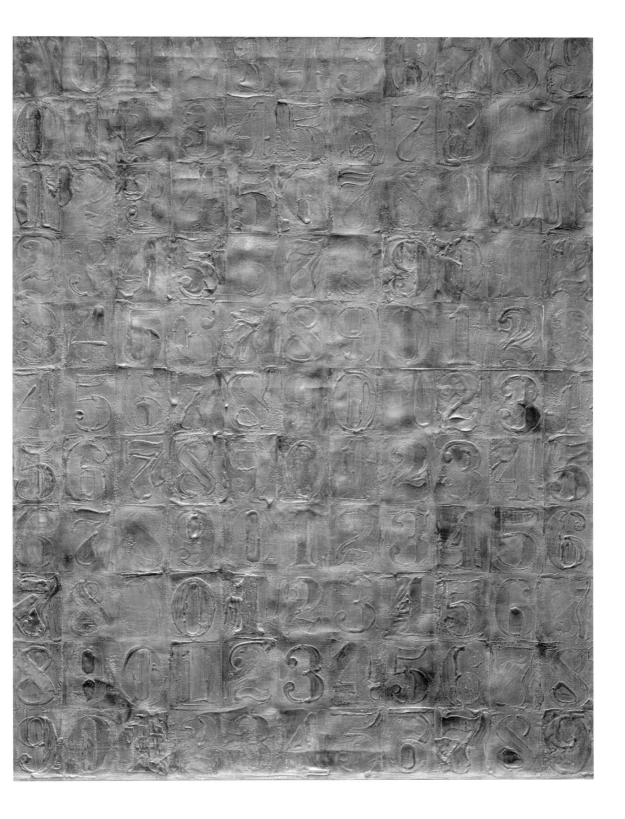

Robert Rauschenberg (American, 1925–2008)

Estate, 1963
Oil and screenprinted inks on canvas, 96 × 69¹³⁄₁₆ in.
(243.8 × 177.3 cm)
Gift of the Friends of the Philadelphia Museum of Art, 1967-88-1
Art © Robert Rauschenberg Foundation / Licensed by VAGA, New York

Robert Rauschenberg's painting assemblages of the mid-1950s, which he called "combines" to evoke their confounding of the limits of painting and sculpture, were followed in the early 1960s by works such as this, which feature layered and repeated silkscreened images on what have been called "flatbed" picture planes. As one of the most significant, inventive, and spirited artists of the postwar period, Rauschenberg was among the first American artists to combine found images using the silkscreen process, a technique in which a picture is grafted onto a specially prepared fine-mesh screen (with the blank areas coated with an impermeable substance) and then transferred onto paper or canvas by pushing paint or ink through the screen. Incorporating imagery culled from, among other sources, newspapers, art reproductions, and his own photographs, Rauschenberg's work of this period is both evocative of particular places and moments, and aleatoric in its lively, dynamic compositions. Like Pop art, which emerged in the early 1960s in the United States and mined mass culture for imagery, appropriation, and critique, Rauschenberg's silkscreens evoke the era in which all categories of culture coexisted in a reality increasingly mediated by television, radio, and advertising. Here he has presented complex combinations of disparate images, including the Statue of Liberty, Michelangelo's *Last Judgment*, a 1962 rocket launch, and a glass of water. The tension between the detailed silkscreened pictures and the gestural, seemingly spontaneous splashes of paint give energy to this incongruent inventory of images. EFB

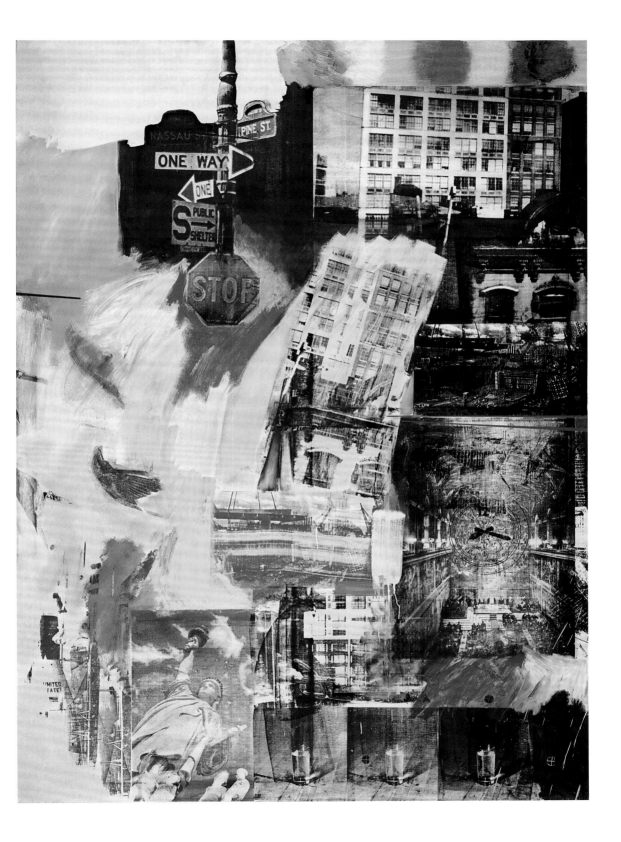

Joseph Beuys (German, 1921–1986)

Lightning with Stag in Its Glare, 1958–85
Bronze, iron, aluminum; H. 20 ft. 6 in. (6.25 m)
Purchased with gifts (by exchange) of Bernard Davis, the estate
of Anne Goldthwaite, Mr. and Mrs. R. Sturgis Ingersoll, James N.
Rosenberg, the Chester Dale gift, and the bequest of Lisa Norris
Elkins, 1988-65-1–39

In the 1960s Joseph Beuys transformed the land-
scape of contemporary art with his provocative
performances, mysterious sculptures, and radical
politics. In this monumental ensemble completed
over nearly three decades, he created an eerie vision of
a silent world seemingly devoid of human presence.
Several of the sculptural elements refer to decades-
old objects from Beuys's studio and represent motifs
found throughout his work. The enormous bronze
lightning bolt, for example, is a metaphor for creative
energy, and the stag, cast in aluminum from an iron-
ing board, long served as an alter ego of the artist. AVI

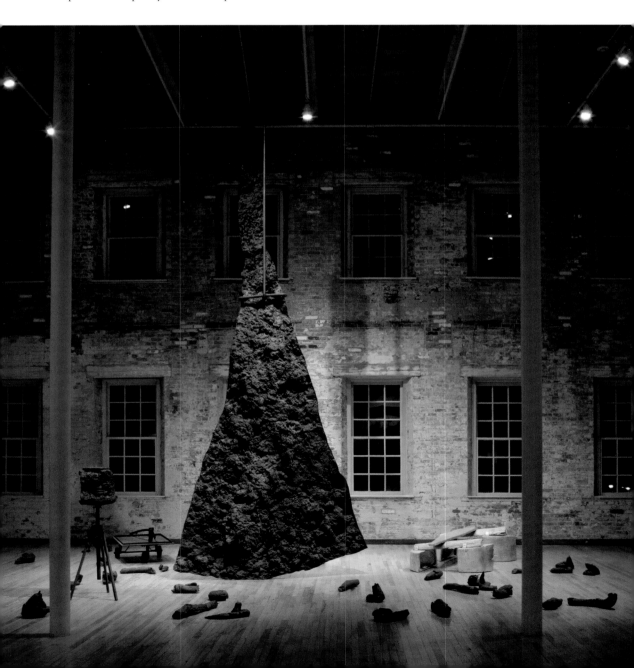

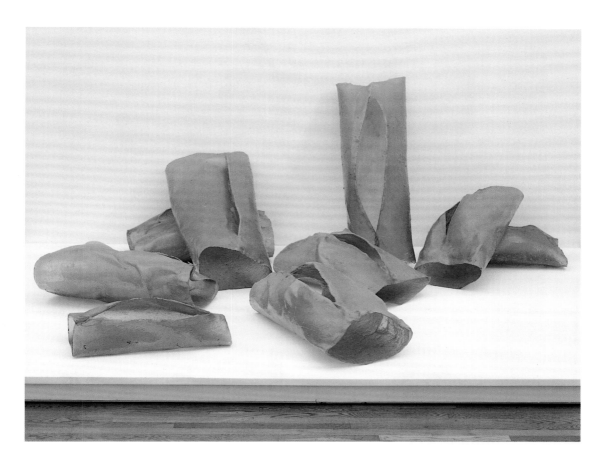

Eva Hesse (American, born Germany, 1936–1970)

Tori, 1969

Polyester, resin, and fiberglass on wire mesh; H. (largest) 47 in. (119.4 cm)

Purchased with funds contributed by Mr. and Mrs. Leonard Korman, Mr. and Mrs. Keith Sachs, Marion Boulton Stroud, Mr. and Mrs. Bayard T. Storey, and with other various funds, 1990-121-1–9

© The Estate of Eva Hesse

Using the malleability of industrial materials such as latex, fiberglass, and resin to great effect, Eva Hesse imbued a subtle eroticism and a sense of human presence in her sculptures. The title of this work, suggested to Hesse by the artist Robert Morris, is the plural of the word "torus," a geometric shape created by the revolution of a circular form around an external axis. The nine forms that make up this work are organic and rigid, fleshy and repellent, corporeal and otherworldly. By allowing the components of the sculpture to be arranged in various configurations, Hesse purposely left the precise allusions of these suggestive forms ambiguous, inviting our associations to guide our experience of the work and its meaning. The irregular surfaces of the elements are typical of "antiform" or "process" art created by a loosely associated group of New York artists, including Hesse, who in the late 1960s responded to hard-edged Minimalism by experimenting with pliable, evocative materials. Hesse completed *Tori* with two collaborators in several stages between January and August 1969. EFB

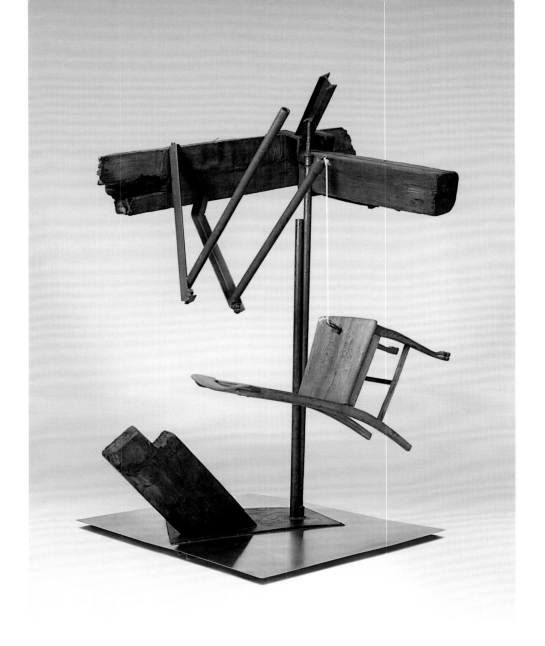

Mark di Suvero (American, born 1933)

Amerigo for My Father, 1963
Wood, steel, iron, clothesline; H. (approx.) 8 ft. 6 in. (2.59 m)
Gift of Mr. and Mrs. David N. Pincus, 1981-112-1
© Mark di Suvero, courtesy Paula Cooper Gallery, New York

Mark di Suvero's sculptures of found objects, furniture, and refuse of the early 1960s have been likened to three-dimensional incarnations of Abstract Expressionist paintings. Yet his dynamic compositions of accumulated materials also resonate with Dada assemblages and with the uncanny juxtapositions and associations of Surrealist art. In his constructions he investigates the physicality of the component parts, in a play between suspension and balance, a sense of heaviness and the possibility of movement. The title of this work pays homage to both the Italian explorer Amerigo Vespucci (for whom the Americas were named) and the artist's father, an Italian soldier who immigrated to the United States during World War II. EFB

Frank Stella (American, born 1936)

Plant City, 1963
Zinc chromate on canvas, 8 ft. 6½ in. × 8 ft. 6½ in. (2.6 × 2.6 m)
Gift of Agnes Gund in memory of Anne d'Harnoncourt,
2008-184-1
© 2014 Frank Stella / Artists Rights Society (ARS), New York

Having moved to New York in 1958 on the heels of Abstract Expressionism, which had waned in popularity and vigor, Frank Stella began to create work that explored discipline and uniformity by stripping down the previous movement's unruly and excessive use of paint. Beginning with his *Black Paintings* of 1958–60—which he made by using a two-and-a-half-inch-wide brush to apply black paint in straight, parallel lines, revealing narrow strips of raw canvas in between—Stella sought to define structural relationships between a painting's surface, its pictorial content, and the constructed shape of its canvas. Part of his *Dartmouth Paintings* series, this work was made in response to the triangular, lapidary details of architect Frank Lloyd Wright's Annie Merner Pfeiffer Chapel, which the artist had seen on an earlier trip to Florida. EFB

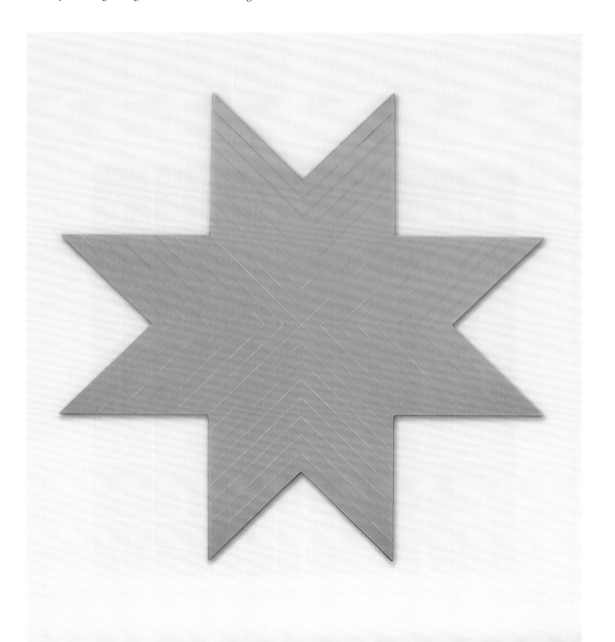

Ray K. Metzker (American, 1931–2014)

Composites: Philadelphia (Sailors), 1964

Forty-nine gelatin silver prints, 12⅞ × 12⅞ in. (32.7 × 32.7 cm) overall
Purchased with the Contemporary Photography Exhibition Fund, the Alfred Stieglitz Center Restricted Fund, and the Alice Newton Osborne Fund, 1977-73-3
© 2014 Ray K. Metzker

A Philadelphia artist of national import, Ray K. Metzker was one of contemporary photography's most innovative masters. Marking his initial experiment with serial and multiframe photography, this work comprises forty-nine diminutive prints of sailors, mounted together on a square grid. The amalgamation of multiple photographs and the gradations of light created by their juxtapositions exemplify Metzker's broad experimentation with the medium. While he went on to create additional works for his series *Composites: Philadelphia*, he produced only one featuring images of sailors, thus making the Museum the sole institution to possess his first composite. NSL

Ed Ruscha (American, born 1937)

Pool, 1968

Gunpowder on paper, sheet: 22¹⁵⁄₁₆ × 29 in. (58.3 × 73.7 cm)
Purchased with the Lola Downin Peck Fund and the Carl and Laura Zigrosser Collection (by exchange), 1998-155-1
© Ed Ruscha

Los Angeles–based artist Ed Ruscha began to depict words and phrases, usually isolated against monochromatic backgrounds, in 1959. Occupying a special place somewhere between Pop, Minimal, and Conceptual art, his meticulously rendered images are variously comic, evocative, ironic, or poetic. Engaged in an ongoing love affair with eye-catching typography, in 1966 he began his series of so-called liquid words in which a word, such as *pool*, appears to have been formed by the sudden splashing of water or a similar fluid on paper. The unusual medium in this work is gunpowder, applied in delicate layers with scraping out and erasing used to create highlights. AP

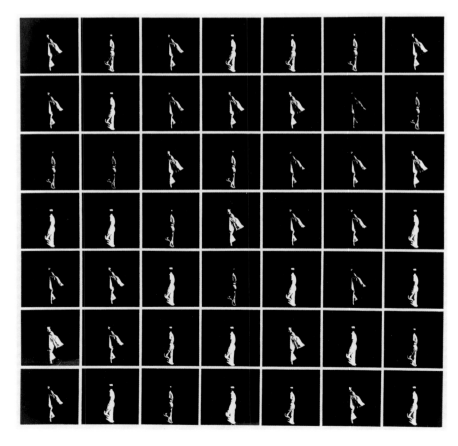

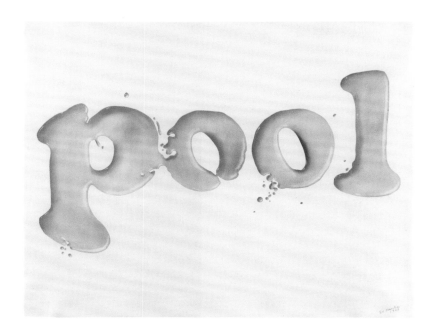

Designed by **Milton Glaser** (American, born 1929) for
Columbia Records (New York, 1888–present)

"Bob Dylan" Poster, designed 1966
Offset lithograph, image: 32⅝ × 22 in. (82.9 × 55.9 cm)
Gift of Collab: The Group for Modern and Contemporary
Design at the Philadelphia Museum of Art, 2002-146-1
© Milton Glaser

Like his "I Love NY" logo, Milton Glaser's silhouette
poster of American folk-rock singer-songwriter Bob
Dylan has become a graphic icon. Kaleidoscopic pat-
terns of hair vibrate against the black field, evoking
the psychedelic rhythms and antiestablishment values
of 1960s culture that Dylan symbolized. Columbia
Records produced nearly six million copies of Glaser's
poster for enclosure in the 1967 album *Bob Dylan's
Greatest Hits.* In 2000–2001 a version of the poster
was featured in the Museum's exhibition *Milton Glaser
Graphic Design: Design, Influence, and Process,* during
which Glaser received the Design Excellence Award
from Collab, a Museum affiliate (see pp. 408–9). KBH

Harry Callahan (American, 1912–1999)

Chicago, Multiple Exposure Tree, 1956

Gelatin silver print, image and sheet: 6⅜ × 6³⁄₁₆ in. (16.2 × 15.7 cm)
125th Anniversary Acquisition. Purchased with funds contributed
by John J. Medveckis, 1997-37-72

© The Estate of Harry Callahan, courtesy Pace/MacGill Gallery, New York

During the first two decades of his acclaimed career,
Harry Callahan experimented with abstraction, using
natural forms as his source material. For this picture,
one of 150 photographs by Callahan in the Museum's
collection, he opened the camera shutter several times,
exposing the film to more than one view of the bare
branches of a tree silhouetted against a bright winter
sky. In so doing, he created a complex, calligraphic
composition that evokes the work of Jackson Pollock
and other Abstract Expressionists. For Callahan, this
photograph is a personal meditation on his immediate
surroundings that grounds an otherwise ethereal and
abstract patterning in everyday visual experience. ANB

Robert Adams (American, born 1937)

Denver, Colorado, 1969–71

Gelatin silver print, image and sheet: 5¾ × 5⅞ in. (14.6 × 14.9 cm)
Purchased with the Alice Newton Osborn Fund, 1982-19-7

© Robert Adams, courtesy Fraenkel Gallery, San Francisco

Robert Adams helped redefine American landscape
photography when in the 1960s he turned his lens
toward the country's expansive West to record its
changing scenery. Here parked cars in front of a
motel, a utility pole, and power lines interrupt the
dusky view of foothills. By capturing the American
West's sublime light in the cloud-swept sky, the glow-
ing eave of the motel, and the gleaming automobiles,
Adams conveyed the landscape's persistent beauty
despite banal human intrusions. This print, which was
published in his 1974 book *The New West,* joined the
collection shortly after it was featured in an exhibition
of Adams's work at the Museum in 1981. JW

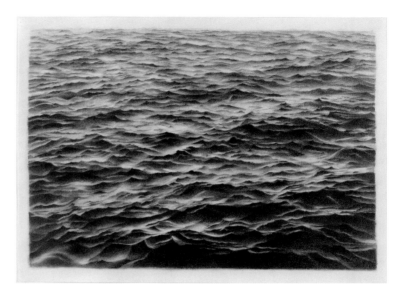

Shomei Tomatsu (Japanese, 1930–2012)

Nagasaki, 1961

Gelatin silver print, image: 12¾ × 8½ in. (32.4 × 21.6 cm)
Purchased with funds contributed by the E. Rhodes and Leona B.
Carpenter Foundation, 1990-51-108
© Shomei Tomatsu

In the 1960s Shomei Tomatsu made haunting and
politically charged photographs of the aftermath of
the atomic warfare of World War II, including images
of horribly scarred survivors of the American bomb-
ing of Nagasaki. This print largely hides its human
subjects in shadow, but the isolation of the figures,
and their palpable disconnection yet obvious inter-
dependence powerfully evoke the prolonged trauma
of the human-made cataclysm. After the Museum's
important 1986 exhibition *Black Sun: The Eyes of Four,*
the institution acquired a representative selection
of Tomatsu's prints, including this image, as well as
examples by the three other contemporary Japanese
photographers whose work was featured in the show
(see also p. 379). PB

Vija Celmins (American, born Latvia 1938)

Untitled (Ocean), 1969

Graphite on acrylic-coated paper, sheet: 14 × 18¾ in.
(35.6 × 47.6 cm)
Purchased with a grant from the National Endowment for the
Arts, and with matching funds contributed by Marion Boulton
Stroud, Marilyn Steinbright, the J. J. Medveckis Foundation,
David Gwinn, and Harvey S. Shipley Miller, 1991-19-1

Vija Celmins has spent her career exploring the
dialogue between fact and fiction in her quiet rendi-
tions of scenes from nature based on photographs,
such as *Untitled (Ocean),* which lacks a point of refer-
ence or discernible depth of field. Working primarily
in nuanced palettes of blacks and grays, Celmins
creates these images of seemingly limitless space—
seascapes, night skies, and the barren desert floor—
with an uncanny accuracy, often spending months on
a single drawing. This is among the earliest and fin-
est of her iconic ocean images in which she achieves
an eloquent balance between abstraction and reality
through her fastidious application of graphite. SRL

Bruce Nauman (American, born 1941)

The True Artist Helps the World by Revealing Mystic Truths (Window or Wall Sign), 1967

Neon, H. 59 in. (149.9 cm)

Purchased with the generous support of The Annenberg Fund for Major Acquisitions, the Henry P. McIlhenny Fund, the bequest (by exchange) of Henrietta Meyers Miller, the gift (by exchange) of Philip L. Goodwin, and funds contributed by Edna Andrade, 2007-44-1

Bruce Nauman has applied his maverick use of mediums—including photography, neon, film and video, installation, drawing, printmaking, and sculpture—to his conceptual and often paradoxical works that evoke the equivocal nature of language and the physical limits of the body. One of his earliest works, *Window or Wall Sign* is also one of his most provocative and enduring. In 1967 Nauman recently had completed his MFA at the University of California, Davis, and established his first studio in a former street-front grocery store in San Francisco. A neon beer sign still functioning in the market's window—a relic of the space's former mercantile capacity—propelled Nauman to produce his own public statement about the personal practice of art-making. He hung his sign facing the street, where it both blended in with the commercial elements of the cityscape and piqued the curiosity of perceptive passersby. However, the boldness of Nauman's declaration expertly belies its interrogation into the role of the artist in society. Positioned in a place of public consumption, *Window or Wall Sign* asks its reader to participate in determining the validity of its statement, which is at once profound and quixotic, forward and facetious, lofty and self-aware. Nauman has continued to work with neon throughout much of his career, most intensely in the 1980s, often creating word-based signs in which the tensions between medium and language are in continuous play. EFB

The true artist helps the world by revealing mystic truths

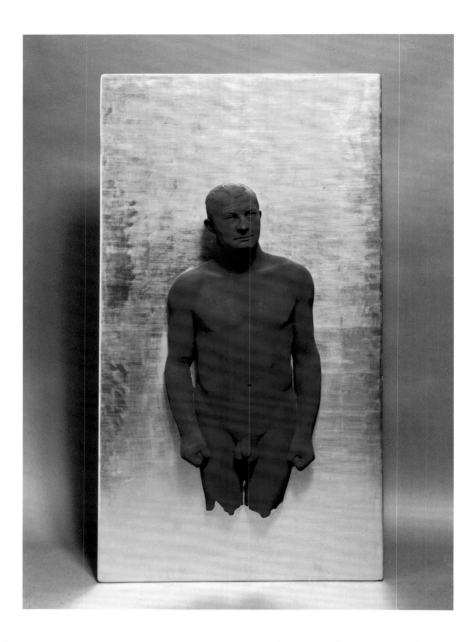

Yves Klein (French, 1928–1962)

Portrait Relief I: Arman, 1962
Painted bronze on gilded panel, 69 × 37 in. (175.3 × 94 cm)
Gift of Dr. and Mrs. William Wolgin, 1978-174-1
© 2014 Artists Rights Society (ARS), New York / ADAGP, Paris

Yves Klein's experimental, conceptual, and at times provocative work was a catalyst for changing attitudes toward art in France in the postwar period. Known for his monochrome paintings, which he first produced in the mid-1950s, Klein invented his own luminous color: International Klein Blue (IKB), which he patented in 1957. He employed his eponymous color—as rich in associations as in its hue—in architecture, sculptures, murals, performances, and even a cocktail at a gallery opening. His plaster cast of friend and fellow French Nouveau Réaliste artist Arman's nude body was no exception, as it was boldly painted in IKB and set against a brilliant gold-leaf background according to the artist's instructions after his untimely death in 1962. EFB

Hélio Oiticica (Brazilian, 1937–1980)

Be an Outlaw, Be a Hero, 1967
Screenprint on fabric, 41⅜₆ × 35⅜ in. (104.9 × 89.9 cm)
Purchased with funds contributed by the Committee on Modern
and Contemporary Art, 2007-10-1
© César and Claudio Oiticica

A member of the Neo-Concrete group in Rio de Janeiro in the late 1950s, Hélio Oiticica has come to be recognized as one of the key artistic figures of the postwar period. *Be an Outlaw, Be a Hero* was Oiticica's contribution to *Exhibition of the Flags*, held in Rio in 1968. On the flag is the dead body of Manuel Moreira, known as Cara de Cavalo ("Horse Face"), a bandit from the shantytown of Mangueira in Rio. At the time of his death in 1966, Cara de Cavalo was considered a romantic fighter for the rights of the disempowered, and his assassination by the paramilitary group Esquadrão da Morte was a clear sign of the deteriorating political conditions in Brazil, where military rule had begun in 1964. Cara de Cavalo was also Oiticica's friend and lover, and the flag is a deeply felt homage, both public and private, from one of the most radical artists of the second half of the twentieth century to an individual who represented a relentless and uncompromising search for freedom. CB

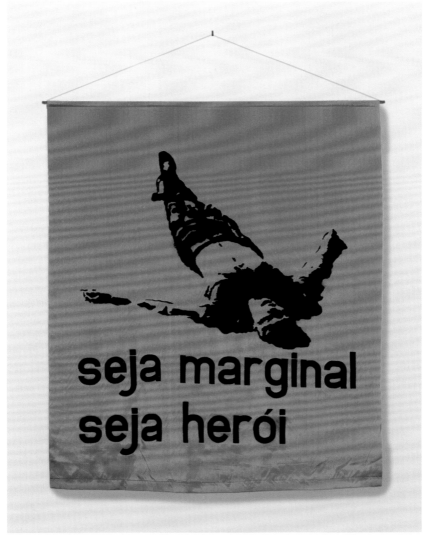

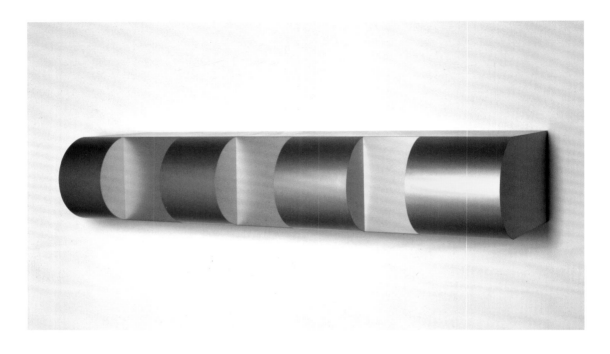

Donald Judd (American, 1928–1994)

Untitled (Yellow), 1974
Anodized aluminum, w. 76½ in. (194.3 cm)
Gift (by exchange) of R. Sturgis and Marion B. F. Ingersoll,
1996-69-1
Art © Judd Foundation / Licensed by VAGA, New York

In 1965 Donald Judd coined the term "specific objects" for his works unified in shape, color, and surface material that are neither sculptures nor paintings, and that, according to the artist, deal in the medium of space, which he felt transcended the limitations of the two-dimensional picture plane. Made by an industrial mill to his specifications and fabricated out of wood, metal, or Plexiglas, Judd's "specific objects" are considered icons of 1960s Minimalism, although the artist contested both the movement's name and his association with it. In this 1974 sculpture, from a series known as his "bullnose" works after a kind of chisel, Judd heightened the effect of the industrial, sleek surface through the use of bold yellow color. EFB

Claes Oldenburg (American, born Sweden 1929)

Giant Three-Way Plug (Cube Tap), 1970
Cor-Ten steel, bronze; H. 9 ft. 9 in. (2.97 m)
Gift of Mr. and Mrs. David N. Pincus in memory of Anne
d'Harnoncourt, 2010-15-1
© Claes Oldenburg

Known for his oversize renditions of everyday objects, Claes Oldenburg has become synonymous with American Pop art. By increasing the scale of mundane items that usually play into themes of consumption, such as food products or household appliances, Oldenburg inflates the potential power of their presence and interrogates their significance, displacing their normative functions with witty, sometimes erotic interpretations. Modeling this giant sculpture after the three-way plug, a standard American design made of Bakelite plastic, Oldenburg has likened its enlarged form to a skull, a cannon, an anchor, a nut, Mickey Mouse, and even the church of Hagia Sophia in Istanbul. EFB

Víctor Grippo (Argentine, 1936–2002)

Analogy I (2nd Version), 1970–77

Potatoes, zinc and copper electrodes, electrical cable, meter, text, table, chair, soil; w. 26 ft. 2^{15}⁄₁₆ in. (8 m)

Joint acquisition by the Philadelphia Museum of Art, with funds contributed by the Committee on Modern and Contemporary Art; and The Art Institute of Chicago, through prior gift of Adeline Yates, 2008-229-1

As a leading South American Conceptual artist, Víctor Grippo applied his background in chemistry to create works that explore the relationship between science and art, religion and society, the factual and the imaginative. A central work in Grippo's oeuvre, *Analogy I* consists of an organic battery made of potatoes connected through electrodes and cables to a voltmeter that measures the energy generated by the tubers when the meter's button is pressed. Demonstrating the equivalence between visible matter and invisible energy, this controlled experiment establishes a parallel between an electro-chemical process and consciousness, between the life-sustaining energy of the humblest of foods and the power of the mind to transform itself and its environment. This analogy, clearly expressed by the artist in an accompanying text, places him in the metaphorical position of an alchemist, poetically revealing the redemptive qualities of transforming matter into art. AVI

Gerhard Richter (German, born 1932)

180 Colors, 1971
Enamel paint on canvas, 78¾ in. × 78¾ in. (200 × 200 cm)
Gift (by exchange) of Mrs. Herbert Cameron Morris, 1998-73-1
© Gerhard Richter 2014

By presenting 180 color blocks set into a grid of raw canvas, Gerhard Richter laid bare the means of painting as a scientific enterprise. Starting by combining the three primary colors into twelve base colors, Richter followed the possible permutations by mixing fifteen hues of each, from light to dark. The shiny, flawless surface of the enamel paint squares against the untreated background further distills the empirical logic that governs the work, likening it more to a color chart or a sample kit than to a narrative or expressive painting. Such explorations of the potential and limits of painting have established Richter as one of the most influential living artists. EFB

Romare Bearden (American, 1914–1988)

Blue Snake, 1971
Collage of printed papers with paint, graphite, fiber-tip pen, and sanding on fiberboard; 35⅞ × 23¹⁵⁄₁₆ in. (91.1 × 60.8 cm)
Gift of Priscilla T. Grace, 2003-226-1

Landscape is a rare subject among the coveted collages from the early 1970s by Romare Bearden, one of the most influential African American artists of his generation. In this dense, tapestry-like composition, a lush jungle of flora and fauna is punctuated by an African mask peering from behind a tree trunk, merging the natural with the spiritual. Collage was Bearden's primary medium and his imagery reflects a rich cultural heritage shaped by his North Carolina birthplace, his childhood exposure to artists, writers, and musicians in Harlem, and African ritual traditions. His wide-ranging sources of inspiration included poetry, jazz, Chinese painting, medieval art, and Cubism. SRL

Masahisa Fukase (Japanese, 1934–2012)

Untitled, from the series *Ravens,* 1976
Gelatin silver print, sheet (approx.): 44 × 62 in. (111.8 × 157.5 cm)
Gift of the artist, 1990-51-21

Masahisa Fukase's celebrated series *Ravens,* begun in 1976 on a train journey to his native island of Hokkaido during a dark period of his life, pushes thirty-five-millimeter photography to startlingly expressive ends. This example, enlarged from the negative to a nearly four-by-five-foot print, reduces the black birds to a menacing silhouette punctuated by the terrifying blank spots of the ravens' eyes. It was among the 160 prints featured in the Museum's 1986 exhibition *Black Sun: The Eyes of Four,* a groundbreaking look at the work of four postwar Japanese photographers—Fukase, Eikoh Hosoe, Daido Moriyama, and Shomei Tomatsu (see p. 369). PB

Barbara Kasten (American, born 1936)

Amalgam, Untitled 79/9, 1979
Gelatin silver print with applied paint, image and sheet:
15⅜ × 19¼ in. (39.1 × 48.9 cm)
Purchased with funds contributed by Barbara B. and Theodore R.
Aronson and Richard L. and Ronay Menschel, 2014-54-1
© 1979 Barbara Kasten

Barbara Kasten's *Amalgam, Untitled 79/9* is a camera-less image that documents the basic characteristics of light and materials, while providing an ambiguous representation of space. To make this photogram, the artist placed a Plexiglas cube on photographic paper and exposed it to light. She then painted geometric marks on an enlargement of the original, emphasizing the nature of the photograph as an abstract design on a flat surface. At a moment when many artists were questioning modernist dictates of medium specificity and exploring the power of art as social critique, Kasten used photography to investigate the boundaries of painting and sculpture, rejecting the idea that photographs should represent the everyday world of human activities. NMS

Barbara Kruger (American, born 1945)

Untitled (We are your circumstantial evidence),
1983
Three gelatin silver prints, 49 × 97 in. (124.5 × 246.4 cm) each
with frame
Gift of Henry S. McNeil, Jr., 1985-36-1a–c
© 2014 Barbara Kruger, courtesy Mary Boone Gallery, New York

Beginning in the 1970s Barbara Kruger, like other important artists of her generation, turned to advertising and pop culture as sources for her pictures. Printed at billboard scale and framed in bright red, the phrase "We are your circumstantial evidence" initially seems to be a strident declaration. However, the text and the image—a shattered mirror reflecting a woman's face and studio lights—do not correspond to each other in any obvious way. Moreover, the shifting pronouns "we" and "your" leave the viewer's position uncertain, as the sentence might refer to power relations between two groups (for instance, women and men), or to the use of photographs as evidence of supposed truths. PB

Cy Twombly (American, 1928–2011)

Fifty Days at Iliam, 1978
Oil, oil crayon, and graphite on ten canvases; largest canvas
9 ft. 10 in. × 16 ft. 1½ in. (3 × 4.92 m)
Gift (by exchange) of Samuel S. White 3rd and Vera White,
1989-90-1–10
© Cy Twombly Foundation

In the summer of 1977, Cy Twombly began working on a "painting in ten parts" based on Alexander Pope's translation of Homer's *Iliad*, the tragic story of the final fifty days of the Trojan War. Completed in 1978 and collectively titled *Fifty Days at Iliam*, Twombly's canvases, permanently installed in one of the Museum's galleries, evoke incidents from the epic poem in the artist's characteristic synthesis of gestural handwriting and diagrammatic depictions. Using the visual language he had started to develop more than twenty years earlier, he created his own tribute to a canonical narrative of Western culture.

Twombly stipulated the spatial configuration of the ten large canvases in a presentation that is sequential as well as thematically logical. In the artist's own words, the use of the letter *a* in "Iliam" (instead of the Latin "Ilium" or the Greek "Ilion") has an indexical function, referring to Achilles. The emblematic painting *Shield of Achilles*—referencing the miraculous armor made for the Greek warrior by the gods, with energy forces drawn from the four corners of the universe—is displayed by itself in an antechamber. Nine paintings in the adjoining gallery present the chronological unfolding of the story. The artist designed the installation so one wall features paintings of a predominantly Greek mood, passionate and aggressive, while the canvases on the facing wall convey an essentially Trojan attitude, contemplative and melancholic. The series progresses from the scene of Achilles's pivotal decision to join the fight against Troy to an almost blank canvas imbued with the silence of death and oblivion. Presiding over the gallery from the far wall is the monumental *Shades of Achilles, Patroclus, and Hector*, an elegiac salute to the three fallen heroes of the war. CB

CONTEMPORARY CRAFT

The Museum began actively collecting modern studio craft in 1945, with the gift of four works by renowned ceramists Gertrud and Otto Natzler (see opposite, top left), whose simple forms and bold glazes are a testament to the Natzlers' important contributions to the field. This acquisition, the foundation for the Museum's modern and contemporary craft collection, enhanced the institution's already rich holdings of ceramics, established early in its history through purchases from the 1876 Centennial Exhibition in Philadelphia and under the direction of curator Edwin AtLee Barber.

In the 1970s these and other core objects of the craft collection were augmented with the formation of Collab, a volunteer group dedicated to supporting the Museum's decorative arts and design collections (see pp. 408–9). In 1976, for example, Collab and the Museum's Women's Committee provided funds for the acquisition of a brooch by renowned metalsmith Olaf Skoogfors (opposite, top right), an influential force in Philadelphia's burgeoning 1960s craft scene who seamlessly integrated organic and mechanical forms into his work. The following year the Women's Committee launched its annual Craft Show, one of the outstanding exhibitions of its kind in the United States. Since 1981 a percentage of the proceeds from each show, the single largest annual fundraising event for the Museum, has been directed to the acquisition of contemporary craft.

Support for the collection has continued into the twenty-first century with the establishment of an endowed curatorship dedicated to American modern and contemporary crafts and decorative arts, funded by Robert L. McNeil, Jr. (see pp. 260–61), and named for his wife, Nancy, one of the founders of the Craft Show. Additionally, through a dedicated fund established by Leonard and Norma Klorfine, the Museum has organized programs and exhibitions and acquired pivotal works by leading artists in the field, including Peter Voulkos, whose ceramic sculpture of 1956 (opposite, bottom) was part of a new body of work that expressed his use of a spontaneous gestural language consistent with that employed by contemporary Abstract Expressionist artists.

With ongoing support from the Women's Committee, the Klorfine Fund, and individual donors, over the past thirty years the collection has doubled in size and furthered not only its regional and national presence, but also, through acquisitions such as Japanese artist Motoko Maio's modern interpretation of the traditional folding screen (p. 421), its international reach. ERA

Gertrud Natzler (American, born Austria, 1908–1971) and
Otto Natzler (American, born Austria, 1908–2007)
Plate, 1941
Earthenware with white ornamental glaze, DIAM. 12 in. (30.5 cm)
Gift of Mrs. Herbert Cameron Morris, 1945-68-3

Olaf Skoogfors (American, born Sweden, 1930–1975)
Brooch, 1975
Gilded silver, ivory, pearl; w. 2 9/16 in. (6.5 cm)
Gift of Collab: The Group for Modern and Contemporary Design at the Philadelphia Museum of Art, and the Women's Committee of the Philadelphia Museum of Art, 1976-2-1

Peter Voulkos (American, 1924–2002)
Untitled, 1956
Glazed stoneware, H. 30½ in. (77.5 cm)
Purchased with the Leonard and Norma Klorfine Foundation Endowed Fund for Modern and Contemporary Craft, 2013-65-1
© Voulkos Family Trust

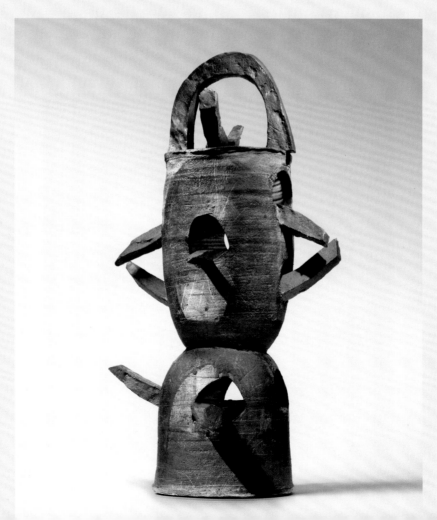

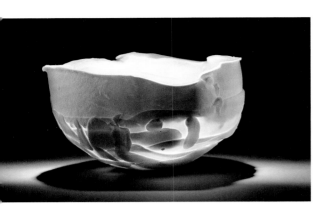

decoration and delicate, thin-walled sections through which ambient light softly glows, this bowl, part of his *Light Gatherer* series, demonstrates his mastery of the fragile and challenging clay. Considered one of the leading ceramic artists of his generation, Staffel brought a new voice to the field with his innovative work in porcelain. ERA

Rudolf Staffel (American, 1911–2002)

Bowl, 1969
Porcelain, H. 9½ in. (24.1 cm)
Gift of the Philadelphia Chapter, National Home Fashions League, Inc., 1970-86-3

In the mid-1950s, Rudolf Staffel, a ceramist and professor in Philadelphia, began his groundbreaking experiments with porcelain in which he attempted to make the material's natural translucency and luminescence integral to his work. With its strapwork

Designed by **Alessandro Mendini** (Italian, born 1931); made by **Atelier Mendini** (Milan, 1989–present)

"Proust" Armchair, designed 1978, made 1998–99
Painted wood and upholstery, H. 42½ in. (108 cm)
Gift (by exchange) of Mrs. Adolph G. Rosengarten, 2000-118-1

One of the first examples of postmodern design, this armchair rejected the undecorated geometric forms, industrial materials, and functionalist values of classical modernism (see, for example, p. 244). Inspired by the idea of creating an ironic object linked to a historic literary figure, Italian designer Alessandro Mendini determined to make an armchair suitable in form and decoration for French writer Marcel Proust. After studying Proust's visual and material world, Mendini selected a ready-made Neo-Rococo-style

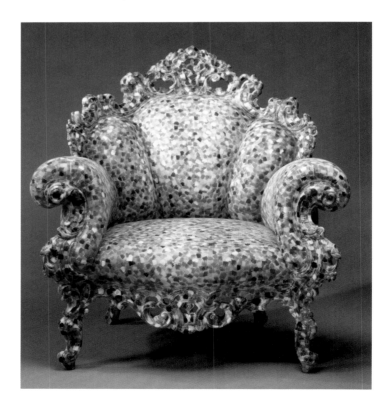

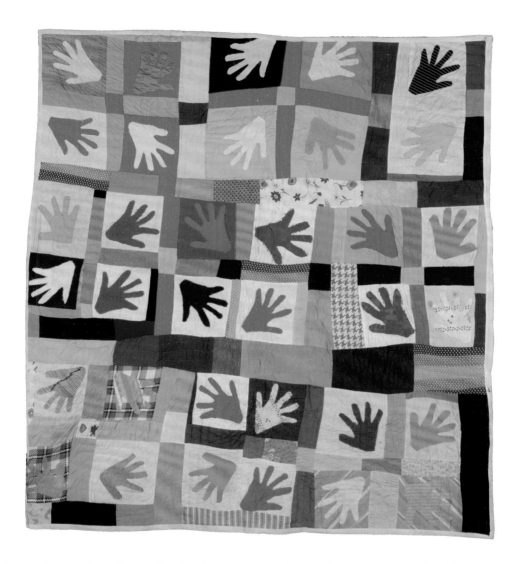

upholstered chair and had it hand-painted with juxta-posed dots of pure color, a technique inspired by the pointillist canvases of Georges Seurat (see p. 209) and Paul Signac, who were contemporaries of Proust. KBH

Sarah Mary Taylor (American, 1916–2000)

"Hands" Quilt, 1980

Cotton, synthetics; 83¼ × 78 in. (211.5 × 198.1 cm)
The Ella King Torrey Collection of African American Quilts, 2006-163-11

Inspired by the success of her aunt Pecolia Warner, whose quilts were included in a 1977 traveling

exhibition featuring the art of four Mississippi women, Sarah Mary Taylor began making appliqué quilts in 1979. For this example, she cut the shapes from old dresses, using a tracing of her hand for the pattern. She later made other versions of this quilt, including one for the acclaimed 1985 film *The Color Purple.* Taylor's quilt is a highlight of the Ella King Torrey Collection of African American Quilts, formed between 1980 and 1983 while Torrey, who became a prominent arts advocate in Philadelphia and San Francisco, was researching this southern art form. DB

Francesco Clemente (American, born Italy 1952)

Hunger, 1980
Opaque watercolor on twelve sheets of handmade Pondicherry paper, joined by cloth strips; 93½ × 96½ in. (237.5 × 245.1 cm) overall
Partial and promised gift of Marion Boulton Stroud, 1991-142-1
© 2014 Francesco Clemente, courtesy Mary Boone Gallery, New York

In this large opaque watercolor drawing executed on conjoined sheets of handmade paper, certain artistic circumstances and strategies characteristic of the late twentieth century are folded into Francesco Clemente's personal culture, which is as literary as it is visual. In him ancient mythographers and the occult meet beat poets, and the popular arts of India meld with the hip-hop culture of the 1980s. Born and educated in Italy, Clemente has long lived in New York and India. Globalization is one attribute underlying his work; another is the tendency to suppress the artist's own hand in its making, as he collaborated with local billboard painters in Madras to produce this and other works created in India. AP

John Woodrow Wilson (American, 1922–2015)

Martin Luther King, Jr., 1981
Charcoal on wove paper, sheet: 38⅛ × 29⁷⁄₁₆ in. (96.8 × 74.8 cm)
125th Anniversary Acquisition. Purchased with funds contributed
by the Young Friends of the Philadelphia Museum of Art in
honor of the 125th Anniversary of the Museum and in celebration
of African American art, 2000-34-1
Art © John Wilson / Licensed by VAGA, New York

In the early 1980s John Woodrow Wilson won a
commission to create a memorial to Martin Luther
King, Jr., for a park in Buffalo, New York. Abandon-
ing the city's initial concept for a conventional
full-figure statue and inspired by his recent explorations
of monumental Buddhist, Easter Island, and Olmec
sculpture, Wilson produced an eight-foot-tall bronze
portrait head of the civil rights leader. The sculpture's
dramatic scale and contemplative expression convey
King's humanity and the universality of his ideals. This
study drawing for the commission is a remarkable
example of the artist's empathetic portrayals of people,
and the masterful modulations of tones and three-
dimensional forms found throughout his work. SRL

Sol LeWitt (American, 1928–2007)

On a Blue Ceiling, Eight Geometric Figures: Circle, Trapezoid, Parallelogram, Rectangle, Square, Triangle, Right Triangle, X (Wall Drawing No. 351), 1981

Chalk and latex paint on plaster, 15 ft. 6 in. × 54 ft. 7 in. (4.72 × 16.64 m)

Purchased with a grant from the National Endowment for the Arts and with funds contributed by Mrs. H. Gates Lloyd, Mr. and Mrs. N. Richard Miller, Mrs. Donald A. Petrie, Eileen and Peter Rosenau, Mrs. Adolf Schaap, Frances and Bayard Storey, Marion Boulton Stroud, and two anonymous donors (by exchange), with additional funds from Dr. and Mrs. William Wolgin, the Daniel W. Dietrich Foundation, and the Friends of the Philadelphia Museum of Art, 1982-121-1

In the mid-1960s, Sol LeWitt emerged as a leading figure of Conceptual art, an international movement that emphasized a work's originating concept rather than its resulting materialization. Known initially for his geometric sculptures, in 1968 LeWitt began to draw directly on the wall, first in spare black pencil lines and later in washes of saturated colors. For these "wall drawings," the artist created a set of instructions that could be followed by museums and private collectors in creating the works, making his role, as originator of the idea, similar to that of the composer of a musical score. LeWitt's wall drawings differ with each installation, or "performance," as they are adapted to the characteristics of the specific site—a variability the artist embraced as a necessary part of his art. The drawing at the Museum appears on the ceiling and end walls of a barrel vault, a setting evocative of the orderly and contemplative mood of a frescoed chapel. JBR/AVl

John Chamberlain (American, 1927–2011)

Glossalia Adagio, 1984
Painted and chrome-plated steel, H. 83 in. (210.8 cm)
125th Anniversary Acquisition. Gift of Mr. and Mrs. David N.
Pincus, 2000-96-1

Known for his smashed car scrap-metal sculptures,
John Chamberlain challenged the distinction between
lowbrow commercial production and high culture
by turning byproducts of industry into works of art.

His unapologetic use of refuse represented a fusion
of influence of Marcel Duchamp's iconoclastic ready-
mades and Abstract Expressionism's concern for line
and color. Here Chamberlain demonstrated his inven-
tive approach to combining scrap metal as a form of
collage. Arranging the aluminum pieces as though
they were brushstrokes in three dimensions, he mas-
terfully struck a balance between the immediacy and
impact of torn metal and the artful composition of
form and color. EFB

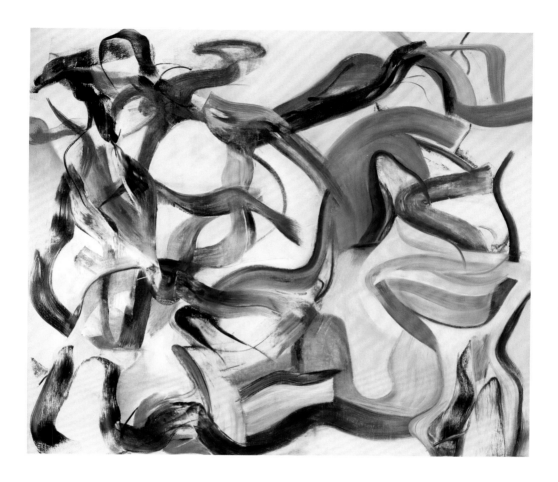

Willem de Kooning (American, born The Netherlands, 1904–1997)

Untitled XXI, 1982
Oil on canvas, 77 × 88 in. (195.6 × 223.5 cm)
Partial and promised gift of Dennis Alter, 1994-158-1
© 2014 The Willem de Kooning Foundation / Artists Rights Society (ARS),
New York

Willem de Kooning, who came of age in the 1940s and 1950s during the efflorescence of the Abstract Expressionists (see, for example, p. 332), was the only original member of the group to continue to extend the basic stylistic premises of gestural painting long after the movement had waned. Characterized by a reduced palette and surfaces that vary from smoothly sanded to sensuously brushed, *Untitled XXI* suggests the clarity, purity, and intensity of the artist's late works. What is at once dramatic and erotic is the language of paint itself, articulated through de Kooning's energetic adjustments of space, line, color, and texture that engage the viewer's eye and emotions. JV

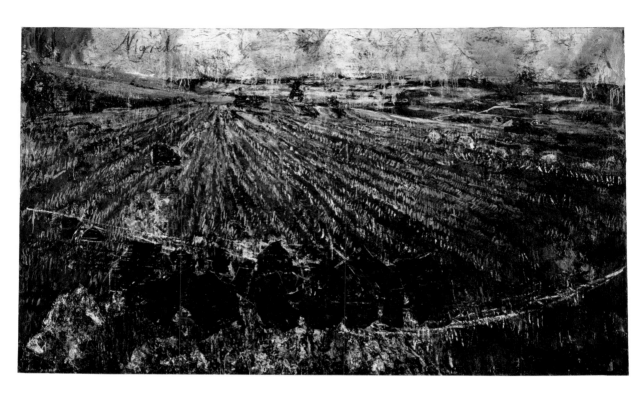

Anselm Kiefer (German, born 1945)

Nigredo, 1984
Oil, acrylic, emulsion, shellac, and straw on photograph and
woodcut, mounted on canvas; 10 ft. 10 in. × 18 ft. 2½ in.
(3.3 × 5.55 m)
Gift of the Friends of the Philadelphia Museum of Art in
celebration of their twentieth anniversary, 1985-5-1
© Anselm Kiefer

Anselm Kiefer's work has been interpreted as an
exploration into German identity and an evocation
of the collective trauma suppressed in the decades
following World War II. This ravaged landscape,
possibly a metaphor for Germany as a whole, consists
of thick layers of oil, acrylic, emulsion, shellac, and
straw applied over a full-size photograph. The paint-
ing's title, *Nigredo*, refers to the first stage of alchemy,
a medieval science that sought to transform ordinary
matter into gold; it is the moment of destruction that
precedes purification. Despite the painting's primarily
dark palette, its surface radiates a shimmering light
that suggests the promise of transformation. AT/AV|

Hiroshi Sugimoto (Japanese, born 1948)

Black Sea, Ozuluce, 1991
Gelatin silver print, image: 16½ × 21⅜ in. (41.9 × 54.3 cm)
Gift of the Friends of the Philadelphia Museum of Art,
1995-112-10
© Hiroshi Sugimoto, courtesy Pace Gallery

In the 1980s and 1990s Hiroshi Sugimoto turned his large-format camera toward the sea, creating a series of black-and-white photographs of water and sky bisected by the horizon. These pictures exclude indices of location, such as landmarks or shorelines, reducing the differences among them to each site's atmospheric conditions. Their distilled compositions nod to the Minimalist and Conceptual art Sugimoto encountered in the 1970s, and their tonal range to the soft gradations of ink in traditional Japanese screen paintings. Reduced to contrasts of dark and light, these seascapes allude to the essence of black-and-white photography's visual language, and are reverent tributes to the fundamental substances of water and air. ANB

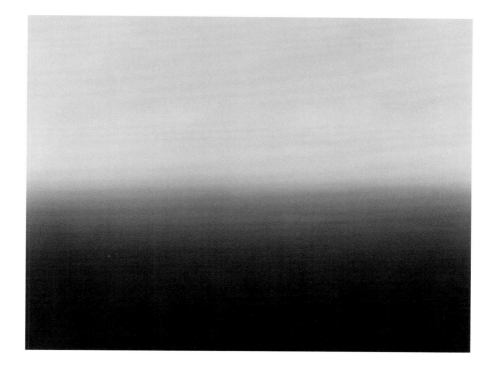

Richard Long (English, born 1945)

Mud Foot Circles, 1985

River Avon mud on wove paper, mounted on board; sheet:
76⅜ × 87½ in. (194 × 222.3 cm)
Purchased with the Hunt Corporation (formerly Hunt
Manufacturing Co.) Arts Collection Program, 1987-14-1

Since the 1960s Richard Long has created most of his work outdoors in locations throughout the world, from Ireland to Nepal, during his walks from one place to another, often displacing grass, soil, or stones to create linear or circular configurations on the earth's surface. These conceptual works assume enduring physical forms through his production of photographs, site maps, text pieces, and drawings made with his hands or feet from mud or muddy water. Here the use of mud from the river Avon in southwest England reflects Long's profound interest in the surface of the earth, and the passage of his footprints around and around the paper evokes his long walks outdoors. AP

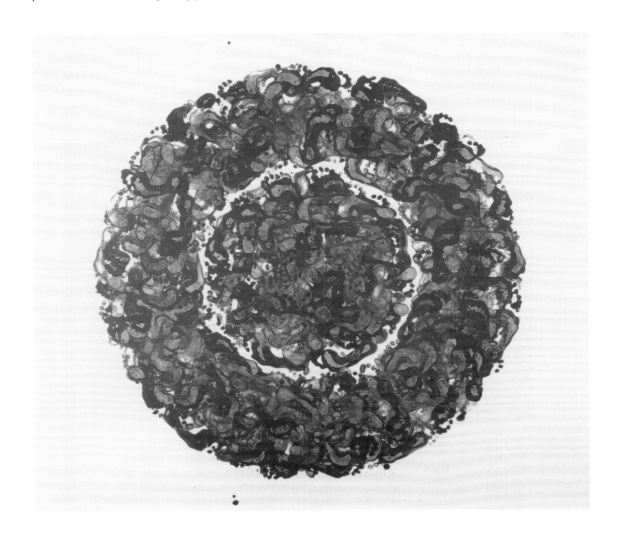

Martin Puryear (American, born 1941)

Old Mole, 1985

Red cedar, H. 61 in. (154.9 cm)

Purchased with gifts (by exchange) of Samuel S. White 3rd and Vera White, and Mr. and Mrs. Charles C. G. Chaplin, and with funds contributed by Marion Boulton Stroud, Mr. and Mrs. Robert Kardon, Gisela and Dennis Alter, and Mrs. H. Gates Lloyd, 1986-70-1

© Martin Puryear, courtesy Matthew Marks Gallery

A telling example of Martin Puryear's ability to meld modernist sculpture and craft, this simple, delicately handmade wood structure embraces a vocabulary of materials and a formal tradition that encompasses the elegant work of Constantin Brancusi as well as the monumental volumes that preoccupied many artists in the 1970s. Puryear made the hollow form by bending and weaving hundreds of thin strips of wood, using a technique that recalls boat-building or basketry. Transforming simple materials and geometry, he created a surprisingly talismanic object, both charismatic and theatrical in its human scale and subtly confrontational presence. AVI

CONTEMPORARY COSTUME AND WORKS IN FIBER

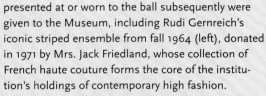

When the Museum's first costume galleries opened in 1947 under the sponsorship of the Philadelphia Fashion Group, an association of industry professionals, it featured a room dedicated to works by thirteen contemporary American designers. Between 1957 and 1973, the Fashion Group organized the Crystal Ball, a biennial event that honored fashion's elite and showcased the latest styles from American and European designers. Garments and accessories

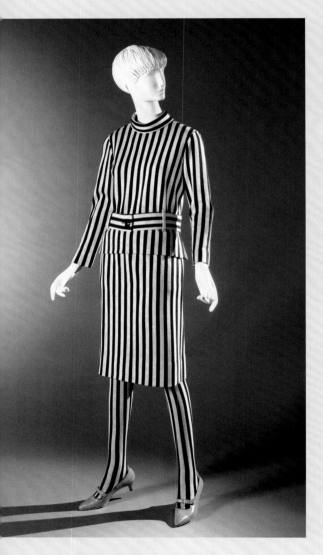

presented at or worn to the ball subsequently were given to the Museum, including Rudi Gernreich's iconic striped ensemble from fall 1964 (left), donated in 1971 by Mrs. Jack Friedland, whose collection of French haute couture forms the core of the institution's holdings of contemporary high fashion.

In the decades since, unique runway models have been acquired from donors such as rock musician John Cale, whose gift of more than one hundred garments and accessories, including Yohji Yamamoto's coat with a lining featuring an image of a mermaid pinup girl (right, top), significantly expanded the Museum's menswear holdings. The recent gift of more than eighty works by designer Patrick Kelly, including several of his signature button dresses (see p. 401), marked an important addition to the institution's rich collection of works by African American artists. Furthermore, the Museum has augmented its holdings with works that demonstrate the intersection between fashion and industrial design, such as Issey Miyake's red plastic bustier (right, bottom).

The collection of contemporary textiles has expanded to include examples of craft-based production, limited-edition artist-designed fabrics, and international industrial designs (see pp. 407, 409), many of which were acquired for the exhibitions *Contemporary British Design* (1974), *Design since 1945* (1983–84), and *Japanese Design: A Survey since 1950* (1994). The thirteen quilts of the Ella King Torrey Collection, including that by Sarah Mary Taylor (p. 387), augmented the Museum's holdings of late twentieth-century American textiles, as well as its holdings of works by African American and self-taught artists (see pp. 348–49).

Fiber art and wearable art, much of which overlaps with contemporary craft, also are represented in the collection, including a dozen works that span the 1960s to the 1990s by Sheila Hicks, internationally known for her experiments with fiber (see p. 411). DB

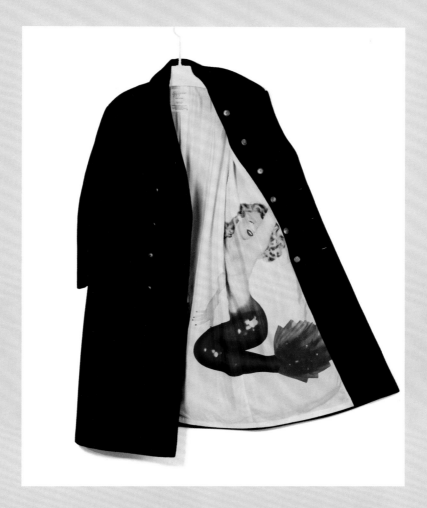

Rudi Gernreich (American, born Austria, 1922–1985) for
Harmon Knitwear (Marinette, Wisconsin)

Ensemble, 1964
Wool
Gift of Mrs. Jack M. Friedland, 1971-67-9a–f

Yohji Yamamoto (Japanese, born 1943)

Coat, 1991–92
Wool, rayon
125th Anniversary Acquisition. Gift from the private collection of
John Cale, 2000-65-55

Designed by Issey Miyake (Japanese, born 1938); made by
Issey Miyake, Inc. (Tokyo, 1970–present)

Bustier, 1980
Plastic
Purchased with the Costume and Textiles Revolving Fund,
1992-136-1

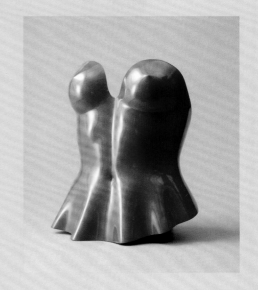

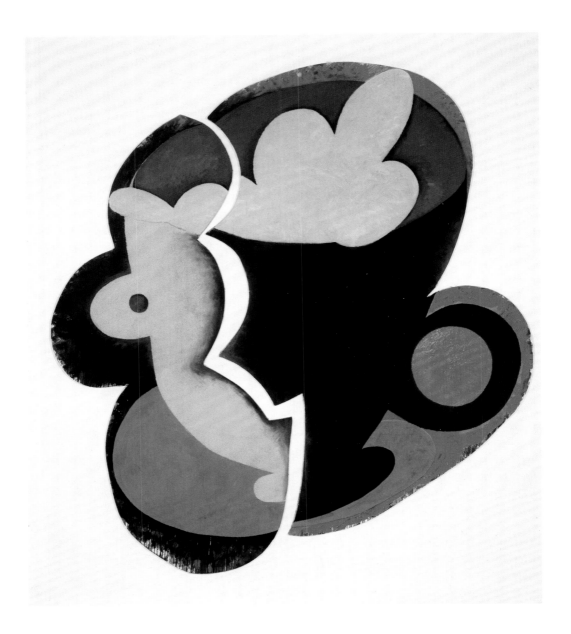

Elizabeth Murray (American, 1940–2007)

Just in Time, 1981

Oil on two canvas sections, 8 ft. 10 in. × 8 ft. 1 in. (2.69 × 2.46 m) overall

Purchased with the Edward and Althea Budd Fund, the Adele Haas Turner and Beatrice Pastorius Turner Memorial Fund, and with funds contributed by Marion Boulton Stroud and Lorine E. Vogt, 1981-94-1a,b

© 2014 The Murray-Holman Family Trust / Artists Rights Society (ARS), New York

Painted in combinations of unexpected colors on irregularly shaped canvases, Elizabeth Murray's exuberant and often humorous images of everyday objects navigate an idiosyncratic line between domesticity and abstraction. Here two parts of a giant cup and saucer seem to hover at the precise point of magnetic tension between snapping together and pushing apart. Although the jagged fissure in the crockery suggests conflict, the two separate canvases are linked by the artist's sensuous use of color and bold, simplified imagery. AVl

Patrick Kelly (American, c. 1954–1990)

Dress, 1987
Wool, synthetic knit, suede, plastic buttons
Promised gift of Bjorn Guil Amelan and Bill T. Jones

The first American couturier admitted to France's
prestigious Chambre Syndicale de la Haute Couture
Parisienne, preeminent African American designer
Patrick Kelly was inspired by the fashion scene in
1980s Paris, where he launched his namesake label in
1985, and by his upbringing in Mississippi. Although
he embellished his garments with many types of
objects, including dice and teddy bears, his use of
assorted buttons, inspired by his childhood memories
of his grandmother's mending, became his signature.
This playful dress is part of the major gift of Kelly's
clothes and accessories that was promised to the
Museum in 2013 by his former business and life
partner Bjorn Guil Amelan and the choreographer
Bill T. Jones. LLC

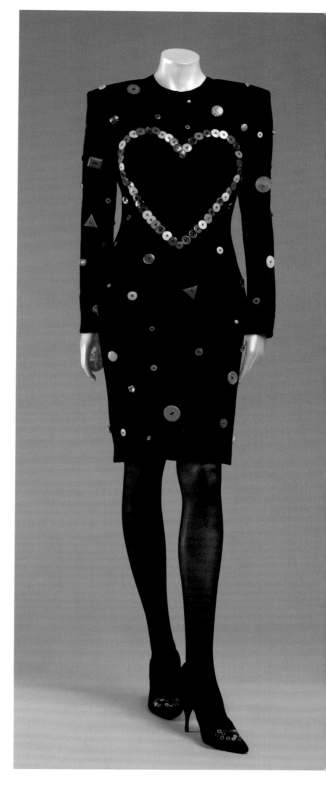

Carrie Mae Weems (American, born 1953)

Untitled, from *Kitchen Table Series*, 1990 (negative), 2011 (print)
Three gelatin silver prints, image and sheet: 27¼ × 27¼ in.
(69.2 × 69.2 cm) each
Gift of Marion Boulton Stroud, 2011-194-2a–c
© Carrie Mae Weems, courtesy of the artist and Jack Shainman Gallery, NY

Carrie Mae Weems's *Kitchen Table Series*, which
chronicles a fictionalized career woman navigating
her roles as a lover and a mother, is one of several
projects by the artist that mine photographic tradi-
tions while exploring the sexual and racial politics of
contemporary life. The use of a fixed, stagelike setting
gives the series the feel of a film or television show,
and the economical use of props and the subjects'
facial expressions further contribute to the sense of
theatricality. This triptych is suffused with erotic
tension and emotional distance, but it provides few
other clues, leaving us to contemplate whether we
are observing stereotyped behaviors or powerful
individual emotions. PB

Sebastião Salgado (Brazilian, born 1944)

Sugarcane Farming, Havana, Cuba, 1988
Gelatin silver print, image: 13⅞ × 21 in. (35.2 × 53.3 cm)
Gift of Eastman Kodak Company, 1999-21-5
© Sebastião Salgado / Amazonas Images / Contact Press Images

Between 1986 and 1991 Sebastião Salgado photo-
graphed manual laborers in more than twenty coun-
tries across five continents. Building on the work of
earlier documentarians such as Lewis W. Hine and
W. Eugene Smith, Salgado's pictures pay tribute to the
workers' grueling labor and enduring spirits. His deft
use of art-historical references—here, for example,
the figures' arrangement recalls seventeenth-century
Dutch group portraits of guild members—places his
subjects within the larger context of the history of
labor. In 1999 the Museum acquired a complete set of
prints from Salgado's book *Workers: An Archaeology of
the Industrial Age* (1993), which features 350 photo-
graphs from this epic project. ANB

Mary Ellen Mark (American, 1940–2015)

Acrobat Sleeping. Famous Circus, Calcutta, India, 1989

Gelatin silver print, image: 15 × 14⅞ in. (38.1 × 37.8 cm)
Gift of the artist in memory of Anne d'Harnoncourt, 2009-221-1
© Mary Ellen Mark

In the 1960s Mary Ellen Mark made portraiture her primary focus, traveling internationally to photograph people and the lives they lead. This image, part of Mark's extended project documenting the itinerant circuses of India, illustrates her journalistic attention to the backstage existence of the circus performers— their daily practices, their improvised living quarters, and the surrogate family relationships that sprung up among them. The sleeping girl, with her makeup applied and her cosmetics arrayed nearby, represents one of Mark's abiding subjects: children approaching the dangerous shoals of adulthood, hovering between innocence and worldliness. PB

Glenn Ligon (American, born 1960)

Untitled (I'm Turning into a Specter before Your Very Eyes and I'm Going to Haunt You), 1992

Oil and gesso on canvas, 80⅛ × 32⅛ in. (203.5 × 81.6 cm)
Purchased with the Adele Haas Turner and Beatrice Pastorius Turner Memorial Fund, 1992-101-1

Glenn Ligon's paintings of stenciled letters employ language to question the meaning of identity and representation. For this work, he used an excerpt from French writer Jean Genêt's 1959 play *The Blacks*, making a slight but crucial alteration to the original text by changing its third-person voice to first person. As the text moves down the canvas in obsessive repetition, its legibility diminishes with the buildup of paint, thus performing its very meaning. By obscuring the identity of the speaker through the use of borrowed text and stenciled letters, Ligon subtly has alluded to the complexities involved in representing racial identity in either paint or words. AVl

Felix Gonzalez-Torres (American, born Cuba, 1957–1996)

"Untitled" (Petit Palais), 1992

Lightbulbs, porcelain light sockets, extension cord; overall dimensions vary with installation
Gift of the Peter Norton Family Foundation, 1992-99-1

A simple string of everyday lightbulbs, Felix Gonzalez-Torres's sculpture rejects a monumental or heroic tone in favor of a quietly personal and elegiac approach. Inspired by Paris streetlights and named after one of the city's historic buildings, it is designed to suggest a wide range of meanings, incorporating both the artist's and the viewer's responses and memories, as well as the poignant tension between light's capacity for revelation and transcendence and its inevitable dimming over time. The sculpture's open-ended quality is reinforced by the artist's stipulation that its configuration may change each time it is installed. AVl

Geoffrey Beene (American, 1927–2004)

"Mercury" Evening Dress, 1994–95
Synthetic lamé velvet
Gift of Geoffrey Beene, 1997-96-1

Throughout his illustrious career, Geoffrey Beene's innovative designs ranged from simply elegant to demurely feminine to subtly witty, always reflecting his singular vision of fashion. Every design presented him with an architectural puzzle, which he resolved by using color and fabric inventively, fearlessly pairing the unexpected, to create meticulously crafted, wearable clothing that was cleanly cut and seemingly weightless. Beene reveled in the female form: In this dress, a gift from the designer himself, the fluid metallic fabric spills over the wearer's contours like liquid silver, while the designer's signature side cutouts and bare back expose and glorify the body. HKH

José Bedia (Cuban, born 1959)
Spell of the Moon, 1991
Pen and brush and ink on amate paper, sheet: 47 × 95 in.
(119.4 × 241.3 cm)
Purchased with the Hunt Corporation (formerly Hunt
Manufacturing Co.) Arts Collection Program, 1991-147-1

The dog-man in this enormous ink drawing, trapped
by concentric force-lines emanating from the moon,
embodies the magic and divination aspects of Palo
Monte, the Afro-Cuban religion combining Catholic
and West African beliefs that José Bedia practices.
Fascinated by aboriginal cultures, Bedia seeks to tap
into a sort of universal quality of primitivism and to
conflate this with present-day reality. This piece was
purchased with one of a series of grants offered by
the Hunt Corporation of Philadelphia in the 1980s
and 1990s that encouraged the Museum to purchase
"adventurous and risk-taking" contemporary works
on paper, a charge that enriched its holdings by close
to three hundred pieces (see also pp. 396, 412). AP

Designed by **Reiko Sudo** (Japanese, born 1953); made by
Nuno Corporation (Tokyo, 1984–present)
Detail of "Feather Flurries" Textile, 1993
Silk with feathers, 9 ft. 10 in. × 3 ft. 9¼ in. (3 × 1.15 m)
Gift of Nuno Corporation, 1995-95-1

Since 1987 Reiko Sudo has served as the chief execu-
tive officer and artistic director of Nuno, the textile
company she founded with designer Junichi Arai in

1984. Under her leadership, the firm has combined
traditional Japanese aesthetics with the latest tech-
nologies to create innovative yet functional fabrics
with unorthodox finishes. For Sudo's 1993 *Heat Shrink*
series, thermoplastic printing was used to produce
textiles with textural effects, such as this example with
heat-infused feathers, and her *Jellyfish* fabric that was
flash-heated to create a crinkled surface. LLC

COLLAB AND CONTEMPORARY DESIGN

Collab (short for *collaboration*) is a Museum affiliate established in 1970 to help the Museum acquire modern and contemporary objects and initiate programs around them. Composed of design professionals, Collab raises funds for Museum acquisitions, exhibitions, lectures, and an annual student-design competition. Since the group's inception, exhibitions supported by Collab have been the Museum's major vehicle for acquiring contemporary design objects, prompting gifts from designers, individuals, and manufacturers. The largest Collab exhibition, *Design since 1945* (1983–84), included Maija Isola's *Melon* fabric, made in 1963 by the Finnish firm Marimekko (below). Drawing parallels to contemporary abstract painting with their colorful geometric patterns and bold scale, Marimekko-manufactured fabrics revolutionized the dress- and furnishing-fabric industries in the 1950s and 1960s.

Over the past two decades, Collab has supported exhibitions featuring recipients of the group's annual Design Excellence Award, given to designers or manufacturers that have made extraordinary contributions to the field. Since 2007 these exhibitions have been held in the Museum's first permanent gallery for modern and contemporary design, generously endowed by trustee and Collab member Lisa S. Roberts and her husband, David W. Seltzer. In 2008, in honor of that year's award recipient, Frank O. Gehry, trustee Marion Boulton Stroud gave the Museum the architect's monumental *Fish* lamp (right, bottom). Gehry used irregular fragments of the Formica Corporation's new ColorCore laminate for the scales of the fish and to suggest the movement of water on the lamp's base.

In 2011, in recognition of Collab's fortieth anniversary the previous year, the Museum presented an exhibition of more than fifty works secured for the collections with Collab's support. For the first time in the institution's history, visitors to the exhibition and to the Museum's website were invited to help select an object for acquisition, to be purchaed by Collab on behalf of the Museum. Of the four chairs presented as candidates, Marc Newson's *Wood* chair of 1988 (right, top), with its simple, double-curve form composed of bent beechwood strips, was the overwhelming popular favorite. This would prove a prescient gift, as in 2013 Collab honored Newson with its design award and the related exhibition *Marc Newson: At Home*. Thus, Collab's exhibition program continues to the present, and with it the Museum's ongoing acquisition of contemporary design. KBH

Designed by **Maija Isola** (Finnish, 1927–2001); made by **Marimekko Oy** (Helsinki, 1951–present)

"Melon" Fabric, designed 1963
Screen-printed cotton, 72 × 54 in. (182.9 × 137.2 cm)
Gift of Marimekko Oy, 1983-131-4

Designed by **Marc Newson** (Australian, born 1963); made by **Cappellini S.p.A.** (Arosio, Italy, 1946–present)

"Wood" Chair, designed 1988
Bent beechwood, H. 27⁹⁄₁₆ in. (70 cm)
Purchased with funds contributed by Collab: The Group for Modern and Contemporary Design at the Philadelphia Museum of Art in honor of Eileen Tognini, 2011-142-1

Designed by **Frank O. Gehry** (American, born Canada 1929); made by **New City Editions** (Venice, California)

"Fish" Lamp, designed c. 1983, made 1984–86
ColorCore, wood, silicone; H. 68½ in. (174 cm)
Gift of Marion Boulton Stroud, 2008-263-1

Gabriel Orozco (Mexican, born 1962)

Black Kites, 1997
Graphite on skull, H. 8½ in. (21.6 cm)
Gift (by exchange) of Mr. and Mrs. James P. Magill, 1997-171-1a,b
© Gabriel Orozco

Described by the artist as a drawing in three dimensions, *Black Kites*—a bleached human skull traversed by a graphite-pencil design—provocatively integrates structure and surface, line and volume. Gabriel Orozco's aesthetic favors modest over monumental and reveals unexpected sensuality in common objects and materials. Although the skull is a motif deeply entrenched in the art and traditions of Orozco's native Mexico, here it is transformed into a strikingly contemporary object of rich ambiguity. The title is typical of the artist's allusive names for his works; the mental image of black diamond-shaped kites soaring in the sky transports the heavy, earthbound skull into an airborne poem. *Black Kites* is a skillful meditation on the complex act of creative thinking, an action that is simultaneously abstract and grounded in the experience of our finite bodies. AVI/AT

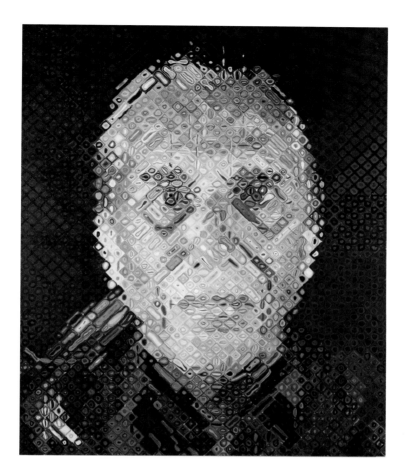

Sheila Hicks (American, born 1934)

Trésors et secrets, c. 1990
Mixed fibers, DIAM. (largest) 9½ in. (24.1 cm)
Gift of the artist, 1995-15-1a–bb, 72-2a–qq
© Sheila Hicks

A pioneer in the fiber-arts movement, Sheila Hicks
has gained international fame for her innovative
works made of textiles, from small weavings to large
sculptural works created in collaboration with archi-
tectural and industrial firms. She often incorporates
into her art found objects, which she reimagines as
new forms. For her ongoing series *Trésors et secrets*
(Treasures and secrets), begun in 1990, miscellaneous
items, such as family memorabilia, are wrapped with
layers of cloth and thread, thus concealing their iden-
tities and histories. The variously sized "soft stones"
that result, seventy-one of which are in the Museum's
collection, can be displayed in any configuration, with
as many or as few as needed. DB

Chuck Close (American, born 1940)

Paul, 1994
Oil on canvas, 8 ft. 6 in. × 7 ft. (2.59 × 2.13 m)
Purchased with funds (by exchange) from the gift of Mr. and Mrs.
Cummins Catherwood, with the Edith H. Bell Fund, and with
funds contributed by the Committee on Twentieth-Century Art,
1994-166-1
© Chuck Close, courtesy Pace Gallery

This full-face portrait of American artist Paul Cadmus
is representative of the unique painting method
Chuck Close has employed since the 1960s. Working
from black-and-white Polaroid photographs that he
takes himself, Close covers them with a grid pattern
and transposes the images onto monumental canvases.
His iconic paintings coalesce into grand, cohesive por-
traits only when viewed from afar; at close range they
remain abstract arrangements of colors and shapes. By
highlighting the tension between paint's materiality
and its power of illusionistic description, Closes's por-
traits challenge the viewer's perception. AT/AVl

Richard Hamilton (English, 1922–2011)

Attic, 1995
Computer-printed transparency, mounted on canvas; 48 × 96 in.
(121.9 × 243.8 cm)
Purchased with funds contributed by the Committee on
Twentieth-Century Art, with additional funds contributed by Mr.
and Mrs. Keith L. Sachs, The Dietrich American Foundation, and
Marion Boulton Stroud, 1997-44-1
© R. Hamilton. All Rights Reserved. DACS and ARS 2014

Considered the founder of the British Pop art move-
ment, Richard Hamilton was a leading member of
the London-based Independent group, a gathering of
artists and thinkers in the early 1950s who questioned
prevailing attitudes toward contemporary visual
culture. In his work since that time, Hamilton appro-
priated devices of consumer culture, often invoking
the look and language of advertising, in order to
critique them. In later work such as this, he posited
computer-generated painting as a new form of col-
lage by incorporating a variety of images that evoke
themes explored throughout his career. These include
the domestic environment and his artistic influences,
such as Marcel Duchamp, to whom Hamilton was a
close friend and kindred spirit. EFB/AVl

Zhang Huan (Chinese, born 1965)

To Raise the Water Level in a Fish Pond, 1997
Chromogenic print, image: 27 × 40½ in. (68.6 × 102.9 cm)
Purchased with the Hunt Corporation (formerly Hunt
Manufacturing Co.) Arts Collection Program, 1999-33-1
© Zhang Huan Studio, courtesy Pace Gallery

In 1997 in Beijing, Zhang Huan persuaded a group
of rural day laborers, who represented China's broad
worker migration from the countryside to the city, to
stand in a shallow pond in a park, thereby elevating
the water level. A seemingly futile gesture whose inef-
ficacy is reinforced by the impassive expressions of
the anonymous participants, the photograph none-
theless documents the presence of these new urban
inhabitants, and demonstrates the unavoidable effects
of bodies upon one another. It also points up the
inextricable links between ideas and things. PB

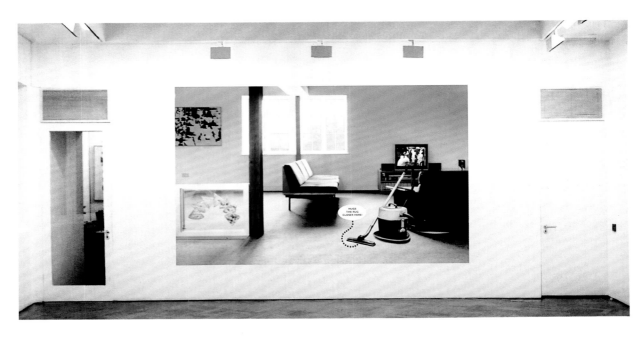

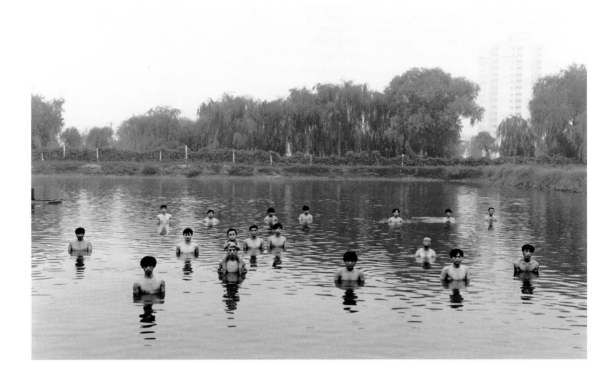

Francis Alÿs (Belgian, born 1959)

Fairy Tales, Stockholm, 1998

Left painting: oil, enamel, and encaustic paints on wood; right painting: oil, enamel, and encaustic paints on canvas on wood; left painting: 7³⁄₁₆ × 11¼ in. (18.2 × 28.6 cm), right painting: 7⅛ × 11⁵⁄₁₆ in. (18.1 × 28.7 cm)

Purchased with the Edith H. Bell Fund, 2007-203-1a,b

© Francis Alÿs

This pair of paintings references a performance walk Francis Alÿs undertook in Stockholm from the Museum of Science and Technology to the Nordic Museum. Each figure's unraveling blue sweater, like the one worn by Alÿs during the walk, leaves a trail suggesting his otherwise intangible journey. When displayed, the two nearly identical paintings are to be shown in separate galleries. The déjà vu experienced by viewers upon unexpectedly encountering the second canvas invites them to consider their individual paths through the Museum's spaces, while the apparent repetition alludes to the artist's interest in the circular temporality of fairy tales. A visual archive documenting Alÿs's performance accompanies the paintings and lends further context to the project. AVI

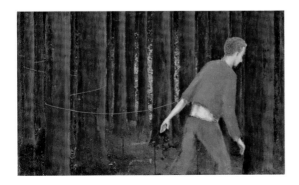

Franz West (Austrian, 1947–2012)

Delivery, 1997
Papier-mâché, gauze, plaster, paint, wood; H. (tallest) 31⅛ in. (79.1 cm)
Purchased with funds contributed by the Committee on Twentieth-Century Art, 1998-72-1–5
© Legal successor of the artist

Extreme sophistication merges with the informal, and at times the abject, in Franz West's drawings, installations, and sculptures. By foregrounding the material quality of his work, he revealed how art is first and foremost matter transformed, but always matter nonetheless. *Delivery* is both joyful and ironic in its celebration of color, arbitrariness, and sheer playfulness. Its unexpected beauty comes from its studied casualness and the assertive singularity of each object. West came of age as an artist during the heyday of the Vienna Actionists, whose gory sensationalism he disliked. Nonetheless, he was imbued with their sense of art as something to be engaged with the body, actively produced and experienced. CB

Yoon Kwang-cho (Korean, born 1946)

Heart Sutra, 2001
Stoneware with white-slip, H. 31⅞ in. (81 cm)
Purchased with the Hollis Fund for East Asian Art Acquisitions, 2003-177-1

A pioneer in the field of modern Korean ceramics, Yoon Kwang-cho is renowned for his creative interpretation of traditional slip-decorated *buncheong* ware, a ceramic type produced during the first two hundred years of the Joseon dynasty (1392–1910). In the mid-1990s he extended his interest to the time-honored Buddhist ritual of copying the ancient Heart sutra, a practice through which worshippers accrue merit for their next existence. Here he transcribed the ancient text into the surface of this large vessel, using a nail to incise each character into the semidried clay. HW

Robert Gober (American, born 1954)

Untitled, 1999
Plaster, beeswax, human hair, cotton, leather, aluminum pull tabs, enamel paint; H. 33½ in. (85.1 cm)
Gift (by exchange) of Mrs. Arthur Barnwell, 1999-51-1
© Robert Gober, courtesy Matthew Marks Gallery

Robert Gober's handcrafted sculptures of recognizable yet fractured objects speak in the ambiguous language of symbols or dreams with which Surrealist artists first conjured powerful images of desire and anxiety in the 1920s. Often incorporating plaster casts of body parts and plumbing fixtures—here two left legs, each donning socks and sandals, dangle from the faucet holes of a sink—his uncanny juxtapositions evoke themes of childhood, loss, memory, sexuality, and spiritual redemption. Wavering between the illusory and the real, the erotic and the macabre, Gober's sculptures allude to strategies and images used by artists such as Marcel Duchamp and Jasper Johns. AVI

Sean Scully (American, born Ireland 1945)

Iona, 2004–6
Oil on linen, 9 ft. 2 in. × 11 ft. (2.79 × 3.35 m) each
Gift of Alan and Ellen Meckler, 2010-186-1a–f
© Sean Scully

Since the late 1960s, Sean Scully has maintained an engagement with the history and ongoing development of geometric abstraction through his paintings combining simple compositions with gestural brushwork and a sensitivity to light and color. Employing references both specific and poetic, his work points to the legacies of Abstract Expressionism and Minimalism as well as to his own personal experiences. Among Scully's greatest achievements, *Iona* was named for a small island off the coast of Scotland, which the artist visited in 1990. Its triptych format—a convention of Christian altarpieces—may allude to the important monastic communities of the island's medieval past. JV

Thomas Hirschhorn (Swiss, born 1957)

Camo-Outgrowth (Winter), 2005
Wood, cardboard, adhesive tape, 119 globes, printed matter;
H. 11 ft. 5 in. (3.48 m)
Purchased with funds contributed by the members of the
Committee on Modern and Contemporary Art, 2005-150-1
© 2014 Artists Rights Society (ARS), New York / ADAGP, Paris

Emblematic of his inventive sculptural works often
made from precarious materials, such as the mask-
ing tape and magazine and newspaper clippings seen
here, Thomas Hirschhorn's *Camo-Outgrowth (Winter)*
responds to contemporary culture's inexplicable
fascination with armed conflict. The sequence of
globes distorted by tumor-like masses juxtaposed with
images of camouflage clothing and motifs stylistically
references the repetitive impulse of Minimal art, while
at the same time suggesting the seemingly oppressive
omnipresence of war. For Hirschhorn the pervasive-
ness of camouflage, including its effortless migration
from combat to fashion, attests to modern society's
troubled relationship with violence. AVI

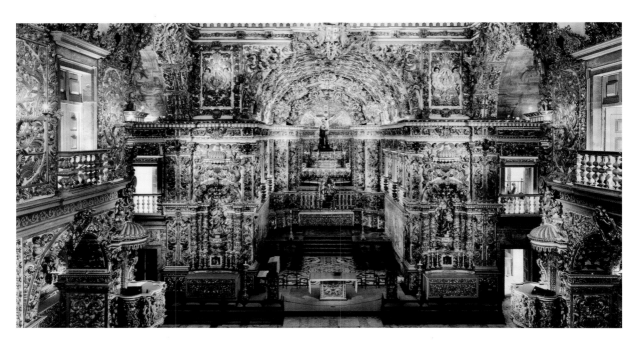

Candida Höfer (German, born 1944)

Church of Saint Francis of Assisi, Salvador, Bahia III, 2005

Chromogenic print, image (approx.): 4 ft. 7 in. × 8 ft. 9½ in. (1.4 × 2.68 m)

Purchased with funds contributed by the Young Friends of the Philadelphia Museum of Art and with the Leo Model Foundation Curatorial Discretionary Fund, 2006-81-1

© 2014 Artists Rights Society (ARS), New York / VG Bild-Kunst, Bonn

This view of a colonial Baroque church interior exemplifies Candida Höfer's meticulous approach in her photographs of public places. Matching the dizzying, resplendent detail of the building with the formidable technologies of her camera and computer, she has invited the viewer to pause and survey the remarkable space. The wealth of details inevitably leads one to ponder not only the mysteries of faith but also the riches of the church that built this monument. As with many of Höfer's finest works, we find ourselves immersed in a dazzling pictorial tour de force that makes us face the social complexities of the past and the present. PB

Shahzia Sikander (Pakistani, born 1969), in collaboration with the **Fabric Workshop and Museum** (Philadelphia, 1977–present); printed by **Durham Press** (Durham, Pennsylvania, 1988–present)

The Illustrated Page Series #1, 2005–6
Color screenprint with additions in watercolor and gold leaf, sheets (two joined): 56⅝ × 71¹⁵⁄₁₆ in. (143.8 × 182.7 cm) overall
Purchased with the Marion Stroud Fund for Contemporary Art on Paper in honor of Innis Howe Shoemaker, 2006-138-1a,b
© Shahzia Sikander

Designed to suggest two pages of an open book, this grand diptych unites Shahzia Sikander's disciplined training in Indian and Persian miniature painting with her penchant for large-scale wall paintings and installations. Combining a Western emphasis on creativity and subjective expression with an Eastern concentration on precision and stylistic consistency, Sikander explores cultural iconographies and open-ended narratives in her work, subtly inserting contemporary elements, such as the soccer balls seen here, into intricate compositions inspired by traditional manuscript miniatures. Working with assistants at the Fabric Workshop and Museum in Philadelphia, she employed the collaborative practice used in Southeast Asian workshops to produce this elaborate silk-screened image with its hand-applied details. SRL

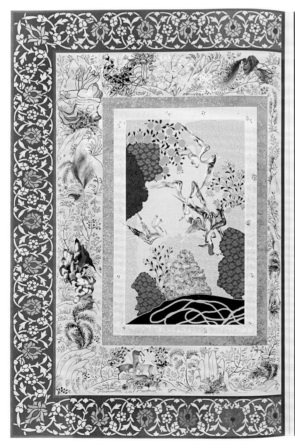
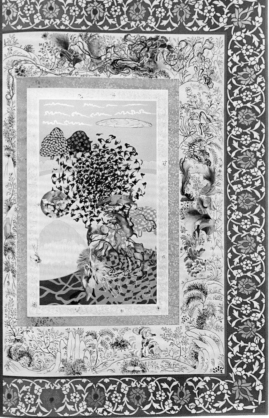

Rachel Harrison (American, born 1966)

Nice Rack, 2006
Wood, polystyrene, cement, inkjet print, hardwood dolly, greeting-card rack, shovel, artificial peaches, bejeweled barrettes, rotary phone; H. 99 in. (251.5 cm)
Purchased with funds contributed by the Committee on Modern and Contemporary Art, 2008-231-1a–g
Courtesy of the artist and Greene Naftali, New York

A feminist paraphrasing of the slang expression "nice rack," Rachel Harrison's witty and inventive mixed-media assemblage negotiates traditional boundaries between photography, sculpture, and installation art. Ostensibly haphazard, her choice of unremarkable objects and materials—fake pearls, an obsolete telephone, a shovel, a greeting-card rack, and a framed print featuring a portrait of Ronald Reagan from a work by the German Conceptual artist Hans Haacke—is extremely precise and deliberate. Referencing commercialism, Reaganism, and the history of Conceptual art as well as the still-life paintings of Paul Cézanne, Harrison's sculptural composition addresses the scrambling of hierarchies in contemporary visual culture. AVl

Designed by **Hella Jongerius** (Dutch, born 1963); made by **Porzellan Manufaktur Nymphenburg** (Nymphenburg, Germany, 1747–present)

"Four Seasons" Candleholder, Hand Mirror, Teapot, and Wine Jug, 2007
Painted porcelain, H. (teapot) 10½ in. (26.7 cm)
Purchased with the John D. McIlhenny Fund, 2010-59-1, 60-1a–d, 61-1,62-1

Like other historical European porcelain factories over the last decade, the Nymphenburg manufactory has invited talented contemporary artists, such as Dutch designer Hella Jongerius, to update its production. Known for using traditional forms and techniques in innovative ways, Jongerius was given access to Nymphenburg's vast archives, including hundreds of molds and paint formulas developed by the factory over its long history. For her *Four Seasons* series, she was inspired by eighteenth-century master modeler Dominikus Auliczek's set of four mythological figures representing the seasons—Hercules for winter, Flora for spring, Ceres for summer, and Bacchus for autumn. Jongerius had casts made of each figure's head, which then were decorated with appropriate seasonal attributes and whimsically applied to everyday objects—the head of Hercules to a candleholder,

Flora to a hand mirror, Ceres to a teapot, and Bacchus to a wine jug. By combining traditional forms in unconventional ways, Jongerius has blurred the boundaries between past and present. KBH

Motoko Maio (Japanese, born 1948)
The Soul of Language, 2008
Silk and paper, mounted as a pair of screens; H. (tallest) 60¹⁄₁₆ in. (152.5 cm)
Purchased with funds contributed by Mr. and Mrs. Howard H. Lewis and an anonymous donor, 2009-79-1a,b

Invented in Japan, the folding screen with paper hinges is both an architectural element, serving as a portable wall, and a focus for aesthetic contemplation. One of the few contemporary artists working with this demanding art form, Motoko Maio has grafted her singular vision onto the traditional screen, adapting it to present-day Japanese culture. A superb example of Maio's work, the surface of this pair of six-fold screens is layered with pieces of red silk cut from a kimono and with scraps of paper from antique books and ledgers. The reverse side of each screen is covered with these paper fragments, creating a dynamic and visual world of words. FF

THE KEITH L. AND KATHERINE SACHS COLLECTION

Comprising more than one hundred works of art made after 1950, the Keith L. and Katherine Sachs Collection is among the most important holdings of contemporary art on the East Coast. In 2014 ninety-seven of these objects were offered to the Museum, representing a transformative gift to the institution. These works both complement and supplement the Museum's existing holdings of contemporary art, a testimony to Mr. and Mrs. Sachs's deep affection and careful concern for the institution and its collection.

Over the course of more than forty years, the couple has nurtured relationships with many of the artists they admire, resulting in particularly rich selections of works by Jasper Johns and Ellsworth Kelly, two pivotal figures of twentieth-century art. Among their holdings is Johns's painting *Nines* (2006; right, top), in which the artist's complex visual vocabulary

of interlacing materials, motifs, and primary colors is powerfully balanced in a composition "dressed to the nines."

The Sachs Collection also encompasses important examples by major postwar artists including Richard Hamilton, Gerhard Richter, and Brice Marden, whose painting *Red Ground Letter* (2007–10; right, bottom) is part of his series of works inspired by Chinese calligraphy. The composition's monochromatic bands of muted color communicate a sense of movement in space that references the art of writing.

As one of the most fruitful channels of expression for artists working today, video art is a particular strength of the collection, with examples by such celebrated figures as Francis Alÿs, Pierre Huyghe, and Steve McQueen. Large-scale photography, including distinguished works by Candida Höfer, Clifford Ross, and Jeff Wall, also is well represented.

Tony Smith (American, 1912–1980)

Die, 1962
Steel with oiled finish; н. 72 in.
(182.9 cm)
Promised gift of Keith L. and
Katherine Sachs
© 2014 Estate of Tony Smith / Artists Rights
Society (ARS), New York

Jasper Johns (American, born 1930)

Nines, 2006
Encaustic and oil on canvas with
objects, н. 73¼ in. (186.1 cm)
Promised gift of Keith L. and
Katherine Sachs
Art © Jasper Johns / Licensed by VAGA, New York

Brice Marden (American, born
1938)

Red Ground Letter, 2007–10
Oil on linen, 72 × 96 in. (182.9 ×
243.8 cm)
Promised gift of Keith L. and
Katherine Sachs
© 2014 Brice Marden / Artists Rights Society
(ARS), New York

In addition, the collection features an exceptional ensemble of outdoor sculpture by, among others, Richard Long, Richard Serra, and Tony Smith. A six-foot cube of quarter-inch hot-rolled steel whose dimensions were based on the proportions of the human body, Smith's seminal sculpture *Die* (1962; left) embodies a Minimalist aesthetic in its form, materials, and relation to space.

The extraordinary gift of the Sachs Collection has significantly expanded the scope of the Museum's collection of contemporary art, deepening its holdings of works by some of the most influential artists of the postwar period while enabling the institution to present a more comprehensive narrative of the art of the last six decades. AVI/CB

Kara Walker (American, born 1969); printed by **Burnet Editions** (New York)

No World, 2010
Etching with aquatint, sugar-lift, spit bite, and drypoint; plate:
24 × 35¾ in. (61 × 90.8 cm)
Purchased with the Marion Stroud Fund for Contemporary Art
on Paper, 2010-142-1
© Kara Walker

Best known for her installations of enigmatic black cut-paper figures that recall Victorian silhouettes, Kara Walker uses provocative imagery to address the complex legacy of discrimination, oppression, and sexual exploitation initiated by the transatlantic slave trade. Blending elegantly crafted forms, biting humor, and horrific, often violent subjects drawn from stereotypes of the antebellum South, she avoids explicit narratives, instead compelling the viewer to contemplate multiple interpretations. Here she conflates a vignette of plantation life with a distressed ship and a nude woman in watery depths, exploiting the carefully modulated black and gray aquatint tones to underscore the graphic power of the silhouetted forms and the dark tenor of her subject. SRL

Steve McQueen (English, born 1969)

Static, 2009
35 mm film transferred to HD; continuous projection; duration:
7 min.
Partial gift of The Katherine and Keith L. Sachs Art Foundation
and purchased with the Modern and Contemporary Art
Revolving Fund, 2010-12-1a–e
Courtesy of the artist; Marian Goodman Gallery, New York / Paris; and Thomas
Dane Gallery, London

Since the 1990s, the Museum has actively been
collecting film and video works by contemporary
artists in an effort to augment its holdings of these
increasingly relevant mediums. Steve McQueen is
among the most accomplished and influential film-
makers today. Characterized by a highly polished
cinematic vocabulary, his films employ a language
in which both formal and psychological elements
intricately complement each other. For *Static* the artist
filmed the iconic Statue of Liberty from a helicopter.
Dedicated in 1886, this monument, a gift from the
people of France to the citizens of the United States,
is acknowledged universally as a symbol of freedom
and democracy. Circling counterclockwise around the
colossal figure for seven minutes, the camera zooms
in and out, capturing the features of the famous land-
mark as well as a series of astonishingly beautiful
images of the surrounding landscape. By choosing the
statue as the subject of his investigation, McQueen
has upheld and interrogated the meaning of the ideals
it represents in today's global context. AVI

Index of Works